Designed Engraved, and Publishd by Wm Hogarth March 5, 1753, according to Act of Parliament.

HOGARTH'S PROGRESS

Also by Peter Quennell

Biography
BYRON: THE YEARS OF FAME
CAROLINE OF ENGLAND: AN AUGUSTAN PORTRAIT
BYRON IN ITALY
THE PROFANE VIRTUES: FOUR STUDIES OF THE EIGHTEENTH CENTURY
JOHN RUSKIN: THE PORTRAIT OF A PROPHET

Essays
THE SINGULAR PREFERENCE

Fiction
THE PHOENIX-KIND

HOGARTH'S PROGRESS

PETER QUENNELL

VARIETY

NEW YORK
THE VIKING PRESS
1955

To
Sonia Leon

Preface

ALTHOUGH WHISTLER once described him as the greatest of English painters, remarkably few books have been written about William Hogarth; and Austin Dobson's authoritative biography has held the field almost unchallenged for more than fifty years. In this book, I have not attempted to assume the role of art-historian: what I have tried to do is to draw a portrait of the artist, and to relate an account of his works to the description of the period in which he lived. I have had much encouragement and many helpers. Lord Ilchester, for example, besides allowing me to examine and reproduce his splendid Hogarth conversation-piece, *The Conquest of Mexico*, has drawn my attention to a number of references in the unpublished Vertue manuscripts: Professor Joseph Burke, with great generosity, placed at my disposal, the typescript of his new edition of *The Analysis of Beauty*, an admirable specimen of analytical scholarship: and Mr. Romney Sedgwick, editor of the Hervey Memoirs, has given me expert advice.

I am also indebted to Mr. Guy Welby and his assistant Mr. Temple, who explained to me the connection between silver-engraving and copper-engraving: Mr. Minto Wilson who increased my understanding of the Covent Garden neighbourhood by showing me his fine collection of eighteenth-century prints: Mr. Guy Charteris who provided some valuable information about his ancestor, Colonel Chartres: the Duchess of Buccleuch for interesting notes

7

on John Gay: Miss Irene Shubik, an authority on English seventeenth-century drama, for answering a vital question: Mr. John Summerson of Sir John Soane's Museum, Sir Leigh Ashton of the Victoria & Albert Museum, and Sir John Rothenstein of the Tate Gallery: Mr. Martin Holmes of the London Museum: Lord Glenconner and Lord Bearsted: Messrs. Routledge & Kegan Paul, publishers of Mr. R. B. Beckett's *Hogarth*, which I have found extremely úseful, although I have sometimes disagreed with his dating of Hogarth's pictures: Mr. Michael Alexander, who presented me with the title: Mr. John Hayward, who has kindly read the proofs: Miss Henrietta Lamb, who has aided me in research, and Mrs. Hutchison who, with exemplary care and patience, has typed out my manuscript.

Illustrations appear by kind permission of the following: Plates from *A Harlot's Progress, A Rake's Progress, Times of the Day, Hogarth's Peregrination,* and *The Analysis of Beauty,* the Trustees of the British Museum; *Marriage-à-la-Mode,* the Trustees of the National Gallery; Roubiliac's bust of the artist, the Trustees of the National Portrait Gallery; *Captain Coram,* the Governors of the Thomas Coram Foundation; *Miss Mary Edwards,* the Frick Collection; the *Self-Portrait of 1745,* the Trustees of the Tate Gallery; *The Lady's Last Stake,* the Albright Art Gallery, Buffalo, New York; the *Election Series,* the Trustees of Sir John Soane's Museum.

<div align="right">P. Q.</div>

Contents

I BARTHOLOMEW CLOSE page 13

II THE BATTLE OF TASTE 31

III ANNUS MIRABILIS 49

IV LONDON BACKGROUND 71

V THE PICTORIAL DRAMATIST 89

VI COVENT GARDEN 104

VII TOM RAKEWELL 126

VIII PEOPLE AND PLACES 144

IX MARRIAGE-À-LA-MODE 166

X PORTRAIT OF THE ARTIST 184

XI CALAIS GATE 202

XII THE LINE OF BEAUTY 220

XIII HUMOURS OF AN ELECTION 240

XIV WILKES AND CHURCHILL 262

XV "TAIL PIECE: THE BATHOS" 278

 BIBLIOGRAPHY 301

 INDEX 305

9

Illustrations

Explanatory plates from *The Analysis of Beauty* *Endpapers*
 By courtesy of the Trustees of the British Museum

Drawing from the title page of *The Analysis of Beauty* *Title page*
 By courtesy of the Trustees of the British Museum

Moll Hackabout and Mother Needham (*A Harlot's Progress*)
 facing page 96

Moll in Keeping (*A Harlot's Progress*) 96

Moll at Breakfast (*A Harlot's Progress*) 97

The Fleet Chaplain and Elizabeth Adams (*A Harlot's Progress*) 97

William Hogarth about 1732 112

Breakfast at Stoke (*The Five Days Peregrination*) 113

Tom Rakewell Holds Court (*A Rake's Progress*) 128

Supper at the Rose (*A Rake's Progress*) 128

Detail from *Morning* 129

Captain Thomas Coram 144

Miss Mary Edwards 145

Detail from the Breakfast Scene (*Marriage-à-la-Mode*) 176

Detail from the Visit to the Quack Doctor (*Marriage-à-la-Mode*) 176

The Countess and Silvertongue (*Marriage-à-la-Mode*) 177

The Death of the Countess (*Marriage-à-la-Mode*) 177

Hogarth Invites a Friend to the Mitre *page* 188

Hogarth and Trump, 1745 *facing page* 192

The Lady's Last Stake 193

11

Illustrations

Hogarth and Garrick *page* 201

Bubb Dodington (*The Election Series*) *facing page* 256

Details from *The Banquet* (*The Election Series*) 257

Tail Piece: The Bathos 272

The Shrimp Girl 273

I

Bartholomew Close

WILLIAM HOGARTH was born in Bartholomew Close, London, "next door to Mr. Downinge's the Printers", on November 10th 1697, under the shadow of an ancient church and in the immediate neighbourhood of a hospital, a prison, a fair-ground and a market-place. The church was that of St. Bartholomew the Great, founded in the year 1123 by Rayer or Rahere, a somewhat elusive and ambiguous personage who had spent a worldly youth at the Court of Henry I, where he was celebrated (we are told) both for his gaiety and his "carnal suavite",[1] as a minstrel and master of revels, possibly as the royal fool. Then, during a pilgrimage to Rome, he sickened of a dangerous fever and imagined that he saw a vision of St. Bartholomew looming above his bed's head. The Saint informed him that the danger would pass, but ordered him, as soon as he returned to London, to establish a priory church and a hospital for the poor and aged. Rahere recovered and punctually honoured the compact, obtaining from the King a piece of waste land just beyond the city walls. The site he chose was dismal and swampy, a rubbish-heap and urban Golgotha, previously noted for its " horrible gibbet of thieves ". Rahere purified and levelled the ground, so that it was re-named " the smooth field "; and there, on the eastern verge, he raised a noble priory of Austin Friars,

[1] Cotton MSS.

13

while, along its south-eastern side, he built the promised hospital. Four centuries later, his monastic foundation, of which he had been first prior, was despoiled and dismantled by Henry VIII, and most of the priory buildings and the whole nave of the central church were completely pulled down. But the eastern gate and the massive Norman choir escaped the fury of the Reformation. St. Bartholomew's the Great became one of a hundred London parish churches, hemmed in among houses and workshops which gnawed ruthlessly at the medieval fabric, taking its colour from the low canopy of heavy London sea-coal fog.

Around it, over the ruins of the priory, grew up a conglomeration of narrow streets and courts and passage-ways —Bartholomew Close, Cloth Fair, Barley Mow Passage, Cloth Court, Rising Sun Court, Half Moon Court, Kinghorn Street—all devoted to some kind of commerce but principally to the textile trade. Beyond the east gate extended Smithfield, the scene, since Rahere had cleared the stage, of many terrible and dramatic actions. Where Wat Tyler had halted to meet the King, and had fallen to the dagger-thrust of an apprehensive Lord Mayor, his body being carried into the shelter of the hospital and ignominiously dragged out again, the Marian martyrs had burned at the stake, shackled on their pyres to face the priory entrance. A renowned cloth-exchange throughout the Middle Ages, anxiously supervised by the Guild of Merchant Taylors, Smithfield during the Elizabethan period was famous for the sale of horses and, during the eighteenth and early nineteenth centuries, as London's largest cattle-market. Driven up through the hours of the night, when they started forth at evensong sometimes deafening village worshippers, vast floods of oxen and sheep converged on the market-place every Monday morning, in a whirlpool of stench and noise, a seething, bellowing pande-

monium of tired men and animals.[1] Smithfield drovers
were notoriously brutal and drunken. But, summer after
summer, the theatre of so much cruelty was abandoned to
four days [2] of uproarious urban jollity. Bartholomew Fair,
instituted by Rahere in 1133, was the immensely profitable
resort of hucksters, showmen and common thieves. Their
operations often alarmed the citizens; and, in the year of
Hogarth's birth, the Lord Mayor was obliged to publish
an ordinance " for the suppression of vicious practices . . .
as obscene, lascivious and scandalous plays, comedies, and
farces, unlawful games and interludes, drunkenness, etc.,
strictly charging all constables and other officers to use
their utmost diligence in prosecuting the same." During the
following year, a French tourist, the observant M. Sorbière,[3]
described his visit to the Fair, which he found to consist of
" most Toy shops, also Fiance and Pictures, Ribbon shops,
no Books; many shops of Confectioners, where any woman
may commodiously be treated. Knavery was here in per-
fection, dextrous Cut-purses and Pickpockets." He wit-
nessed an exhibition of admirable rope-dancing; and,
" coming out, I met a man that would have took off my
Hat, but I secur'd it, and was going to draw my Sword . . .
when on a sudden I had a hundred People about me, crying
' Here, Monsieur, see *Jepthah's Rash Vow* '; ' Here,
Monsieur, see *The Tall Dutchwoman* '; ' See *The Tiger*,'
says another; ' See *The Horse and No Horse* whose Tail
stands where his head should do '; ' See the *German Artist*,
Monsieur '; ' See *The Siege of Namur*, Monsieur ' "; till,
" betwixt Rudeness and Civility " he could elbow his way
out of the throng and seek the refuge of a hackney coach.
Although stage plays were formally prohibited in 1697

[1] See *Oliver Twist*. Chapter XXI.

[2] Since 1691 the Fair had been shortened to four days; but its promoters
were constantly attempting to elude the vigilance of the City magistrates.

[3] Quoted by Henry Morley, *Memoirs of Bartholomew Fair*, 1859.

and again in 1700, the strolling players soon resumed their stands; and, on scaffoldings high over the heads of the crowd, while Merry Andrews sang and postured, tragedians, in tinsel robes and gilded leather buskins, showed " how Majestically they could tread . . . how Imperiously they could sit." The Fair had invaded the precincts of the church; lotteries and raffles were held in the dilapidated great cloister; and, among the booths that had been rigged up beneath its blackened vaulting, traps were also laid to catch the vagrant amorist. For the thirsty and greedy there was a multitude of eating-houses, selling " over-roasted pork " and " small beer bittered with colocynth "; and, besides the players, acrobats and clowns, the exhibitors of giants and dwarfs and curiously misshapen beasts, Bartholomew Fair was frequented by a host of doll-makers whose " Bartholomew Babies ", " trickt up with ribbons and knots " and exquisitely dressed and packed, were the finest that could be purchased anywhere in the United Kingdom [1] . . . But it was the noise of the gathering that particularly impressed and confounded—a " Belphegor's concert, the rumbling of Drums, mix'd with the intolerable squeaking of cat-calls and penny trumpets ", rendered yet more shocking by the " shrill belches of Lottery pickpockets, thro' Instruments of the same Metal with their Faces ". Thus *The London Spy* in 1699; and, after the lapse of more than two hundred years, Dickens's house-breaker was to complain to his friends that, even behind the ramparts of Newgate Gaol, the uproar of the festive mob had considerably disturbed his sleep.[2] For the prison lay on the

[1] The dolls sold at Bartholomew Fair are often mentioned in seventeenth-century literature. See Nabbes's comedy, *Tottenham Court*: " I have packed her up . . . like a Bartholomew Baby."

[2] " It was Bartlemy time when I was shopped ; and there warn't a penny trumpet in the fair, as I couldn't hear the squeaking on. Arter I was locked up for the night, the row and the din outside made the thundering old gaol so silent, that I could almost have beat my brains out against the ironplate of the door." *Oliver Twist*, Chapter XVI.

16

edge of the market. Moving eastwards away from the fairground, down the beautifully named Giltspur Street, past the extremity of tortuous Cock Lane, where the Golden Boy stands hugging his ribs in a perpetual ecstasy of fear or cold, the London perambulator arrived at Newgate and St. Sepulchre's church. Of the venerable gaol which appeared on his left, not to be replaced by Dance's dignified classical building with its severe ornamentation of fetter-garlands until 1777, we can no longer establish any very accurate representation. But it had been constructed, we know, round one of the original City gates—New Gate or Chamberlain's Gate, a " most miserable Dungeon . . . re-built by Rich Whittington ", which, having been destroyed in the general conflagration of 1666, was " again rebuilt in 1672, with great magnificence though nearly on the same plan." The west front bore " four emblematical figures viz. Liberty, Peace, Security & Plenty ", and the east front similar statues of Justice, Fortitude and Prudence. As the population of the prison gradually overflowed the exiguous rooms above the gate, and the dungeons beneath the pavement of the arch, to which it had once been consigned by its medieval gaolers, we must assume that a warren of cells and yards was thrown up on either side in more or less haphazard fashion. Among them, for example, was the Press Yard, where offenders who had refused to plead were subjected to *peine forte et dure*, or ceremoniously crushed to death. The effluvium of Newgate was strong and offensive; and Howard the prison-reformer found that it impregnated every garment he wore, so that, for some time after leaving the gaol, he could not venture to ride in a post-chaise.

Over against Newgate, like a prick-eared sentinel, stood the tall tower of St. Sepulchre's. Damaged but not destroyed by the Fire of 1666, which had burned itself out at Pie

17

Corner near the north-eastern angle of the church, it housed both the curfew bell, rung every evening to mark the end of the City's labours, and the great bell " used only to toll when the prisoners are carried to be executed at Tyburn ". . . But an additional rite emphasised the connection between the laws of Man and the laws of God. According to the terms of a charity founded by Robert Dowe during Shakespeare's life-time,[1] the bellman of St. Sepulchre's visited the condemned hold at midnight before the day of an execution, rousing the prisoners from their straw with " twelve solemn towles with double strokes ", clanked forth by the tongue of a heavy hand-bell, and reminding them in sententious prose and lugubrious doggerel verse that the hour was approaching when they must prepare to confront a Heavenly Judge:

> *All you that in the condemned hole do lie,*
> *Prepare you, for tomorrow you shall die.*
> *Watch all, and pray: the hour is drawing near . . .*

As day broke, the bell of St. Sepulchre's once again aroused them; and, passing its lofty porch, the death-cart briefly drew up. The parish clerk, who waited on the threshold, took the opportunity of delivering a pious exhortation, bidding the bystanders repent of their wickedness and pray for the condemned sinners. Then nosegays were thrust into the felons' hands, and they were allowed to continue their jolting procession down the rural length of the Tyburn Road.

Such, in some of its details at least, was the metropolitan background of Hogarth's early childhood. It contained subjects that frequently recur in his work—crime and

[1] References to this custom have been detected in *Macbeth* and *The Duchess of Malfi.*

punishment: gaiety and cruelty: the spectacle of strolling players in their make-shift dressing-rooms, and of the London mob with their coarse and battered faces, genial citizens of *Beer Street* or haggard frequenters of *Gin Lane*. The quarter of London in which he was born had survived the Great Fire; and, whereas neighbouring districts had recently been re-built in a lighter and more spacious style, Bartholomew Close was ancient and shadowy, inhabited either by old-fashioned merchants or by poor and inconspicuous strugglers. To the second group belonged Richard Hogarth, the kind of parent whose earnest, but awkward and pitiably ill-rewarded, efforts afford a grim warning to the sensitive and thoughtful child. The third son of a family of yeoman farmers—Hogards, Hogarts or Hogarths—established at Kirkby Thore in the Vale of Bampton, some fifteen miles from Kendal—Richard had deserted the farm and decided to become a schoolmaster. Perhaps he was encouraged by the career of his brother, a celebrated local versifier latterly known as "Auld Hogart". But his school had failed, and he had removed to London. Travelling thither, presumably in the common wagon, the cheapest and slowest means of transport, where he had the company of a poor scholar called Edmund Gibson who afterwards wore lawn sleeves, Richard Hogarth fetched up at Bartholomew Close and started a new school in Ship Court near the Old Bailey. It succeeded a little better than the first. His second venture seems to have clung to existence during Richard Hogarth's lifetime; and, as a means of increasing the income it brought him, the ambitious country schoolmaster joined the large and unfortunate regiment of industrious London hack-writers. Probably much of his work was unsigned; and he doubled the rôle of writer, we are informed, with that of professional proof-corrector. But in 1712, when William was fifteen,

W. Taylor, at the sign of the Ship in Paternoster Row, issued a small octavo volume entitled *Disputationes Grammaticales*,[1] an " Examination of the Eight Parts of Speech by way of Question and Answer, English and Latin, whereby Children in a very little time will learn, not only the knowledge of *Grammar*, but likewise to Speak and Write *Latin*, as I have found by good Experience ". The author, *Ricardus Hogarth, Ludimagister*, appended an elaborate, if not exhaustive, "Chronological Index of Men and Things". The same publisher, in April 1719, was to put forth *Robinson Crusoe*.

His Latin Dictionary, however, would appear to have been Richard Hogarth's most substantial bid for fame. But, although, according to his son, it elicited " letters of approbation . . . from the greatest scholars in England, Scotland, and Ireland ", the manuscript was never published and remained, as a useless heirloom, in the archives of his family—a monument to defeated hopes and unrewarded diligence. Meanwhile his responsibilities grew. On November 10th 1697, his wife, of whom we know little except that her maiden name was Ann Gibbons, bore him his eldest child and only son, William, carried from the Close to the church eighteen days later. There, amid the high box-pews that succeeding generations had erected to temper the austerity of solemn Norman arches, within sight of the canopied tomb of *Raherus Primus Canonius et Primus Prior Hujus Ecclesiae*, and just below an elegantly designed Jacobean funerary plaque which represents the youthful Elizabeth Freshwater, " late wife of Thomas Freshwater . . . daughter of John Orme of this Parish Gentleman ", in hood, ruff and farthingale kneeling at her prie-dieu, William was christened beside a small octagonal

[1] Among Richard Hogarth's other works was a collection of Latin epistles and *Thesauranium Trilingue Publicum: Being an Introduction to English, Latin, and Greek, 1689*, evidently by Richard Hogarth, though anonymously published.

font of fifteenth-century workmanship. Two girls, named Mary and Ann, were born to the schoolmaster and his wife in November 1699 and October 1701; and, some time before the christening of his second daughter, Richard Hogarth had moved house to the adjacent district of Clerkenwell, continuing, nevertheless, to maintain his school in Old Bailey. William, no doubt, was educated by his father; but such education as he received did not strike very deep roots. His mind, constitutionally active and restless, was already busied elsewhere; and life at home had strongly impressed on him " the precarious situation of men of classical education ", obliged to supplement the glories of unpaid authorship with the meagre rewards of proof-reading. He had no aptitude, he soon discovered, for the acquisition of dead languages. But there was another language that interested him profoundly and, given good fortune and practical experience, he believed that he might master it. Among William Hogarth's more notable traits was a just appreciation of his own talents.

Whither his abilities tended, he seems to have been quick to grasp. Almost everything we know of this formative period is summed up in a series of autobiographical jottings[1] compiled many years afterwards; but together they provide the basis of a vivid youthful self-portrait. His mimetic gifts, he informs us, had developed at a tender age. While he was an infant, " shows of all sorts gave me uncommon pleasure "—how appropriate, then, that he should have been born and brought up close to Smithfield fair-ground!—and mimicry, characteristic of all children, was especially " remarkable in me ". What he had first illustrated with the help of pantomime he presently endeavoured to reproduce by less impermanent methods; and, as he had " naturally a good eye and a fondness for

[1] See J. B. Nichols's *Anecdotes of William Hogarth.*

drawing ", he set to work embellishing the margins of his copy-books. The letters of the alphabet he had early " learnt to draw . . . with great correctness "; and the exercises he prepared at school were recommended by " the ornaments which adorned them " rather than by the accuracy of the written text: in the latter " I soon found that blockheads with better memories could much surpass me ", whereas in the decorative additions " I was particularly distinguished ". At the same time, he gained the entry to a neighbouring painter's studio. The artist's name he does not record—presumably he was in no way celebrated, or Hogarth would have noted it down. But at that moment any artist would have possessed an equally powerful fascination. The exhilarating atmosphere of a crowded studio —so agreeably different from that of an impoverished scholar's book-closet—the sight of the mysterious tools he handled and of a picture gradually coming to life upon a well-stretched canvas, roused the instincts of the nascent creator who lay concealed within the imitative child. Even a journeyman painter was the inheritor of a secret—a secret, moreover, not far beyond the child's grasp.

Visits to the studio distracted his attention from play. He had now begun to make sketches " at every possible opportunity ", and " picked up an acquaintance " who shared his love of draughtsmanship. In one respect he was unusually fortunate. There is no hint of parental opposition; and Richard Hogarth, defeated and disappointed, seems to have agreed that the pursuit of a learned profession, with all the " difficulties ", " inconveniences " and " cruel treatment " it involved, might for his only son, that lively and versatile but unlettered boy, have obvious disadvantages. What use could be made of the gifts he evinced? Apart from instilling the rudiments of a classical education, which, as William had already shown, he was incapable of turning

to any real profit, there was very little that his father could do to assist him on his course through the world. " My father's pen, (wrote his son concisely) like that of many other authors, did not enable him to do more than put me in a way of shifting for myself; " and the unpromising pupil was therefore removed from school—somewhat sooner, we deduce, than might otherwise have appeared right—and apprenticed to a silver-plate engraver, a certain Mr. Ellis Gamble, who kept a shop under the sign of " The Golden Angel ", in Cranbourne Street or Cranbourne Alley, a commercial thoroughfare off Leicester Fields. The new apprentice was enchanted with this change of scene. It was (he subsequently observed) " very conformable to my own wishes ".

At least, he could draw—or learn a mechanical routine that might reasonably be mistaken for drawing. In Mr. Gamble's shop the fine solid plate of the early eighteenth-century was enriched with the intricate armorial devices of its wealthy purchasers, the heraldic beasts that supported the coat of arms, the shield itself sub-divided in a complex chequerwork, the crest that surmounted it and the family motto beneath. As was usual among eighteenth-century apprentices, William Hogarth probably slept at his master's place of business, and thence extended his explorations of the rapidly developing London world. By moving westwards he was following London's growth; and, whenever he made the journey from his father's house in Clerkenwell or the school in Old Bailey to his employer's house off Leicester Fields, he was re-tracing the life-line that united the populous City, which occupied the site of the original Roman settlement, to the remote royal and official strongholds of St. James's Palace and Westminster. As he set forth, Wren's great new cathedral, its clear-cut masonry still almost unsullied by urban damp and dirt, rose immediately

23

behind him. At his feet was the sharp declivity of narrow cobbled Ludgate Hill; and, descending, he must pass through the mediaeval Ludgate, which continued to span the street until 1760, and, having crossed the Stygian Fleet Ditch [1] and ascended the gentler slope opposite, through Wren's majestic Temple Bar, its classical dignity in curious contrast to the customary frieze of severed legs and blackening skulls. Rather than pursue the length of the Strand, overlooked by the magnificent houses of Elizabethan and Jacobean grandees, Hogarth may have preferred to turn northward into Covent Garden. Laid out by the Duke of Bedford, with the inspired assistance of Inigo Jones, across the open fields beyond the garden wall of Bedford House, the Garden had an oddly foreign and pleasantly cosmopolitan air, the residence of writers and painters and playwrights and miscellaneous London wits, of persons of fashion who were deserting the district, and of the innkeepers, brothel-keepers and women of pleasure who were gradually filling the void. Not far ahead lay Leicester Fields, another example of well-considered modern planning. On three sides of a garden-enclosure stood the plain brick-built homes of prosperous London citizens. The northern extremity was dominated by Leicester House, an impressive seventeenth-century structure with a spacious gravelled forecourt, from the part that it played in the disputes of the royal family presently to be nicknamed " The Pouting Place of Princes ".

If life in Cranbourne Alley irked Hogarth, his records make no mention of it. He merely refers to his " long apprenticeship " and indicates that, before his apprenticeship closed, he was already looking around for some

[1] This dirty and noisome rivulet, which separated Ludgate Hill from Fleet Street, was crossed by the Fleet Bridge, re-built after the Great Fire, an elegant stone structure ornamented with pineapples and coats of arms, finally demolished in 1765.

happier method of self-expression. The business of silver-engraving he had found " in every respect too limited ", and he determined that he would practise the craft " no longer than necessity obliged . . ." He had none of the traits of the Industrious Apprentice—indeed, he describes himself as the victim of constitutional sloth—but the squalid features of the Idle Apprentice were equally unlike his: for Hogarth's idleness extended only to the humdrum labours of the working day, while his imagination was perpetually hovering ahead, elaborating fresh schemes of advancement and groping towards new ingenious short cuts. Again a painter helped to excite his fancy; and now the paintings he admired were not in a studio, but displayed around the dome of a cathedral and across the lofty walls of a riverside palace. James Thornhill may have had little genius; yet few Englishmen have so well understood the difficult art of fresco-painting, and his blend of executive energy and decorative ability was considered to put him on the same level of accomplishment as Laguerre [1] and Verrio. During the period of Hogarth's youth, Thornhill was collaborating with Wren—at St. Paul's, however, somewhat against Wren's own desire—in two of the great architect's most ambitious buildings. The dome of the cathedral was decorated between 1715 and 1721; and 1707 he had begun to embellish the Painted Hall of Greenwich Palace, an undertaking that he continued to prosecute with his usual high-spirited gusto until 1728, at the modest rate of £3 for a square yard of ceiling and £1 for a square yard of wall. In 1720, he received a knighthood, and his reputation stood at its highest point. To Hogarth he was a doubly portentous example, since, besides being a performer in

[1] Louis Laguerre, a pupil of Lebrun, was born at Versailles in 1668, and came to England in 1683, where he remained until his death in 1721. He had been defeated by Thornhill in the competition for the frescoes at St. Paul's. His earlier works were executed under the direction of Verrio. Later commissions included work at Petworth, Chatsworth, Hampton Court and Blenheim.

the grand manner whose dashing brush illuminated a whole realm of turbulent mythological fancies, he was also an artist of English descent, a native Prometheus who had stolen his fire from celestial regions hitherto guarded by the haughty foreigner. His paintings, says Hogarth, " ran in my head ". Their imaginative effect was never completely shaken off.

Above all, they suggested a method of escape; and Hogarth's first step in the process of emancipation was to turn his thoughts from the embellishment of silver to the use of copper. Silver-engraving, he now felt, was a pedestrian and mechanical trade, dealing with symbols and devices that seldom varied throughout the course of years; whereas the copper-engraver—the illustrator of books or the author of current satirical prints, even the anonymous manufacturer of advertisements and shop-bills—was concerned not (for example) with *a griffin per fess argent* or *a wyvern gules collared*, but with images that reflected the opinions and passions of contemporary human beings, as they were to be seen elsewhere in the faces of the crowd or in the commercial background of the London streets. To become a copper-engraver, he must perforce improve his draughtsmanship; " it was necessary that I should learn to draw objects something like nature, instead of the monsters of heraldry "; and for a while Hogarth was deterred by a consideration of the effort involved, as he mused on the time he must spend, on the hours and days he must sacrifice in learning that might have been better employed in enjoying and experiencing. His account of these youthful debates possesses a special interest. The outlines of the self-portrait are gradually acquiring life; and the young man whose lineaments emerge is both intensely ambitious and, one guesses, strongly sensual. That he loved his pleasures, he is ready to admit; but those pleasures had

come to him later than they come to many youths—there can have been little gaiety in his parents' house at Clerkenwell—and he was therefore anxious, now that they at length beckoned, to hunt them down boldly and to enjoy them greedily. In a strategic position betwixt Clerkenwell and Leicester Fields lay the taverns, coffee-houses and brothels of Covent Garden and Drury Lane.

Such a predicament is common enough—idleness and a thirst for pleasure are often associated with the creative spirit; but the solution that Hogarth presently discovered was highly characteristic and very far from commonplace. Some hints he borrowed from his father, the teacher of dead languages. Accustomed to thinking in linguistic terms, Hogarth divined that art might itself be a form of language —with this difference, that, whereas the vocabularies that Richard Hogarth taught were rigid and comparatively lifeless, the idiom that his son was hoping to perfect would be newly modelled on his experience of the world. No doubt the mature conclusions of the famous artist were much more clearly articulated than the wild imaginings of the adventurous apprentice; but the basic idea was evidently the same, and can be traced back to a conflict of feelings that frequently occurs in the latter stages of adolescence when an unconscious impulse to rival one's father is counterbalanced by a determination to avoid resembling him. He would not learn as his father had learned. Any system of aesthetic training that suggested the early stages of a classical education was, of course, anathema. Both at school and during his apprenticeship he had had enough of copying; for even drawing after the life (he opined) will not make the student an artist since, by drawing "a bit at a time", he is constantly obliged to transfer his scrutiny from the model to the page beneath his eyes, and often loses his vision of the whole in a consideration of separate parts. Thus the

27

diligent copyist may know little more of the object he is endeavouring to reproduce when he puts down his pencil, than when he first takes it up, but resembles a laborious engrosser of deeds who copies every phrase of some crabbed legal document, whether it be in English, law Latin or mediaeval French, and yet at the end of his task has failed to memorise a single word. Hogarth was averse, therefore, either from working in an art-school (though, as we shall see, the prejudice was short-lived) or from the customary procedure of copying the Old Masters. Much too forcibly those celebrated names reminded him of the great men of the classical world. His imagination was perpetually haunted by the idea of a " shorter path "—a simplified and abbreviated means of self-improvement that would enable him to " fix forms and characters in my mind, and, instead of *copying* the lines, try to read the language, and if possible find the grammar of the art, by bringing into one focus the various observations I had made ". What he needed to learn the living language of art was a kind of shorthand; and, in order to acquire it, " I . . . endeavoured to habituate myself to the exercise of a sort of technical memory ". A swift comprehensive glance was to summarise the whole; the component details into which it had been analysed were to be quickly, carefully stored away; finally, when copper-plate or canvas was ready, they would once again be brought together, in a design neither completely imaginative nor dully and slavishly realistic.

Athough Hogarth the middle-aged man may well have credited Hogarth the youth with many of his own theories —at the age of seventeen or eighteen we can few of us claim to have formulated a distinct aesthetic point of view—it seems evident that his technical memory began to be exercised at an early period, and that he had adopted the habit of rapid notation before he said goodbye to Cranbourne

Alley. We hear, for instance, of a country ramble, under-
taken with some fellow apprentices, up the northern hills
to the little village of Highgate. The day was Sunday; the
weather was warm; and, soon after they had entered a
public house, a violent quarrel broke out in the bar parlour.
One of the furious disputants, wielding a quartern tankard,
laid open his opponent's scalp. Eighteenth-century Lon-
doners were not unaccustomed to the sight of bloodshed.
But the grotesque absurdity of the scene was dramatic and
effective. " The blood running down the man's face, with
the agony of the wound, which had distorted his features
into a most hideous grin, presented Hogarth (we are in-
formed) [1] . . . with too laughable a subject to escape the
powerful efforts of his genius ", and he immediately pro-
duced a pencil and set to work upon a rapid sketch, ren-
dered " the more pleasing ", when he showed it to his
friends, because to an " exact likeness of the man " were
appended a portrait of his savage antagonist and the " fig-
ures in caricature of the principal persons gathered round
him ". The sketch has vanished; yet the impression re-
mains. We have no difficulty in evoking the spectacle as,
thanks to the tireless exercise of his technical memory,
Hogarth at a later stage of his career might have revived and
re-created it. With what sportive ferocity—divorced,
however, from moral severity or mawkish literary senti-
mentality—he would have rendered that *rictus* of pain and
pinned down the variety of expressions—dazed, doltish,
delighted, sadistic or wonderingly compassionate—in the
officious crowd of onlookers! The tankard would have
rolled to the floor; wine or beer, spilt in the scuffle, would
be soaking into the table-cloth; a rush-bottomed chair
would almost certainly have been over-turned; and these
accessories would be depicted by the painter with the same

[1] Nichols's *Anecdotes.*

enthusiastic detachment as he exhibited in portraying the masks of the crowd. But then, a window would be open on to the garden and, through the rectangle of the old-fashioned leaded casement, we should catch a golden romantic glimpse of the sultry summer afternoon, a shimmering prospect of hedges and trees and fields, bounded by light blue hills along the distant sky-line.

To origins so small and haphazard may be traced the mature accomplishment of an adult artist. But his evolution is necessarily slow and painful; and at the age of twenty—that is to say, about the year 1717 or 1718—when Hogarth seems at last to have emerged from his apprenticeship, to become a proficient copper-engraver (he tells us) was still the limit of his highest ambition. In 1718 his father died—of an " illness occasioned partly by the treatment " he had received from grasping book-sellers and " partly by disappointment from great men's promises "—and was buried on May 11th in the vaults or yard of St. Bartholomew's Church. His son meanwhile would appear to have returned home. Soon after his father's death, he was established with his mother and his two sisters at the house where Richard Hogarth had expired, in Long Lane, adjoining Smithfield Market; and it was from this address, " near the Black Bull ", that, on April 23rd 1720, " W. Hogarth Engraver " put forth his earliest business card, its neat quadrangular frame decorated with garlands, surmounted by a pair of cupids and supported by two emblematical figures—a goddess or nymph, bosom half discovered, gazing pensively upward, who may be taken to symbolise Art: a bearded personage, writing or engraving, presumably intended to typify Science.

II

The Battle of Taste

HOGARTH'S MENTAL development had far outstripped his
physical growth. He remained a very short man, barely
over five feet high; but, like many unusually short persons,
he carried off his lack of inches with a certain air of trucu-
lence, which he seems to have reinforced with some attempts
at dandyism. We know, at least, that he wore a sword, a
piece of masculine equipment that indicated the man of
pleasure rather than the man of business, and was more
suitable to a frequenter of Covent Garden than to an inhabi-
tant of Long Lane. No doubt it possessed a symbolic
value. He could remember a period, wrote Hogarth of
those early days, " when I have gone moping into the city
with scarce a shilling in my pocket; but as soon as I re-
ceived ten guineas there for a plate, I have returned home,
put on my sword, and sallied out again, with all the confi-
dence of a man who had ten thousand pounds in his pocket."
At the same time, he had not forgotten his duties. Until
he was " near thirty ", he afterwards declared, he could
" do little more than maintain myself "; but even then, he
added with characteristic pride, " I was a punctual pay-
master ". He was also, apparently, a devoted brother and
son. His portrait of the widowed Mrs. Hogarth shows us
a large, heavy-looking elderly woman, whose benevolent, if
somewhat flaccid, features are framed in a black mourning-
hood; while the twin likenesses of his sisters, Mary and

31

Ann, reveal transparently honest but irremediably unattractive girls, who have their brother's blunt nose and clumsily protuberant chin.

Mary and Ann were destined for the millinery business; and among the best of the numerous trade-cards produced by the young engraver at his City work-room, is a delightful representation of a well-found milliner's shop, with shelves reaching to the roof and a metal chandelier, whither a citizen and his wife have brought their stout and troublesome eldest boy, whom a couple of feminine ministrants are persuading into a new coat. Beneath this domestic scene appears the announcement that " MARY & ANN HOGARTH from the old Frock-shop the corner of the Long Walk facing the Cloysters " have now " Removed to yᵉ KING'S ARMS joyning to yᵉ Little Britain gate, near Long Walk ", and there sell " yᵉ best & most fashionable Ready Made Frocks, sutes of Fustian, Ticken & Holland, stript Dimmity & Flañel Wastcoats, blue & canvas Frocks, & bluecoat Boys Drarˢ Likewise Fustians, Tickens, Hollands, white stript Dim̃itys & stript Flañels in yᵉ piece, by Wholesale or Retale, at Reasonable Rates." Other cards help to complete the setting of Hogarth's laborious commercial youth; and, as we examine them one by one, we seem to be accompanying him through some of the busiest streets of the eighteenth-century metropolis, beginning at Ellis Gamble's familiar establishment under the sign of the *Golden Angel*, pausing at a second goldsmith's —William Hardy in the Radcliffe Highway—visiting a tobacconist's called *The Golden Tobacco Roll*, kept by Richard Lee in Panton Street—for whom Hogarth executed a lively vignette, strikingly reminiscent of his later work, the *Midnight Modern Conversation*—and investigating the glorious variety of " MRS HOLTS Italian Warehouse at yᵉ two Olive Posts in yᵉ Broad part of the Strand almost opposite

to Exeter Change ", which purveyed " all Sorts of Italian Silks as LUSTRINGS, SATTINS, PADESOIS, VELVETS, DAMASKS, &c., Fans, Legorne Hats, Flowers, Lute & Violin Strings, Books of Essences, Venice Treacle, Balsomes, &c. And in a Back Warehouse all Sorts of Italian Wines, Florence Cordials, Oyl, Olives, Anchovies, Capers, Vermicelli, Bolongnia Sausidges, Parmesan Cheeses, Naple Soap."

As Mrs. Holt's advertisement suggests, the period of Hogarth's youth was one of growing prosperity and (moralists were apt to complain) dangerously increasing luxury; and among the new fashions that sprang up at home, and outlandish foreign modes that came flooding in from across the Channel, his satirical gift would soon discover the targets that it needed. Every artist is born a critic of his age; and, like every age, the opening decades of the English eighteenth century for those who lived through them wore a peculiarly unpromising and ungracious aspect. They were the " pudding times " described in a popular ballad, when " moderate men " looked unnaturally big, and Whig moderation, according to Tory observers, was often synonymous with vulgar mediocrity. What could be duller than the Royal House? What administration more venal than Sir Robert Walpole's government? It was in 1714, while Hogarth was still an apprentice, that George I, benefiting by the indecision and furious internecine dissensions of the Tory leaders, had succeeded unchallenged to the throne of England: and in 1721, while the engraver's shop near Smithfield was beginning to make headway, that Walpole embarked on his long tenure of office as the King's chief minister. Peace was the minister's object; and, although both the monarchs he served were obstinate and unenlightened princes, stubbornly devoted to their Hanoverian possessions, with only

a secondary interest in their British heritage, Walpole achieved his aim, and the great *Pax Walpoliana* was to continue unbroken until 1739. Few statesmen have been so fiercely lampooned—as " Robin ", " Bob the poet's foe ", even " Mr. Peachum "; he was attacked by most of the writers of his day, and savagely calumniated by Opposition journalists; yet no contemporary politician could claim to have done so much to advance the material, if not the spiritual, welfare of his fellow citizens. During the two decades that he remained in office—thanks to his adroit management of the reigning dynasty and to his brilliant re-organization of the existing system of political patronage —Walpole's was a dominant influence, which strengthened and confirmed some of the main traits of the English eighteenth-century character, before the advent of " enthusiasm " and of the new-fangled " patriotism ": its immense vitality, masculine self-sufficiency and whole-hearted preoccupation with the pleasures of the physical life. By contrast the previous century seemed a far-off unhappy Heroic Age, notable for the gallant defence of lost causes, for a history of agonizing spiritual conflicts and bloody civil discord. Sir Robert's abilities were practical and unheroic. He introduced an era of stability and wealth, which his bitterest literary opponents found indirectly profitable.

From the point of view of an aspiring artist, however, the bloodless revolution of 1714 had yet more important consequences. It brought to an end a period of taste, and opened a new period during which the activities of the creative artist were gradually to be diverted into very different channels. For nearly fifty years a single man of genius, distinguished alike by his executive energy and by the astonishing multiplicity of the gifts he handled, had presided over almost every field of English art and science.

The Battle of Taste

As long ago as 1654, when Evelyn recorded his first glimpse of " that miracle of a youth, Mr Christopher Wren ", the " prodigious young scholar " (who signalised the occasion by presenting Evelyn with a " piece of white marble stained with a lively red ") had made a deep impression upon the world of learning, in those days still indistinguishable from the world of art and literature. Offspring of a courtly and erudite stock, whose uncle had been a celebrated Royalist bishop, and whose father— himself renowned as a " good general scholar and a good orator ", mathematician, musician, draughtsman and architectural student—was Dean of Windsor and Registrar of the Order of the Garter under Charles I, Wren had received the preferment he deserved on the restoration of Charles II. Professor of Astronomy at Gresham College, London, since 1657, he had become Savilian Professor of Astronomy in the University of Oxford in 1661 and one of the Committee appointed to advise the government about the repair of old St. Paul's. Two years later, he had begun his designs for Oxford's Sheldonian Theatre and the new chapel of Pembroke College, Cambridge. That a young scientist, whose talents hitherto had been largely concentrated on astronomy, geometry and biology, should be expected to display the qualifications of a successful architect, may seem possibly a little surprising to the modern reader. But the seventeenth century had not yet learned to differentiate between the various branches of polite learning; and (a recent biographer sensibly reminds us [1]) " Wren, with his skill as a draughtsman . . . his mathematical attainments, and mechanical ingenuity ", would strike men of his own age as particularly well qualified for planning and building in the grand style. Architecture was the solid expression of a civilised way of thought and life, which extended

[1] *Wren* by Geoffrey Webb. Duckworth, 1937.

35

from the chemist's laboratory to the study and the music room.

Yet, notwithstanding the remarkable breadth of his interests, Wren's composition included nothing of the dilettante. He had a huge appetite for constructive work; and the disastrous conflagration of 1666, by destroying ancient St. Paul's and razing large areas of mediaeval London, had cleared the way for the accomplishment of his most impressive labours. Appointed to the Commission for the rebuilding of the City during the months that followed the Great Fire, he obtained the Royal Surveyorship in 1669 and drew up his earliest plans for the reconstruction of London's central monument. Thenceforward his progress was steady and smooth. Above the roof-tops of the resurgent City, steeple after steeple—each the product of an intensely imaginative, yet positive and disciplined, spirit—now rose into the smoky air. An old palace was embellished at Hampton Court; a new and magnificent royal residence was laid out west of London among the fields of Kensington; beside the Thames, splendid hospitals were erected at Greenwich and at Chelsea. In 1710, St. Paul's was declared complete; but Queen Anne, who in September 1704 had paid a state-visit to her Surveyor General's masterpiece to give thanks for Marlborough's great victory, was already an ailing and feeble woman; and, with her death in 1714, his patriarchal authority suffered a sudden, violent setback. In the scramble for places that accompanied the transference of power, the King's German favourites and their English hangers-on naturally turned against this distinguished servant of the earlier dynasty; and by a discreditable piece of palace-intrigue—one of those " dark stroaks in the King's closet " which also threatened his chief associates, Vanbrugh and Hawksmoor—Wren was dismissed from the Surveyorship and, a year later, obliged

to petition that he might be allowed to die in peace, "having worn out (by God's mercy) a long Life in the Royal Service, and having made some Figure in the World". His plea was granted, and he survived without further molestation until April 1723, when he expired by his own fireside, sleeping quietly after dinner.

Political revolutions are often artificial; but Wren's dethronement, which involved the fall of Hawksmoor and the partial eclipse of Vanbrugh,[1] would seem to have corresponded to a real change of feeling. The "school" he founded is somewhat difficult to define, since (as his biographer has pointed out) "though Hawksmoor and Vanbrugh were personally close to Wren and learned much, if not everything, from him, their curious 'Heroic' Baroque is a different thing, more declamatory, more coarse-grained than the architecture of their master, which kept to the end of his days something of the spirit of the lyric poets of his youth".[2] But, in so far as a school existed, even before the patriarch's disappearance it had begun to meet with opposition. Thus, in 1712, Lord Shaftesbury, an influential dilettante critic, whose *Characteristics of Men, Manners, Opinions, Times,* was published a year earlier, had written, in his *Letter Concerning Design*, of the wasteful and unfortunate operations of "one single Court Architect through several reigns", and of the "many spires arising in our great city with such a hasty and sudden growth", and had suggested that one must seek elsewhere for the principles of true taste. A rival school, indeed, was rapidly assembling. Wren's successor in the Royal Surveyorship was a certain William Benson, an unusually incompetent craftsman, who, besides being a protégé of the German

[1] Hawksmoor died in 1736: Vanbrugh, whose political connections had enabled him to escape the worst consequences of Wren's fall, ten years earlier.

[2] Geoffrey Webb ; *op. cit.*

clique, was a close friend of Colin Campbell, renowned author of *Vitruvius Britannicus* and associate of Lord Burlington; and it was Campbell who succeeded Hawksmoor, when, sharing the fate of Wren, that brilliant but modest architect was deprived of his official post. *Vitruvius Britannicus* became the handbook of the new age, which despised the modified English Baroque of the late seventeenth and early eighteenth centuries, and looked ahead to a revived Palladian style, more in harmony (its exponents believed) with the advance of contemporary civilization.

Once Wren had retired from the field, his empire (which had covered nearly the whole extent of existing human knowledge) was broken up among a host of variously gifted specialists. None of them could equal his scope, for none of them possessed his prodigious fund of erudition and, since knowledge was constantly increasing, it became more and more improbable that they would attempt to do so. In England at least, the builder of St. Paul's and Greenwich, who was also President of the Royal Society, a metaphysician, a mathematician, a physicist, a physiologist, a botanist, a student of music and a delicately accomplished draughtsman, was to be remembered as the last of the polymaths, the last artist who incorporated the ideals of Renaissance Humanism. The practical man of affairs, who played his part in the business of modern parliamentary government and superintended every detail of the buildings he had conceived and planned, was yet haunted by dreams of the unknown stellar universe and of undiscovered worlds " hang'd in the vast abyss of intermundious vacuum ". His imagination had a strongly poetic turn; but his love of beauty was closely connected with his worship of scientific truth; and " Mathematical Demonstrations (he had observed in an early public lecture) . . . are the only Truths, that can sink into the Mind of

Man, void of all Uncertainty ". The basis of beauty was rule and order; and it is characteristic of Wren that, in a letter to Faith Coghill whom he afterwards made his first wife, he should have compared his emotions to the movements of a finely balanced watch. There was a simplicity and symmetry in his vision of existence, quite beyond the grasp of a more complex and less poetic age.

Thus Wren left no legitimate heirs. The next generation, nevertheless, was to produce an enthusiastic emulator, who ranged busily, though often somewhat superficially, through many different fields of work. But, before confronting him, we must return to Hogarth; on the margin of a widespread aesthetic struggle the small alert figure of the young engraver now distinctly re-emerges. He was still immature and entirely undistinguished. Yet the frescoes of Thornhill " ran in his head "; the painter was an associate of the mighty architect; and it would have been strange indeed if the contemporary battle of taste had failed to excite his interest or arouse his fighting-spirit. By temperament an extremely pugnacious character, he was further aroused by a chance meeting said to have occurred at a studio in St. Martin's Lane.[1] There, during the year 1720, two artists, John Vanderbank and Louis Chéron, had established a new drawing-school. Despite his alleged aversion from drawing-school methods, Hogarth seems to have attended it. Joseph Highmore was a fellow pupil. But among the acquaintances he made in the class-room the oddest and showiest was William Kent. A burly, sanguine, fleshy-faced personage, he was no doubt pointed out by his less adventurous neighbours as having just returned from Italy where, since 1710, he had been studying and collecting art. Italianate Londoners were common enough; the

[1] See *Artists and their Friends in England 1700–1799*, by W. T. Whitley. Medici Society, 1928.

Italianate Yorkshireman was a more special and peculiar breed; and Kent, who was reputed to have been born near Hull—at which city, according to some stories, he had been apprenticed to a coach-painter—combined a provincial accent and considerable Northern shrewdness with an easy and pleasure-loving disposition, ripened in the Southern sun. By his London friends he was nicknamed " the Signior "; his " Italian constitution " (he was fond of declaring) fretted at the rigours of " this Gothick country "; but he found some consolation in his visits to the Italian opera. Such a personality and such pretensions were unlikely to appeal to Hogarth. His own youth had been hard and obscure; the temperament it had fostered was neither supple nor easy-going; and for any phenomenon he failed to understand he felt an immediate suspicion, not untinged by jealousy. Kent, too, was an artist of humble birth; but life, while he was still a young man, had begun to treat him with extreme indulgence, providing, among other advantages, a group of wealthy patrons who continued to flatter and support him until the very end of a prosperous and honoured career. Despatched to Rome at the age of twenty-six by a band of cultivated country gentlemen who had admired his earliest efforts, and on whose behalf he had spent ten agreeable years, copying Old Masters and purchasing pictures and scraps of antique statuary, he presently fell in with the great Lord Burlington. The warm personal friendship that resulted was destined to have important effects upon the evolution of British taste.[1]

Some veins of talent lie close to the surface, and are easily, quickly uncovered. Such, for example, was the talent of Kent, whose inward wealth—mixed, one must agree, with a certain proportion of base material—was

[1] See *The Work of William Kent* by Margaret Jourdain. With an introduction by Christopher Hussey. *Country Life*, 1948.

brought to light almost as soon as he had the chance of using it. The Signior was an industrious craftsman; but his methods of work were so unhurried, his professional mannerisms so wordly and so carefree, that he sometimes produced the impression of being the laziest of human creatures. He " often gave his orders when he was full of Claret "; and, now and then, having abandoned his drawing-board, he would next be heard of stretched in supine enjoyment beneath the trees of Chiswick, where Lord Burlington used to assemble the friends whom he especially loved, solacing himself with " syllabubs, damsels and other benefits of nature ". Yet, unlike many easy-going and self-indulgent artists, Kent seems not to have forfeited any degree of his artistic independence. He was seldom at pains to conciliate the rich—even to the extent of spelling their names and titles rightly: in Kent's letters to him, the " princely " Duke of Chandos and Buckingham usually figures as " Lord Duck Shandoes "—and was reputed " by no means a Respecter of Persons ", but an autocrat capable of " using sharp speech " to the very greatest. With his more generous attributes, however, went some touches of artistic vanity. He was inclined, for example, to look down upon his native colleagues. " All these power-spirited English daubers (he would complain in his large, high-handed way) raile and make partys against me, but I hope to overcome ym all "—an attitude particularly exasperating to an artist of another type, whose genius still lay underground, awaiting gradual development, and who, although irritable and captious, was certainly not poor-spirited.

Hogarth's exasperation had salutary results. Mollifying influences are never amiss; but an artist must also be grateful for his share of minor irritants. Whether personal resentment was the cause or considered critical indignation—probably both were aroused: and Hogarth

41

was not the man to assess his motives carefully—his hatred
of Kent provided a valuable stimulus, which imparted new
zest to his use of his engraving tools. Meanwhile he
worked as a bookseller's hack. Having begun by producing
shop-bills, he had soon graduated to book-illustration and
the invention of satirical prints, among his first efforts
being *An Emblematical Print on the South Sea Scheme* and a
plate entitled *The Lottery*, each a somewhat laborious gibe
at one of the chief passions of contemporary social life—
the pursuit of easy profits, which had risen to an unpre-
cedented frenzy during the delirious expansion of the
South Sea Bubble. Stock-jobbing had become a national
mania; and, even after the collapse of the Bubble itself
during the early months of 1721, when Walpole (who had
made a handsome profit from the Scheme) was hastily
recalled to power as the only statesman capable of restoring
public confidence, government lotteries continued to exer-
cise the same exciting and demoralising spell. His early
satirical prints, like the book illustrations by which they
were accompanied—embellishments for a travel-book, a
translation of Apuleius and a variety of miscellaneous
volumes—show us an apprentice draughtsman with a cer-
tain imitative flair but very little grasp of imaginative com-
position. Truth is broken on the wheel: speculators of
every class sit perched upon a merry-go-round. The
satirist's reproof is heavily underlined; but no real satirical
energy seems to drive his graver along. William Kent, and
his rapid rise to fame and wealth, offered a more inspiring
subject. In 1724 Hogarth launched his attack. His
draughtsmanship had scarcely improved; but the satirist
employed it with a fresh self-confidence.

At the same time, he struck out for professional liberty.
Tired of his unremunerative servitude to the booksellers
and print-vendors, he decided to issue his latest print as an

independent businessman—a project that would have been
more successful, had pirated copies not immediately ap-
peared in many London print-shops. *Masquerades &
Operas, or Burlington Gate* assaults " The Taste of the
Town "—the title by which Hogarth afterwards referred
to it—from several different points of view. That taste is
hopelessly vitiated, its worst disease being an inordinate
lust for novelty and luxury. Thus, while the old dramatists
are neglected, and the printed works of Shakespeare, Dry-
den, Otway, Ben Jonson and Congreve are seen being
trundled away in a female huckster's wheelbarrow, eager
citizens rush to a conjuring display, to the pantomime in
Lincoln's Inn Fields, to the midnight masquerades or-
ganized by the Swiss impresario Heidegger, or to the
Italian opera at which Kent sought an unmanly refuge from
the rigours of the British climate. Especial derision is
reserved for a diminutive Italian singer named Francesca
Cuzzoni, who, having recently arrived in London, was
already well on the way to amassing a large fortune and is
here depicted, rake in hand, gathering up the showers of
good English guineas that Lord Peterborough, Swift's
friend and a renowned courtier and lover, throws down at
her imperious feet. A pleasure-seeking mob, led by a
devil and a jester in cap-and-bells, occupies the foreground;
Heidegger leers from a window above; but the background
is a lofty Palladian screen, pierced by a single imposing
arch—the main entrance of Lord Burlington's magnificent
house in Piccadilly.

It was still comparatively new. In 1716, soon after his
return from an extended Grand Tour, Burlington, with the
assistance of James Gibbs and Colin Campbell, had begun
to enlarge and reconstruct the house he had inherited; and,
although Campbell subsequently claimed that the concep-
tion had been his alone, Burlington's influence seems to

have appeared in most of the features of the completed
building. The pillared forecourt was his particular pride;
and Horace Walpole (who remarked that Burlington had
all the traits of an artist and a genius except envy: whereas
Chesterfield observed that, in his capacity of great noble-
man, he had " to a certain degree lessened himself by
knowing the minute and mechanical parts of architecture
too well ") applauds the lightness and gracefulness of the
semi-circular colonnade, which, first seen at the hour of
sun-rise from the ball-room opposite, reminded him of
" one of those edifices in fairy tales that are raised by genii
in a night's time ". It is beneath the outer wall of the
courtyard that Hogarth places his satirical pageant. Bur-
lington Gate looks down on the crowd—arrogant approach
to the citadel of false taste; and, pinnacled high above its
classical pediment, William Kent strikes the attitude of a
Roman emperor, with Raphael and Michelangelo at his
feet in the attitude of dejected slaves. The conceit obvi-
ously appealed to Hogarth; for there exists a second repre-
sentation of this proud and odious gateway—typical, no
doubt, of all the doors that an ambitious but uncultivated
young artist might find closed against him—engraved in
1731, when the citadel was still as strong as ever, and Kent
and Burlington were still prosecuting their successful
partnership. But a fresh villain has now entered the scene
—a tiny grotesque figure in an enormous tie-wig at work
upon a builder's scaffold, busily whitewashing the fabric of
the gate, while Burlington shins up a ladder, and white-
wash from the pigmy's bucket and brush bespatters harm-
less passers-by, among others that rival Maecenas, the
Duke of Chandos and Buckingham. The industrious man-
ikin is a caricature of Pope, then at the height of his fame
and genius, and recently the author of a *Moral Essay: On
the Use of Riches*, in which Burlington's achievements are

warmly praised and those of Chandos, a former patron, somewhat unfairly ridiculed. Pope, therefore, ranked as the laureate of the movement, the prophet of Palladian building and of the artful simplicity of Romantic gardening; but Kent retained his position as its chief executive. Grasping palette and pencil, his effigy continues to preside over the efforts of his busy labourers, insufferably remote from the cares and tribulations of everyday existence—life, for example, as it had been known in Long Lane.

Hogarth's shafts were never to dislodge him. But, whereas the first was delivered at a venture—the Signior's bad eminence was generally and rather vaguely satirised— the print with which he followed it up dealt a more accurate and much more damaging blow. A good architect and a versatile designer, who was prepared to turn his hand to any commission from a cradle to a state-barge, from a chimney-piece or a pair of consoles to a petticoat to be worn at Court, Kent was also, in the phrase of Horace Walpole, " painter enough to taste the charm of landscape " and to enjoy " the delicious contrast of hill and valley ", thus becoming one of the greatest artificers of the English Romantic park or garden. But he was not painter enough to succeed on canvas; and, though his frescoes are pleasing if uninspiring, his portraits and religious pictures are often weak and clumsy. Among his worst attempts in the pictorial field was the altar-piece that, during an unusually careless or unguarded moment, he had dashed off for St. Clement Danes—a performance so strangely inept that the parishioners, a conservative middle-class body, presumably less awed than his aristocratic patrons by Kent's growing reputation as a fashionable artist, implored the Bishop of London to have it taken down: a request with which the Bishop complied, being anxious, he said, to " preserve peace and unity ". Removed in disgrace from

the altar, the canvas was relegated to the vestry during the autumn of 1725;[1] and Hogarth signalised the occasion by engraving a satirical plate, with a lengthy caption inscribed beneath it that helped to ram its message home. It is an excellent specimen of destructive fooling. Kent's pious subject had been a celestial choir, which included five seraphic choristers, a crowd of attendant cherubs and the Holy Spirit in the shape of a dove. Hogarth's caricature— " exactly Engrav'd after yᵉ Celebrated Altar-Peice in St. Clement's Church . . . taken down by Order of yᵉ Lord Bishop of London (as tis thought) to prevent Disputs and Laying of wagers among yᵉ Parrshioners about yᵉ Artists meaning "—reduces the whole composition to a tangle of ungainly limbs. Separate features, distinguished by letters of the alphabet, are enumerated in the printed " Key ". Thus, *C* represents " the Shortest Joint " of an angelic arm: *D* denotes " the longest Joint ": *F*, the inside of a harpist's leg, " but whether right or left is yet undiscover'd": *H*, " the other leg judiciously Omitted to make room for the harp." As for the controversy aroused by the theme, Hogarth's " Explanation " is at pains to insist that "'Tis not the Pretenders Wife and Children as our weak brethren imagin", nor yet St. Cecilia as the Connoisseurs profess to think. It depicts merely a band of angels, gathered in harmonious consort. The suggestion is " humbly Offerd to be writ under yᵉ ORIGINAL, that it may be put up again by which means yᵉ Parishe's 60 pounds which thay wisely gave for it may not be Entirely lost." The joke is effective though not particularly subtle; and for the first time in a satirical print we have the impression that the satirist has thoroughly enjoyed his work.

Book-illustration, on the other hand, presented a far more

[1] The disgrace was permanent. The picture remained in the vestry, whence it is said to have been occasionally borrowed to decorate the music-room of a neighbouring tavern..

uncongenial problem. In 1726 appeared an edition of
Samuel Butler's *Hudibras*, for which Hogarth had prepared
a frontispiece and a series of twelve engravings, during the
course of the same year re-issued as large separate plates.
They are capable and business-like, rather than inspired,
designs. The engraver, indeed, who was never averse from
picking up ideas among his collection of prints by other
artists, made free use of an illustrated *Hudibras* published
sixteen years earlier; and what he himself supplies is a
certain broad relish of humorous and ridiculous detail.
Probably his best plate is " Burning the Rumps "; for
there we have a bold and accurate representation of
an eighteenth-century street-scene—Temple Bar, bearing
on its classical summit two traitors' skulls and a severed
leg: the irregularly embossed expanse of the cobbled
pavement, studded with stout posts that separated the car-
riage-way from the narrow foot-way: the wooden balconies
of the houses and the merchants' swinging boards. His
illustrations for *Hudibras*, however, are said first to have
brought Hogarth's talents to the notice of his professional
colleagues; and that he had at length begun to establish
a solid standing seems proved by the law-suit that he fought
and won two years later, in May 1728, against an uphol-
sterer called Joshua Morris who, wishing to execute a
number of tapestry-panels, had commissioned him to design
" The Element of Earth ", and then, being dissatisfied
with the result, had alleged that Hogarth was " an engraver,
and no painter " and refused to pay the promised fee.
Thirty pounds were at stake. Also at stake was the self-
respect of an obstinate and ambitious man; and, although
litigation at that period was often a dangerously expensive
affair, Hogarth declined to be daunted, flew to the attack,
marshalled an army of imposing expert witnesses (who
included Sir James Thornhill, Serjeant-Painter to the Crown,

and Vanderbank of St. Martin's Lane), vindicated his professional credit and carried off the sum agreed. Thornhill, it is clear, was already an ally; he, too, detested Kent and had reason to fear his rapid rise—had not Kent, through his influence at Court, baulked him, as early as 1721, of a commission to decorate the great Cupola Room in Kensington Palace?—while John Thornhill, the painter's son, was becoming Hogarth's close friend.

III

Annus Mirabilis

THE FORMATIVE years of an artist's existence are generally
divisible into three main stages. There is a first stage
when his hopes are vague and high, as were Hogarth's
while he wandered in a pleasant dream beneath the frescoes
of St. Paul's and Greenwich. But the next phase is often
marked by a decisive setback. No longer at liberty to hope
and plan, postponing the realisation of his plans till some
remote period of the blessed future, he comes face to face
both with the practical difficulties of life and—a discovery
even more galling—with the limitations of his own talent.
For Hogarth this second stage would appear to have lasted
from 1720 to 1728. The youth who wished to paint in the
grand manner was obliged to earn his living as a hard-
worked craftsman; his illustrations and satirical prints had
attracted some notice, but brought him little wealth or
fame; and, although he was learning something of the world,
he could not persuade its rulers and arbiters to assess him
at his real value. Yet obscurity has certain advantages;
for the artist as anonymous observer may obtain oppor-
tunities afterwards denied to the artist as a public per-
sonage. Still intent on improving his draughtsmanship
(which obviously required improvement) Hogarth, having
renounced his brief allegiance to Vanderbank's academy,
had now begun to attend classes at Sir James Thornhill's
drawing-school, established by the Serjeant Painter at the

rear of his house in Covent Garden. But, otherwise a ready learner, where academic instruction was concerned he had never been an apt pupil; and the most valuable lessons he received were probably not at the school, but beneath the piazzas of the Garden itself and among the crowded and lively population of the adjacent streets and lanes. The artist was also a man of pleasure; but, when he put on his sword, he did not forget his sketch-book.

Few of his early sketches have escaped destruction. A series of drawings, afterwards engraved by Samuel Ireland, with the title "Characters who frequented Button's Coffee-house about the year 1720", which were once thought to represent Addison, Pope, Dr. Arbuthnot and Dr. Garth, are to-day considered to have been portraits of far less distinguished citizens. But portraits they evidently were; and like the charming sketch of a negligent coffee-house waiter and his thin and hungry customer, they show the draughtsman's delight in physiognomy and his gift of catching a characteristic pose. Button's, which stood on the south side of Russell Street and was kept by an old servant of Addison's wife, the former Lady Warwick, served the great journalist both as a literary meeting-place and as an editorial office, from which, however, according to Johnson, "when any domestic vexations arose", he would withdraw the company, retiring to the tavern where he had eaten his dinner, and "where he often sat late, and drank too much wine". It was at Button's, that the *Spectator's* correspondents dropped their letters "into a till . . . through the mouth of a lion's head tolerably well carved"—an agreeable adaptation of the sinister Venetian practice. Button's belonged to the Tories, just as Child's belonged to the Whigs; and all around them in the adjacent thoroughfares were many other places of resort, closely neighboured by establishments of a more raffish and

disreputable type, each with its separate synod of talkers and its established code of social behaviour, at which a young man whose eyes and ears were open could gain a comprehensive impression of the literary and political life of his age.

Thus the second period of Hogarth's existence was passed not only in the execution of laborious hackwork—and hackwork is a form of technical exercise from which an energetic and versatile artist seldom fails to benefit—but in a lengthy process of observation and critical comparison, carried out sometimes deliberately, sometimes half unconsciously, while its harvest continued to accumulate in the depths of the creator's mind. The third development was now due to occur—that miraculous stage in an artist's progress when his scattered imaginings suddenly fall into a coherent and distinctive pattern, and a balance is at last achieved between his abilities and his opportunities. Such a solution arises from within: it is born of an interior struggle, of which the artist himself perhaps has never fully taken cognisance. But it is usually precipitated by some exterior event, acting, so to speak, as a kind of mental catalyst, which the creator may afterwards forget, and of which his subsequent critics may remain completely unaware. Hogarth had been hard at work for more than a decade; and during those ten years, besides diligently observing and committing a record of what he observed to the pages of his sketchbooks, at Thornhill's studio or at home he had begun to master the art of painting in oils. Why did his patient efforts so unexpectedly bear fruit? To a question as difficult as this, in the absence of any hint provided by Hogarth there can be no final answer. But at least one influence that contributed to produce the result may have reached him, I believe, from behind the footlights of a London playhouse, where a new and fascinating form

of operatic entertainment had added colour and hilarity to the opening of the new reign.

The Beggar's Opera was first presented to London, at the Theatre Royal, Lincoln's Inn Fields, on January 29th 1728. Seven months earlier, George I, always hankering after the calm, comprehensible routine of his Hanoverian dominions, had left England for the last time; and on June 14th an exhausted courier reached Sir Robert Walpole with the information that the King lay dead, having collapsed in his carriage during a headlong journey through the Low Countries and expired in the residence of his brother, Duke of York and Prince Bishop of Osnabrück. It was a moment of confusion but also of some elation. Whereas the old king, remote and alien, closely hedged around by foreign body-servants and uncouth German mistresses, had made no attempt to attract the sympathy of his inexplicable British subjects, the new monarch—if only to annoy his father—had allowed it to be understood that he was not unwilling to be regarded as an adopted Englishman. In this politic pretence he was abetted by his wife, one of the keenest feminine intelligences ever associated with the British throne. " *Grandissime comédienne* " and arch-diplomatist, Caroline of Anspach had a just appreciation of Sir Robert's brilliant statecraft; and, although Walpole's prospects for a while seemed poor—the King had gruffly implied that his services were no longer needed —within thirteen days, thanks both to Caroline's support and to the astonishing incapacity of his nearest rival, he had quietly reassumed his position as the King's chief minister. George and Caroline were crowned on October 11th 1727, the Queen a large and majestic presence clad in purple velvet and ermine, decked out—since much of the royal jewellery had vanished into the coffers of the old King's German favourites—with all the jewels she could

borrow from her English ladies or from the Jewish merchants in the City of London. But the change effected was more apparent than real. George was still at heart a punctilious German martinet who, according to a privileged observer, Lady Mary Wortley Montagu, considered subjects of any complexion as creatures to be kissed or kicked; and Caroline, though she loved intelligent conversation and the society of learned men, was first and foremost his devoted ally, passionately attached alike to his person and to the source of power he represented. The courtiers they had gathered around them at Leicester House—the large private house on the northside of Leicester Fields, whither the Prince and Princess had fled after a violent and scandalous altercation with the King during the year 1717—often discovered that they were somewhat less welcome in the state-rooms of St. James's Palace.

Among those particularly aggrieved were Jonathan Swift and John Gay. Swift bore his disappointment with sardonic fortitude—the Queen's failure to redeem her promises [1] was merely the last of a long series of bitter disappointments that had begun in 1713: the shadows of senile dementia were already gathering over his head. But Gay, whose constitution was of thinner, flimsier stuff, retaliated as best he might. He resented the predominance of Sir Robert Walpole, who, with less than his usual good nature, had labelled him " the fat clown ", and advertised his warm adherence to the Opposition côterie. Encouraging him were many distinguished friends—Pope, for example, a Tory by tradition since he had been born a Catholic, who in the epitaph he presently wrote immortalised the legend of the " innocent " Gay, destined to lead a " blameless life " and sink into an early

[1] See *Verses on the Death of Dr. Swift*, published six years before the author's death, in 1739.

grave, unnoticed by a royal patron and unrewarded by the noble and rich. A graceful encomium; but it had curiously little substance. In fact, Gay, the son of a West-Country yeoman, apprenticed during his youth to a London silk-mercer, had soon received the recognition he sought and had found admirers, who were also friends, to make his worldly path smooth. Did not the Duchess of Queensberry and Lady Burlington—the one exceptionally beautiful, the other amusing and gifted—snatch their favourite poet from hand to hand? If he grew tired of the pleasures of Drum-lanrig, for him, as for William Kent, there was always his room at Burlington House; and, should the metropolis become hot and noisy, he could take refuge with Pope and Kent amid the groves of Chiswick. Nor does Gay—an idle and self-indulgent personage even in that age of idle poets, when Thomson, the author of *The Seasons*, was once observed devouring the riper side of a peach, where it hung against a sunny wall, without troubling either to break the stalk or remove his fists from his breeches' pockets—seem to have regarded such aristocratic support as a degrading form of servitude. But evidently he had a pettish—perhaps a slightly petty—nature. The rewards he gathered were seldom entirely adequate. From 1723 to 1731, he held a sinecure position as a Commissioner of the State Lottery. But on the accession of King George II, to whose second son, the Duke of Cumberland, he had just dedicated a volume of *Fables*, he was confidently looking forward to some much more lucrative mark of interest. Offered a minor post at Court, which carried with it an annual stipend of a mere two hundred pounds, he professed himself deeply affronted and indignantly declined the bait.

The Court's loss (he now determined to show) should turn out to be the Opposition's gain. Comfortably established under the protection of the faithful Duchess—a high-

spirited and charming, but rather crack-brained, *élégante*, who liked to combine the affectations of a woman of fashion with an air of milk-maidish simplicity—he revived a project that had been suggested to him by Swift many years earlier. Swift had spoken of a " Newgate Pastoral "; and Gay adapted the idea to suit the current trend of taste. Operas had been popular in England since the beginning of the eighteenth century—foreign operas with foreign singers: from which Burlington and Shaftesbury and their disciples of the Palladian School deduced that English taste, in music as in architecture, was at length becoming truly civilised, and that we had " raised ourselves an ear and a judgement not inferior to the best . . . in the world "; while Swift supposed that Mediterranean harmony would soon be accompanied by sodomy, clandestine stiletto-play and other typically Italian vices. During 1720, a Royal Academy of Music had been established to present operatic works in London, and Handel, the Hanoverian choir-master, had produced his *Radamisto*. Here, as elsewhere, political controversies became confused with æsthetic differences; and the friction between Prince and King had its counterpart in the strife between German and Italian modes. Since the old King approved of Handel, the Prince and Princess and their courtiers at Leicester House did what they could to advance the cause of his chief opponent in the operatic field, Giovanni Batista Bononcini. But Handel had surmounted these trials; *Radamisto* was followed by *Ottone, Giulio Cesare, Tamerlano,* and then, on the accession of George II, by an opera with an English subject, *Riccardo Primo, Rè d'Inghilterra,* a musical peace-offering to the middle-aged monarch, in which he is represented as the chivalrous hero of medieval legend—" *Grande, amoroso, affabile, sincero* "—prompt to subdue his foes, never reluctant to extend his royal mercy. But, oddly enough, the

character of Richard was interpreted by Senesino, one of the most celebrated of the *castrato* singers.

Such was the opera familiar to Gay and his circle—a form of art predominantly foreign, which took its subjects from the heroic past, served by female singers who spoke no English and by male artists, who, to give them an additional remoteness, were often only half-men. The *castrati* scandalised, yet also surprised and delighted. Gentle and bovine, plump and heavily beringed, they might be as slow and awkward in their movements as the famous Farinelli; but, once their extraordinary voices began to ascend the scale —voices as pure as a boy's, as sweet and various as a woman's—the stout figure that held the stage appeared to be possessed and transformed by some invisible spirit of music. Exquisite artificiality was the opera's keynote; and Gay's idea of imposing operatic conventions upon a satirical drama of contemporary low life, in which catches and ballads would take the place of airs, and thieves, fences, turnkeys and strumpets of the dignified, disconsolate protagonists of *Tamerlano* or *Radamisto*, seemed therefore particularly bold and strange. To refresh his memory of the criminal background, he informed Swift that, at the earliest opportunity, he intended to revisit Newgate; and into the text he poured all his not very large stock of originality and executive talent. The completed manuscript, nevertheless, was refused by both the managers to whom it had first been offered. At Drury Lane it was rejected by Colley Cibber; and Aaron Hill would have none of it for the Queen's Theatre in the Haymarket. While his literary friends expressed their anxiety—Congreve and Pope could not conceal the alarm that this audacious project caused them—Gay's fashionable acquaintances were almost equally disconcerted. As the Duke of Queensberry was pleased to remark: " This is a very odd thing, Gay. I am

satisfied that it is either a very good thing or a very bad thing ". But the Duchess of Queensberry hastened to the opera's support; and, since she was a woman of unusual spirit and charm, John Rich, the intrepid actor-manager, who not long ago had been amusing audiences as a pantomime Harlequin, was presently persuaded to accept this odd production for his new theatre in Lincoln's Inn Fields.

Rehearsals, as always, were a perplexing and exhausting business. Quin, a renowned interpreter of tragic rôles, provokingly, if not unreasonably, declined the part of Macheath; whereon Thomas Walker, a comparatively obscure performer, was hurriedly chosen to portray the amorous highwayman. Next, there was the question of music. Gay himself had not envisaged any musical accompaniment. He was overruled, however, by Rich and the Duchess, who instructed Rich's musical director, a certain Dr. Pepusch, to provide a score built up of old English ballads and traditional country dances: to which he added Handel's march from *Rinaldo*[1] as a happy after-thought. But the producer's luckiest find was Miss Lavinia Fenton, the blonde nineteen-year-old girl whom Rich had already hired at a salary of fifteen shillings a week. The daughter of a coffee-house proprietor in the Charing Cross neighbourhood, where her engaging appearance and her delightful voice had soon attracted the attention of contemporary " humming beaux "—the nickname then given to stylish melomaniacs—she had every attribute calculated to do justice to the rôle of Polly. " Her face, her form, her grace, her voice, her archness, her simplicity " could not have been better suited to that enchanting heroine; and, although *The Beggar's Opera* was to " make " Lavinia,

[1] It formed the accompaniment of the Highwaymen's chorus, " *Hark! I hear the sound of coaches!* " in Act II, Scene II.

and to launch her on a triumphant career eventually crowned by a strawberry-leaved coronet, the young actress was also to make the play, since her rendering of a famous song saved the dubious fortunes of the first night.

On January 29th, a " prodigious Concourse of Nobility and Gentry " had assembled in Lincoln's Inn Fields to witness the opening performance of " Mr. Gay's new English opera ". Sir Robert Walpole himself occupied a side box; and it was known that the piece included many oblique gibes at the insolence and corruption of the ministry. Few innovations are received with immediate applause; and here, once again, political partisanship complicated the aesthetic issue. So undecided was the audience's mood that supporters of the opera endeavoured to puff it by loud expressions of their own approval. " It will do. It *must* do! " declared the Duke of Argyll in resonant tones, as he pretended to survey the house. " I see it in the eyes of them." Yet the performance continued to hang fire until it had arrived at the tenth scene, when Polly, kneeling before her parents, begs that they will spare her husband, and Lavinia Fenton's delicious trill attacked the listeners' hearts and senses:

> *Oh, ponder well! be not severe;*
> *So save a wretched wife!*
> *For on the rope that hangs my dear*
> *Depends poor* Polly's *life.*

From that moment, doubt was at an end; and, despite numerous references, even in the first songs, to the general iniquity of statesmen, and a series of personal jokes at the expense of the King's chief minister—the dispute between Licket and Peachum, for instance, was understood to represent a recent undignified squabble between Sir Robert and his brother-in-law, Lord Townshend—the Minister, on

view in his side-box, was observed smiling broadly and applauding generously. "No Theatrical Performance for these many years (wrote the critic of the *Daily Journal*) has met with so much Applause." It was "written in a manner wholly new, and very entertaining"; and, for a time at least, *The Beggar's Opera* was said to "entirely triumph over the Italian one". By running without interruption until March 9th, the piece broke every previous record. Meanwhile Lavinia, as Polly, became the universal rage. Her portrait appeared in all the print-shop windows: the book-sellers brought out her biography, accompanied by apocryphal collections of her jests and sayings. That summer she eloped with the Duke of Bolton, an admirer twenty-three years older than herself, who legalised their union in 1751, upon the unlamented death of his first wife.

Hogarth attended the Opera, evidently more than once; and the strong appeal that it made to his imagination is not difficult to understand. Besides flattering a variety of prejudices—Kent's advertisement of his exotic musical tastes had left him a determined foe of all Italian singers and players—*The Beggar's Opera* depicted an aspect of London that he himself had known from childhood. If Bartholomew Fair had implanted a love of the stage, Newgate Gaol had founded his knowledge of the London underworld. He, too, had seen the young, defiant, good-looking criminal, as the cart drew up and he received his nosegay on the threshold of St. Sepulchre's, and as it moved out of sight again towards Tyburn and the last act. A condemned highwayman was the hero of the mob:

> *The youth in his cart hath the air of a lord,*
> *And we cry, There dies an* Adonis!

Polly's prophetic picture of Macheath's end was no mere rhetorical flight of fancy:

" Methinks I see him already in the cart, sweeter and more lovely than the nosegay in his hand!—I hear the crowd extolling his resolution and intrepidity!—What vollies of sighs are sent from the windows of *Holborn* . . . I see him at the tree! the whole circle are in tears!—even Butchers weep . . ."

Gay was working on authentic material. The names of the highwaymen Jack Sheppard and Joseph Blake, alias " Blueskin ", were well known to his London audience; and they would remember how, during the course of his trial, Blueskin had made a murderous and nearly successful attack upon his confederate Jonathan Wild, and how Wild —the prototype of Peachum—had long flourished both as an informer and as a receiver of stolen goods, who regularly betrayed his accomplices when he had no further use for them. Although fences and footpads were generally despised, highwaymen, or thieves on horseback, were credited with some of the gallant and extravagant qualities of the soldier of fortune. They were said to be favoured by expensive courtesans; and one highwayman at least, the " gentleman highwayman ", Maclean, later kept lodgings in St. James's Street, exactly opposite the door of White's. From such material as this Gay had formed his Macheath—a character which Samuel Johnson was afterwards to describe as " a labefaction of all principles ", but which possessed a strong hold upon the feelings of James Boswell,[1] who sometimes liked to picture himself as a romantic and lovable desperado.

[1] See Boswell's account of a visit to Newgate on May 3rd, 1763. *London Journal*, edited by Frederick A. Pottle, 1950.
" In the cells were Paul Lewis for robbery and Hannah Diego for theft. I saw them pass by to Chapel. The woman was a big unconcerned being. Paul, who had been in the sea-service and was called Captain, was a genteel, spirited young fellow. He was just a Macheath. He was dressed in a white coat and blue silk vest and silver, with his hair neatly queued and a silver-laced hat, smartly cocked . . . He walked firmly and with a good air, with his chains, rattling upon him . . ."

Hogarth, it is true, was neither a romantic nor a senti-
mentalist. He may not have appreciated Gay's implied
suggestion that respectability and criminality were at best
but relative terms, and that the good and evil in human
affairs were often curiously intermixed. Yet he had the
same absorbing interest in the life of his period, the same
ambition to give its transient shows a permanent aesthetic
shape.

Gay's contribution, however, need not be exaggerated;
and it is probably enough to remind the reader (without
seeking to draw any very definite inferences) that the year
of *The Beggar's Opera* was the *annus mirabilis* of Hogarth's
youth, and that his early pictures often adopted a deliber-
ately dramatic form, so that they seem to be bounded by
the framework of an imaginary stage. In subsequent
generations, the affinity of Hogarth to Gay did not go un-
recognised; and Hazlitt, who declared that " all sense of
humanity must be lost before *The Beggar's Opera* can cease
to fill the mind with delight and admiration ", describes
the spontaneous tribute of an elderly citizen who, having
seen the opera for the first time, suddenly arose from his
seat in the audience, ejaculating " Hogarth, by God! "
Later, as he explains in his record, Hogarth came to regard
himself as a pictorial playwright. But his only account of
the remarkable revolution that would appear to have trans-
formed his existence during the years 1728 and 1729 is
conveyed to us in a single brief paragraph, beginning with
the sentence: " I then married and commenced painter
of small Conversation pieces, from twelve to fifteen inches
high." Here he was falsifying the sequence of events. He
had already been engaged on conversation pieces for many
months before he married; and the basic idea that originally
produced them must somehow have entered his conscious-
ness during the opening days of 1728—or, it may be, even

earlier—to judge by the rapidity with which the project bore fruit. Like most seminal ideas, it was a surprisingly simple one. The popular portrait-painters of the seventeenth century had gradually reduced their art to an exact convention. Their studios were thriving pictorial factories, in which the decorative details of a picture were supplied by separate hack-artists, while the proprietor perfected the face and superintended the general treatment. The "master phiz-monger" (to borrow Hogarth's phrase) would have been sadly at a loss without his expert "drapery man". Kneller, for instance, whose long tyranny in the realm of portrait-painting did not conclude until 1723, had brought this practice to a high level of technical efficiency, but, by doing so, had given his canvases a somewhat standardised and lifeless air. Life was the quality that always excited Hogarth—the living relationship between human beings, and between the sitters he portrayed and their temporal, spatial background. He saw them as actors in an unending play, and now resolved to produce a series of portraits that should reflect the variety and vitality of the contemporary world beneath his eyes.

Thus he founded the great tradition of the English Conversation Piece. But, although in England itself he had had no genuine fore-runners—if we except such delightful rarities as the picture of King Charles II being presented with a pineapple, the work, incidentally, of a foreign artist, Henry Danckerts—we must admit that he was deeply obliged to the seventeenth-century Dutch school. The masterpieces of de Hoogh and Vermeer may be populated with anonymous personages; but Jan Steen had painted " The Artist's Family ",[1] taking their ease in a bedroom-parlour, eating fruit, stuffing their pipes and listening to a domestic concert; and, to choose an example from the

[1] In the Mauritshuis, The Hague.

work of a lesser-known painter, during the second half of the seventeenth-century Pieter van Anraadt (who died in 1676) had depicted Jeremias van Collen, his wife, Susanna, and their twelve children, all disporting themselves upon a chequered garden-terrace, in a style that recalls the freedom and gaiety of Hogarth's finest portrait-groups.[1] The English artist was never to visit Holland; but it is clear that the genius of the Low Countries—studied either through engravings or in the houses of the *cognoscenti*—had a sympathetic connection with his own creative gift. Dutch genre-painters, on the other hand, seem to portray a static, almost timeless universe. As through a curtain of golden haze, the cavalier lifts his flute-shaped glass: his mistress, in oyster-coloured satin, sits poised before the virginals. They are contemporary characters, arrayed in the costume of their time; yet they show little of Hogarth's absorption in the drama of the passing momen.

With his interest in the drama of the present day, Hogarth combined a remarkable insight into changes of contemporary taste. The social climate of England was growing gradually but surely milder. Years of peace at home and abroad, and the vast influx of prosperity derived from foreign commerce, were developing the character of the eighteenth-century Englishman, in whom a tolerant affection for his fellow human beings frequently took the place of the more dangerous, if more heroic, virtues. He may have been selfish: he was eminently sociable. In no other epoch of English history can so many tributes be found to the pleasures of gregariousness, or so many vivid accounts of successful social gatherings. We read of drinking

[1] This picture is now in the Rijksmuseum, Amsterdam. An interesting comparison may also be made with the work of Cornelius van Troost (1697–1750), sometimes called " the Dutch Hogarth." But, although van Troost was probably familiar with Hogarth's pictures through engravings, it is exceedingly unlikely that Hogarth knew of van Troost's existence. See *Conversation Pieces* by Sacheverell Sitwell. Batsford, 1936.

parties, dancing parties, musical parties, card parties, and parties at which the chief diversion was to listen to intelligent talk. Good parties require comfortable surroundings; and the desire for comfort was having a radical effect upon domestic architecture. Indeed, one of the main criticisms levelled against Lord Burlington and the architects who followed him was that they sometimes sacrificed interior comfort to the demands of bleak magnificence. Rooms nowadays were designed for warmth and ease. Elegance, of course, was essential; but especially in smaller Georgian dwellings, built to accommodate the landed gentry or the rising middle-class, elegant proportions went hand in hand with practical planning and sound construction. Among the inhabitants of these new-built houses, where big looking-glasses glimmered on the walls, chandeliers depended from the Italianate plasterwork of the drawing-room ceilings, and huge sea-coal fires were banked high behind the polished metal grates, Hogarth saw the protagonists of his contemporary conversation pieces. There was no need for him to invent a pretext, or to imagine a conversation that was not already under way. Obviously, he might correct or improve a pose; but the naturalness of the sitters' positions would seem to suggest that he found it an easy task.

The air of naturalness increased with experience; for in his early pictures the vivacity of the artist's conception still tends to be impeded by the limitations of the draughtsman's skill. Heads and bodies, for example, are rather summarily screwed together; a face may radiate life and energy, but the trunk to which it is attached serves chiefly as the conventional support of the head, and adds little to our understanding of his sitter's real habit. Among the earliest of Hogarth's conversation pieces, executed for wealthy patrons between the years 1728 and 1732, are a scene from *The Beggar's Opera* (of which he was eventually

to produce no less than five variants), *The Assembly at Wanstead House*, painted for Lord Castlemaine, *Lord Hervey and his Friends*, *The Wedding of Stephen Beckingham and Mary Cox*, *The Wollaston Family* and the delightful picture of a children's play, known as *The Conquest of Mexico*. Both in the last-named picture and in the *Beggar's Opera* scenes, the painter resorted to a device that obviously much attracted him—the representation, so to speak, of a stage within a stage. The painted audience looks on at the actors: we are ourselves privileged to enjoy a two-fold spectacle. Here Polly Peachum pleads for her lover; there the Duke of Bolton, distinguished by his star, sits book in hand, his acquaintances around him, listening and admiring from a narrow side box. Even though the stage is absent, and the solid walls of a church or drawing-room have taken the place of a flimsy coloured back-cloth, we observe in Hogarth's family-portraits the same theatrical grouping, the same ingenious distribution of dramatic interest. Thus Stephen Beckingham and Mary Cox are just advancing towards the altar-rails. Her hand has begun to slip into his; and the bland and innocent expressions of the young man and the young woman are in amusing contrast with the parson's heavy jowl, the doltish profile of his curate or clerk, and the two elderly and world-wise personages who have appeared to support the bride and groom, one of them—presumably Mary's father—leaning on his stick in a familiar carefree attitude. The scene is mildly idyllic, yet also happily prosaic. A brace of cherubs fluttering over-head scarcely detract from its air of sober realism.

Similarly matter-of-fact is the Wanstead Assembly. Indeed, the verisimilitude imposed by his subject may, in this particular instance, have caused Hogarth certain private pangs. For Wanstead House had been designed by Kent; and it was his painful duty to depict an interior

that, dignified and sumptuous as it seems to modern eyes, he himself would have considered the height of clumsy tastelessness. Yet it is unmistakably on a sofa from Kent's workshop, before the kind of richly scrolled, heavily gilded table that Kent also contrived for the state rooms of Houghton and the noble apartments of Wilton, that Sir Richard Child, Viscount Castlemaine, afterwards first Earl Tylney, presides over this large gathering of his family and household friends. In the background a footman is lighting the candles; while the foreground is occupied by some twenty-five different actors, centred in a party at cards with a graceful feminine player holding out the ace of hearts, her extended arm directing our attention towards the table at which Lord Castlemaine sits. Dusk thickens: the assemblage in the candle-lit drawing-room will soon become more animated. Three solemn-faced children have gathered tentatively around the big dog: on the flowered carpet two Italian greyhounds lift an inquisitive muzzle and a delicate paw.

If Wanstead House [1] stands for domestic sobriety, and the wedding-group is an exquisite pre-figuration of conjugal felicity—episodes from the life of an age that cultivated the family affections in an atmosphere of social stability and assured financial well-being—*Lord Hervey and his Friends* introduces us to a more masculine and independent world. We are among men of fashion and men of pleasure. Hervey, not yet immortalised as Pope's " Sporus ",[2] was then thirty-four or thirty-five. The favourite

[1] Commissioned in 1729, this picture remained unfinished until January 1731.

[2] The *Epistle to Dr. Arbuthnot* appeared in 1735. The dating of this conversation-piece is somewhat problematical. Mr. R. B. Beckett suggests that it was painted as late as 1738: Lord Ilchester, in *Lord Hervey and his Friends*, gives the date as 1736. It must have been painted after 1730, when Hervey became Vice-Chamberlain. On the other hand, it seems probable that it was produced before the death of Queen Caroline in 1737—an event that reduced Hervey to the depths of dejection and left him looking prematurely aged. Moreover, the picture itself has the appearance of an early work. As such I have considered it here.

and confidant of Caroline of Anspach, in 1720, when she
was still Princess of Wales, he had married the most
beautiful of her Maids of Honour; but his relations with
his wife were never very passionate; and such passion as
his curious nature contained would appear to have been
expended in romantic friendships with his own sex—
notably with the brothers Henry and Stephen Fox, after-
wards the first Lord Holland and the first Lord Ilchester.
To Stephen he was particularly devoted; and it was in
Stephen Fox's company that, during the year 1728, he had
left England on an Italian tour, seeking health and peace
of mind; for, despite a feverishly active existence, he
claimed to possess many of the disabilities of the consti-
tutional invalid. At the moment he looks blooming and
healthy, the handsomest of the new King's courtiers, the
key, to which his post as Vice-Chamberlain entitled him,
pinned above his coat-pocket. He stands in a garden at
the edge of a lake; a flask, glasses and fruit have been set
upon a small table; and we seem to be participating in the
vinous aftermath of an unusually successful dinner-party,
when the effects of wine are enhanced by the exhilarating
coolness of the open air. Everybody is disposed to talk;
and the clerical guest, no doubt the chaplain, who has
climbed on to a chair, which tilts backwards at a dangerous
angle, is gazing into the distance rather wildly through his
telescope. More soberly the host and his friends—
Stephen and Henry Fox, the Duke of Richmond[1] and
Thomas Winnington—discuss the plans of a projected
house; and the Duke submits his advice with an air of
self-satisfied connoisseurship.

Whereas *Lord Hervey and his Friends*, notwithstanding

[1] In most descriptions, this person is said to be the Duke of Marlborough.
But Mr. Romney Sedgwick, the learned editor of Hervey's *Memoirs*, points out
that the Duke of Marlborough did not receive the Order of the Garter (which
the nobleman portrayed is wearing) until the seventeen-forties, and that, unlike
the Duke of Richmond, he was never a close associate of the Hervey circle.

the charm of the subject, has still some of the stiffness and angularity of a primitive painting, *The Conquest of Mexico* is one of the most sophisticated and most elegantly contrived of all Hogarth's conversation pieces. Again a stage is depicted within a stage; but here the drama is played out at a fashionable children's party, given in 1731 by Mr. John Conduitt, Master of the Mint, for the ten-year-old Duke of Cumberland and his younger sisters, the Princesses Mary and Louisa. They are being entertained by a group of spirited young actors, Miss Conduitt, Lord Lempster and Lady Sophia Fermor, son and daughter of Lord Pomfret, and Lady Caroline Lenox, daughter of the Duke of Richmond; while, in Mr. Conduitt's fine drawing-room (possibly the work of Kent) adorned with family-portraits of the previous age and Roubiliac's bust of Sir Isaac Newton, Mr. Conduitt's uncle by marriage, upon the lofty chimney-piece, the actors' parents and the royal Governor and Governess, Mr. Poyntz and Lady Deloraine, sit complacently surveying the show. The play that the children have selected, or that has been selected for them, is Dryden's recently revived tragedy, *The Indian Emperor, or the Conquest of Mexico by the Spaniards;*[1] and, as we learn from the prompt-book held by Dr. Desaguliers,[2] they have already arrived at Act IV, Scene IV, where Cortez is " discovered bound " and the rival princesses, Cydaria and Almeria, engage in a lengthy debate across the captive conqueror's person.[3] If Cydaria has just entered, their lines would run as follows:

> CORTEZ: What words, dear saint, are these I hear you use?

[1] Revived at the Theatre Royal on May 12th, 1731.
[2] John Theaphilus Desaguliers (1683–1744) was a Huguenot refugee. A distinguished " natural philosopher ", he was patronised by Sir Isaac Newton and became chaplain to the Prince of Wales.
[3] Alibech, played by Miss Conduitt, does not appear in the scene. No doubt she was included for the sake of pictorial completeness.

What faith, what vows, are those which you accuse?

CYDARIA: More cruel than the tiger o'er his spoil;
 And falser than the weeping crocodile:
 Can you add vanity to guilt, and take
 A pride to hear the conquests, which you make? ...

CORTEZ: With what injustice is my faith accused!
 Life, freedom, empire, I at once refused;
 And would again ten thousand times for you.

ALMERIA: She'll have too great content to find him true;
 And therefore, since his love is not for me,
 I'll help to make my rival's misery [*Aside*
 Spaniard, I never thought you false before: [*To him*
 Can you at once two mistresses adore?

The Indian Emperor may not reveal Dryden's majestic talents at their best and liveliest; but young Cortez, in his puffed and slashed Elizabethan doublet, and the girls, in their hooped skirts and elaborate feathered coiffures, are mouthing his text with exemplary aplomb and dramatic gusto. They have the intense seriousness of children enjoying themselves; and, although the Princesses seem only moderately amused, and their brother, the future victor of Culloden, disregarding the stage, concentrates his attention on being every inch a Royal Duke, they have completely captured the interest of a spectator in the front row. Hogarth's affection for children—inspired not so much by sentiment as by an intuitive understanding of the childish point of view—is conspicuous in this exquisite glimpse of Lady Deloraine's two little daughters. The more distant is completely stage-struck, looking and listening bolt upright, so absorbed in the magic of the spectacle that we feel sure that she will scarcely change her position until the very last line.[1] But the other

[1] See Leslie's *Handbook for Young Painters*, 1855. Quoted by Austin Dobson.

is one of those naturally volatile and incurably fidgety children who, as soon as they are commanded to sit still, begin to pivot on their own axes; and Lady Deloraine (described by Lord Hervey as a " pretty idiot ", with hopes of ascending from the royal nursery to the royal alcove) in order to give the child something useful to do, tells her briskly to pick up her fan.

Such was the rapidity of Hogarth's progress in the art of conversation-painting. The new venture, according to his autobiographical notes, having the merit of novelty, " succeeded for a few years ": after which its attraction declined and he was obliged to investigate fresh fields. That statement is a trifle misleading, since the conversation-piece was a form he never wholly gave up, witness *The Graham Children*, painted in 1742, *Lord George Graham in his Cabin* which dates from 1745, and *David Garrick and his Wife* which belongs to 1757. It is time, however, to return to the first half of the brief but important sentence I have already transcribed. He " then married ", the artist writes. For some while he had been an intimate of the Thornhills' house in Covent Garden, where John Thornhill was his friend and boon-companion, and he had also attracted the notice of the Serjeant-Painter's daughter, Jane. How the attraction matured we have no means of telling; but Sir James, although he admired his work, seems to have indicated that he did not think of Hogarth, who was neither well-bred nor yet very well-established, as a future son-in-law. During March 1729, therefore, Jane Thornhill left her father's house, eloping (tradition assures us) to a " villakin " or " country-box " that her lover had taken in a quiet Thames-side neighbourhood. They were secretly married in Paddington Old Church on the 29th of the same month. Jane was nearly twenty: William Hogarth was thirty-one.

IV

London Background

JANE HOGARTH's character is difficult to evoke; for the
simplest personalities leave the slightest imprint; and, so
far as we can judge, it was exceptionally simple and straight-
forward. Her husband painted her on several occasions;
and each portrait shows a mild, large-featured young
woman, rather handsome than beguiling, whose placid face
beneath soft dark hair seems fashioned to reflect only the
gentlest human impulses. There is no doubt that she had
contracted a marriage of love. But, once she had defied
her parents, any ideas of further rebellion were imme-
diately put aside; and she continued to regard the man
she had married with deep, unquestioning admiration. Of
Hogarth's response there is little to say, except that he
succeeded in making his wife an affectionate and loyal
partner, and that, if his amusements were apt to take him
from home, his feelings of duty and respect for propriety
always brought him back again. The circumstances of his
courtship, however, deserve especial scrutiny. Just as his
temperament was richer than Jane's, his motives in wedding
her had a very much more complex origin. Thornhill was
the luminary of his youth; and by marrying Jane Thornhill
(even in direct defiance of her father's wishes) he may
have felt that he had secured a symbolic prize, the crown of
plans and imaginings that he had nursed since early child-

hood. There was also the question of social prestige. Son
of a struggling school-master, grandson of a yeoman farmer,
Hogarth was not likely to have forgotten that the Thornhills
were products of the landed gentry, that their ancestors had
flourished as squires at Thornhill in the County of Dorset,
an estate they had been obliged to sell but which Sir James
had re-purchased on his profits as a popular artist. A
third attribute may have been equally decisive. " Stately "
was an epithet applied to Jane Hogarth in her old age; and
it is a word that we seldom employ when we are describing
very short persons. We may assume, therefore, that she
was moderately tall, whereas William Hogarth was five feet
high, and that, whether or no he looked up to her socially,
he certainly looked up in the physical sense. Her advantage
was perhaps an added charm. Small, bellicose, determined
men are notoriously addicted to the companionship of
large, quiescent, maternal women, whose swelling comeli-
ness ministers to their masculine pride, and whose un-
critical devotion envelops them like a fleece-lined cloak.
But, whatever qualities Hogarth had found in Jane, and
however mixed were his motives when he lured her from
her father's home, their long marriage proved singularly
happy—so happy that it was destined to run its course
without scandal or commotion, almost without friendly
record.

Beside his wife's gentle and retiring portrait, Hogarth's
physiognomy, modelled during the opening years of his
marriage, appears dominant and determined to the point of
arrogance. About 1732 his head was portrayed in terra-
cotta by the French statuary, Louis François Roubiliac[1];
and we could wish for no more graphic representation of
the artist's early middle age. He is shown wearing a silk

[1] Roubiliac (1702–1762), an artist of Huguenot descent, had come to England
in 1727. His reputation was finally established by the full-length statue of
Handel, executed for the proprietor of Vauxhall Gardens in 1737.

[Cf. Painting of P.]

or velvet cap, of the kind adopted by eighteenth-century gentlemen as often as they removed their wigs, the cap that painters wore at the easel and authors at the writing-desk. He stares forth, aggressive and humorous and shrewd. The underhung jaw is slightly crooked; and the prominent lower lip, which hangs rather loose, has both a militant and a sensual air. There are pouches beneath the eyes—perhaps the mark of dissipation, combined with regular overwork; and the eyes themselves are sharp and suspicious, below eyebrows irritably drawn together. The forehead is lofty, grooved by a deep scar, the result of an accident in early childhood. As for the nose, it is tilted at the tip, and adds to the general effect of inquisitiveness and liveliness. An intelligent face, yet a far from delicate face—the mask, indeed, of a " self-made man ", who trusts no friendships and values no opinions until he has had time to subject them to a close and jealous scrutiny: who prefers talking to listening, and appreciates candour in those he meets only when it happens to harmonise with the prejudices he has already formed. Unquestionably, it is not the face of a man who welcomes criticism.

Yet, above all, we have an impression of energy; and Hogarth's achievement between 1728 and 1732 suggests an astonishingly energetic life. His conversation pieces do not stand alone. They were accompanied by many other experiments in the delineation of his own times. From 1730 or 1731, for example, date the two canvases that he called *Before* and *After*—pictures of a young man attempting seduction, while a girl, endeavouring to preserve her virginity, over-turns her dressing-table, and of the same young man, when he has accomplished his purpose, the broken looking-glass lying in fragments at his feet, and his mistress, dishevelled and lacrymose, pleading for advice and affection. Both are awkward and somewhat unpleasing

works; but they throw an interesting sidelight on the painter's temperament. Think of similar subjects handled by Boucher and Fragonard,[1] of the voluptuous beauty they contrived to distil from such diverting *contretemps*, and of the airy poetic charm with which they invested their sentimental libertinism! By comparison, Hogarth's treatment is a prosaic transcript of direct experience. Sentiment and *grivoiserie* are equally lacking. This, we feel, is a possibly disastrous and undoubtedly ridiculous episode, such as happened yesterday and will happen again to-morrow, in the too-accommodating shelter of half a hundred curtained beds. The girl is a goose: her lover is a booby. The very gesture with which the young man hurriedly tugs at his breeches reveals his coarse ineptitude.

The artist's eye, in fact, resembles a camera's lens; and, during the early stages of his professional existence, Hogarth anticipated many of the functions of an expert press-photographer. Besides reflecting the social world, he also commented upon current affairs. Thus, in 1733, he would interview and paint the portrait of Sarah Malcolm, a convicted murderess; and, in 1729, he attended at least one session of the Select Committee appointed by the House of Commons " to inquire into the state of the gaols of this kingdom, and report the same, with their opinion thereupon, to the House ". The spokesman of the Committee, which included the Chancellor of the Exchequer and a bevy of well-known politicians, Pulteney, Pelham, Yonge, Wyndham and Bubb Dodington, was a soldierly philanthropist, James Edward Oglethorpe, the friend of Pope and latterly of Johnson and Burke, a man of " strong benevolence of soul ", who was afterwards to found a colony in the New World.[2] Despite the popularly held

[1] In 1730 Boucher was twenty-seven. Fragonard was born in 1732.
[2] Oglethorpe (1696–1785) founded the Colony of Georgia in 1733, partly as a refuge for released debtors. During his youth, he had fought against the

belief that public men of the early eighteenth century felt little or no interest in the welfare of the lower classes, and that problems of poverty, disease and crime were left to slumber almost undisturbed, the great age of English philanthropy was already dawning; and Oglethorpe, whose indignation had been aroused by the horrid fate of a friend of his, the unfortunate architect, Mr. Castell, committed to the Fleet Prison for debt and allowed to die of the small-pox in an adjacent spunging-house, resolved to attack some of the worst abuses of the contemporary prison-system. He saw much there to increase his disgust and pity. Debtors' goals particularly engaged his attention; and the Committee he led made successive inroads into the Fleet, the Marshalsea and the King's Bench gaols, discovering in each case that the office of Warden or Marshal was regularly bought and sold: that a lawyer or tradesman might decide to purchase it as a sound investment, paying a heavy price but wringing even heavier fees from the prisoners of whom he had been put in charge. Recalcitrant prisoners, or those who could not pay, were often disciplined by ingenious devices borrowed from the medieval torture-chamber.

An English prison (as Fielding later observed) was not only a " prototype of hell ", but " one of the dearest places " a man could find to live in. The most miserable lodgings, where the prisoner might share a bed with a companion suffering from a fistula or from some virulent contagious sickness, must be paid for by the occupant as if he had hired a tavern room; while penniless debtors " in the common side " slept on straw or bare boards.[1] As the Committee

Turks under the command of Prince Eugène. Pope's tribute, in Epistle II of his *Imitation of Horace*, is well-known:
> " One driv'n by strong benevolence of soul,
> Shall fly, like Oglethorpe, from pole to pole."

[1] The " Master's side " was the privileged quarter of the gaol. Entrance could only be obtained by paying a fee; and, once he had entered, the debtor was

explored these pestiferous places, among the miscreants they drove from covert were John Huggins and Thomas Bambridge. Huggins, a former Warden of the Fleet, had recently sold the appointment to Bambridge, a professional lawyer, under whose control its emoluments became a large and steady source of revenue; and, in addition to his financial acumen, the lawyer seemed to have possessed unusually strong sadistic instincts. Several deaths were charged to their score; and of these none made so violent an effect upon the contemporary imagination as that of Arne, an impoverished undertaker, whom Huggins had caused to be thrown into an unlighted and unventilated dungeon, newly built, according to his own design, just above the common sewer (from which it was separated by a few planks) and in the immediate proximity of the prison dunghill. Having been stripped naked, Arne was obliged to seek warmth in the bowels of an ancient mattress, somehow smuggled through to him by a kindly fellow prisoner; and one Sunday, when he managed to escape and " ran into the parlour, adjoining to the chapel, during the time of divine service ", the feathers from the mattress, stuck to the filth of his skin, were said to have given him the appearance of a fantastic and repulsive bird. Huggins ordered him to be returned to the dungeon, where he crouched, shivering and speechless, " lifting up his eyes to Mr. Huggins. The said Huggins had no compassion on him, but caused the door to be close locked . . ."

The Committee's examination was long and severe; but Bambridge, although confronted with the manacles, leg-irons, collars and " tongs " that he had devised for the correction of his more unruly inmates, treated

faced by a further demand for " garnish money "; " and if the unhappy wretch (which is the general case) hath not money to pay, the prisoners strip him in a riotous manner which, in their cant phrase, they call letting the black dog walk."

the Committee to a display of insolent hardihood, as
if he dared these distinguished busy-bodies to question
the legitimate profits of a decent businessman. Nor was
his bravado wholly unjustified. True, he was to die by
his own hand—but not before he had been acquitted by
two London juries.[1] Meanwhile, as he was standing at
bay, under the stern inspection of Oglethorpe and other
eminent parliamentarians gathered behind the prison-walls,
Hogarth, apparently at the instigation of a member named
Sir Archibald Grant of Monymusk, was admitted to the
bare, dismal, stone-walled room in the Fleet, with a single
heavily barred window, in which the Committee held their
daily sittings. Tradition says that he was concealed by a
pillar. Some of the details he provided were, no doubt,
imaginary—the finished composition must have " worked
up " from a pen or pencil sketch; but the figure of Bam-
bridge would seem to be an accurate portrait, and was
assumed probably to be such by that intelligent critic
Horace Walpole, into whose omnivorous collection one
of the two variants of the original design passed. Faithful
to the taste of his age, Walpole considered that the great
Salvator Rosa himself, portraying Iago at the moment of
detection, could not have produced a more dramatic picture.
The Committee-men, headed by Oglethorpe with his noble
aquiline profile, appear remote and dignified. Bambridge's
features are convulsed and furious:

" Villainy, fear and conscience are mixed in yellow and
livid upon his countenance; his lips are contracted
by tremor, his face advances as eager to lie, his legs
step back as thinking to make his escape, one hand is
thrust forward into his bosom, the fingers of the other

[1] See *A People's Conscience* by Strathearn Gordon & T. G. B. Cocks. Constable,
1952. Accounts of the subsequent prosecutions may be found in the volumes of
State Trials.

77

are catching uncertainly at his button-holes. If this
was a portrait, it is the most striking that ever was drawn
. . ."

Artists fascinated by the contemporary background are,
as a matter of course, drawn towards the daily newspapers;
and we have a good deal of evidence to suggest that Hogarth
studied them regularly and noted their contents with
unusual care. Following the same path his eye must
have taken, up and down the crabbed close-packed columns
of those flimsy single sheets, again and again we alight on
a scrap of news—or, it may be, on the high-flown advertise-
ment of a London tradesman—that clarifies some detail,
or illustrates some fresh aspect, of the commentator's life
work. The *Daily Journal, Daily Post* and *Daily Courant*[1]
yield a particularly large haul; for these papers are con-
cerned both with the permanent occupations of the com-
mercial metropolis and with its passing social pleasures.
Vessels are continually entering the Thames or—below a
neat little wood-cut of a ship under full sail—are an-
nounced as ready to set forth. Innumerable auctions are
to be held " by the candle "—sales of houses and furniture,
carriages and carriage-horses. We also read of periwigs,
masquerade-costumes and powerful patent medicines:
electuaries, balsams, elixirs, sometimes advertised by the
proprietors of the fashionable " toy-shops ", and guar-
anteed to cure venereal diseases, affections of the chest,
dropsical conditions, headaches and tooth-ache and a
tendency to hysteria or spleen. Wigs we learn, for example,
were priced by the colour. Thus Thomas Astley, who
" Makes & Sells for Ready Money ", can provide the
" Lightest Colour'd Human Hair Tye Peruke for 4 *l.*, the

[1] The *Courant*, first London daily newspaper, began publication in 1702: an
" inundation " of daily papers followed ten years later.

next Colour 3 *l.* 10s. and so the Price in Proportion to the Colour down to 2 *l.* For a Dark Grizel Tye Wig and Horse Hair Tye Wigs, 1 *l.* 10s. The Price of Bobs and Cue Perukes in Proportion."

To the varying appearance of wigs Hogarth would presently devote a plate of detailed caricatures. This odd fashion seems always to have amused him—a wig looked especially absurd when, in moments of perturbation or alcoholic exhilaration, it worked loose upon the wearer's head; but reference to masquerade costumes introduces a far more serious range of subjects. For the masquerades, or public masked balls, organised by Heidegger, at which assignations were often made, and innocence was supposed frequently to receive a moral death-blow, were among the manifestations of " The Taste of the Town " he had already satirised. But the noxious craze had continued to flourish. There was an incessant demand for masks and travesties; and in an issue of the *Daily Post,* published during the Spring of 1731, its readers are informed that " BETTY SMITH From the OPERA-HOUSE Furnisheth Gentlemen and Ladies with all Sorts of Masquerade Habits, entirely new, at the Iron Gate, between the Horse-Shoe and the Highlander, in the Hay-Market, near the Corner of Pall-Mall; where they may be accommodated with all Manner of Venetian and Silk Masks." It was through the adventures of a mid-night masquerade that the hero and heroine of one of his finest and most ambitious pictorial series were to reach their tragic climax; and the student of *Marriage-à-la-Mode* may pause at this specimen of fashionable intelligence, published by the *Daily Post,* on May 13th of the same year:

" A few Days ago the Lord Polwarth, eldest Son and Heir to the Right Hon. the Earl of Marchmont, was

married to Miss Weston, a Merchant's Daughter in Bishopsgate-Street, a young Lady of 30,000 *l.* Fortune."[1]

The spirit of the new age—restless, volatile, amusement-seeking—was simultaneously at work among the London playhouses; the vogue of the ballad opera was still at its height; and we hear of " a Scotch Ballad Opera, call'd PATIE and PEGGY: or *The Fair Foundling, with Entertainments of Dancing* ", a " *Welch Opera* ", " *The Sailor's Opera* ", a " *Pastoral Ballad Opera* ", even a " *Grubstreet Opera* ". Fawkes the Conjurer (who died in 1731, leaving a handsome fortune) drew enthusiastic audiences to his exhibitions of sleight of hand, at which a twig in a flower-pot appeared to blossom and bear fruit—a performance that he supplemented by the display of coloured panoramas. But more revelatory are the reports on crime. The diverse and elaborate civilisation of eighteenth-century England, with its growing opulence and increasing elegance, its appetite for social pleasures and greedy interest in commercial gain, was vexed by problems that it could neither solve nor ignore, that were to remain, indeed, largely unsolved throughout the following hundred years. Poverty grew, even as wealth had grown. Poverty and misery encouraged the spread of crime; and the crime-wave that flooded the country, and seems to have achieved its highest point about the year 1749 (when Henry Fielding's practical measures first encountered and helped to drive it back) was closely connected with the pernicious habit of gin-drinking. The evils of the habit must be dealt with elsewhere. Although an effort to restrain the gin-traffic had been made in 1726, in 1733, according to the *Gentleman's Magazine*, " one half of the town seems set up to furnish poison to the other half "; and the explosive fluid, at a penny a dram,

[1] There the resemblance apparently ceases. Anne, daughter and co-heir of Robert Western, bore her husband four children and survived until 1747.

was flowing unchecked in every public house and night-cellar.

Gin, for instance, was the favourite tipple—almost the staple diet—of the Drury Lane neighbourhood; and it was there, in and around the long, narrow, ancient street running towards Covent Garden, that prostitutes and bawds and thieves had gathered since the seventeenth century. But conditions in Drury Lane were not exceptional; and, faced with the terrifying audacity of the London criminal classes, magistrates resorted to savagely repressive measures. This was a harsh period, accustomed to violence. From Oxford itself, on July 29th 1730, the *Daily Journal* reports a pitched battle fought over the body of William Fuller, purchased as material for dissection, between gownsmen, mob and proctors, which concluded with the buffeted corpse being carried off to Christ Church—an episode that recalls the final scene of Hogarth's *Four Stages of Cruelty*; and London magistrates suited their methods to the somewhat brutal character of the times. No doubt the brutality of eighteenth-century legal procedure has often been exaggerated. Judging by the number of persons who received an acquittal, it was not always summary, and the pleas of the prisoner at the bar did not invariably go unheard. But the Penal Code was certainly ferocious; and many laws remained on the Statute Book, dating from the medieval or the Elizabethan epoch, which were still frequently enforced with every circumstance of public horror.

By way of contrast to the elegant decorum of Hogarth's conversationpieces, we should reflect on the punishment meted out in 1731 to a convicted forger named Japhet Crooke, " alias Sir Peter Stranger ". Brought by the Keepers of the King's Bench to Charing Cross, he stood in the pillory there from twelve to one. " The Time being then expired, he was set on a Chair on the Pillory, when

the Hangman dress'd like a Butcher, came to him, attended
by two Surgeons, and with a Knife, made like a Gardener's
Pruning Knife, cut off both his Ears, and with a Pair of
Scissors slit both his Nostrils, which were afterwards seared
with a hot Iron. Afterwards he was carried to the Ship
Tavern in Charing Cross " to have his wounds and his
burns bandaged, and then back to the King's Bench to
suffer life-imprisonment. Such might well be the ordinary
course of the law; and, during the years 1730 and 1731, a
series of extraordinary minor legal operations were under-
taken by a Westminster magistrate, Sir John Gonson,
against " night houses ", " night cellars " and similar
disorderly houses, " whereby several Persons who kept
the same " were " brought to condign Punishment, and
others fled from their Habitations to avoid the like Fate".
Sir John's campaign was enthusiastically approved of by
his fellow citizens. He soon earned a high reputation as
the " harlot-hunting magistrate ", the terror of bawds and
prostitutes, from obscure courts in the eastern slums,
where Moll Hervey, alias Mackeig, and Elizabeth Allen,
alias " Fighting Bess ", and myriads of their kind, until
Sir John's advent had held almost undisputed sway, to
Mother Needham's expensive establishment in Park Place,
off St. James's Street. Drunken pickpockets and aristo-
cratic lechers found his abrupt descents equally objection-
able.

The newspapers reported his efforts daily; and there
is a certain fierce and primitive picturesqueness—reminis-
cent of Hogarth's impressions of the contemporary London
underworld—about the incidents they relate and the per-
sonalities they disclose. Moll Hervey, for example, was
both a brothel-keeper and a gang-leader, established at the
Blackamoor's Head and Sadlers' Arms in Hedge Lane;
and, having been sentenced to three months' imprisonment

and to stand in the pillory at Charing Cross, she was rescued from the officers of the law " by twenty or thirty of her Gang arm'd with Clubs and Staves ", fled to Holland, fell foul of the Dutch authorities, returned to London, " lurk'd about Wapping ", was betrayed by an accomplice and then captured in bed " with her pretended Husband ". " She was (as usual) very outrageous in her Behaviour, and not only beat the Constables, but the Justices too before whom she was carry'd, so that they were forced to tie her Hands together, and with much Difficulty got her to Prison ": whence she " had the Dexterity to make her Escape ", this time dressed in a man's clothes, only to be again re-captured, and exposed in the pillory at Charing Cross, where the mob, according to its usual practice, administered a severe pelting.

As redoubtable a personage entered Sir John's net on August 1st 1730, when (in the words of the *Daily Post*) " the Chairman and Committee of Justices, appointed at the last Sessions at Westminster for the suppressing the Night-houses and other disorderly Houses in and near Drury Lane, met at Covent Garden Vestry . . . Eleven Men and Women were at the same Time brought before the Justices; but seven of them being young Sinners, and never in Bridewell before, were discharged, upon their seeming Penitence and Promise of Amendment; and the remaining four were committed to Bridewell in Tothill Fields to hard Labour. Three of them were taken at Twelve and One o'clock, exposing their Nakedness in the open Street to all Passengers, and using most abominable filthy Expressions; the fourth was the famous Kate Hackabout (whose Brother was lately hang'd at Tyburn), a woman noted in and about the Hundreds of Drury, for being a very Termagant, and a Terror not only to the Civil Part of the Neighbourhood by her frequent Fighting,

Noise, and Swearing in the Streets in the Night-Time, but also to other Women of her own Profession, who presume to ply or pick up Men in her District, which is half one Side of the Way in Bridges-street."

" Hackabout "[1] was a name that Hogarth remembered, and uncounted admirers of his engravings would remember after him. But, since " Kate " seemed possibly a little insipid, he conferred on his imaginary strumpet the Christian name of " Mary " or " Moll ", by way of tribute perhaps to the no less celebrated Moll Hervey. It was a brilliant stroke to combine the fictitious Moll Hackabout with Mother Needham of Park Place, the bawd to whom the inexperienced girl, fresh from a country parsonage, is supposed to be indebted for her initiation into a life of sin. She, too, had been one of Gonson's victims. The bawds and procuresses of eighteenth-century London were numerous and well known. They included Mrs Gould (reputed to keep an especially elegant and fashionable house): Mrs Stanhope, otherwise " Hell Fire Stanhope ": Mrs Douglas in Covent Garden: Mrs Goadly in Berwick Street: Mrs Theresa Berkeley in Bloomsbury: and Mrs Potter in Albion Terrace, Chelsea. But Mother Needham had the advantage of living close to St. James's Palace. The Press spoke of her as " famous " or " noted ". Sir John Gonson, however, had decided to take drastic action; and in April 1731 (wrote a journalist of the *Daily Post*) " at the Quarter-Session of the Peace for the City and Liberty of Westminster ... the noted Mother Needham " was " convicted for keeping a disorderly House in Park Place, St. James's, was fined 1s." and condemned " to stand twice

[1] It has been suggested by Miss Hilde Kurz, the author of an interesting contribution to the *Journal of the Warburg Institute* (Vol. xv, 1952), that Hogarth may have taken the name from a chapbook plagiarism of *Moll Flanders*, published in Dublin in 1730, where the heroine's governess is called Jane Hackabout. It seems more probable that the writer and the artist took the name from an identical source—that is to say, from the common gossip of the Drury Lane neighbourhood.

in the Pillory, viz. once in St. James's-street, over against the End of Park Place, and once in New Palace Yard, Westminster, and to find Sureties for her Good Behaviour for three Years."

She duly appeared on Friday, April 30th, to suffer the earlier part of the justices' sentence, a heavy elderly woman apparently in poor health. St. James's Street was thronged with spectators. " Yesterday (remarked the *Daily Courant*) the infamous Mother Needham, who was convicted of keeping a common Bawdy House . . . being much indisposed, was suffered to sit on the Pillory in St. James's-street; at first she received little Resentment from the Populace, by reason of the great Guard of Constables that surrounded her; but near the latter End of her Time she was pelted in an unmerciful Manner." So much enjoyed was the spectacle of Mother Needham's degradation, and so excited was the crowd which filled the royal thoroughfare, that " a Boy getting upon a Lamp Post . . . fell from the same upon Iron Spikes " and " expired in a few Hours, in great Agony ". Mother Needham's own agony was not prolonged. On May 3rd she died in the old prison of the Gatehouse, Westminster, her death being attributed by the coroner's jury exclusively to natural causes.

Since Hogarth's portrait was immediately recognised, we must assume either that he took his stand among the crowd in St. James's Street or that he had encountered her during happier days in Park Place, London, after all, was not a very large city; and its inhabitants knew one another well, at least by sight and reputation. The artist's material was drawn from personages and events with which every citizen capable of reading the newspapers, had already a fairly close acquaintance. We may imagine Hogarth at one of his favourite resorts, the Bedford Arms in Covent Garden, poring over the long columns of the *Daily Post* or

the *Daily Courant*, and, as the sea-anemone absorbs its food, gathering to himself not only impressions of faces but scraps of gossip that drifted towards him from adjacent tables. He was never tired of improving his " technical memory "; every detail he managed to collect might at some time slip into its proper place—as happened, for instance, during the latter half of 1731, when the scattered notes he had collected on the London *demi-monde* began gradually to take shape in the six episodes of *A Harlot's Progress*.

This choice of subject impressed Hogarth's contemporaries—and was to impress later generations—as strikingly original. But then, originality is a relative term; for the most adventurous artist does not create in a void, being hemmed about and subtly influenced, if not distinctly moulded, by many of the characteristics of his social period. Hogarth's was a mercantile age; and periods of great commercial expansion are frequently periods during which Realism prevails in the fields of art and literature. Emphasis falls on what Man is—an active, acquisitive, restless, independent animal—rather than on what he ought to be, according to classical standards, or what, in romantic moods, he often dreams he might be. Thus, the Age of Walpole, prosaic and businesslike, turned its eyes towards the plain prose, or least common denominators, of the human situation; and almost for the first time since the production, in 1603, of Thomas Heywood's noble blank verse tragedy, *A Woman Killed with Kindness*, tragic dramas appeared on the English stage that depicted the sufferings of ordinary men and women, merchants and their wives and apprentices, against the familiar background of the London streets. George Lillo's play, *The London Merchant* —described in the prologue as " A tale of artless woe. A London prentice ruined . . ."—which was staged at Drury Lane during the summer of 1731, had been preceded, ten

86

years earlier, by Aaron Hill's *The Fatal Extravagance.* Neither Hill nor Lillo was a writer of genius; but each showed a remarkable insight into the possibilities of realistic art.

It remained for a novelist to combine that insight with the possession of astonishing narrative gifts. By 1700 Daniel Defoe was already an experienced middle-aged man —a wholesaler in the stocking trade who had failed to the tune of £17,000: a Whig pamphleteer who had been rescued from a debtors' prison by a Tory minister, and a Tory journalist, covertly allied to the Whigs, who had accepted control of the Tory *Weekly Journal* with the secret intention of blunting its controversial sting. If he was unscrupulous, he was also immensely industrious. Perhaps he despised politicians as a race—those hereditary rulers of mankind, who basked in the atmosphere of courtly power and privilege: since, true to the spirit of the times, he was among the earliest advocates of modern " business government ", and was convinced that the ordinary merchant (whose interest was growing more and more decisive, but whose voice was still too seldom heard) " is qualified for all sorts of employment in the State, by a general knowledge of things and men ". General knowledge was the writer's forte. His own business activities had ended in complete collapse; but they had left him with a wide experience of the workaday commercial life; and, as he had demonstrated in his *Essay upon Projects*, published in 1698, he was full of suggestions for the practical betterment of the contemporary social mechanism. Like most innovators, he was singularly unhampered by the tyranny of preconceived ideas; and, when he deserted the realm of things and transferred his study to the existence of men, he revealed the same unprejudiced clarity of view as he had shown in his examination of their trades and handi-

crafts. How did humanity get through the task of living? There were even weightier problems to be elucidated than how they earned their daily bread.

So the theorist and satirist became at length a novelist. *Robinson Crusoe* emerged, in April 1719, from the bookshop that, in 1712, had published Richard Hogarth's ill-starred *Disputationes Grammaticales*, to be followed by *Moll Flanders* in 1722 and *Roxana* in 1724. Throughout his novels, Defoe is concerned with the painstaking presentation of an ordinary human being; for, although Crusoe's adventures are undoubtedly strange, that strangeness is thrown into relief by the sober and methodical turn of the adventurer's temperament; while Defoe's heroines are essentially commonplace women, only redeemed from mediocrity by their obstinate determination to make the best of an indifferent world. Survival rather than triumph, a decent livelihood rather than a splendid superfluity, is the aim on which Defoe's characters seem usually to have set their hearts. Yet this vision of life, so drab and uncoloured, did not preclude an imaginative appreciation of the value of exact detail. It is the fascinating minuteness of the pictures he draws, the sudden flashes of observation with which he illumines every episode—Robinson Crusoe finding the shoes on the beach and mournfully remarking how seldom they formed a complete pair: Moll Flanders tempted to commit a murder and fingering the gold beads around the little girl's neck—that lend a poetic quality to his most prosaic chronicles. There is no evidence that Hogarth was an admirer of Defoe; but both were artists intensely alive to the spirit of the age they lived in. Moll Flanders and Moll Hackabout spring ultimately from the same stock.

V

The Pictorial Dramatist

ACCORDING TO Hogarth's contemporary and one-time associate, the engraver George Vertue,[1] the whole series of *A Harlot's Progress* originated in a single oil-sketch. " Amongst other designs " (he informs us) the artist " began a small picture of a common harlet, supposed to dwell in drewry lane, just rising about noon out of bed, and at breakfast, a bunter [2] waiting on her. This whore's desabillé " and her " pretty Countenance & air " pleased many of his visitors, who " advised him to make another to it as a pair; which he did. Then other thoughts multiplyd by his fruitful invention, till he made six different subjects, which he painted so naturally . . . that it drew everybody to see them." Hogarth's own intention, when he launched his new venture, is clearly set forth among his reminiscences. Still preoccupied with ideas of the theatre, he had determined to " compose pictures on canvas similar to representations on the stage," expecting them to be " tried by the same test, and criticised by the same criterion . . . Let the figures in either pictures or prints be considered as players dressed either for the sublime—for genteel comedy, or farce—for high or low life. I have endeavoured to treat my subjects as a dramatic writer: my picture is my stage,

[1] George Vertue, (1684–1756). Engraver and antiquary. His notebooks, purchased by Horace Walpole, were employed in the preparation of *Anecdotes of Painting*. The above quotation, its punctuation modernised, has been taken from *Vertue III*. Walpole Society.

[2] " A woman ragpicker; hence a low, vulgar woman ": Webster.

and men and women are my players, who by means of
certain actions and gestures, are to exhibit a *dumb show*."
As for the dramas enacted, they were to be derived from
" that intermediate species of subjects ... between the
sublime and grotesque ", a field hitherto " totally over-
looked " and not yet " broken up in any country or any
age ". He now proceeded to cultivate this ground with his
usual bold enthusiasm, " making all possible use of the
technical memory I have before described, by observing
and endeavouring to retain in my mind lineally, such
objects as best suited my purpose; so that be where I
would, while my eyes were open, I was at my studies ...
Whatever I saw ... became more truly a picture than one
that was drawn by a *camera obscura*. And thus the most
striking objects, whether of beauty or deformity, were by
habit the most easily impressed and retained in my imagina-
tion. A redundancy of matter being by this means acquired,
it is natural to suppose I introduced it into my works on
every occasion that I could."

To the harvest accumulated by his " technical memory "
Hogarth added—as he would always continue to add—
suggestions that he had gathered from the work of other
artists, and even from the primitive imagery of the popular
blockbooks.[1] The artist's studio, like the artist's brain,
was, no doubt, crammed with miscellaneous material; and
the mood of inspiration that enabled him to collect and
combine it—throwing into coherent dramatic form the
random notes he had collected throughout many years of
London life—finally descended during the course of 1731.
By September 1731—the date inscribed in the last scene
upon the Harlot's coffin lid—six pictures had already been
painted; and the painter, discarding his brushes, could

[1] The penultimate episode of *A Harlot's Progress* is indebted to such a popular
model. See Introduction to *Hogarth's Peregrination* by Charles Mitchell. Claren-
don Press, 1952.

take up his engraver's tools. Hogarth had not originally intended to engrave every plate with his own hand; but, at the end of January 1732, an advertisement was published in the *Country Journal: or, the Craftsman*, announcing that " The AUTHOR of the Six COPPER PLATES, representing a Harlot's Progress, being disappointed of the Assistance he proposed, is obliged to engrave them all himself, which will retard the Delivery of the Prints to the Subscribers about two Months . . ." Thanks to subscription—afterwards a favourite method—he had decided that he would market his prints without the intervention of greedy book-sellers and print-merchants; and, remembering his apprenticeship as a commercial draughtsman, he produced a pleasant little subscription-card, incorporating a receipt, to be signed by the artist, for the sum of " half a Guinea being ye first Payment for Six Prints . . . which I Promise to Deliver when Finish'd on Receiving one half Guinea more." In the design,[1] a youthful satyr is showing peeping beneath the lifted petticoats of a many-breasted Mother-Goddess.

No less than twelve hundred subscribers—most of whom may already have known Hogarth as the versatile author of " curious Miniature Conversation Paintings "—proved willing to put down their preliminary half-guineas. In March 1732, through the advertisement-columns of two daily newspapers, the *Daily Journal* and the *Daily Post*, they learned that the plates were being printed off and that they could look forward to collecting their purchases during the second week of April. The advertiser appears to have kept his promise. Issued about the appointed time, *A Harlot's Progress* struck England with the impact of a rare discovery —the kind of discovery that seems the more surprising

[1] This design seems to have been inspired by Rubens' picture, *Nature Adorned by the Graces*, then in the possession of Sir James Thornhill. It is now in the Glasgow Art Gallery.

because it gives definite shape to a vision already half
formed, and because so often, in the immediate past, it has
nearly been anticipated. Since the original paintings were
destroyed by fire,[1] our knowledge of the *Progress* is now
based on the engraved series; and, to enjoy them as they
deserve to be enjoyed, we must consult the earliest states.
There, undimmed by copying and re-engraving, is the
simple and matter-of-fact, yet still strangely impressive,
drama of Moll Hackabout's brief pilgrimage through the
London *demi-monde*. Hogarth, we should always remember,
wished to be regarded as a pictorial dramatist. At a later
period, his interest in design was to counterbalance his
preoccupation with the story he had set out to tell. But,
for the moment, it was the play that absorbed him—the
characterisation of actors and actresses, the careful con-
struction and minute embellishment of six appropriate
stage-settings. No detail must be neglected that could add
point to his " dumb shows ".

The drama opens in the City of London, where the York
Waggon, favoured by travellers who cannot afford the
stage-coach, has lately rolled into the squalid yard of the
Bell posting-house in Wood Street. It has brought a
young girl up from the depths of the country, protected
only by her father, an old and absent-minded clergyman,
who has followed the waggon on his ancient horse and is
now anxiously scanning the superscription of a letter
addressed to some influential prelate, while his mount
snatches at the straw packing of a pyramid of pots and pans.
As she awaits him, the ingenuous country-girl, distin-
guishable amid the London crowd by the plain kerchief
that covers her shoulders, the fresh rose pinned to her
bodice and the pair of workmanlike scissors dangling from

[1] Sold by Hogarth to Alderman Beckford in 1745, five at least were destroyed,
ten years later, in a conflagration at Fonthill.

the bag she carries, encounters a large, imposing, magnificently dressed personage in laces, ribbons, velvet mantle and expansive satin skirts. Moll's pathetic luggage is spread at her feet—her trunk with her initials, *M. H.*, stamped on the top in brass nails, a corded box and a basketed goose—perhaps it is a " green goose "—a gift labelled " *For my lofing Cosen in Tems Street in London* ". Alas, her helpful acquaintance is the " pious Needham "!— so called by contemporary satirists because she was reputed to be " very religious " according to her own lights, and constantly prayed that she might gain enough by her profession to leave it off in good time. Her prayer, as we know, was to remain unanswered: not far ahead loom the dreadful Sir John Gonson and the vindictive mob around the pillory. But, in the *Progress*, she continues to ply her trade; and an employer, more notorious even than herself, is hovering in the background. Colonel Chartres, attended by his jackal, John Gourlay, a pimp whom, we are told, he " always kept about his person ", has just appeared in a doorway and looks on with a lickerish grin.

Like Mother Needham, he had recently died—during the course of the previous year, at the age of sixty-two, having persevered (observed a satirical epitaph) " with an inflexible constancy and inimitable uniformity . . . in the practice of every human vice, excepting prodigality and hypocrisy ": he was exempted from the latter by his " matchless *impudence* ", from the former (we are told) by his " insatiable *avarice* ". Drummed out of his regiment for card-sharping, banished for the same reason from several European cities, he had become a money-lender at exorbitant rates and had thereby increased his substantial private fortune. His residence, the chroniclers add, was a " perpetual bawdy house ". Twice convicted of rape, he had twice been pardoned—on the second occasion, how-

ever, " not without imprisonment in Newgate " and large financial penalties; and, when he died in Scotland in 1731, the legend of Francis Chartres had grown so dark and widespread that his funeral procession provoked a serious riot, his body was nearly torn from the coffin, and the indignant mob hurled " dead dogs &c. into the grave along with it ".[1] At Hogarth's bidding he rises again, a sly, shabby figure, escorted by his dapper pimp, prepared to step into the foreground once Mother Needham has secured her prey. He will provide Moll Hackabout's introduction to the hazardous world of kept women.

Her development is unusually rapid, as we discover from the next plate. Moll now embellishes the alcove of a wealthy Jewish merchant. Presumably she has been deserted by Chartres, but not without a thorough schooling; and the *amant de cœur* with whom she amuses her leisure, a sleek young fencing-master, probably a Frenchman, has been surprised in her room and quickly secreted in his mistress's bed. She produces a diversion to mask his escape, kicking over the spindle-legged table and demolishing its egg-shell china. Hogarth—from a modern admirer's point of view, it is among his more unpleasing traits—loved to reproduce the effects nowadays captured by instantaneous photography. Teacups and teapot hang in the air; the faces of the three actors at the front of the stage, behind an imaginary row of footlights, reflect feelings that occupy a fraction of a second, while the table is still on the slant, and the tinkle and crash of broken porcelain has not yet had time to die away. But each face is alive

[1] Colonel Chartres (or Charteris, to give the name its modern form) appears in both Epistle II and Epistle III of Pope's *Moral Essays*. Much interesting, though possibly over-coloured, information about his exploits is to be found in *Some Authentick Memoirs of the Life of Colonel Ch——s, Rape-Master-general of Great Britain* by an Impartial Hand. 1730. The author of this pamphlet mentions his habit of posting his agents in the inn-yards to pick up girls arriving by waggon from the country. His only daughter, Janet, married in 1720 the fifth Earl of Wemyss, whose son, the seventh Earl, assumed his maternal grandfather's surname.

with character; and—such was the quality of Hogarth's dramatic skill—from each of them we seem able to divine what its owner is likely to do next. While the negro page will continue to gape in alarm, horrified by the senseless destruction of so many rich and valuable objects, the merchant may go down on his knees—not ceasing, however, to grumble and expostulate—determined to save as much as he can of a new tea-service that has cost good money. As to Moll, she will arise and pace the room, relishing her factitious outburst of rage long after her concealed gallant has slipped forth on to the staircase. Her petulance, wantonness and charm are set off by the keen Sephardic profile of her startled and indignant companion. His voice is sharpening to a scream, as a cascade of scalding tea burns his unprotected shanks. The native decorum of his race has been irremediably outraged.

That Moll's protector should be of Jewish descent is a detail the social historian may find particularly interesting. The Jewish colony in England was small; twenty years later, it is said not to have exceeded more than seven or eight thousand families; but they held important positions in London and Bristol; and during the notorious Oxford-shire Election of 1754 (with which Hogarth's connection must be mentioned in a subsequent chapter) the influence that they were believed to exercise, and the dastardly inten-tions that they were alleged to entertain, would arouse a storm of anti-Semitic fury that reverberated in the House of Commons. The poorer sort retained their traditional habits—a Jewish pedlar tramping from place to place was among the very few wearers of a beard that the average Englishman had yet seen; but the merchant whom Moll exploits and deludes, and who, no doubt, bears a name that is either Portuguese or Spanish, has assumed the embroidered coat, ruffled shirt and crisply curled wig

of a metropolitan man of the world. He cuts, nevertheless, a slightly exotic figure—for Hogarth's audience he was, indeed, something of a rarity; and the apparatus of the room he has furnished, where parts of Moll's masquerade-costume lie scattered on the dressing-table, include two large and elaborate canvases with subjects from Old Testament legend. Here Jonah is seated beneath his gourd: there the amorous King David prances jubilantly before the Ark.

At this point, the chart of Moll's progress sweeps downhill in a sudden curve. Rich men are not to be affronted: they value their comfort and self-conceit yet more highly than they esteem their pleasures. Seductive fencing-masters may prove fly-by-night friends; and Moll re-emerges, no longer the well-kept and widely fashionable courtesan, but a prostitute who lodges in a dilapidated garret above Drury Lane, with an uncurtained window, a broken-down bed and a single antiquated rush-bottomed chair. Hogarth's third plate seems to incorporate the design from which he evolved the entire series—that of a young harlot " just arising about noon out of bed " and beginning her bohemian breakfast. The " bunter " char-woman, who has lost the end of her nose, is preparing a slovenly dish of tea; and Moll, who looks coarsened but cheerful, is exhibiting a stolen watch. A punch-bowl on the gate-legged table, tankards and pipes on the uncarpeted floor, are accompanied by ominous medicine-bottles upon the narrow window-sill. Two prints pinned to the plaster wall depict the highwayman-hero of *The Beggar's Opera* and Dr. Sacheverell, turbulent champion of the English High Church. A real highwayman, James Dalton, executed at Tyburn in 1730, has left behind his wig-box, now stored away, half out of sight, between the tester and the ceiling. A witch's birch-broom and hat—Moll still frequents the popular masquerades—dangle at her bedshead.

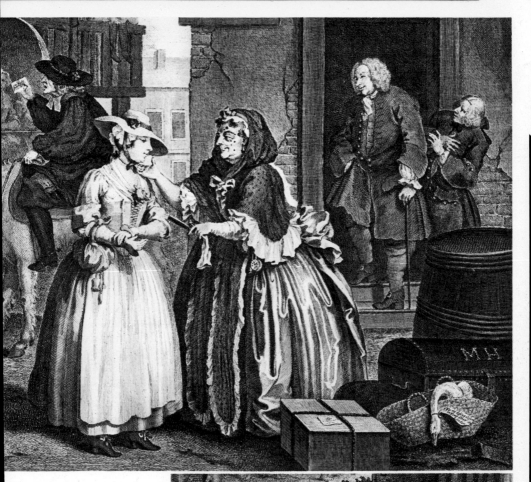

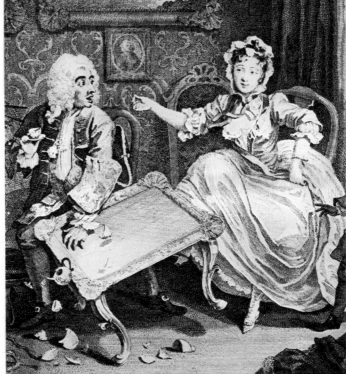

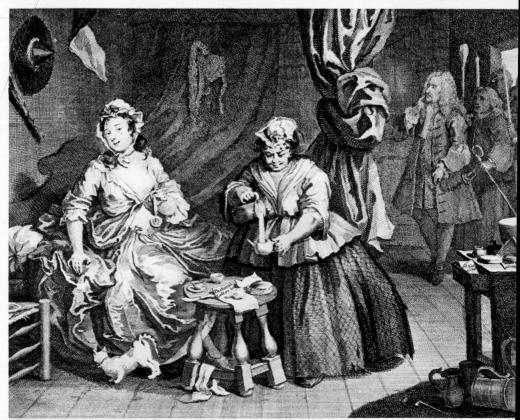

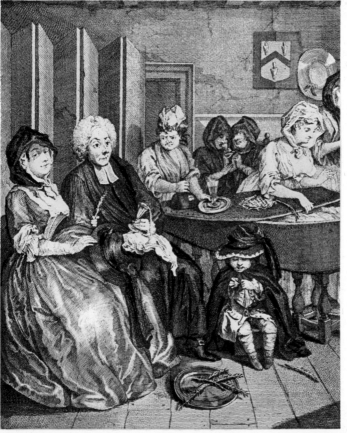

To the stage-setting of a prostitute's *levée*—attended, although she has not yet turned to confront him, by a terrible uninvited guest—Hogarth has made one addition of which only he, and perhaps members of his family, would have recognised the full satirical value. The pat of butter, bought for her breakfast, has come from the dairy-man's shop wrapped in a crumpled waste sheet. It is the front page of a Pastoral Letter, recently issued by the Bishop of London; and Dr. Gibson,[1] when a poor young scholar, had travelled to the metropolis in Richard Hogarth's company, but seems subsequently to have joined the ranks of those unfeeling " great men " from whom the schoolmaster expected help and encouragement, and whose unredeemed promises were thought to have embittered his last years. Meanwhile, as the bunter is brewing tea, and Moll is considering the watch spirited out of the pocket of last night's drunken client, an avenging figure stands poised on the threshold, closely supported by a troop of constables and tipstaves. Sir John Gonson is in search of victims, carrying the terror of his name into the very heart of Old Drury. Like his Mother Needham and his Colonel Chartres, Hogarth's Gonson was an exact portrait; and, although the series was generally popular, the third plate, with its representation of the harlot-hunting magistrate, elicited particularly loud applause. The Lords of the Treasury themselves, who did not share either Sir John's puritanical zeal or his moral prejudices, were said to have been so anxious to acquire the print, that, in order that they might lose no time, they cut short the day's business and abandoned their official posts.

[1] Edmund Gibson (1669–1748). Like Richard Hogarth a native of Bampton, he was admitted as a " poor serving child " at Queen's College, Oxford, in 1686, took Holy Orders in 1694, and thereafter had made rapid progress. He was a considerable scholar; and, as a moralist, he petitioned the King for the abolition of masquerades. The appearance of his *Pastoral Letter* on Moll's breakfast-table has therefore a double meaning.

By Gonson Moll is committed to Bridewell, the House of Correction in Tothill Fields, where prostitutes, card-sharpers and bawds were condemned to serve terms of hard labour, and stubborn offenders were regularly beaten after the hours of divine service.[1] Threatened by the gaoler's whip, robbed and derided by brutal veterans of the London pavements, she endeavours feebly to pound her ration of hemp, still wearing the rather tarnished remains of her rich professional wardrobe.[2] At length, we assume, she is released; but, between that moment and the opening of the next scene, some four or five years have evidently elapsed, since she has given birth to a little boy who shares his mother's sick-room. Squatting on the hearth, he scratches his head and, with the other hand, does his best to roast a scrap of butcher's meat. The room is crowded and hot and noisy. Yet more implacable than the relentless Sir John, syphilis, occupational disease of her class, has pursued Moll Hackabout from her Drury Lane attic, its window-ledge already ranged with significant jars and medicine-bottles, to the bare lodging in which she has now taken refuge, probably in the same disreputable and insalubrious neighbourhood. Two doctors are arguing her case, one of whom was recognised by Hogarth's contemporaries as Dr. John Misaubin, quack-specialist in venereal diseases and inventor and purveyor of a well-known prophylactic pill. Dr. Ward,[3] his companion, has also a specific ready; for this was a period when English medicine, despite the rapid advance of scientific knowledge, was still in a confused and daringly experimental stage, and almost

[1] See *Dunciad*, Book II, i, 270.

[2] On September 24th, 1730, the *Grub Street Journal* reports that " one Mary Muffet, a woman of great note in the hundreds of Drury, has recently been committed to Bridewell, where she is now *beating hemp in a gown very richly laced with silver*".

[3] Ward's Pill is mentioned in *Tom Jones*, where it is described as " flying at once to the particular Part of the body on which you desire to operate."

every renowned physician had evolved and given his name
to some mysterious private concoction—his powder, elixir
or drop, reputed to relieve the symptoms of several different
illnesses. So the pill-mongers have got into a noisy dispute;
and, while Misaubin bullies and scolds, his plump colleague
appears to be waving him away with the gold-headed cane
he is carrying as his wand of office. That cane was the
doctor's badge, its gold knob being raised to the lips and
gravely gnawed or nuzzled at, as he bowed over the patient's
bed and prepared to announce his considered opinion.
By no opinion or remedy can they hope to save Moll
Hackabout. Mercury-treatment, or salivation, has been
tried without success; the advertisement of an " Anodyne
Necklace " lies discarded on the naked boards, beside a
heap of coals, a shovel, a chafing-dish and a broken plate.
Moll's agony, propped up in an armchair, is observed only
by her faithful charwoman. The little boy is twirling his
lump of meat: the nurse rummages in an old-fashioned
trunk—the very trunk, stamped with brass-headed nails,
that once accompanied Moll to London during her journey
on the York Waggon.

Finally, we arrive at the funeral party—a ceremony of
leave-taking, attended by professional friends, at which
gin and tears are confusedly mingled. Only the bunter
had seen Moll die; now only the bunter, who clutches a
glass and flagon, displays the fixity of real grief. Sighing,
sipping or improving the occasion with some pious senti-
ment, the ladies of Drury Lane, in their gloves and mourn-
ing-hoods, are assembled as members of the chorus to
descant upon the Harlot's end. Some are lacrymose; some
are confidential; some quickly pass, thanks to the influence
of Hollands, from solemn valediction to surreptitious
byplay. Near the sprigs of rosemary arranged on a
platter, the chief mourner sits swaddled in his weeds and,

99

being a philosophic and much-experienced child, devotes his attention to his brand-new spinning-top. Hogarth's sympathy with the characters of children clearly extended to an appreciation of their intermittent callousness; or, rather, he would seem to have understood what narrow and arbitrary limits confine their powers of suffering. But at least the child's indifference is a form of innocence; and just above him, as he sits by the coffin, Hogarth has placed two of the oddest and most subtly ill-favoured of all his adult personages. The clergyman, who will conduct the funeral, is the portrait of a " Fleet Chaplain ", a shady cleric established in the purlieus of the gaol, who earned his keep by the celebration of clandestine or irregular weddings. A soft, slippery, sheep-faced man, whose dull prominent eyes, which goggle straight ahead, are beginning to brim over with a vague concupiscence, he spills his glass of gin into his lap, while his fingers make tentative explorations among his neighbour's petticoats. She does not repulse, but pretends to ignore, his sally, attempting, however, to conceal it behind the wide brim of his mourning-hat. This decorous and resourceful female was accepted as a likeness of Elizabeth Adams, a *demi-mondaine* destined to be convicted of theft and hung in 1737. The dwarfish mænad at the left of the stage recalled a bawd named Mother Bentley.

Altogether, the *Harlot's Progress* presents a cast of thirty-one, excluding some shadowy *figurantes* who are never destined to reach the front of the stage; and no less remarkable than the variety of these six episodes is their underlying unity. The pictorial playwright, concerned with the effective development of his plot and sub-plot, was also an impassioned observer who loved his background for its own sake. Just as an accomplished novelist may be said to have lived in his novel, so Hogarth would seem to have inhabited all his different stage-settings—to

have explored these rooms, trodden their uneven boards, glanced through their half-open doors and, forcing open their rickety lead-framed casements, peered down into the street below. Not only is he sensitive to the character of the room, imprinted on walls and ceiling by many years of human usage; he is fascinated by the miscellaneous relics of its most recent occupants, by the wrack and rubbish of everyday life washed up into its shadowy corners. Inanimate objects—jugs, tankards and old clothes—assume a curiously expressive air. Her shift, looped over the dying woman's head, has the forlorn and despondent look peculiar to discarded garments. That perforated disk, next to the broken door, is a cake of " Jew-bread " or Passover Bread —perhaps a reminiscence of her early protector—suspended as a trap for flies. Between the rafters some ribald acquaintance has written *M. H.* with a smoky candle. The letters are followed by an obscene word, now partially faded or smudged away.

Hogarth's method, as I have already suggested, bears an instructive resemblance to that of Daniel Defoe. More unexpected is the kinship he sometimes reveals with the greatest poet and critic of the English eighteenth century. Pope, too, had a piercing eye for detail; and the last hours of the derelict Duke of Buckingham—

> *In the worst inn's worst room, with mat half-hung,*
> *The floors of plaister, and the walls of dung,*
> *On once a flock-bed, but repair'd with straw,*
> *With tape-ty'd curtains, never meant to draw,*
> *The George and Garter dangling from that bed*
> *Where tawdry yellow strove with dirty red . . .*

are described by the author of *Moral Essays* with a minuteness and dramatic vividness that recall Hogarth's moral dramas. In what respects, though, was Hogarth a genuine

moralist? By his contemporaries he was certainly regarded as the wielder of a satirical scourge, swingeing fashionable follies and belabouring current vices; and there is no doubt that the rôle of pictorial censor appealed to the temperament of a naturally passionate and irritable man. The motives, however, that impel an artist are very often strangely mixed; he is apt to confuse the joy of creating with the sober pleasures of correcting or teaching; and, if Hogarth had a message to impart, in *A Harlot's Progress*, at all events, it is not a message of a very lofty kind. That vice seldom pays is the only conclusion we draw. Unlike Defoe's more submissive heroines, Moll Hackabout does not round off a life of indulgence by paying lip-service to the beauties of virtue. So far as we can ascertain, she has never repented; she is merely an adventuress whose adventure has failed; and, were we to credit Moll either with a " philosophy of life " or with a talent for expressing it, her farewell might echo the words of George Lillo's Millwood in *The London Merchant*, the domestic tragedy staged at Drury Lane during the course of the same year: [1]

> " I hate you all, (cries Lillo's courtesan) I know you, and expect no mercy . . . I have done nothing that I am sorry for; I followed my inclinations and that the best of you does every day. All actions are alike natural and indifferent to man and beast . . ."

Moll dies at the age of twenty-three; and it is the wastefulness, rather than the intrinsic wickedness, of such a career that seems chiefly to have moved Hogarth.

Whatever his motives, his reward was splendid; the triumph of the *Harlot's Progress* reproduced the immense popularity of *The Beggar's Opera*. Subscriptions alone

[1] In June 1731 (see p. 86). Moll's death is supposed to take place in September.

brought him, according to Vertue, " fifty or a hundred pounds in a Week, there being no day but persons of fashion and Artists came to see these pictures ". At length he was both famous and prosperous. Yet the degree of success he had achieved had certain disadvantages. Grub Street was eager to pounce on his work; every piratical bookseller saw a chance of easy profits; and, while, only a month after the appearance of the engravings, one hack produced *The Harlot's Progress; or the Humours of Drury Lane*, written in the style of *Hudibras*, another, after a more decent interval, published *The Lure of Venus*, a tawdry narrative in heroic couplets. A ballad-opera, *The Jew Decoy'd*, is said to have been composed, though never performed; and Theophilus Cibber made Moll the centre-piece of a Drury Lane pantomime. Her features were painted on crockery and fan-mounts; and—far worse from the artist's point of view—pirated copies of the engravings were very widely circulated. Eight different spurious series were rapidly prepared for sale.

In the meantime, a reconciliation had occurred between the Hogarths and the Thornhills. It is said that Lady Thornhill, who took William's side, arranged that some of the pictures should be exhibited on the walls of her husband's dining-room, and that, having learned that they had been painted by his son-in-law, Sir James, in the niggardly paternal way, remarked that a " man who can furnish representations like these, can also maintain a wife without a portion". The breach, however, was soon completely healed; for, during the production of the engravings, Hogarth, we know, was established at the Thornhills' house " under the Middle Piazza " in Covent Garden. John Thornhill was again a close friend; and Sir James Thornhill bore Hogarth company when he visited Sarah Malcolm in the condemned hold at Newgate.

VI

Covent Garden

ALTHOUGH A year later Hogarth was to move away, and set up his own establishment at the sign of the Golden Head in Leicester Fields, Covent Garden remained the quarter of London with which he was most closely linked. He enjoyed its bohemianism, its variegated bustle, the hubbub of human activity which never ceased by day or night; for, while the market-women were unloading their country-produce, and early worshippers, prayer-book in hand, hurrying into the great church between the austere columns of Inigo Jones's portico, Rakewell and his raffish friends would still come tumbling out across the lighted threshold of Tom King's scandalous coffee-house. Described by Richard Steele as " the Heart of the Town ", the Garden had been originally designed to provide Londoners with a new market, now that the modern metropolis was rapidly advancing westwards. To serve that purpose, the Duke of Bedford had sacrificed his pleasant meadows; and Inigo Jones, at the Duke's direction, had begun to construct a noble arcaded square, possibly taking some hints from the *Place des Vosges*, then the *Place Royale*, in Paris. The surrounding arcade was never completed; but, during Hogarth's lifetime, the Great Piazza (of which the portion where the Thornhills lived, two doors beyond James Street, going towards Russell Street, was also called the Middle Piazza) ran along the northern side, and the Little Piazza

decorated the eastern end, exactly opposite the front of the church.[1] Beneath these spacious arcades were coffee-houses, shops and taverns.

Until 1704, the square, on its southern side, had been overlooked by the tree-tops of the Duke of Bedford's garden and orchard; and, despite the disappearance of Bedford House and the gradual transformation of the surrounding neighbourhood, as rich householders withdrew and shopkeepers and tavern-keepers moved in, the market-place itself retained something of its country charm. Its quadrangular expanse was rolled and gravelled; and in the midst of a central enclosure, fenced by wooden posts and rails, stood a " stone Pillar or Column raised on a pedestal ", bearing a " curious Sun-Dial, four square, having about it a mound gilt with gold, all neatly wrought in Freestone ".[2] Around the steps at the foot of this monument gathered the straw-hatted, blue-aproned women who sold flowers, fruit and vegetables, but who smelt so strongly of brandy and tobacco that one could scarcely distinguish the fragrance of their heaped-up nosegays. Here, too, were the stalls of the " simplers ", every finger laden with a row of massive brass rings, who collected medicinal herbs in the woods and fields, which they purveyed to apothecaries and quack-chemists. At times the entire market became a noisy football-ground[3]; prentices rushed from their shops to

[1] See John Rocque's *Plan of London, 1746.*
[2] This sun-dial, still standing in 1738, had vanished before the end of the century, while most of the square was covered with one-storey wooden booths.
[3] See Gay's *Trivia,* Book II.

> " Where Covent-Garden's famous temple stands,
> That boasts the work of Jones' immortal hands;
> Columns with plain magnificence appear,
> And graceful porches lead along the square:
> Here oft my course I bend, when lo ! from far
> I spy the furies of the foot-ball war:
> The 'prentice quits his shop to join the crew,
> Encreasing crouds the flying game pursue.
> Thus, as you roll the ball o'er snowy ground,
> The gath'ring globe augments with ev'ry round.

join the hurtling crowd of players; timid pedestrians took to their heels; the heavy ball leapt and rebounded, accompanied by the jingle of breaking glass.

Such was Covent Garden in its innocent countrified aspect; but, encompassing this rustic enclave, was a densely built-up pleasure-quarter. Since the close of the seventeenth century its fame had been equivocal; for there was something in the atmosphere of the Garden that seemed to favour loose conduct. " This market and that church (declared the *London Spy*)[1] hide more faults of kind wives and daughters among the neighbouring inhabitants than any pretended visits either to my cousin at t'other end of the town, or some other distant acquaintance." Both would furnish a convenient alibi; after eleven o'clock in the morning or during the afternoon, an adventurous young woman need only say that she had been at prayers in church; and, earlier in the day, she might easily pretend that she had been walking through the market, to refresh her constitution with the scent of flowers and herbs: " bringing a flower or a sprig of sweet briar home in her hand suffices to confirm the matter." All the taverns and bagnios had accommodating upper rooms; and, together with resorts of a quasi-respectable kind, there were brothels and houses of assignation in almost every side-street. Among better-known keepers of bawdy-houses was Hogarth's acquaintance Mother Douglas,[2] whose establishment was comfortably situated near the door of Tom King's.

But whither shall I run? the throng draws nigh,
The ball now skims the street, now soars on high;
The dext'rous glazier strong returns the bound,
And gingling sashes on the pent-house sound."

[1] *The London Spy* by Ned Ward, 1698.

[2] Portraits of Mother Douglas appear in the *March to Finchley*, *Enthusiasm Displayed* and *Industry & Idleness*, Plate XI.

Covent Garden

" What rake is ignorant of King's Coffee House? " wrote Fielding in his prologue to the *Covent Garden Journal*. Tom King himself was no doubt a curious character—the offspring of a respectable Wiltshire family, educated at Eton and King's College, Cambridge, who had marked his descent of the social scale by marrying a well-known bawd. After Tom's death, his widow, Moll or Mary, continued to keep open house; and, although she was fined and imprisoned in 1739, and spent her last years in church-going obscurity among the villagers of Hampstead, she and her husband had established a legend that Covent Garden long remembered. " A kind of low hutt rather than an edifice ", a " habitation of lowly structure, but of general congress, of great comings-in and goings-out ", Tom King's occupied a prominent position at the western end of the square, just within the rails of the market and not far from the church steps. Its panelled interior, painted by Laroon in a canvas that once formed part of the Strawberry Hill collection, is also illustrated in a rare contemporary pamphlet, entitled *Tom K——'s: or the Paphian Grove*.[1] We enter a smoky, crowded, low-ceilinged room, with a large indecent picture, representing a monk and a nun, displayed above the fireplace, where women of the town sit tippling and gabbling, surrounded by their male cronies, in all the heat, noise and claustrophobic confusion of a modern night-club. Like every *boîte*, Tom King's had its quota of faithful but eccentric clients; and through the dishevelled, disorderly throng stalks the lonely and stately figure of a certain Mr. Apreece, " a tall, thin man in rich dress ", who, drawn by some mysterious compulsion, arrived here almost every morn-

[1] *Tom K——'s: or the Paphian Grove. With the various Humours of Covent Garden, The Theatre, The Gaming Table, &c. A Mock Heroïc Poem. 1738.* See also *A Night at Derry's, or The Ghost of Moll King's, 1761.*

ing. Not until twelve o'clock were the doors flung open;
but between midnight and the dawn of the next day
"thither . . . hurried all who were shut out from other
more regular houses of entertainment." As night waned,
the company that drifted in became extremely various; for
"noblemen and the first *beaux* after leaving Court would
go to Moll King's in full dress, with swords and bags . . .
in rich brocaded silk coats ", so that " the chimney-sweeper,
the pick-pocket, and maudlin peer, were often to be seen
in the same seat together". At dawn, over the heads of
the market-women, a drunken young dandy might be
observed riding home on the roof of his sedan-chair.

If he had not finished his night at King's, he would
probably be emerging from the Rose Tavern in Russell
Street, a place that "stood pre-eminent among the dan-
gerous houses of the neighbourhood". "Painted faces . . .
in tally'd clothes "[1] flocked towards its golden sign; and
it employed a porter, nicknamed " Leather-coat ", or
" Leathersides ", celebrated for the toughness of his ribs,
who, promised the price of a pot of beer, would stretch out
on the cobbles and let a carriage-wheel run over him. By
1721, in addition to taverns, brothels, bagnios and night-
houses, Covent Garden contained some twenty-two gamb-
ling-hells. There were, indeed, few human passions that
the district did not satisfy; and Hogarth, the anatomist of
the passions, always eager to translate their effects into his
own accomplished short-hand, could have had no better-
placed or more inspiring vantage-point. The Bedford Arms
Tavern and the Bedford Coffee House, at the eastern end

"Not far from thence appears a pendant sign . . .
Whence to the travellers' eye the full-blown Rose,
Its dazzling beauties doth in gold disclose;
And painted faces flock in tally'd clothes . . ."
The Rake Reformed. *1718.*
" Tally'd clothes " were clothes bought at a " tally shop " on the instalment
system.

of the square, opposite the performers' door of the Covent
Garden Theatre, were both resorts that he particularly
favoured. At the coffee-house, he was afterwards the
member of a Shilling Rubber Club; and it was from the
tavern that, during the early summer of 1732, Hogarth
set forth upon his famous *Peregrination*. He had spent the
evening there with a party of friends—his brother-in-law,
John Thornhill, Samuel Scott, the topographical painter, a
woollen draper named William Tothall, and a literary
lawyer, Ebenezer Forrest—and, when midnight sounded,
they had evidently passed the moment of wishing to
separate and retire to bed. Why not turn a new page and
begin a ramble? A bogus antiquarian tour—one of those
learned pilgrimages beloved of eighteenth-century travellers
—seems somehow to have suggested itself. All lived in the
immediate neighbourhood: and, only pausing to collect
clean shirts and allow Samuel Scott (who dreaded the
night-air) leisure to obtain an overcoat, they started out
from the Bedford Arms, singing as they went, along the
winding streets to Billingsgate.

*An Account of what Seem'd most Remarkable in the Five
Days Peregrination ... Begun on Saturday May 27th 1732
and Finish'd on the 31st of the same Month*[1] was drawn up on
their return by Ebenezer Forrest, read aloud at the Bedford
Arms and attested by the signatures of Hogarth, Scott,
Tothall and Thornhill. It is a document of unusual value;
for nowhere else do Hogarth and his friends, and the atmos-
phere of rather boisterous good-fellowship that must have
prevailed at the resorts they frequented, receive such vivid
illustration. It is also the picture of a social period. During
the second half of the eighteenth century, once Laurence

[1] The *Account* was later rendered into Hudibrastic verse by William Gostling,
a Kentish antiquary, who claimed to have been " well acquainted with some
of the Travellers ". The original manuscript volume is now in the British
Museum.

Sterne had given currency to the insidious adjective " senti-mental ", the tourists would have seasoned their fun with reflections of a more romantic kind: we should have had some vague philosophising, perhaps a little moralising. Earlier, too, had it been undertaken by Pepys, this carefree expedition would have assumed a slightly different air: in Pepys's baggage, however scanty, room would have been found for a musical instrument, and we should read of concerts by land and water, diversified by conversations on technical or scientific themes. But Hogarth and his com-panions belonged to the Walpolian Age; and, when they lifted their voices as they walked to the river, the songs that they chose were resounding popular ditties. Their sense of humour was broad and schoolboyish: their enjoyment of the occasion was expressed in vigorous practical jokes and Rabelaisian horse-play.

Yet each of the rowdy travellers was a gifted and dis-tinguished man: John Thornhill, the future Serjeant-Painter: Scott, an artist whose rendering of London scenes —more especially of London's waterways—earned him a reputation as " the English Canaletto ": and Forrest, a cultivated attorney, interested in the modern theatre, author of a ballad-opera, entitled *Momus turn'd Fabulist*, which had had a successful run in 1729 under Rich's management. As for Tothall, he was a merchant-adventurer, devoted both to the pursuit of gain—he supplemented the profits of the woollen trade with a lucrative traffic in brandy and West-Indian rum—and to enlarging his important collection of exotic shells and native fossils. Tothall's career had already been varied. A fishmonger's nephew who had run away to sea and acquired his passion for shells on the beaches of the West Indies, one-time prisoner of the hostile Spaniards, marched off into bondage clad only in his waistcoat and

cap, he had survived these vicissitudes to become a pros-
perous woollen draper, but would presently retire to a
sea-side cottage where he tried his luck at smuggling. All
Hogarth's fellow-travellers had some connection with the
liberal arts: all were well-known and well-established per-
sonages. But decorum and gravity were soon abandoned
when they set out from the Bedford Arms.

To the tune of *Why should we Quarrel for Riches*, the
party first "drop'd Anchor" at a Billingsgate night-cellar,
named "The Dark House". Billingsgate is situated
below London Bridge; from between the piers of that
ancient structure poured a boiling cataract, and the
cautious traveller generally "took oars" at the market-
stairs on the seaward side. But a craft could not at once be
found; and, while they waited, Hogarth, who naturally
had not forgotten his drawing-materials, "made a Charac-
ateur of a Porter who Call'd himself the Duke of Puddle
Dock. The Drawing was (by his Grace) Pasted on the
Cellar Door; Wee were agreably entertain'd with the
Humours of the Place, Particularly an Explanation of a
Gaffer and Gammer a Little Obscene tho[h] in presence of
Two of the Fair Sex". Thus they amused themselves until
the clock struck one, when they set sail upon a Gravesend
boat they had hired, in which "Straw was our Bed and a
Tilt our Covering". The wind blew hard, and there were
squalls of rain; but the sleepless travellers, beneath their
tarpaulin roof, continued rehearsing catches and ballads—
Sir John as they passed Cuckold's Point, and *Pishoken* as
they drove by Deptford. In Blackwall Reach they picnicked
off biscuit, beef and neat gin. Gravesend was reached about
six o'clock; and "wee Wash'd our Faces and hands & had
our Wiggs powder'd, then Drank Coffee, Eat Toast and
Butter; paid our Reckoning and Sett out at Eight".

During the next five days they wandered at large across the

flowery landscape of north-eastern Kent, from Gravesend by way of Gad's Hill to Rochester and Chatham, thence through Upnor and Stoke to the Isle of Grain, where, with much difficulty, they scrambled aboard a small sailing vessel which wafted them over to Sheerness. Having explored Queenborough and Minster in the Isle of Sheppey, they again took to the water at Sheerness and began the journey back to the Bedford Arms. Meanwhile they had sung and laughed loudly, eaten and drunk heartily, and often halted to admire a prospect, copy an inscription or sketch an ancient monument. Teasing Scott was a favourite pastime; for, like Hogarth, he was uncommonly short but, unlike Hogarth, a somewhat fastidious and apprehensive character. Yet, although he was inclined to grow peevish, his vexation seldom lasted long. Thus, on the road from Gravesend to Rochester, he suffered " Some Small Distress " because the going was rough and miry; " but the Country being Extreamly pleasant alleviated his Distress and Made him Jocund . . ."

Jocundity, in fact, was the dominant mood of the tour. At Rochester they inspected the Castle, climbed to the battlements of the Norman keep " and took a View of a Beautifull Country a Fine River and Some of the Noblest Shipps in the World "—the magnificent men-of-war of early eighteenth-century England; but, once they had gratified their historical and topographical interests, they sat down to a solid dinner, which employed them for a couple of hours, and consisted of " a Dish of Soles & Flounders with Crab Sauce, a Calves heart Stuff'd And Roasted yᵉ Liver Fry'd and the other appurtenances Minc'd, a Leg of Mutton Roasted, and Some Green pease, all Very Good and well Dress'd, with Good Small beer and excellent Port ". At Rochester their reckoning amounted to the rather considerable sum of one pound seven shillings and

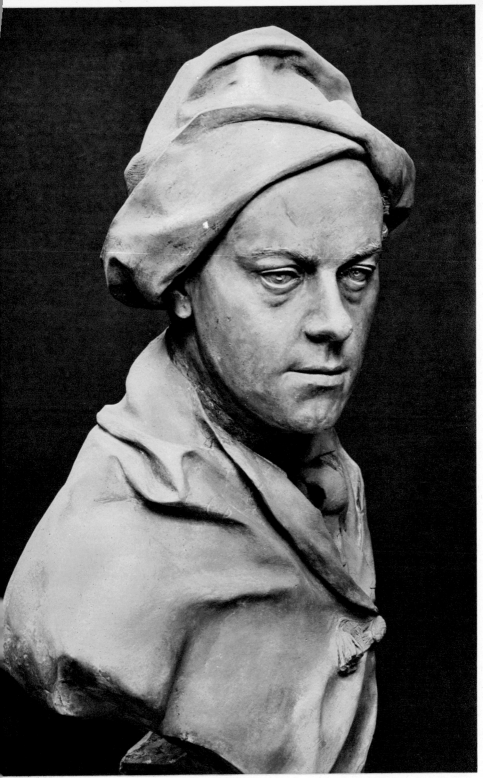

William Hogarth about 1732. Bust by Louis François Roubiliac
By courtesy of the National Portrait Gallery, London

A The Fisherman Shaving.
B Mr Thornhill
C Mr Tothall shaving himself
D Mr Hogarth drawing my Drawing
E Mr Forrest at Breakfast

threepence; and after dinner " Hogarth and Scott Stop'd
and played at Hop Scotch in the Colonade under the Town
Hall ". The game finished, they walked on to Chatham,
where they ate shrimps before taking a stroll around the
royal dockyard.

That evening, they were " Quite Fatigu'd with Pleasure";
and next day their flow of animal spirits was as brisk and
uninhibited. It spilled over into a series of outrageous
jokes. Scott's minor misfortunes never ceased to amuse his
friends—as, for example, when he crept under a hedge to
escape a sudden shower of rain, soiled " the Back of his
Coat with an Ordural Moisture of a Verdant Hue " and,
while being cleansed, " Miss'd a White Cambrick Hand-
kerchief which (he Declared) was lent him by his Spouse..."
That same day they enjoyed " a Battle Royall with Sticks
pebbles and Hog's Dung ", an engagement in which
" Tothall was the Greatest Sufferer and his Cloaths carried
the Marks of his Disgrace some time . . ." Later, Hogarth
had occasion to unbreach in a secluded country churchyard,
and Tothall, considering his attitude irreverent, " admin-
istred pennance to yᵉ part offending with a Bunch of
Nettles . . ." At another village the travellers passed
through, " wee all agreed to Quarrell and being near a
Well of Water full to the Brim, Wee Dealt about that
Ammunition for some time till the Cloaths and Courage of
the Combatants were Sufficiently Cool'd . . ." At the first
indications of Scott becoming argumentative, they surrep-
titiously loaded his pockets with pebbles; and, Scott and
Forrest being obliged to share a bed, the rest of the company
was pleased to celebrate a mock-marriage, " Threw the
Stocking Fought perukes and did a Great many pretty
things in a Horn . . ."

It needs no exercise of literary imagination to make the

picture come alive. Now Hogarth and Thornhill are relating their dreams. Now the party falls in with a group of discontented sailors, who complain that their midshipman has left them in the lurch, " without any Sustenance but a few little Cockles or one penny of Money to buy any "; at which " wee gave yᵉ Fellows Six pence who were Very thankfull and Run towards the Town to buy Victualls for themselves & their Companions . . ." Now Hogarth sits drawing, upon a chair in the public street, surrounded by " a great Many Men Women and Children abt him to see his performance ". Now Scott, at a Sheerness battery, is " Laughd at for smelling to the Touchholes of Some of the Guns lately Discharged ", and so is " Hogarth for Sitting Down to Cutt his Toe Nails in the Garrison ". Unlucky as always, the mettlesome landscape-painter loses " his penknife Value Five Shillings " and—an even graver mischance —mislays his borrowed overcoat. A rough meal " at the Chequer Alehouse kept by Gooddy Hubbard, who Entertain'd us with Salt Pork Black Bread Butter and Bunns and Good Malt Liquor ", is almost as much relished as the luxurious dinner they had consumed at Rochester; at their Queenborough lodgings, they bawl catches in competition with a party of convivial Harwich lobstermen. Although in no sense a work of narrative art, many of the details of the *Account* have the true Hogarthian quality. The text is supplemented, moreover, by Scott's and Hogarth's illustrations. Hogarth provided an emblematic head-piece and tail-piece of " Mr Somebody " and " Mr Nobody ",[1] sketches of Upnor Castle, " Breakfast at Stoke ", Queenborough High Street and the " Tomb of ' The Lord Shorland ' "; and the two artists collaborated in the delightful embarkation-scene. When he is representing

[1] A learned and interesting account of the history of these devices will be found in Charles Mitchell's preface to the *Peregrination*. Oxford, 1952.

himself, Hogarth, it is interesting to observe, makes no attempt to disguise his own exiguous stature. Forrest and Tothall are taller by a head; Hogarth and Scott appear equally diminutive.

Of all these plates, the finest is " Breakfast at Stoke." There, according to Forrest, after an exceedingly uncomfortable night, tormented by gnats and laid between damp bed-clothes, they arose early, " had our Shoes Clean'd were Shav'd and had our Wiggs Flower'd by a Fisherman in his Boots and Shock Hair without Coat or Waistcoat . . . Wee had milk and Toast for Breakfast . . ." Hogarth's pen-drawing, heightened by touches of colour, shows us the frowsy but cheerful assemblage in a cottage living-room, with brick-paved floor, a tight-shut lattice-window, wet clothes on a line and a small looking-glass, hung from a nail, in which Tothall, a stout, untidy, night-capped figure, is doing his best to shave himself. Forrest, in a red coat, his shaven head tied up in a clout, is breakfasting at the parlour-table, and Scott, in hat and wig, is finishing a sketch at the other end. The sturdy shock-headed young fisherman, his breeches unbuttoned around the knee, is scraping Thornhill's upper lip; and " Mr. Hogarth Drawing this Drawing " sits at his work on the left of the picture, perched sideways across a rush-bottomed chair. Their stay at Stoke, we learn from Tothall's careful " account of disbursements ", cost them eleven shillings and sixpence; the expense of the whole expedition was precisely six guineas; and they were neither out of pocket nor out of spirits when on Tuesday, the fourth day, they decided to start their homeward journey and " Hired a Small Vessell (vulgarly call'd a Bomb boat) " which was to take them up the estuary from Sheerness as far as Gravesend. The wind was then blowing a fresh gale, and poor Scott became very sea-sick; " soon after Hogarth Grew Sick . . ." Tothall,

however, who had been bred to the sea, " going on Board Cap^tn Robinson in one of the Customhouse Sloops Riding in Holy Haven ", procured " Milk punch and . . . some Fire to Light pipes which was greatly Wanted ". Although it rained hard throughout the voyage, they were distracted by a glimpse of " Severall porcpoises Rolling in pursuit of their prey "; and that evening they arrived at Greenwich, where they " Sup'd and Drank Good Wine " and laughed over Scott's perturbation about the disappearance of his overcoat—a mishap that, albeit grief to him, " was Sport to us and he Soon got the better of his uneasiness and Grew Merry as wee "; and " thus Wee continued till pretty Late . . ."

The following day Scott was again in trouble—drenched by a heavy sea and obliged to dry the tail of his shirt by extending it banner-wise against the sun and wind. Otherwise, this was the conclusion of their " Adventures and Extraordinary Mirth " as, driven by a " Mackrell Gale ", the boat that they had hired at Gravesend, and had equipped with " a Truss of Clean Straw a Botle of Good Wine, Pipes of Tobacco & Match ", bore them past meadows and villages, warehouses, riverside hovels and the dense urban thicket of spars and mast-heads, smoothly home to Billingsgate. They regained the Bedford Arms during the early part of the afternoon, " in the same Good Humour we left it to Set out on this Very Pleasant Expedition "; and within two days Forrest's completed manuscript, written in his beautiful round cursive hand, incorporating seven sketches by Hogarth and Scott, and a detailed map by Thornhill, had been bound in leather and titled in gold: TRAVELS. 1732. VOL. I. It eventually passed into the library of Forrest, who preserved it among his archives for almost half a century.

Against Hogarth it was afterward alleged by his first full-

length biographer, John Nichols,[1] and by Nichols's venomous collaborator, the Shakespearian critic, George Steevens,[2] that, "having rarely been admitted into polite circles, none of his sharp corners had been rubbed off, so that he continued to the last a gross uncultivated man ... To be a member of a Club consisting of mechanics, or those not many removes above them, seems to have been the utmost of his social ambition; but even in these assemblies he was oftener sent to *Coventry* for misbehaviour than any other person who frequented them ". Nichols and Steevens were writing at a time when the earlier half of the century already appeared a distant epoch, clumsy, antiquated, a trifle barbaric, glorified by the existence of men of genius but lacking in the social refinements that formed the distinction of their own day. They condescended towards their immediate forebears as we ourselves are apt to condescend towards our own Victorian ancestors, remarking that, although Hogarth's gifts were magnificent, his habits were not dignified. The roughness and boisterousness observed in the *Peregrination*, however, were by no means confined to the little côterie at the Bedford Arms. They might also have been observed upon a far loftier social level—at Houghton, for instance, where Sir Robert Walpole loved to entertain his friends with a prodigious abundance of food and drink and an equally copious supply of bawdy talk. Nor did Hogarth's companions belong to the class of mechanics. Tothall, it is true, was a London tradesman; but the tradesmen of that age were often widely educated; while the rest were intelligent professional men, representatives of the cultured middle-class, and each distinguished in his separate field. Such was the social

[1] The first edition of Nichols' *Biographical Anecdotes of Mr. Hogarth* appeared in 1781. It provoked a bitter quarrel with the artist's widow.
[2] Described by the celebrated Dr. Parr as " one of the wisest, most learned, but most spiteful of men ".

milieu that Hogarth preferred. By nature the least aristo-
cratic of artists, he had neither talent nor inclination for
more patrician company.

Next Nichols credits his hero with a surly and cantank-
erous temper. " The slightest contradiction " (we are
told) would " transport him into a rage ", and he was often
sent to Coventry even by his ungentlemanly friends. Well,
there can be no doubt that he was sometimes aggressive
and suspicious. Yet Forrest's account of the peregrination,
although it mentions the peevishness of Scott, contains no
reference to irascibility on the part of Hogarth; he seems
throughout to have displayed a sunny spirit and to have
contributed much to the " extraordinary mirth " that
irradiated the whole voyage. Indeed, at this stage of his
life, Hogarth had excellent reasons for appearing good-
humoured. Not many weeks had elapsed since the publi-
cation of the *Harlot's Progress*. He was now thirty-four
and, if not at the height of his powers, full of the energy
and self-confidence that go with the feeling of rapid growth.
A year later, he took the decisive step of quitting the
Thornhills' house " under the Middle Piazza ", and
founding a separate household in Leicester Fields, at the
third house from the bottom on the eastern side. His
professional sign hung over its door, a bust of Vandyke
carved by Hogarth himself " out of a mass of cork made up
of several thicknesses of cork compacted together " [1] and
richly gilded. The gardens in which he had once walked
as an apprentice, carrying his master's child, now saw him
enjoying the air as an independent citizen. Like other
citizens, he had his " summer lodgings " amid the pastures
and villages that bordered the Thames, at South Lambeth
or Isleworth. But until, the day of his death, Leicester
Fields remained his headquarters.

[1] Nichols, *op. cit.*

It was during the early Spring of 1733 that Hogarth and Sir James Thornhill (who had visited the gaol on a similar errand when he painted his celebrated portrait of the highwayman, Jack Sheppard) decided to interview Sarah Malcolm, then awaiting death in Newgate. Both her crime and her demeanour in the dock, where she had defended herself in a " long and fluent speech ", had already created a considerable stir. There was a hint of Lady Macbeth, a suggestion of Borgian magnificence, about the personality of this Temple bed-maker, who had strangled an eighty-year-old widow named Mrs. Lydia Duncombe, accounted for her companion, Elizabeth Harrison, by the same method, and had then cut the throat of their maid-servant, Ann Price, aged seventeen. Apprehended on the information of their neighbour, a Mr. Kerrol, who had " found some bloody linen under his bed, and a silver tankard in his close-stool ", she had endeavoured to cast suspicion on three alleged confederates, but was discovered to be carrying a hoard of stolen coins concealed " between her cap and hair ". She bore her conviction with remarkable fortitude; and, far from resenting the visit of Hogarth and Thornhill, which took place only two days before she was fated to ascend the scaffold, she rouged her cheeks—she was a hard, handsome young woman, believed to be about twenty-five —preparatory to sitting to Hogarth for her portrait in the condemned cell. Hogarth was evidently moved: " this woman (he said) by her features, is capable of any wickedness "—she was, in fact, strongly suspected of having committed an earlier murder for which another felon had paid the penalty; and the sixpenny print that appeared soon afterwards, signed " *W. Hogarth (ad Vivam) pinxit & Sculpsit* ", depicts the criminal, composed and arrogant, her arms leaning easily on the table and her determined chin defiantly set, the shadow of a sneer upon her tight-lipped

greedy mouth.[1] A little, later she was to approach the gibbet, erected near the scene of her crime, " opposite Mitre Court, Fleet Street ", with no less courage and effrontery, " neatly dressed in a crape mourning hood, holding up her head in the cart with an air, and looking as if she was painted, which some did not scruple to affirm ". Such was the density of the attendant mob that " a Mrs. *Strangways*, who lived in *Fleet Street*, near *Serjeant's Inn*, crossed the street from her own house to Mrs. *Coulthurst's* " without once setting foot to the ground, as if upon a living carpet. When justice had been duly done, Sarah Malcolm's corpse was carried to an undertaker's, " where multitudes of people resorted, and gave money to see it: among the rest a gentleman in deep mourning, who kissed her, and gave the people half a crown." [2]

Hogarth's interest in this tragedy was noticed by the London press. His name and fame were becoming familiar to journalists; and, on Saturday March 10th 1732, the *Craftsman* recorded that, on the previous Monday, Sarah Malcolm had " sat for her picture in *Newgate*, which was taken by the ingenious Mr *Hogarth;* Sir *James Thornhill* was likewise present ". Meanwhile the ingenious artist was turning his attention to a new scheme. The *Harlot's Progress* was to have a successor: and a series representing a *Rake's Progress* was undertaken during 1733. By the end of the year, he had completed the pictures and had already begun to engrave the plates. One obstacle, however, stood in his way. Though the *Harlot's Progress* had brought him a large reward, it would have been larger still without the competition of unscrupulous piratical booksellers. Exhibited all over London were reversed copies of

[1] Hogarth's painting, once in the Strawberry Hill collection, is now in the National Gallery of Scotland. The fine, and much later, portrait, " A Lady in Brown ", now in the possession of Sir Francis Cook, Bt., sometimes called " Sarah Malcolm ", represents a considerably older woman.
[2] Nichols, *op. cit.*

Hogarth's plates, printed in green ink, with the accompaniment of doggerel verses, prepared by that arch-villain Elisha Kirkhall of Whitefriars.[1] He resolved, therefore, to hold back the engravings (which were, nevertheless, advertised in the *Craftsman* of December 29th 1733) until he could devise some means of protection that guaranteed the artist's rights. Nothing would serve his end but an Act of Parliament; and we have the strange spectacle of a solitary painter-engraver, who had achieved a measure of fame but was neither rich nor powerfully supported, preparing to impose his will upon the country gentlemen of the House of Commons. The measure he contemplated was drawn up with the assistance of a learned friend, William Huggins;[2] and the professional allies, who put their names to his petition, were John Pine, George Lambert, George Vertue and Gerard Vandergucht. Evidently the preparation of the campaign, which Hogarth tells us was conducted " almost at his sole expense ", lasted throughout 1734, while the task of engraving the pictures was gradually completed. In other fields, his progress was chequered. Hitherto he had been remarkably independent of aristocratic or royal patronage; no single patron had ever supported him; nor had he depended upon the interest of any member of the royal family. But the celebration of a dynastic alliance, between the Princess Royal of England and the Prince of Orange in March 1734, stirred him to an unusual effort. We need not assume that he hoped to become a courtier. It is more probable that he wished to discomfit an artistic adversary—William Kent, against whom, in 1731, he had let fly a further satirical broadside, *The Man of Taste, or Burlington Gate*.[3] He would challenge

1 " Bounteous Kirkall " is among the victims pilloried by Pope in the *Dunciad*.
2 William Huggins (1696–1761) was the son of the notorious Warden of the Fleet, John Huggins, but evidently a man of very different character. He composed the Oratorio *Judith* and translated Ariosto and Dante.
3 See page 44.

" the Signior " with his own weapons and defeat him on his own ground.

The moment he had chosen appeared propitious. Soon after arriving in England, the Prince of Orange had fallen gravely ill, and his malady had caused the postponement of all immediate wedding-plans. But, although " during his tedious and dangerous illness (writes Lord Hervey) no one of the Royal Family went to see him ", since " the King thought it beneath his dignity, and the rest, whatever they thought, were not allowed to do it ", this misshapen but good-humoured young prince made an extremely sympathetic impression upon King George's subjects. True, he was dwarfish and had a curvature of the spine. As Hervey reported to his royal mistress, who had begged her favourite to " let her know . . . what sort of hideous animal she was to prepare herself to see ", his " body was as bad as possible ", but his " countenance was far from disagreeable, and his address sensible, engaging and noble ". In marked contrast to the boorish manners of the King and the suffocating ennui of the royal household, where " every night in the country, and three nights in the week in town ", the monarch would strut restlessly to and fro, discoursing of armies or genealogies to a few downtrodden intimates, while the patient Queen " knotted and yawned, till from yawning she came to nodding, and from nodding to snoring ",[1] the Prince's attitude was dignified, yet his social demeanour frank and easy. When he paid his respects at St. James's, the palace was " so thronged that he could hardly get up stairs or pass from one room to another "; and, on the day and night of his wedding, which finally took place on March 14th 1734, bonfires blazed in the crowded streets, windows were illuminated, church-bells pealed and the crash of saluting artillery reverberated along

[1] Hervey: *Memoirs.*

the banks of the Thames. From the King's apartment in St. James's, a covered gallery, through which the procession walked, had been built " quite round the palace garden to the little French chapel adjoining to St. James's House . . . The gallery held four thousand people, was very finely illuminated and, by the help of three thousand men who were that day upon guard, the whole was performed with great regularity and order, as well as splendour and magnificence. Lord Hervey had the care of the ceremonial, and drew the plan for the order of the procession . . . The chapel was fitted up with an extreme good taste, and as much finery as velvets, gold and silver tissue, galloons, fringes, tassels, gilt lustres, and sconces could give . . . The Prince of Orange was a less shocking and less ridiculous figure . . . than one could naturally have expected such an Æsop, in such trappings and such eminence, to have appeared. He had a long peruke like hair that flowed all over his back, and hid the roundness of it; and, as his countenance was not bad, there was nothing very strikingly disagreeable but his stature." [1]

The décor had been devised by William Kent. But Hogarth, determined to score a point by making his own contribution to this popular solemnity, had approached the Queen—perhaps through Lord Hervey, the Vice-Chamberlain—for permission to sketch the interior of the Chapel and then depict the wedding in the style of one of his early conversation-pieces. Caroline had expressed her approval. On his appearance at St. James's, however, carrying his sketch-book, he had no sooner begun to draw than he was rudely accosted by a member of the Master Carpenter's staff who directed him to leave the building. Not at the best of times a particularly patient man, Hogarth retorted that he had the Queen's permission; and he had positively

[1] Hervey: *Memoirs.*

refused to stir an inch, when the Lord Chamberlain himself was summoned by his flustered underlings and gave orders that the truculent draughtsman should at once be thrown out. In vain Hogarth appealed to the Queen; for, although Caroline agreed that she had given her permission, she admitted that in doing so she had not allowed the matter sufficient thought, and said that she had certainly had no intention of curtailing Mr. Kent's privileges. Hogarth's discomfiture created considerable hubbub; and, as a result of his tactless protests, he now forfeited a yet more promising commission. He had received a command to execute a conversation piece of the entire royal family; and Prince William, the monarch's second son, had already accorded him a preliminary sitting.[1] "This also has been stopp'd (records Vertue), so that he can't proceed, and these are sad mortifications to an ingenious man. But it's the effect of caricatures with which he has heretofore touch't Mr. Kent and diverted the town—which now he is like to pay for when he has least thought on it". Vertue adds that Hogarth's relationship to Sir James Thornhill, who was identified with the representatives of the political opposition, had no doubt been a secondary cause.

As it happened, Hogarth's alliance with Thornhill was very soon to be cut short. Sir James died suddenly in May 1734; and his extinction removed one of the most powerful influences that had moulded the course of his son-in-law's life. Thornhill's frescoes had aroused his imagination not only because he admired their bold pictorial qualities: they also suggested the distinguished rôle that might be played by a rightly ambitious "historical painter". On the margin of the central panel, which rises behind the dais in the Painted Hall at Greenwich, the artist had represented himself, wearing a gay lilac coat and

[1] This delightful little study is now in the collection of Lord Glenconner.

an expression of creative pride, glancing back over his
shoulder as he points to the great pageant of British royalty
that he and his assistant had conjured up. It is a self-
portrait that, during his youth, must often have impressed
Hogarth. Later events had confirmed his regard; and,
although in some important respects he may be said to
have outgrown his master, he was never to outgrow the
dangerous ambition that Thornhill's example had implanted
in his mind. The Serjeant-Painter had left no will, and
permission to administer his estate was presently granted
to his widow and to his daughter, Mrs. Hogarth. But
Hogarth inherited the apparatus of Sir James's drawing-
school, which had eventually collapsed owing to the mal-
practices of a dishonest treasurer; and, " thinking that an
Academy conducted on proper and moderate principles
had some use," he " proposed that a number of artists
should enter into a subscription for the hire of a place large
enough to admit thirty or forty people to draw after a naked
figure. This was soon agreed to, and a room taken in
St. Martin's Lane. To serve the society, I lent them the
furniture which had belonged to Sir James Thornhill's
academy; and as I attributed the failure of that and Mr.
Vanderbank's to the leading members assuming a super-
iority which their fellow students could not brook, I pro-
posed that every member should contribute an equal sum
to the establishment, and have an equal right to vote in
every question relative to the society." Towards the end
of his existence, he was able to report that the Second
Martin's Lane Academy (which had its studio just off the
Lane, in Peter's Court, opposite Tom's Coffee House) had
" now subsisted near thirty years ".

VII
Tom Rakewell

A YEAR after the death of Sir James Thornhill, the elder
Mrs. Hogarth died, overcome by her terrifying experiences during a recent London fire. Hogarth was now
free and independent; and that same year saw the
successful completion of one of the boldest undertakings
he had yet launched. The bill he had planned to vest
in designers and engravers an exclusive right to the
use of their work, for a period of fourteen years from the
time of publication, was triumphantly steered through
Parliament and received the Royal Assent, as *Act* 8 *Geo. II.
cap.* 13, on May 15th 1735. Though later events revealed
some errors in the drafting, Hogarth professed himself
entirely satisfied. He had sought redress, he declared,
" and obtained it in so liberal a manner, as hath not only
answered my own purpose, but made prints a considerable
article in the commerce of this country; there being now
more business of this kind done here, than in Paris, or
anywhere else . . ." Nor was his optimism premature.
Thanks largely to Hogarth's preliminary efforts, the
Continental market for English engravings continued to
flourish throughout the eighteenth century; and the way
was now open for such print-purveyors on the grand scale
as the gifted and enterprising Alderman Boydell,[1] who
informed the House of Commons in 1803 that his receipts

[1] See Alderman Boydell, Printseller by Thomas Balston. *History Today,*
August, 1952.

from foreign sales had long been sufficiently lucrative and regular to finance all his operations at home, and that not until the opening of the Revolutionary War with France in 1793 had the export of English prints showed any signs of falling off.

Having thus obtained the protection he required, Hogarth immediately issued his new series. The Harlot was to be followed by a Rake; after a young woman whom the world destroys, he would depict a young man obstinately bent on the task of self-destruction. The Prodigal is, of course, a common type in every country and in every age; but no doubt it is particularly common during periods of social peace and great material prosperity, when there are neither wars abroad nor revolutions at home to absorb the more anarchic tendencies of the human character. The spend-thrift is often a *parvenu*; and Tom Rakewell certainly emerges from a grim commercial background, the son of a squalid and miserly businessman who, just before he dies, has been repairing his shoes with soles hacked out of the cover of an ancient family Bible. The drama of Tom's rise and decline embraces both a plot and a sub-plot; and the sub-plot—a somewhat unfortunate addition to the simple outlines of the main theme—concerns the girl whom he has seduced at the University and who pursues him, with importunate devotion, through all the vicissitudes of his later life. Her name, we learn, is Sarah Young; but, although he provides a name, Hogarth, alas, was never able to give his heroine a real face. Throughout the series, she remains a lay-figure, lacking any of the vital energy that he has infused into the personage of the Rake himself.

More loosely constructed than the previous series, the story of Tom Rakewell is even more richly illustrated with references to the contemporary scene; and once he has

introduced us to his awkward hero, recently arrived from Oxford and endeavouring at the same time to take stock of his patrimony, ward off Sarah and her indignant mother, and get himself measured for a new suit, he shows us Rakewell holding his levée amid a crowd of hangers-on, who represent the various aberrations of modern taste and sportsmanship. The Man of Fashion is also a connoisseur; and it was against the taste of his period, rather than against the vices and follies of individual human beings, that Hogarth frequently delivered his most enthusiastic diatribes. Many of his satires belong as much to the history of taste as to the study of morals and manners; and Rakewell the misguided Patron of Art is at least as important as Rakewell the dissolute frequenter of the Drury Lane *demi-monde*. Kent and other æsthetic adversaries raise their formidable heads again. The Signior may have decorated his rooms, and advised Rakewell on his choice of pictures. The " Judgement of Paris ", hung between portraits of fighting cocks, has clearly come from Italy; and a musician, seated at the harpischord, is turning the pages of a foreign opera. Meanwhile a group of clients contend for his interest. Charles Bridgeman,[1] the celebrated landscape-gardener, and forerunner in that field of Kent, Repton and ' Capability ' Brown, lurks disconsolately just behind him; but a French dancing-master minces gaily forward, and Dubois,[2] the well-known French duellist, who is watched with sulky disdain by James Figg,[3] the English

[1] Charles Bridgeman, (d. 1738). Gardener to George I and George II. Bridgeman, a member of the Burlington Group, advised Pope on the layout of his pleasure-grounds at Twickenham, began the replanning of Kensington Gardens for Queen Caroline, and designed the park at Stowe. He was responsible for the introduction of the *haha* into English landscape-gardening.

[2] Dubois fought his last duel—with an Irish fencing-master of the same name—and died of the wounds he received, in May 1734.

[3] James Figg, (d. 1734). " The Atlas of the Sword " kept an Academy, much frequented by fashionable and pugnacious young men, in Oxford Road, Marylebone Fields. He is also depicted by Hogarth in the *Midnight Modern Conversation, Southwark Fair* and a separate portrait-study.

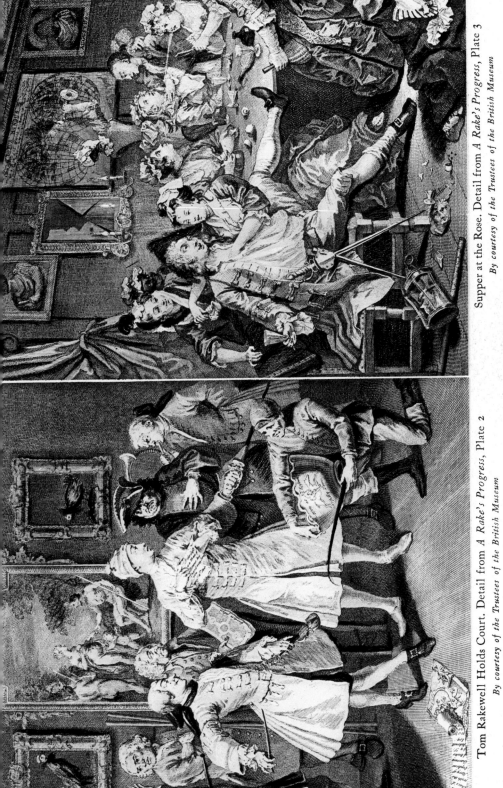

Tom Rakewell Holds Court. Detail from *A Rake's Progress*, Plate 2

By courtesy of the Trustees of the British Museum

Supper at the Rose. Detail from *A Rake's Progress*, Plate 3

By courtesy of the Trustees of the British Museum

Detail from *Morning*. From *Times of the Day*

prize-fighter, champion of broad-sword, cudgel and quarter-staff, makes a fierce lunge into the empty air. A jockey displays the cup won by " Silly Tom " at Newmarket; and a professional bully, clapping his hand on his heart, offers his experienced services as Rakewell's private body-guard.

In the engraved version of the second plate, Hogarth has inserted a long paper scroll, trailing across the carpet from the back of the musician's chair. It contains a list of valuable tributes recently offered by his admirers to the *castrato* singer Farinelli, the last item being " a gold snuff-box, chased with the story of Orpheus charming the Brutes, from T. Rakewell, Esq.". Near it lies an emblem-atic print which exhibits the virtuoso enthroned amid his feminine devotees, with the sacrilegious legend " *One God, One Farinelli!* "—words said to have been actually uttered by a " a lady of distinction " during a crowded performance at the London opera-house. Rakewell holds the centre of the stage, in slippers and velvet cap and a rose-pink dressing-gown, magnificently frogged with gold and lined with tender sky-blue. His new-found dandyism, however, still fits him rather awkwardly; and he is probably more at his ease exploring the primitive delights of the Covent Garden neighbourhood. Thus the scene now shifts to the Rose Tavern where, having fought and defeated a watch-man whose broken lantern and staff lie tumbled at his feet, he and a friend are entertaining a party of prostitutes in a shabby upper room. Holman Hunt, more than a hundred years later, anxious to illustrate a *demi-mondaine's* lodging and determined, like a true Pre-Raphaelite, to portray every detail from first-hand knowledge, made it a point of honour to visit certain questionable establishments in the vicinity of St. John's Wood, but did so with the utmost repugnance and after many scrupulous heart-searchings. The eighteenth century was less inhibited; Hogarth (we

are assured by Nollekens's biographer, John Thomas Smith) was, in the usual course of his existence, a " great frequenter of houses supported by libertines ", and perfectly familiar with the kind of tavern-room to which Rakewell and his type resorted. The third scene of the *Rake's Progress* is, indeed, especially interesting because it assists our study of the pictorial dramatist's creative method. Not only did he incorporate a variety of portraits and numerous refer- ences to contemporary tastes and trends—often so slight or so cryptic that, at a glance, they may be scarcely noticeable —but he employed the rough notes that he had already committed to his sketch-books, reviving an incident, a characteristic gesture, the transitory expression of an unknown face.

Such a note he transferred to the scene at The Rose. According to the author of *Nollekens and his Times*, Hogarth and his crony, Francis Hayman the painter, had happened to find themselves among the nocturnal crowd at Moll King's Coffee House. " They had not been in the brothel ten minutes ", before Hogarth whipped out his book to draw two women quarrelling. One of the contestants spat a stream of wine or gin straight into her rival's eye, a gesture of defiance " which so delighted the artist, that he ex- claimed, ' Frank, mind the bitch's mouth! ' ", and recorded that detail too in his rapid cursive shorthand. He remem- bered the episode when he came to deal with the Rake, here depicted as a limp and exhausted adventurer, washed up on the isle of Circe, his sword out of its sheath, shirt and breeches unbuttoned, his wig dishevelled and his hat askew, being robbed by the young dark-haired girl across whose silken lap he is half reclining. Punch has been brewed; bottles have been opened. Meanwhile there are further diversions in store; for among the amusements provided by the Rose were exhibitions of the sort with which every

well-organised brothel attempts to whet its customers'
appetite. Leather-coat is the master of ceremonies.
Musicians have been recruited from the street; and he is
holding the large pewter dish that an habitué of Covent
Garden would at once have recognised. The " posture
woman " is undressing on the left, with the patient and
practised movements of a mercenary who thoroughly under-
stands her trade; and, as soon as she has stripped, she will
mount on the platter, " to whirl herself round, and display
other feats of indecent activity ". Rouquet, Hogarth's
Swiss-French commentator and near neighbour in Leicester
Fields, who, apparently at the artist's instigation, produced
an account of his work for the benefit of the foreign public,
supplies an illuminating postscript: " *Ce grand plat va
servir à cette femme comme à une poularde; elle s'y placera
sur le dos; et l'ivresse et l'esprit de débauche feront trouver
plaisant un jeu, qui de sang-froid ne le paroit guères.*"
Leather-coat, doltish and obsequious, is also carrying a
lighted candle " *Il suffit de vous laisser à deviner la destin-
ation de la chandelle,*" Rouquet observes with somewhat
unnecessary minuteness.

Rouquet was almost equally interested by the national
affluence that this scene revealed. The comfort and pro-
priety of English taverns astonished foreign visitors; and,
though the Rose is dingy and ramshackle, though the old
pictures of the Twelve Cæsars have been gashed with
knives or sword-blades, and one emperor has been replaced
by a portrait of Pontac, the renowned cook, from a foreign
point of view it is still remarkably well arranged: "*du linge
toujours blanc—de tables de bois qu'on appelle ici mahogani—
grand feu et gratis.*" But Tom's share of the national wealth
soon shows signs of running out. One first of March,
the feast of St. David and the anniversary of Queen Caroline,
he is arrested for debt on his way down St. James's Street,

bound for the birthday celebrations at St. James's Palace. The roof of his sedan chair is thrown up, and Rakewell is roughly hauled forth. Only the intervention of Sarah Young, now turned London milliner, who sees his plight as she happens to be passing by, saves him from the spunging-house. Behind them stretches the long irregular perspective of the ancient thoroughfare, arched over with a patchwork sky and dim with the colours of a smoky English afternoon. A dense throng of coaches and chairs is hurrying towards the palace gates; at the corner of St. James's Street and Piccadilly, a Cockney workman, his ladder poised against the bracket, is replenishing an oil-lamp; and a ragged boy, carrying a basket, takes advantage of the excitement to remove the Rake's cane. Later, Hogarth was to delete the boy and substitute a knot of urchins—shoe-blacks and sneak-thieves and beggars, lounging and gambling upon the flag-stones of the pavement. Among them is a child absorbed in the *Farthing Post*— a small piratical newspaper that published news and gossip at a low cost by avoiding stamp-duty.

At length, a moment arrives when the Rake must marry; and this he does, choosing as his bride a rich, elderly, one-eyed spinster, to whom he is united in Marylebone Old Church, a tumbledown edifice then almost in the open country, and because of the remoteness of its situation much favoured for hasty or secret weddings. Sarah Young does her best to intervene; but she is beaten back by a pew-opener; and Tom, having replenished his fortune, becomes a gambler on the grand scale. Since the end of the previous century, the English passion for gambling had grown more and more extravagant. Harley, we learn, during the age of Anne, never passed White's " without bestowing a curse upon that famous academy, as the bane of half the English nobility "; and, although it is doubtful

whether White's [1] itself is portrayed in the fifth episode of the *Rake's Progress*—the room seems too sordid and bare, and a professional highwayman, with his pistol protruding from his pocket, is among the personages represented—the plate includes a reference to the disastrous conflagration that had gutted the building two years earlier. For fire has broken out in a corner of the apartment; but few of the gamblers assembled have yet observed the spreading flames. Each of them has his eyes turned inward—the Rake cursing his luck in a transport of fury: an unfortunate parson who, using both hands, wrenches his hat down over his face as if to exclude the intolerable future: a plump androgynous young beau negotiating a financial arrangement with his private Shylock: the highwayman who sits by the hearth, so deep in his melancholy cogitations that the little boy who has brought him a glass must shout at him and tug at his sleeve to call him back to real life.

Through narrowing spirals of misfortune, Tom Rakewell reaches a debtors' prison. Here he is plagued by the reproaches of his wife, distressed by the importunities of the devoted Sarah, who visits the gaol with his illegitimate child only to collapse in a deathly swoon, and vexed by the demands of the gaoler and the gaoler's pot-boy. He has tried his hand at writing a comedy; but Rich, the successful actor-manager, has returned it with a curt note. The smooth foolish physiognomy of his youth has now been carved by experience into the mask of a haggard middle-aged man. It is not surprising that, in the end, he should lose his grip on sanity, and he removed from the gloom of a prison to the squalor and confusion of a public madhouse. The eighth and last scene shows the interior of Bedlam, the great receptacle for pauper lunatics just

[1] White's Chocolate House did not become a club, in the modern sense of the word, until 1755.

beyond the City wall. A noble building with mansard roofs, completed to the design of Robert Hooke in the year 1676, its entrance-gate adorned with " admirable statues ", representing " Melancholy " and " Raving Madness ", by Caius Gabriel Cibber,[1] Bedlam looked out over the " spacious and agreeable walks " of the large open space named Moorfields.[2] For more than a century the hospital was a popular resort of London sightseers. No age, no period of civilisation, if we examine its practices at close range, will prove to have been completely callous. But areas of sensitiveness change; and the Augustan age was oddly insensitive in the attitude that it adopted towards many forms of human suffering. Its apparent callousness was an admission of helplessness. Just as infant-mortality was unavoidable, the majority of lunatics were totally incurable. Apart from restraint and confinement, repeated bleedings and strenuous purgings, no treatment had yet been devised to combat the hidden disorders of the mind; and no attempt was therefore made either to disguise the lunatic's condition or to segregate him in a world of his own. Not until 1770 did it occur to physicians that the constant influx of inquisitive sightseers " tended to disturb the tranquillity of the patients "; and, meanwhile, several generations of distinguished men and women had inspected and admired the building, and marvelled at the strange humours displayed by the inhabitants. Even Cowper, tenderest of creatures, and one who had himself passed through the valley of the shadow of madness, admits that he has been there. " In those days (he writes to Newton, after the hospital had shut its doors) when Bedlam was open to the cruel curiosity of

[1] Caius Gabriel Cibber. (1630–1700). A native of Holstein. Father of Colley Cibber, the actor and dramatist.

[2] The hospital stood on the south side of the modern Finsbury Square. St. Luke's Hospital in Old Street was the only other public institution devoted to the care of the insane. See *A People's Conscience* by Strathearn Gordon & T. G. B. Cocks.

holiday ramblers I have been a visitor . . . Though a boy, I was not altogether insensible of the misery of the poor captives . . . But the madness of some of them had such a humorous air, and displayed itself in so many whimsical freaks, that it was impossible not to be entertained, at the same time that I was angry with myself for being so." Johnson and Boswell, both introspective and neurotic characters, frequently haunted by the fear of madness, visited Bedlam as late as 1775; and Boswell merely observes that the visit went off without mishap, but that " the general contemplation of insanity was very affecting ". Incidentally, its " indiscriminate admission of visitants " increased the revenues of the hospital by " at least £400 a year . . ."

Other details emerge from contemporary records—the wooden bowls in which the lunatics were served with "their appointed messes ": the knavery of nurses and attendants who, on Sundays, put aside a good part of the patients' food for the benefit of their " ancient relations and most intimate friends, who are to come and visit them in the afternoon ": and the oppressive horror of hot, still nights when the noise of the maniacs within their prison, " rattling their chains and making terrible out-cry ", echoed across Moorfields. To this hideous refuge—the old, unreformed Bedlam of shackles and straw and wooden bowls—our broken Rake has at last descended. Sarah Young, who has as usual reappeared, weeps over him, but weeps in vain: Tom has sunk into utter oblivion, fettered and nearly naked, writhing on the hospital floor. For the figure of the Rake himself and that of the religious enthusiast, crouched in an adjacent cell, Hogarth had taken suggestions from Cibber's pair of statues.[1] Their companions were probably drawn from life—the unclothed monarch, whom a fashionable visitor is studying through the sticks of her fan, the star-gazer, the

[1] Now in the Guildhall Museum.

musician, the ineffably pontifical and euphoric pope. An element of contemporary satire is provided by a crazy theorist, who illustrates on the dirty plaster wall a scheme then being seriously discussed by the devotees of Natural Science—" Whiston's proposed method of discovering the Longtitude, by the firing of bombs.[1]" Finally, seated at the bottom of the stairs, is an object-lesson in the perils of love. There Hogarth has inserted a portrait of William Ellis, who was believed to have run mad as a direct result of his passion for a youthful strumpet. He has inscribed her name on the balustrade—" *Charming Betty Careless* ": a young woman, celebrated alike for the sweetness and innocence of her face and the outrageous lubricity of her conduct, who is also mentioned in *Amelia*. He had happened, during his youth, writes Fielding, " to sit behind two ladies in a side-box at a play, where, in the balcony on the opposite side, was placed the inimitable Betty Careless . . . One of the ladies, I remember, said to the other—' Did you ever see anything look so modest and so innocent as that girl over the way?' Yet . . . I myself . . . had a few mornings before seen that very identical picture of all those engaging qualities in bed with a rake at a bagnio, smoking tobacco, drinking punch, talking obscenity, and swearing and cursing with all the impudence and impiety of the lowest and most abandoned trull of a soldier ". Blind and deaf to the riot that surrounds him, William Ellis, in rigid abstraction, sits mourning over his lost beloved.

Issued to subscribers on June 25th 1735, a day after the act protecting designers and engravers first came into legal operation, Hogarth's new series, though it achieved a considerable sale, proved a little less popular than the *Harlot's Progress*. It lacked the dramatic simplicity of the earlier

[1] William Whiston (1667-1752). Country clergyman and eccentric physicist. Friend of Newton and protégé of Queen Caroline.

narrative; and, whereas his critics were bound to agree that a parson's daughter who allows herself to be picked in an inn-yard by a notorious London bawd must undoubtedly come to a bad end, they pointed out that the Rake's decline and fall was " of rare occurrence in real life ", with the result that the final catastrophe produced " no more effect than a bugbear would. It is not in the ordinary course of events that profligates and debauchees become the inhabitants of a madhouse ": otherwise White's Chocolate House, Moll King's and the Rose Tavern would have been lonelier and sadder places. Notwithstanding such sensible objections, the *Rake's Progress* confirmed Hogarth's celebrity as a powerful modern moralist. Before its appearance, *The Gentleman's Magazine*, in an obituary notice on Sir James Thornhill published during the previous year, had mentioned Hogarth merely as the ingenious author of miniature conversation pieces. The success of his portraits was temporarily forgotten; and writers now hastened to congratulate him upon his triumphs in the moral sphere.

Some of his panegyrists were little-known scribblers; but in 1736, from beyond the Irish Sea, came a rumble of deep-voiced approbation:

> *How I want thee, humorous Hogarth!*
> *Thou, I hear, a pleasant rogue art.*
> *Were but you and I acquainted,*
> *Every monster should be painted:*
> *You should try your graving tools*
> *On this odious group of fools;*
> *Draw the beasts as I describe them;*
> *Form their features, while I gibe them . . .*
> *Draw them so that we may trace*
> *All the soul in every face.*[1]

[1] From *The Legion Club*, a violent attack upon the Irish House of Commons.

Even in doggerel verse, there was no mistaking the accent: Dr. Swift felt that he had recognised a satirist of the same stamp. He professed himself a " great admirer " of Hogarth and often drank his health with George Faulkner, the famous Dublin bookseller; and Hogarth returned the compliment by sending the Dean a number of engravings.

Fielding, too, detected an affinity between Hogarth's series and his own work. In 1735 he was still a struggling commercial dramatist, a tall hawk-nosed young man who, before his marriage, had explored all the circles of contemporary dissipation. But Walpole's Licensing Act of 1737 would put the dramatist out of business; he would gradually lay the foundations of a new type of modern prose literature; and it was in 1740, exhilarated, no doubt, by a sense of his expanding genius, that he paid a warm tribute to the artist's complementary gifts. " The ingenious Mr. *Hogarth* ", he declared in the paper he edited,[1] was " one of the most useful Satyrists any Age hath produced . . . I almost dare affirm that those two Works of his, which he calls the *Rake's* and the *Harlot's Progress*, are calculated more to serve the Cause of Virtue . . . than all the *Folios* of Morality which have been ever written; and a sober Family should no more be without them, than without the *Whole Duty of Man* in their House." He was to continue and extend the eulogy in the preface that he wrote for *Joseph Andrews*, laying particular emphasis on Hogarth's psychological penetration: " It hath been thought a vast Comendation of a Painter, to say his Figures *seem to breathe;* but surely, it is a much greater and nobler Applause, *that they appear to think.*"

No artist is averse from recognition; and Hogarth's appetite for praise was unusually strong. But, like many artists, he was seldom completely satisfied, either with the

[1] *The Champion,* edited by Fielding from 1739 to 1741.

applause he received—a creator is apt to be most warmly commended for the creations that he values least—or with his achievement itself when he measured it against his own standards. Thus the year in which he published the *Rake's Progress* marks an extremely important stage in his æsthetic evolution. He might well have decided merely to consolidate his previous gains. But, although it is true that he never abandoned them, and continued to pursue his experiments in the field of the pictorial drama, he also made a headlong attack upon territory that he had not yet explored. Even in middle age we are dominated by the visions of youth; and always nagging at the pictorial dramatist's mind was the recollection of Thornhill's frescoes. The goal of his youthful imaginings was the target at which he still aimed; and, having once concluded the Rakewell series, he reverted to an earlier plan. Not only was he haunted by the ghost of Thornhill—and determined, now that he had mastered his medium, to realise the vague aspirations he had cherished as an inexperienced boy—but he was convinced that the work he proposed was work that urgently needed doing. The English art-world must be revived and refreshed: English painters must be aroused from a state of slavish imitativeness. Foreign pictures flooded the market; and Hogarth was right in supposing that they were generally very bad pictures—alleged Italian " Old Masters " of the late sixteenth and seventeenth centuries, often in extremely poor condition and obscured by a coating of varnish and dirt. Credulous connoisseurs followed the lead of unscrupulous picture-jobbers; and, every time he looked in at a sale-room, Hogarth, with his love of clear, bright colours and his unquenchable faith in the possibilities of a genuine English school, seems to have felt his critical choler rise. The Connoisseurs became his favourite enemies. They were the sworn opponents both

of Art as a whole, and of an artist who adored his art and defended his birth-place with the same obstinacy and the same passion.

How he hated them, those presumptuous " experts "— and how, as they eluded or ignored his shafts, he was soon convinced that they hated him! The possessor of an un- tutored literary gift, he occasionally exercised an English- man's privilege of writing to the newspapers—for example, in 1737, when, enraged by some disparaging journalistic comments upon his father-in-law's frescoes, he confided his views at length to the *St. James's Evening Post*.[1] The English cognoscenti might be bad enough; but " there is another set of gentry more noxious to the Art than these . . . your picture-jobbers from abroad, who are always ready to raise a great cry in the prints whenever they think their craft is in danger; and indeed it is their interest to depre- ciate every English work, as hurtful to their trade, of con- tinually importing ship-loads of dead Christs, Holy Families . . . and other dismal dark subjects, neither enter- taining nor ornamental." Foreign impudence, he asserted, was matched by native ignorance. Suppose Hogarth or a critic of his kind should protest that " that grand Venus (as you are pleased to call it) " had not sufficient beauty " for the character of an English cook-maid ", one could be certain that an English expert, the famous " Mr. Bubbleman ", would instantly fly to the picture's defence. " O, Sir, (he would simper) I find that you are no con- noisseur—that picture, I assure you, is Alesso Baldovin- etto's second and best manner, boldly painted, and truely sublime; the contour gracious; the air of the head in the high Greek taste . . ." And, having warmed to his theme, Hogarth appends an admirable vignette of Mr. Bubbleman in action, " spitting on an obscure place and rubbing it

[1] Quoted by Nichols: *Genuine Works*.

with a dirty handkerchief ", then skipping away to the further end of the room and screaming out in raptures: " There is an amazing touch! a man should have this picture a twelve-month in his collection before he can discover half its beauties." Meanwhile the prospective buyer, " though naturally a judge of what is beautiful, yet ashamed to be out of the fashion in judging for himself," little by little succumbs to Mr. Bubbleman's blandishments, " gives a vast sum for the picture . . . and bestows a frame worth fifty pounds on a frightful thing, without the hard name on it not worth as many farthings ".

Hogarth's efforts, nevertheless, were not limited to destructive satire: he was also determined to make his criticisms good by equalling and excelling the more cele- brated ancient masters. In the artist's opinion and that of most contemporary students, a sharp distinction existed between the various branches of pictorial art. There was a higher and a lower style, each adapted to the subject- matter that an artist treated; and Hogarth now pro- posed to take off from the lowlier level—on which he had been largely occupied with portraits and domestic drama—for the exalted regions in which the greatest painters were out-soared only by the greatest poets. His dramatic series he was inclined to dismiss; and his autobiography contains a perplexing passage in which he observes that before he had " done anything of much conse- quence " in the field he had originally set himself—that is to say, in the representation of the tragedies and comedies of everyday life—he " quitted small portraits and familiar conversations, and, with a smile at my own temerity, com- menced history painter . . ." We find no mention of either *Progress*; but, in fact, it was not until the publication of the *Rake's Progress* lay a year behind him that the results of his temerity were at length exhibited to the public gaze.

The ambition that inspired them, however, dated from the artist's youth. He had long " entertained some hopes of succeeding in what the puffers in books call *the great style of History painting*"; and he therefore seized the opportunity presented by Gibbs's alterations to St. Bartholomew's Hospital. Since he had been born in the immediate neighbourhood, it seemed doubly fitting that he should offer to embellish, free of charge, the Hospital's main staircase. The subjects he chose were grandiloquent—the *Parable of the Good Samaritan* and the *Miracle at the Pool of Bethseda*.

Neither work was to fulfil his hopes. Right in his conviction that English painting needed a new impetus, he was totally wrong in his obstinate belief that he himself could provide that impetus by adventuring into the grand manner. Beneath the trappings of an alien style, his native energy appears to droop. The figures introduced are seven foot high—a point upon which, in his autobiography, he dwells with a certain satisfaction; but their size does not add to their splendour; and we have the impression throughout that we are examining small compositions laboriously enlarged to fit an extensive architectural frame. Nor in the process is the framework ennobled: Hogarth's wall-paintings remain pictures on the wall, which bear little real relationship to the space they are designed to cover.[1] The heroic personages are strangely lifeless; and Hogarth's vitality only revives when he is portraying the blind, the halt and the maimed; for there he can relax his attempt at sublimity and descend to safer and more familiar ground. " The historical paintings of this staircase (reads an inscription) were painted and given by Mr. *William Hogarth,* and the ornamental paintings at his expence, A.D. 1736." But the scaffolding before the *Good*

[1] Hogarth, of course, continued to paint on canvas. He did not venture into fresco.

Samaritan was not finally removed until July 1737; and it was then, according to the *Grub Street Journal*, " esteemed a very curious piece ". The applause of later critics was decidedly half-hearted, Horace Walpole, for instance, observing how " the burlesque turn of our artist's mind mixed itself with his most serious compositions "; and, in the engraved version of the *Pool of Bethseda*, they were amused to see that he had followed his usual practice by inserting a contemporary portrait. From " an old acquaintance of Mr. *Hogarth* ", Nichols learned that, among the other heads, there was a faithful likeness " of *Nell Robinson*, a celebrated courtezan, with whom, in early life, they had both been intimately acquainted ". Hogarth's own opinion was that the venture had failed. He had hoped that, " were there an inclination in England for encouraging historical pictures, such a first essay might prove the painting them more easily attainable than is generally imagined. But . . . religion, the great promoter of this style in other countries, rejected it in England." No bishop or patron of the Church came forward with a generous offer: no public body commissioned him to decorate a guildhall or a court of law. He therefore " dropped all expectations of advantage from that source " and, since he was " still ambitious of being singular ", and " unwilling to sink into a *portrait manufacturer* ", returned for the moment to the cultivation of his true gifts.

VIII

People and Places

WALTER BAGEHOT wrote of Dickens that he "described London like a special correspondent for posterity"; and the phrase might be applied to one aspect at least of Hogarth's many-sided lifework. He, too, was a born reporter, and in his reporting of current affairs had anticipated some of the modern journalist's functions; but his attitude towards the material he gathered was that of the creative artist, who confers on every detail he reproduces the quality of his own mind. His vast picture of the age he lived in is both a record and a re-creation—an imaginative re-working of the results of direct experience and a carefully naturalistic panorama of people encountered and places visited—where æsthetic fancy is combined with a high degree of objectivity. In the two *Progresses* his scope was wide: we meet prostitutes, rakes, gamblers, physicians, sportsmen, lunatics, and move from the City to Drury Lane, from a drawing-room near St. James's Palace to the chains and straw of Bedlam. During the next few years he was to enlarge this composition with many striking minor scenes. Their background is almost always London; and the metropolis itself, as in Dickens's novels, assumes the importance of a chief character. Often we can determine the precise locality, and sometimes distinguish the features of a building that has remained intact until the present day; and, even though the neighbourhood cannot be identified,

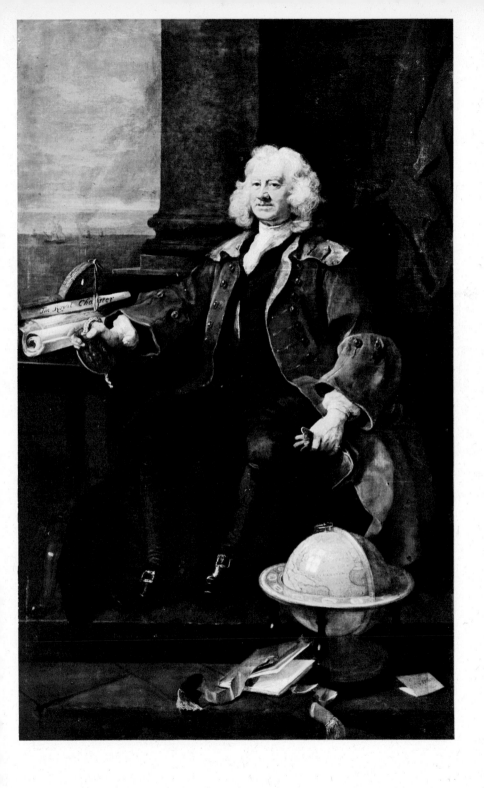

Captain Thomas Coram
By courtesy of the Governors of the Thomas Coram Foundation for Children, London

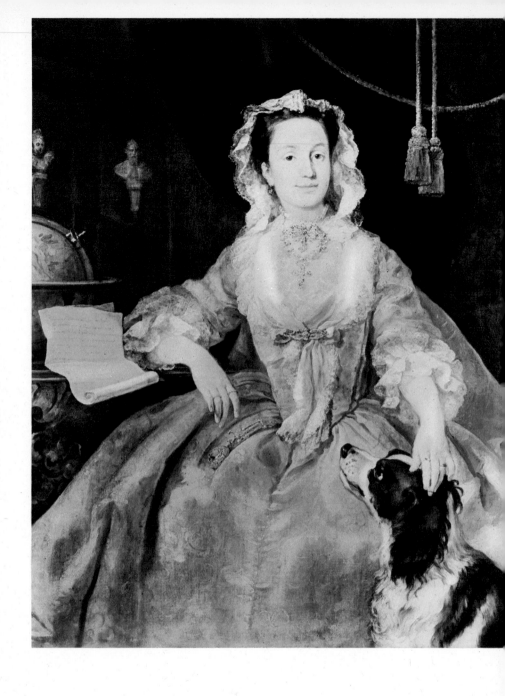

Miss Mary Edwards
By courtesy of the Frick Collection, New York

the light and atmosphere of London colour the entire stage. Around us, we are constantly aware of the familiar urban skyline—ridge upon ridge of jumbled tile and brick, pierced by lofty church-towers.

Between 1733 and 1744 a long series of admirable prints emerged from Hogarth's workshop. Two of then, *A Midnight Modern Conversation* and *The Laughing Audience*,[1] had been published in 1733 before the appearance of the *Rake's Progress*. Then, in 1735, came *Southwark Fair*,[2] followed, in 1736, by *A Consultation of Physicians, or The Company of Undertakers, The Sleeping Congregation* and *The Distressed Poet*: in 1737, by *Scholars at a Lecture*: in 1738, by *The Four Times of the Day* and *Strolling Actresses dressing in a Barn*: in 1741, by *The Enraged Musician*: by *The Charmers of the Age* in 1742, and *Characters and Caricaturas* in 1743. Prices varied from sixpence to three shillings. Disappointed in his brief bid for aristocratic or official patronage, which would have enabled him to spread his wings as an exponent of the grand manner, Hogarth had now resumed the rôle of popular pictorial dramatist. If his *Progresses* are full-length plays, the separate prints are interludes. Some— for example, *The Laughing Audience, A Consultation of Physicians* and *Characters and Caricaturas*—might perhaps be classed as pantomimes. Here, crammed on to single sheets, are harlequinade-collections of the kind of grotesque and satirical portrait-sketches he assembled in his note-books. Probably the best is the *Consultation of Physicians*, a rogues' gallery of celebrated London doctors, all nuzzling the knobs of their canes with true professional *sangfroid*, headed by Mrs. Sarah Mapp, a muscular giant of a woman, who at that period was doing a brisk trade as a bone-setter. Other prints are miniature dramas in themselves; and, while the

[1] Also issued as a subscription-ticket for the *Rake's Progress* and *Southwark Fair*.
[2] Dated 1733, but not issued until June 1735, when the new Act had come into force.

Times of the Day evidently form a group, and *The Distressed Poet* and *The Enraged Musician* must, of course, be considered side by side, *Strolling Actresses* and *Southwark Fair* both deal with the splendours and miseries of the eighteenth-century player's life—a subject that the artist had first studied during his boyhood in Bartholomew Close.

Each has an exuberance suited to the theme. Although it is odd and regrettable that, instead of portraying Bartholomew Fair, Hogarth should have crossed the Thames to record the Fair at Southwark,[1] he found the same mummers there presenting the same plays, the same celebrated clowns and acrobats, prize-fighters, conjurors and freak-showmen. All London fair-grounds must have been much alike—a temporary encampment of stalls and booths, overlooked by flimsy scaffoldings, whence the tragedians and comedians postured and ranted, beneath banners and painted sign-boards, to illustrate their comic or heroic repertoire. In Hogarth's plate, which shows the aerial evolutions of a rope-dancer and a " steeple flyer ", and includes advertisements of Elkanah Settle's burlesque version of the Sack of Troy, a farce entitled " The Stage Mutiny ", a tragedy, " The Fall of Bajazet ", Fawkes the Conjuror's exhibition of " Curious Indian Birds " and waxworks depicting " the whole Court of France", such a platform has succumbed to the weight of the players and precipitates them in a wild confusion of sprawling shapes down on to the heads of the mob below. Meanwhile a helmeted hero is arrested for debt, and a prosperous farmer has his pocket picked. But the focus of the design is the girl who beats a drum. The personification of freshness and juvenile grace, with her ruffled collar, her bare bosom, her wide sleeves and her feathered hat, she steps forward, regardless of the brutish

[1] The resort of " persons of all distinctions of both sexes ", Southwark Fair, like Bartholomew Fair, aroused the wrath of the London magistrates, who ordered its suppression in 1762.

admirers who follow her and gape at her, as if lost in some vision of her own, a nymph among satyrs, the spirit of youth and spontaneous gaiety at large in a discordant and ugly world. This "handsome drumeress" (who was also the subject of a delightful preparatory oil-sketch) Leslie cites as an example of Hogarth's knack of placing "great beauty and delicacy of feature" amid incongruous surroundings. The rhythmic measure with which she seems to advance, the poetic air with which she touches her drum, suggest Victorian descriptions of another lovely drumeress, the "Swedish nightingale" Jenny Lind. She is one of those apparitions which, suddenly glimpsed in the crowd, lend an edge of enjoyment to the dullest and most dispiriting day.

Beyond her is a view of the Surrey hills; and above the hills are rolling clouds. There was nothing earthbound about Hogarth's genius, although the material on which he began work was generally of the earthiest kind; for he had the gift of transfiguring his subjects with unexpected flashes of psychological or pictorial insight, these different methods of illumination being frequently combined in a single pen- or brush-stroke. Even *Southwark Fair*, thronged with figures and densely packed with humorous or satirical detail, is not the reflection of an actual scene, so much as the imaginative re-combination of many varying moments and moods. *Strolling Actresses* has a similar unity. This print—the picture itself has been destroyed—was Horace Walpole's favourite; and, nearly seventy years before the plate was engraved, Samuel Pepys, having visited the King's playhouse after dinner with a group of friends, and gratified his insatiable curiosity by peering about behind the stage, had committed his impressions to his diary in a passage that recalls the artist.[1]

[1] An interesting comparison may also be made between Hogarth's print, *The Cockpit* (see p. 254), and Pepys's description of his visit to a cockpit on December 21st, 1663.

They had inspected (he writes) " the inside of the stage and all the tiring rooms and machines; and, indeed, it was a sight worth seeing. But to see their clothes . . . and what a mixture of things there was; here a wooden leg, there a ruff, here a hobby horse, there a crown, would make a man split himself to see with laughing . . . But then again, to think how fine they show on the stage by candle-light, and how poor things they are to look now too near at hand, is not pleasant at all."

It was as " poor things "—figures of fun, yet deserving of human sympathy and not untouched by a fantastic beauty—that Hogarth saw his " Strolling Actresses ". The print had a topical application, since an act had recently been passed, aimed at the companies of strolling players, which prohibited the representation of plays outside the City and Liberties of Westminster. Hogarth's composition is a swirl of grotesque activity, designed on the serpentine principle that he was now developing, in which every group appears to form a separate vortex. One actress needs her stocking mended: another shows her naked thighs. The *jeune premier*, deprived of breeches, blubbers copiously as he accepts a glass of gin; Flora pomades her hair with a tallow candle; and two *figurantes* are clutching a tabby cat and drawing blood from their victim's tail, to add verisimilitude, no doubt, to some sanguinary death-scene. Beside a truckle-bed, a sinister little personage, arrayed as an eagle, stuffs a spoon into the mouth of a swaddled infant. Her nursery-table is a pasteboard crown; and near it stands a chamber-pot. Heaped about them, under the ragged thatch of the barn, we can examine the performers' theatrical properties—knobbed rollers to imitate a stormy sea, a chariot, a cloud-supported dragon, a garlanded doorway and a classical altar. Clothes-lines are looped from the rafters above: chickens, expelled from

their perches, roost upon the wave-machine. But the squalor that surrounds them has not submerged the company's spirits. They are full of the ebullient energy that goes with their calling, inspired by a sublime conviction that the next performance will certainly be their best; and that conviction alone lends their poverty a tinge of grandeur. Several faces are still vivid and young; and Leslie draws his readers' attention to the " exquisite prettiness " of Juno in the left-hand corner, who recites her part with uplifted eyes, while a friend or attendant repairs her laddered stocking.

With *Times of the Day* we return to London; and none of Hogarth's London impressions is more evocative of the spirit of time and place than the first of the series, which he entitled *Morning*. A wintry sky hangs over Covent Garden; according to the dial on the pediment of St. Paul's Church, it is nearly seven o'clock. There is a feeling of snow in the air; a thin crust of frozen snow has blanched the roofs and window-ledges; and icicles hang from the eaves of Tom King's lowly coffee-house. Market-women arrive with baskets and lanterns; children, burdened by satchels, stump miserably away to school; and an elderly maiden lady,[1] her chilly footboy trudging behind her, hurries towards Early Service. To enter the church, she must pass Tom King's, where, as we observe through the open door, a drunken brawl has suddenly exploded. A pair of young rakes, who have just emerged, fall upon two pretty girls; and the elderly *dévote* lifts her fan to her lips, watching their struggles with a mixture of overt prudery and repressed amusement. In the engraved version, following his customary method, Hogarth has reversed the design; so that Lord Archer's noble seventeenth-century

[1] Said to be a portrait of one of Hogarth's relations, who, having recognised the likeness, immediately cut the artist out of her will.

149

mansion, of which traces still exist, appears on the wrong, or left-hand, side, and Tom King's on the extreme right. To see *Morning* at its best, a student must consult the picture [1]—not only for the view of Covent Garden (which, despite many decades of re-building, bears a remarkable resemblance to the present market-place) but for the gaiety and subtlety of the painter's colour-scheme. The background is a pattern of wintry tones—a huddle of drab-hued passers-by: a leaden firmament weighing heavily upon the spectral pallor of snow-bound roofs. But the foreground is alive with colour and movement; although the air is sharp and the light is dim, the young men, hot from a night's dissipation, are full of zest and rowdy vigour, boldly towsling and bussing the girls, one of whom has a hat with a bright blue lining; while the scarlet ribbons of the church-goer's cap match the spurting scarlet flames of the market-women's bonfire. Her expression, incidentally, is far less disdainful in the canvas than in the engraved plate; and she, too, has come out in her gayest plumage. She carries a fashionable ermine muff, and wears a pale pink apron over a champagne-yellow dress, which has trimmings of a delicate sea-green.

Almost equally evocative is the effect of *Night*, where the mysterious glimmering grey of summer moonshine replaces the murk of iron-clad winter. It is as sultry as its companion is icy. The streets are stifling; sashes are thrown up; and a woman's arm empties a chamber-pot from the window of a darkened bedroom, sousing an intoxicated Masonic dignitary [2] who, still hung around with the emblems of his craft, is staggering home on a waiter's arm. A vehicle has been overturned—we notice that it is

[1] Now in the Bearsted Collection.

[2] Believed to represent a magistrate named Sir Thomas de Veil, notorious for the campaign he waged against London houses of assignation. *The Cardigan's Head* and the *Rummer Tavern* were well-known bagnios.

the " Salisbury Flying Coach "; and a barber-surgeon is
bleeding, and simultaneously shaving a patient, in whom
the hot weather and a too sanguine constitution have
induced the fear of apoplexy. Both the place and the time
have been fixed by the painter. We are in the narrowest
part of Charing Cross, approaching Charles I's equestrian
statue, which can be seen in the distance between the
pendant signs of the Cardigan's Head and the Rummer
Tavern. The fire in the gutter, which has upset the
Flying Coach, the oak-leaves wreathed round the barber's
pole and the candles stuck on the window-frames show that
this is May 29th, celebrated by Englishmen as " Restora-
tion Day "; for among Hogarth's contemporaries the
Jacobite opposition had not yet begun to lose its strength.
It was to survive the failure of the '45 rebellion and raise
its head again during the Oxfordshire Election, so fiercely
contested in 1754.

Beside the first and last of the series, Hogarth's *Noon* and
Evening seem comparatively prosaic works. *Evening* takes
us to the Sir Hugh Middleton, a suburban public house
near Sadler's Wells, whither a harassed citizen—a dyer by
trade—and his fat, sweating, bad-tempered wife have
brought their three children for a breath of country air.
The eighteenth-century equivalent of that familiar Bank
Holiday admonition—" *Enjoy* yourselves, can't you! "—
has evidently just been uttered. But one little girl has
fallen fast asleep; the little boy, dressed up like an adult
beau, indulges in a fit of tantrums, and is savagely repri-
manded by his shrewish sister. Their parents are foot-sore
and tired and cross; and the artist, with somewhat ponderous
humour, has arranged the horns of a grazing cow so that
they appear to sprout from the citizen's wig. This insular
episode is preceded by an impression of London's foreign
colony. Since the Revocation of the Edict of Nantes, it

had been steadily increasing; the exiled French Protestants had their own chapel in Hog Lane, close to St. Giles's Church; and *Noon* shows a procession of Huguenot worshippers filing through the chapel door, led by two fashionable middle-aged persons with a stout and equally fashionable child, both gesturing largely and chattering vivaciously, regardless of the filth of the street—a dead kitten has been tossed into the gutter—and the proletarian English crowd carrying dishes from a cook-shop. The weeping urchin, who has broken the plate he holds, is said to have been noticed by Hogarth while he was seated in a barber's chair: at which he rushed to the window, shaving-soap on his chin and a napkin still around his neck, and immediately jotted the incident down. A paper kite has been caught on the roof of the chapel—one of those details that he was apt to record without ulterior symbolic motive, but merely because, as he walked and observed, they had happened to attract his fancy.

Using only the material that Hogarth provides, it would be possible to build up an elaborately detailed and (according to the artist's contemporaries) neither embellished nor distorted picture of the eighteenth-century metropolis. Few districts remain undescribed—often we begin to imagine that we could find our way from street to street; and there is scarcely a category, or sub-category, of London's inhabitants that is not at some time illustrated. But every commentator has his limitations; even Hogarth's commentary does not exhaust the whole subject; and here the antiquary and literary historian supply many useful footnotes. They tell us, for instance, the size of the urban community from which Hogarth drew his characters. Just over 674,000 in 1700, the population of London in 1750 numbered some 676,250 souls. This rate of growth may seem strangely sluggish; and the probable explanation

must be dealt with on a later page. Still, more than half-a-million men and women peopled the great sprawl of buildings that ran, up and down hill, from the ancient commercial fastnesses of the City to the aristocratic squares of the West End, developed during the last half century as far as the verge of Hyde Park.[1] The urban landscape was rich but confused. Wren's magnificent plans for reconstruction after the Fire of 1666 having been dismissed as totally impracticable, London had soon reverted to its native formlessness—a " *Hotch-Potch* of half-moon and serpentine narrow Streets, close, dismal, long Lanes, stinking Allies, dark, gloomy Courts and suffocating Yards ", in which such beauties as it possessed were carefully concealed from the public view. A church would be thrust " into some Hole " (complained a journalist in 1748)[2] or masked by " some smoaky Shed . . . so as to cover it from Observation ". The streets harboured a medley of trades and classes. " A Personage of high Distinction " might be discovered living next door to a " Butcher with his stinking Shambles! A Tallow-Chandler shall front my Lord's nice *Venetian* Window; and two or three brawny naked Curriers in their Pits shall face a fine Lady in her back Closet, and disturb her spiritual Thoughts: At one End of the Street shall be a Chandler's Shop to debauch all the neighbouring Maids with Gin and gossipping Tales, and at the other End perhaps a Brasier, who shall thump out a noisy Disturbance, by a Ring of Hammerers, for a Quarter of a Mile round him." Virtue and vice were packed in cheek by jowl: " in the Vicinity of some good Bishop, some good *Mother* frequently hangs out her Flag. The Riotous, from their filthy Accommodations

[1] Berkeley Square was built about 1698: Grosvenor Square, of which Kent later designed the gardens, about 1695.
[2] *Old England*, July 2nd, 1748. Quoted by W. S. Lewis, *Three Tours through London*. Yale University Press, 1941.

of a *Spring Garden* Bagnio, shall echo their *Bacchanalian* Noise to the Devotions of the *opposite* Chapel . . . Thus we go on in *England*, and this owing wholly to private Interest and Caprice."

The same spirit of rampant individualism was to be remarked both in the condition of the London thorough-fares and in the behaviour of the London crowd. The passer-by was incessantly shouldered and jostled; and Gay's *Trivia* (of which the third edition appeared in 1730, two years before the author's death) contains a long list of the dangers a pedestrian runs and of the people and places he would do better to avoid. If he is wearing black, he may be smirched by the barber, the perfumer or the baker. If the colour of his coat is light and youthful, let him beware of "the little chimney-sweeper", the coal-man and the dustman, the chandler with a tallowy basket and the blood-bespattered butcher carrying a greasy tray. To them certainly he should give up the wall:

> *Let due civilities be strictly paid.*
> *The wall surrender to the hooded maid;*
> *Nor let thy sturdy elbow's hasty rage*
> *Jostle the feeble steps of trembling age:*
> *And when the porter bends beneath his load,*
> *And pants for breath; clear thou the crouded road . . .*
> *You'll sometimes meet a fop, of nicest tread,*
> *Whose mantling peruke veils his empty head,*
> *At ev'ry step he dreads the wall to lose,*
> *And risques, to save a coach, his red-heel'd shoes;*
> *Him, like the miller, pass with caution by,*
> *Lest from his shoulder clouds of powder fly.*
> *But when the bully, with assuming pace,*
> *Cocks his broad hat, edg'd round with tarnish'd lace,*

154

Yield not the way, defy his strutting pride,
And thrust him to the muddy kennel's side;
He never turns again, nor dares oppose,
But mutters coward curses as he goes.

It must be remembered, however, that, although her
by-ways were dark and noisome, and even her main streets
dirty and tumultous, London, in the opinion of English
travellers, compared very favourably with her greatest rival,
Paris, whose labyrinthine squalor still suggested the Middle
Ages. For much of London was relatively modern—re-
built after the Fire, in vistas of dignified flat-fronted brick
houses, overlooked by Wren's steeples, or thrown up on
new foundations across the fields of Mayfair. And then,
Londoners had always the Thames—a high-road that was
never uncomfortably crowded and, despite the outpourings
of innumerable sewers, still sufficiently unpolluted to pro-
vide Billingsgate with excellent fish.[1] Below London
Bridge stood a thick-set forest of shipping; above the
bridge, its surface was furrowed by every sort of small craft
—from the skiffs of professional watermen, who waited
for hire at the riverside stairs, to the long painted and
gilded barges, in which the City companies and members
of the royal family made their ceremonious progresses to
and fro, often with musicians on board or following them
in another vessel—violins and hautboys, accompanied by
drums and trumpets.

Until the completion of Westminster Bridge in 1750,
London Bridge was the only link between the north and the
south bank. Hogarth painted it once—framed by an old-
fashioned window; and in his day the houses that covered
it were already toppling into a crazy decline. The bridge

[1] Incidentally, the water-works at London Bridge were one of London's chief
sources of drinking-water. In the mid-eighteenth century, salmon still came up
the Thames to breed.

155

was finally stripped of its antique encumbrances in the year
1758. Meanwhile, the roar of the cataracts that swept
through the arches beneath was matched by the thunder
of the traffic above, as a torrent of coaches and waggons
and intrepid pedestrians threaded the long enclosed
passage-way, lined with shops and stalls, but " narrow,
darksome, and dangerous ", that led from a medieval
gateway at the Southwark end, under the Elizabethan pile
named Nonsuch House,[1] towards the cobbled slope of Fish
Hill Street. " Frequent arches of strong timber (writes
Thomas Pennant[2]) crossed the street from the tops of
houses, to keep them together, and from falling into the
river. Nothing but use could preserve the rest of the
inmates, who soon grew deaf to the falling waters, the
clamours of watermen, or the frequent shrieks of drowning
wretches." Here and there the ranks of houses divided;
and sight-seers could look down on to the whirlpools of
the stream below, watch hardy watermen shooting the
rapids and fishermen angling from the piers of the bridge.
A remarkable water-front curved away eastwards and west-
wards. Both Canaletto and Samuel Scott portrayed the
banks of the Thames about 1750; and, in their pictures
and, contemporary engravings, we can re-trace, almost roof
by roof, the riverside prospect slowly, smoothly unrolled
before a mid-eigthteenth-century traveller, who " took
oars " at London Bridge and ordered the waterman whom
he had engaged to set him down at Whitehall Stairs.

First he skirted a dense jungle of commercial buildings
—the Steelyard, which contained the warehouses of the
German merchants of the Hanseatic League: the wharves
of Queenhithe and Puddle Dock: the Dung Wharf, from

[1] One of the chief curiosities of London Bridge, Nonsuch House was entirely
wood-built, constructed with pegs instead of nails. It had been imported in
sections from Holland.
[2] *London*, 1790. Quoted by Hugh Phillips, *The Thames about 1750*, Collins,
1951, an invaluable guide to mid-eighteenth-century London.

which horse-dung, collected in the London streets, was
ferried upstream to the market-gardens of Pimlico: wharves
that were heaped with mountains of coal or stacked with
piles of new-sawn timber. The prospect grew more urbane
when he passed the entrance of the Fleet Canal. The
Fleet-River itself was black and stinking, full of kitchen-
refuse and dead dogs;[1] but the quays that bordered it and
the high-arched bridge that spanned it—at least as reflected
in the imagination of Samuel Scott—had an elegant
Venetian air. Next came the district named " Alsatia ",
a populous and ill-famed slum, the haunt of pickpockets
and footpads, separating the Thames from Fleet Street,
and adjoining the gardens of the Temple, which were
succeeded, in their turn, by a range of once fashionable
but now somewhat run-down houses, built over the former
pleasure-grounds of the Earls of Essex and Arundel. But
Somerset House, the refuge of court-pensioners, retained
its ancient dignity, with fountains, gravelled walks and
long clipped avenues; though moored opposite was
usually to be found a notorious pleasure-boat, known as
" The Folly ", the resort of " innumerable harlots ", where
wine and beer were sold in curtained booths. Just beyond
Somerset House appeared the Palace of the Savoy, a
romantic medieval ruin lately converted into a military
gaol: York Water-Gate, said to have been designed by
Inigo Jones, at the bottom of Buckingham Street: and the
impressive obelisk-shaft of the adjacent water-works. The
towers of Westminster Abbey were now in sight; and
above Westminster one reached the open fields.

Thanks to a drawing by Paul Sandby and celebrated
London landscapes by Canaletto, we may continue to follow

" . . . where Fleet-ditch with disemboguing streams
Rolls the large tribute of dead dogs to Thames,
The king of dykes! than whom no sluice of mud
With deeper sable blots the silver flood."
Dunciad, Book II

157

the traveller who disembarked at Whitehall Stairs. Sandby shows us the tumbledown entrance-court of what had once been the royal palace, a tree-shaded enclosure of two-storey buildings under the lee of Inigo Jones's lofty classical Banqueting House, through which he must pass going to Charing Cross or Westminster: Canaletto, the splendid prospect that awaited him when he emerged from the narrow arch at the further end. Turning right, he would look up to Charing Cross: turning left, he would see close at hand the sumptuous brick-and-stone structure of the sixteenth-century Treasury Gate, which projected at right angles half across the carriage-way. Over against the Treasury Gate, between the Banqueting House and Westminster Hall, were the princely London residences of the Duke of Montagu and the Duke of Richmond, set back behind the remains of the Privy Garden, still as extensive as a miniature park. From an upper window in Richmond House, where the artist had erected his easel, we can distinguish the small figure of the Duke himself paying a visit to his stable-yard and bright-hued passers-by, like summer insects, scattered on the paths below. The scene is leisurely and luminous, and suggests the suburbs of a country town rather than the outskirts of a great commercial city. Despite the noise and congestion of the central districts, the London that Hogarth knew had not completely lost touch with the woods and fields surrounding it; and he and his contemporaries enjoyed some of the advantages to-day reserved for countrymen.

Yet, although Canaletto presents an unblemished sky—he was apt to confer a sparkling Italian charm on every impression that he fixed in paint—a dark haze must actually have rimmed the horizon, the pall of sea-coal smoke, discharged from innumerable factories and shops and an estimated total of nearly a hundred thousand dwelling-

houses.[1] The monstrous metropolis described by Dickens
still lay many years ahead; but its development had already
begun; and the human product of industrial civilisation
—stunted and ill-favoured, but active, wiry and resourceful
—was gradually appearing as a separate type. Urban
existence rarely encourages grace, whether it be grace of
body or grace of mind; and in Hogarth's vision of the
London world physical beauty and moral dignity seldom
play a large part. The modern critic sometimes complains
of their absence. Hogarth, one has heard it said, created
a nightmare universe, only peopled by images of folly,
guilt and suffering; his imagination, intolerably dark and
distorted, reflects the brutal outlook of a callous and
corrupt age. In fact, the cruelty of Hogarth's satire has
often been exaggerated. He depicted the world he knew;
and his world, despite the raw vitality with which it
abounded, was neither harmonious nor morally appealing.
Hogarth recorded it without fear or favour; the indignation
he displays is that of the thoroughly practical man, who
observes with disgust the catastrophic effects of human vice
and vanity; yet, being untroubled by a sense of sin, he had
little of the *saeva indignatio*—the deep horror of his fellow
human beings—that tormented and unbalanced his admirer
Jonathan Swift. While he deplored its ugly manifestations,
he never learned to hate life; and, always far stronger than
the impulse to condemn, was his constant desire to absorb
and transform, to seize the rough material that experience
offered and reproduce it, on the plane of art, in a more
durable and more compact shape.

Nothing was alien to this passionate observer—old
clothes, crumbling walls, haggard faces with gap-toothed
grins, fine ruffles and delicate draperies, smoky or sunny
skies spread above the city roofs, the glitter of steel, the

[1] Maitland's *Survey of London*, 1756, quoted by Hugh Phillips, *op. cit.*

gleam of silver or the dull shine of a pewter dish. But, although his appetite for life was omnivorous—and there are occasions when he seems to have treated Man and his environment as part of the same engrossing spectacle—it had not blunted his sensitiveness to the subtler qualities of the human spirit. The charm of goodness does not escape him; nor does the dignity of an upright character. Every portrait that deserves a second glance reflects the artist's critical view of the man or woman represented; and Hogarth's portraits—a branch of his art in which he had recently been making rapid strides—express his opinions with a candour that is sometimes almost comically vehement. Turn, for example, to *Captain Thomas Coram*, painted in 1740, and *Dr. Benjamin Hoadly, Bishop of Winchester*,[1] about the year 1742. The first is the portrait of a hero, the second an essay in affectionate irony. Among his less bohemian friends, Hogarth was acquainted with the Bishop's sons—Benjamin, a doctor of medicine and the author of a brisk comedy entitled *The Suspicious Husband*, and John, a literary clergyman, who had written some didactic verses to accompany the *Rake's Progress*. They had introduced him to their genial parent; and Hogarth often visited him at his London house in the riverside village of Chelsea and at his establishment in Hampshire. All the Hoadlys had a passion for amateur theatricals. Hogarth aided them by designing the scenery; and, in a farce derived from *Julius Cæsar*, he took the part of Cæsar's ghost, but, since his verbal memory was extremely bad, found it difficult to deliver his couple of lines until they had been inscribed upon a paper lantern. Having portrayed both Benjamin and John—a plump, eupeptic-looking pair, sleek with bonhomie and good-living—he presently set to work on the affable features of the Bishop himself. Hoadly's

[1] Benjamin Hoadly (1676–1761). Bishop of Bangor and Winchester.

left hand appears to be raising in blessing. Or is he simply marking the cadence of one of those long, long periods for which his style was celebrated? He had won renown as a master of controversy; but his efforts were invariably directed towards smoothing and simplifying the believer's path. He had freed the religious life of half its difficulties by blandly dispelling its dogmatic terrors.

Earlier theologians had increased the Christian's load: thanks to the gentle directions of the Bishop of Winchester, religion could now be regarded as a matter of enlightened common sense. The Lord's Supper? " A mere commemorative rite ", to which were attached no especial ghostly benefits. As for the problem of how one should save one's soul—the Christian's " title to God's favour cannot depend upon his actual being or continuing in any particular method, but upon his real sincerity in the conduct of his conscience and of his own actions under it ". At the same time, Hoadly was a zealous Erastian, who preached the subordination of Church to State, and his shrewdness and urbanity made him a successful courtier. The Queen, at least, delighted in his company, although the King, who detested scholars as heartily as he detested painters and poets, often inveighed furiously against the preference she showed him, complaining of the Bishop's rheumatic limp, his " silly laugh " and his " nasty stinking breath ". But, in the affairs of the Church, if in no other department of public business, he allowed the Queen considerable latitude; and Hoadly had moved on triumphantly from benefice to benefice, never visiting Bangor when he held that see, and, while he was Bishop of Winchester, generally preferring to reside near London. Withal he was a kindly and affectionate character, whom Hogarth evidently liked and esteemed; and the portrait he produced is at once a tribute to friendship and an ironic exposure of his subject's short-

comings. Thus the baroque intricacy of robes and ribbons, of the Bishop's expansive lawn sleeves, the heavy order around his neck and the rich tassels that hang from the arm of his chair, emphasise the plumpness and babyish pinkness of the pursy and self-satisfied face. No doubt Hoadly was a good friend; clearly he was an accomplished man of the world. The portrait, however, supplies a forcible hint that he need not be highly regarded as a Man of God.

Captain Thomas Coram, on the other hand, is a work in the heroic style. This was the portrait, Hogarth afterwards declared, " which I painted with most pleasure, and in which I particularly wished to excel . . ." The subject attracted him for several reasons—but chiefly, no doubt, because the old sea-captain, who, labouring with such methodical diligence, had done so much to lessen the sum of human guilt and misery, epitomised his own conception of the truly just and upright spirit. Like himself, Thomas Coram was an eminently practical person. Born at Lyme Regis in 1667 or 1668, he sprang from a seafaring stock and, while still young, had crossed the Atlantic and settled down in Taunton, Massachusetts, and latterly in Boston. A successful shipwright, he had taken to the sea and sailed as captain of a merchantman on various foreign voyages. In 1719 he had returned to London, and set up as a merchant at Rotherhithe; but American affairs continued to hold his interest; Coram, said the Prime Minister's brother, the elder Horatio Walpole, was " the honestest, most disinterested, & most knowing person about the plantations, I ever talked with "; and, when Oglethorpe[1] founded his new colony, the Captain was naturally appointed one of the Trustees for Georgia. Next we hear of his scheme for settling Nova Scotia with unem-

[1] See p. 74.

ployed English artisans. His business constantly took him backwards and forwards between Rotherhithe and the City of London; it was his habit to travel on foot, usually late at night or during the early hours; and again and again, as he walked the streets, he would find infant children, abandoned or dead, casually dropped under the shadow of a wall.

The same sights had already revolted Addison,[1] who protested in 1713 that, unlike Paris, Rome, Lisbon and Madrid, London made no charitable provision for this pathetic human wreckage; but it was Coram, the merchant-philanthropist, whose moral revulsion took a practical shape. The campaign he initiated was waged for seventeen years, until finally in 1737, with the support of an influential body of noblemen and gentlemen, headed by Lord Derby, and twenty-one ladies " of Quality and Distinction ", he could present a petition to " the King's most Excellent Majesty in Council ". Having recalled the " frequent Murders on poor Miserable Infant Children at their Birth " and the " Inhumane Custom of exposing New-born Children to Perish in the Streets or the putting out of such unhappy Foundlings to wicked and barbarous Nurses ", he proposed the erection of " an Hospital after the example of France, Holland and other Christian Countrys . . . for the Reception, Maintenance and proper Education of such abandoned helpless Infants . . ." There followed two years of debate and delay. But in October 1739 the new Foundling Hospital—or, to give it its proper title, the Hospital for the Maintenance and Education of Exposed and Deserted Young Children—was at length granted a Royal Charter of Incorporation. Coram's battle had not been easily won. Thus, when he attempted to deliver a petition to the Princess Amelia at St. James's Palace, " the Lady Arabella

[1] *The Guardian*, No. 105.

Finch (Coram noted on the margin), who was the Lady in waiting, gave me very rough Words, and bid me begone with my Petition, which I did . . ." Scurrilous journalists had attacked the institution of the Hospital as a positive encouragement to loose living—as *Joyful News to Batchelors and Maids*, a measure evidently calculated—

> *To encourage the progress of vulgar Amours,*
> *The breeding of rogues & th' encreasing of Whores.*[1]

But Coram had weathered these journalistic storms, as he survived the rough words of the outrageous Lady Arabella.

Men of good-will flocked to his side, foremost among them William Hogarth, who is listed in the Hospital's Charter as a " Governor and Guardian ". The first testimony of the artist's approval was the little emblematic plate he engraved to stand at the head of a power of attorney, which authorised the hospital authorities to seek contributions from the benevolent public. Then, in May 1740, at the Annual Court, " Mr. Folkes (we learn) acquainted the Governors, that Mr. Hogarth had presented a whole length picture of Mr. Coram, for this Corporation to keep in memory of the said Mr. Coram's having solicited, and obtained His Majesty's Royal Charter for this Charity." [2] Hogarth's portrait was not only a gesture of regard: it was also the means of satisfying one of his deepest private aspirations. He had always longed to succeed " in what puffers in books call *the great style of History painting* "; his decorations at St. Bartholomew's Hospital had neither stirred the artistic conscience of his fellow countrymen nor —presumably even in his own opinion—quite reached the level of sublimity that the artist had originally set himself; here was an opportunity of applying the grand style to a

[1] Quoted by H. F. B. Compston in *Thomas Coram*. S.P.C.K., 1918.
[2] See *The History & Design of the Foundling Hospital* by John Brownlow. Warr, 1858.

subject derived from the everyday world. The picture that resulted is planned on heroic lines—a vision of the plain man as hero, whose grandeur is rooted in his very ordinariness. This was a hero after the painter's heart; and to the lineaments of the robust old captain, seated upright in his leather chair, whence he can overlook a distant prospect of the waves, Hogarth gives an unforgettable expression of solid four-square dignity. Everything about him is sober and modest—the roomy old-fashioned coat of some dull rust-coloured material which he wears above a black suit, his massive gold-buckled shoes and his narrow linen wristbands. At his feet is a terrestial globe, turned to illustrate " The Western or Atlantick Ocean ". The parchment scroll of the Charter is heaped upon the table beside him and in his right hand he is holding its seal, while the other, with its small gold ring, is loosely grasping a pair of gloves. That hand—the veined, thick-knuckled hand of energetic old age—is painted with a firmness and delicacy that makes it as characteristic as the sitter's face. Just as he refused ruffles at the wrists of his shirt, Captain Coram had no use for the decorative absurdity of a modern periwig. His long silvery hair, through which the scalp shows, curls freely down on to his broad shoulders, framing the ruddy coarse-grained features of an adventurer accustomed to sun and wind. The eyes are shrewd, the nose and the prominent chin conspicuously determined and bluff. But all these details have been combined with extraordinary art into an imaginative impression of personal and moral greatness. The magnitude of the painter's design is in proportion to his strength of feeling.

IX

Marriage-à-la-Mode

HOGARTH WAS not yet concerned with man as a political animal; but it is odd how few references we can detect, either in his pictures or in his engraved series, to the main dramas of public life between 1733 and 1745. We find no mention, for instance, of the furious Excise Riots—an outburst of popular rage, provoked by Sir Robert Walpole's very moderate and sensible proposal that a system of inland duties on wine and tobacco should replace the expensive and inefficient maritime customs, which in the early month of 1733 had nearly wrecked his government. More surprising, we receive no hint of the equally violent disorders that occurred in 1736 when, for the first time, a serious effort was made to check the evils of the gin traffic. From an average of about half a million gallons fifty years earlier, the annual production of British distilled spirits had risen to almost five and a half millions.[1] But the passing of the Gin Act infuriated the London mob; and roars of " No Gin, No King! " followed the Queen (then Regent, during the King's absence in Hanover) as she drove from Kensington to St. James's Palace. Nor did Hogarth commemorate the Queen's death. " Curious in everything ", a person of keen natural intelligence, whose amusements ranged from theological controversy to building, garden-design and the collection of ancient manuscripts, Caroline

[1] See G. M. Trevelyan: *History of England.* Longmans, 1926.

166

had shared none of her husband's tastes—except, of course, his taste for power—but had loved him devotedly, served him faithfully and continued to govern him by the simple expedient of allowing him to believe that she obeyed his every whim. In 1737 her strength gave way and, watched over by the King and Lord Hervey—the former blustering and scolding amid his tears, the latter, beneath his mask of fashionable indifference, suffering agonies of real grief— Caroline had expired on November 20th, pagan and philosophic even in her last moments.

The loss of so powerful an ally alarmed her friend, the Prime Minister, who soon discovered, nevertheless, that he could manage the King without the Queen's help. But the attacks of the Opposition had begun at length to wear him down; the City, jealous of its colonial interests, was pressing for a war with Spain; Walpole was eventually obliged to submit; and the beneficent *Pax Walpoliana*, which he had championed so long and so doggedly, came to a disastrous end in 1739. Then, in 1742, after a fierce parliamentary struggle, during which he displayed all his usual craft and courage, Walpole was himself defeated and retired regretfully from the political ring. That Hogarth should have disregarded such major public events is perhaps not difficult to understand. But, since he was fascinated by the changing spectacle of everyday existence, why did he fail to record the miraculous transformation-scene imposed on London by the Great Frost? Throughout the exceptionally hard winter of 1739 and 1740, the whole Thames from bank to bank was locked in a rugged sheet of ice; tradesmen and inn-keepers set up their booths across this polar landscape; and coster-mongers, like the unfortunate apple-woman described in *Trivia*,[1] trundled their

1 " *Doll* ev'ry day had walk'd these treach'rous roads;
Her neck grew warpt beneath autumnal loads

wheelbarrows or hauled their baskets among its glassy hills and valleys.

Beside these omissions in Hogarth's picture of his age, we must set the impressive catalogue of his actually completed works. To the years that elapsed between the production of the *Rake's Progress* and the appearance of *Marriage-à-la-Mode* can be attributed the majority of his finest portraits, more than forty of them altogether, including *Bishop Hoadly* and *Captain Coram*, though in some instances exact dating seems a little difficult. Among the women he portrayed was a Miss Mary Edwards or Edwardes [1] of Kensington, also depicted in the conversation-piece entitled *The Edwards Family*, a heiress of large fortune and independent views, said to have incurred much contemporary ridicule by the strange and unfashionable clothes she wore. Hogarth's picture shows a woman of a certain age, with an unusually abundant lace cap, four rings, two diamond crosses and a pearl necklet. Her wide mouth gives the not unattractive face a whimsical and generous look. But, like other rich eccentrics, she was deeply offended by any touch of hostile criticism; and she conceived the plan of commissioning Hogarth, at a fee of sixty guineas, to paint a canvas in which the fashionable censors who presumed to condemn her wardrobe should themselves be satirised. The result was *Taste in High Life*—a delightfully extravagant improvisation on the reigning follies of the year 1742.

Of various fruit; she now a basket bore.
That head, alas! shall basket bear no more . . .
Ah *Doll!* all mortals must resign their breath,
And industry itself submit to death!
The cracking crystal yields, she sinks, she dyes,
Her head, chopt off, from her lost shoulders flies,
Pippins she cryed, but death her voice confounds,
And pip-pip pip along the ice resounds."

Gay was, of course, referring to the Frost Fair of 1715–1716.
[1] This portrait is now in the Frick Collection, New York.

As in many of his most accomplished satires, Hogarth invests the absurdities he set out to castigate with a colouring of poetic fantasy. The three personages presented recall the actors and actresses of an eighteenth-century light opera —the wizened *beau* and his elderly friend rapturously examining a tiny Oriental tea-cup, their lovely companion stroking the chin of a turbaned negro page-boy. Not the least violent of Hogarth's æsthetic prejudices was directed against the prevailing craze for Chinese and Japanese objects of art [1]—tea-services and vases and jars, and the monstrous array of " pagods ", " squabs " and dragons, imported from the factories of Canton and Yedo to crowd English shelves and chimney-pieces. During the seventeen-forties as during the eighteen-nineties, a nice taste in " blue-and-white " was one of the chief distinctions of a fashionable æsthete, and went with an appetite for French cooking and an interest in French modes. The ape on the carpet is studying a French bill of fare, and wears the bag-wig of a foreign dandy. As to the lady who holds the tea-cup, she illustrates the tendency of current fashions to give the feminine figure a pyramidal shape, as the dimensions of the hoop-skirt, supported by concentric hoops of whale-bone, grew more and more preposterous. In her fellow enthusiast—said to be a likeness of an aged nobleman named Lord Portmore—who carries a huge muff and dangles a cane from his fragile wrist, we see the extraordinary development of the seventeenth-century periwig which, having lost the full-bottomed shape that had brought it down on to the wearer's shoulders, now extended far behind him, frequently reaching the small of his back, sometimes in a wild profusion of curls,[2] sometimes braided

[1] " How absolutely void " of elegance (he wrote) " are the pagods of China, and what a mean taste runs through most of their attempts in painting and sculpture, notwithstanding they finish with such excessive neatness . . ." *The Analysis of Beauty:* Preface.

[2] See **Hogarth's** *The five orders of Perriwigs,* 1761.

together—the style Lord Portmore has adopted—to form a tapering whip-lash. The third member of the assembly is believed to be a portrait of Kitty Fisher, the fashionable courtesan, whom Sir Joshua Reynolds was to paint, and whose eyes Mrs. Thrale remembered as the bluest she had ever seen—an intense celestial azure like the colour of a blue riband.

From this extravaganza on the theme of fashion, it is but a short step to *Marriage-à-la-Mode*. Possibly Miss Edwards's picture provoked a train of ideas that crystallised in the new series; for that, too, was to deal with the effects of Fashion—but with Fashion regarded as a destructive goddess, who accomplishes the slow ruin of her devoted worshippers. At the beginning of April 1743, an advertisement had appeared in the *London Daily Post*, announcing that " MR HOGARTH intends to publish by Subscription, SIX PRINTS from Copper-Plates, engrav'd by the best Masters in Paris, after his own Paintings; representing a Variety of *Modern Occurrences* in *High-Life*, and called MARRIAGE-À-LA-MODE ". " The Heads (added a subsequent notice) for the better Preservation of the Characters and Expressions " were " to be done by the Author ". The engraved sets, however, were not finally published until May 1745, the work of engraving having been undertaken by Scotin, Baron and Ravenet;[1] and meanwhile the painter had decided that it was time to clear his studio. Always suspicious of intermediaries, he determined to organise a public sale, for which he drew up regulations with his customary thoroughness. First, prospective purchasers must register their names in his book. Then, " on the last day of this instant February "—the

[1] Louis Gérard Scotin (1690–c.1755), Simon François Ravenet (1706–1774), Bernard Baron (c.1700–1776). All three were Parisians, who spent much of their working-life in London. Scotin also worked for Hayman; while Ravenet was employed at the Battersea Enamel Works.

year was 1745—" a Clock (striking every five Minutes)"
would be placed in the sale-room, " and so soon as it
shall strike five Minutes after Twelve, the first Picture
mention'd in the Sale-book will be deem'd as sold; the
second Picture when the Clock hath struck the next five
Minutes, and so on successively till the whole are sold."
No one was to " advance less than gold at each
Bidding ". Admission to the sale was by ticket only; and
the ticket was embellished with a spirited little satirical
design, *The Battle of the Pictures*, in which Hogarth's
canvases are shown waging a Homeric struggle against the
dusky legions of decadent Italian art. This auction realised
the sum of four hundred and twenty-seven pounds seven
shillings, the thirty-eight guineas paid for *Night* being the
largest sum fetched by any single picture.[1] Horace
Walpole, a brisk young man of the world, was present in
the sale-room, among a throng of other " noble and great
personages "; and many years later he described to his
correspondent, Lady Ossory, how he had watched a " poor
old cripple ", desperately bidding for the *Rake's Progress*,
repeating " ' I *will* buy my own progress ', though he
looked as if he had no more title to it than I have . . ."

Now the curtain could go up on *Marriage-à-la-Mode*, the
best painted and most imaginative of all Hogarth's moral
dramas. If *A Harlot's Progress* and *A Rake's Progress* bear
some resemblance to morality plays—enlivened, of course,
by fascinating modern details—*Marriage-à-la-Mode* has
many of the qualifications of true poetic tragedy. Its pro-
tagonists are not merely the victims of a well-established
copybook code: we watch them growing, changing,
gradually deteriorating, brought low by passions and weak-
nesses inherent in their separate natures. Two characters

[1] The pictures of the *Harlot's Progress* went for fourteen guineas each: those of
the *Rake's Progress* for twenty-two guineas each. *Strolling Actresses* was knocked
down for twenty-six guineas.

so ill-equipped and ill-matched as the unhappy Earl and Countess must eventually come into disastrous collision, and the origins of the inevitable clash lie both in themselves as they naturally are and in what society makes them be. Society is at work when the curtain rises; for this is the Betrothal Scene. A marriage has been arranged, and will shortly take place, between the daughter of a rich City merchant and the heir to an ancient but impoverished earldom. Their fathers compete in arrogance; and, while the old Earl, with crutch and gout-stool, expatiates on his pedigree, the square-toed merchant, resolutely unimpressed though somewhat hampered by his unaccustomed sword, assumes his spectacles to scrutinise the financial provisions of the marriage settlement. The future bridegroom ogles his reflection in the glass; and the girl, who has recently been crying, fiddles with the engagement ring which she has threaded on her handkerchief, as she listens to the murmured advice of a sleek young lawyer, Counsellor Silvertongue. Evidently they have an understanding: perhaps they are already lovers. The old Earl is a man of taste; and his unfinished Palladian residence—designed for him, no doubt, by William Kent, or even by Lord Burlington—can be distinguished through the open window.

The marriage is solemnised, and we discover the pair at breakfast. A healthy and sensuous girl turned loose among all the pleasures of the fashionable end of London, the future Countess is learning to enjoy herself; and her party, with music and cards, has lasted until the break of day. How voluptuously she stretches and yawns, casting a sidelong glance, sleepy but sharp, at her exhausted husband, who has just staggered in after a party of his own, probably at Tom King's or the Rose Tavern! A woman's cap is stuffed into his pocket; and his wife's little " shock dog " sniffs at it inquisitively. Hogarth makes an acute distinc-

tion between the characters of husband and wife; for whereas the wife, though capricious and greedy and idle, has a middle-class robustness inherited from her merchant forebears and enjoys every crowded moment of the fashionable life she leads, her husband is perpetually bored and prematurely disillusioned. The young woman stretches deliciously: the young man lolls despondently. The droop of his head, the sprawl of the long silk-stockinged legs thrust out straight in front of him, as if every joint ached and every fibre and muscle sagged, combine to produce an impression of overwhelming lassitude; while the pallor of his skin (Hazlitt observed) is set off by the "yellow whitish colour of the marble chimney-piece". Since neither of them is in the mood for business, the old Dissenting steward, who carries a sheaf of unpaid bills, has been told to come back another day. Beyond the blue marble pillars that frame the further room, we catch sight of a tired footman. The walls are hung with large Italian pictures, one of which has so indelicate a subject that it is protected by a heavy curtain; but the folds have been pulled aside to reveal a naked foot.

The exact significance of the next episode has puzzled many commentators: a contemporary critic begging leave to doubt whether Hogarth himself really understood the scene, while a Victorian writer nervously suggests that the "subject is not one upon which detailed discussion is expedient". But its general purport is clear enough. The young nobleman, who has contracted a venereal disease, visits the establishment of a quack doctor—probably Dr. Misaubin (already represented in the *Harlot's Progress*) of 96 St. Martin's Lane. Flourishing his stick, half jocular, half blustering, he holds out a tell-tale box of pills; the practitioner snarls defiantly back at him, and a beribboned procuress, who may be the doctor's wife,

173

exasperated by this attack on her professional reputation, threatens to take violent measures. Her rage is directed at the nobleman's favourite—" *une petite fille* (remarks Rouquet) *du commerce de laquelle il ne s'est pas bien trouvé* ". Presumably he has lost his appetite for normal adult pleasures; and his new mistress, who stands by mum but guiltily snuffling, although dressed in adult finery is a child of twelve or thirteen. There is a curious fascination (as Hazlitt noted) about her face and attitude—the " vacant stillness " and " doll-like mechanism of the whole figure, which seems to have no other feeling but a sickly sense of pain ". The quack-doctor is also an alchemist; and from the background looms the grotesque apparatus of his occult studies—a skeleton and a mummy, presses and retorts, stuffed reptiles and a narwhal's horn.

Hogarth contrasted scenes as carefully and deliberately as he contrasted characters; and the sombre background of the doctor's consulting room accentuates the gaiety and elegance of the Countess's bedroom. A coronet surmounts her looking-glass; for the old Earl has at length expired, and she can now plunge more and more deeply into the absorbing pleasures of high life. Although she has recently given birth to a child, whose coral comforter hangs on the back of her chair, at the moment it is safe in the nursery and, while a Swiss barber prepares to dress her curls, she listens to the easy talk of dear seductive Silvertongue as, with Crebillon's novel beside him, he reclines comfortably on a brocaded sofa. He is proposing that they should attend a masquerade . . . Again we return to questions of taste. The walls are decorated with large Italian canvases—among others a copy of Correggio's *Jupiter and Io*; a basket, loaded with exotic objects of *virtu*, has just been carried in from the sale-room; and two foreign performers—a German flautist named Weidman and the well-known

Italian singer, Giovanni Carestini—arouse the ecstatic admiration of the red-haired lady in the straw hat, who billows towards them, almost swooning with delight, like some huge dependent bell-flower.

To each his separate self-centred world. The porcine singer, every finger of his plump right hand exhibiting a jewelled ring, is so lost in the beauties of his own art that he pays little attention to the behaviour of his audience— even to his red-haired admirer, recognised at the time as the portrait of a Mrs. Fox Lane, afterwards Lady Bingley,[1] whose fat husband, clutching his whip, has long ago begun to drowse. Between the sleeping squire and the warbling singer, a lean dandy, his hair still in curl-papers, broods contentedly over a cup of chocolate. The barber, too, inhabits a world of his own, testing his curling-tongs with a scrap of paper, yet lending an inquisitive ear to the talk of Counsellor Silvertongue. Hogarth displays his usual regard for detail—the sly, shifty, preoccupied barber is a representative of humanity's idiot fringe, which he had studied with close attention and always loved to represent: Mrs. Fox Lane has the dead-white complexion and nearly invisible eyebrows that often accompany flame-red hair. Yet, thanks to the rhythmic line that flows through the groups of figures, this profusion of detail does not in any way detract from the work's underlying unity. The frieze of courtiers and sycophants, stretched out across the stage, forms a long continuous arabesque.

Silvertongue has suggested a visit to the masquerade. He next induces the Countess to spend the night with him at a Covent Garden bagnio, one of those *louche* establishments, medicinal bath-houses and convenient places of assignation, which had flourished in the metropolis since

[1] Mrs. Fox Lane was the " lady of distinction," whose cry of " One God, one Farinelli ! " had electrified the opera-house. See p. 129.

the seventeenth century. It is old and dingy and disreputable. The bedroom they have engaged is hung with faded tapestries and antiquated pictures. Masquerade costumes, pulled off in haste, are scattered on the uncarpeted floor; beside the Countess's discarded bodice and shoes, a fire-lit mask lies staring upwards from beneath the rim of her hooped skirt; even the two hoods have a look of complicity, huddled together by a chair-leg; while the dying fire projects the monstrous shadow of a pair of fire-tongs. In this shabby but romantic retreat they are surprised by the Earl himself, at length goaded, presumably much against his will, into acting the part of an indignant husband. Silvertongue, challenged to draw, has transfixed his opponent with a panic-stricken thrust. He is now scrambling desperately out through the window, as the Watch breaks open the door, and the watchman's lantern casts a circular pattern of light upon the bedroom ceiling.

Eventually, disgraced and widowed, the Countess retires to her father's house. It is on the northern bank of the Thames, probably near Fishmongers' Hall;[1] Old London Bridge, still crowded with dilapidated Elizabethan buildings, appears in the frame of an ancient leaded casement; but, although the merchant's parlour may strike us to-day as having a pleasing air of picturesque antiquity, to an observer of Hogarth's period it was merely bleak and squalid. In these uncongenial surroundings, the Countess, having just read Counsellor Silvertongue's " last dying speech ", takes a fatal dose of laudanum. The doctor, who has washed his hands of her case, stalks off, nuzzling his stick, on to an old-fashioned wooden staircase, lined with clumsy leather fire-buckets; the apothecary abuses her messenger; and the merchant, stolid and practical as always, sets to work removing her expensive diamond ring.

[1] See Hugh Phillips: *op. cit.*

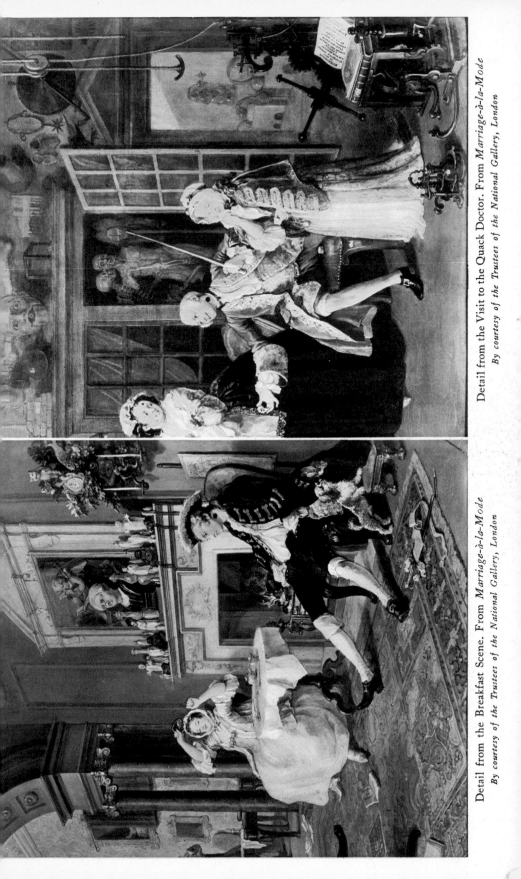

Detail from the Breakfast Scene. From *Marriage-à-la-Mode*
By courtesy of the Trustees of the National Gallery, London

Detail from the Visit to the Quack Doctor. From *Marriage-à-la-Mode*
By courtesy of the Trustees of the National Gallery, London

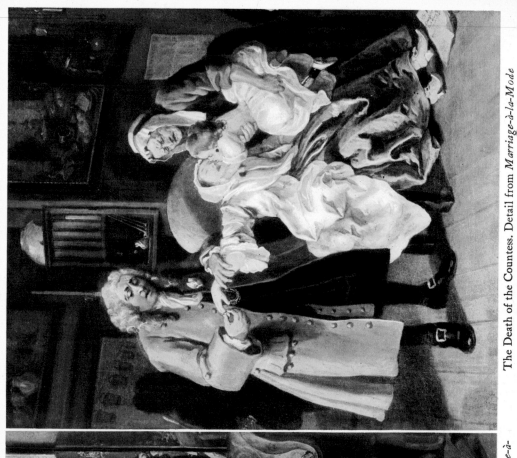

The Death of the Countess. Detail from *Marriage-à-la-Mode*

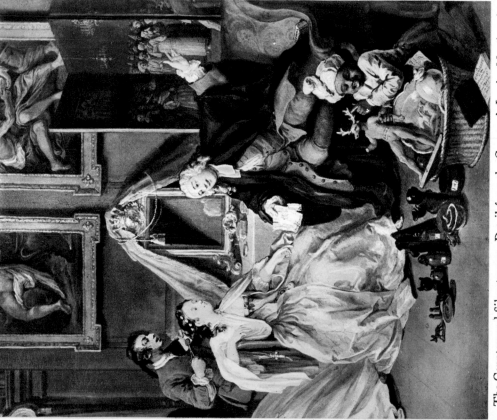

The Countess and Silvertongue. Detail from the Countess's Levée, *Marriage-à-*

The old nurse, the child and the moribund woman provide a splendid central group. Hogarth seldom came closer to the heart of tragedy than in his picture of the little crippled girl, who wears a heavy leg-iron, being lifted up, blubbering and fearful, towards her mother's livid face. Since she is a girl, the title is extinct: such are the Dead Sea fruit of Marriage-à-la-Mode. But with almost equal delicacy and zest Hogarth has depicted the apparatus of the merchant's meagre breakfast-table—the sheen of the plates, the glitter of a polished knife, the oily lustre of an earthenware jug and the flaccid texture of boiled meat.

He represents them as impartially and lovingly, as in the second episode of his drama he had represented the Countess's ruffles, her husband's broken sword, the open pages of her music-book. By isolating details, it would be possible to produce a long series of exquisitely painted still-lives; and *Marriage-à-la-Mode* also includes a brilliant survey of contemporary fashions, in which the dresses of the seventeen-forties are illustrated with careful realism down to the smallest scrap of gold lace. Thus, at her levée, the Countess displays a dressing-jacket of lustrous golden-yellow over a rose-pink petticoat and, in the last episode, a white satin bodice and skirt and an under-skirt of dull green. The Earl's wardrobe is as rich as his wife's. For his betrothal he has put on a sky-blue coat, which has multi-coloured embroidered cuffs; and he returns home, after his night's debauch, in a suit of black-and-gold. He visits the Quack Doctor in silver-and-leaf-brown, and meets his death wearing a dove-grey coat, embroidered with silver, above a pair of black silk breeches. But, although they demonstrate both his achievements as a meticulous chronicler of contemporary life and the mastery of paint that Hogarth had acquired since his completion of the *Rake's Progress*, the details that make up a picture must not

distract us from the basic plan. Each canvas is designed
as a rhythmic whole. Through the exercise of his " tech-
nical memory ", the artist had developed a habit of recording
groups and separate figures by means of an ingenious
system that he had invented and perfected himself. Every
scene was reduced to its component lines, which he presently
reclothed in their appropriate physical covering. But,
having served its purpose, the linear frame-work did not
entirely disappear; and we notice, for example, how, in the
" Visit to the Quack Doctor", the narwhal's horn, projecting
from the cupboard, prolongs the line of the nobleman's
right leg, and how the line of his stick, if extended, would
cut across it at an acute angle: how the overturned chair,
in the second picture, complements the Earl's attitude:
and how a succession of rolling and rebounding curves
wind their way through the picture of the Countess's
levée. Like a Baroque painter, Hogarth was enamoured
of movement; and his preoccupation with the beauty of
movement corresponded to the restlessness and mobility of
the artist's own spirit.

He was an " historical " artist, as Hazlitt perceived; and
" when I say that Hogarth treated his subjects historically,
I mean that his works represent the manners and humours
of mankind in action ... Everything in his pictures has
life and motion in it. Not only does the business of the
scene never stand still, but every feature and muscle is put
into full play; the exact feeling of the moment is brought
out, and carried to its utmost height ... The expression
is always taken *en passant*, in a state of progress or change,
and, as it were, at the salient point. Besides the excellence
of each individual face, the reflection of the expression from
face to face, the contrast and struggle of particular motives
and feelings ... are conveyed in the happiest and most
lively manner. His figures are not like the background on

which they are painted; even the pictures on the wall have a peculiar look of their own.—Again, with all the rapidity, variety, and scope of history, Hogarth's heads have all the reality and correctness of portraits." [1] An acute sense of time distinguishes the true historian; and it is noteworthy how many of Hogarth's scenes, both indoors and outdoors, happen to contain a clock, and that the clock he introduces always appears to tell the real hour. Time is perpetually moving, as his personages move: they are travellers, on their road to a destination that only the artist has yet glimpsed. The period does not merely provide a setting —the right furniture and clothes and ornaments: it is implicit in the personal demeanour, in the whole spiritual ambiance of every man or woman shown.

Soon after the publication of *Marriage-à-la-Mode*, Hogarth revealed a very different aspect of his gifts as an historical painter. During the second half of 1745, the Stuarts, exiled since 1688, made a last armed attempt to regain their British heritage, and for the last time a full-scale military campaign was fought out in the United Kingdom. Having landed on August 2nd and scored an initial success at Prestonpans, Prince Charles Edward crossed the Border and rapidly advanced south. By December 1st he had arrived at Macclesfield: three days later, Highland pipes were shrilling along the streets of Derby, and cannon were unlimbered and broad-swords were whetted in the city's market-place. [2] Meanwhile, the King's second son, the Duke of Cumberland (already familiar to us, as a boy, in the conversation piece entitled *The Conquest of Mexico*) had been hurriedly recalled from the Low Countries, where he commanded the bulk of the British forces, and was organis-

[1] From *The Round Table*, first published as an article on a collection of pictures in the *Examiner* of 1814.

[2] See *1745:* "The Last Campaign on English Soil" by T. H. McGuffie. *History Today.* December 1951.

ing the defence and marshalling his troops at Stafford. But his men were said to be hungry and exhausted; and it seemed possible that he would fail to intercept the fast-advancing Jacobites. London might be plundered by ragged Highlanders: the pyres of Smithfield would blaze again. "Black Friday" was a day of general alarm; and His Majesty's Foot Guards, accompanied by militia regiments and a host of volunteers, marched northwards to the improvised camp that had been set up at Finchley. Hogarth elected to follow them, as did many other citizens. But the gravity of the occasion somehow escaped the sightseer with a sketch-book. In Hogarth's eyes, *The March to Finchley* became an uproarious public holiday, which exemplified the remarkable English habit of appearing most light-hearted in moments of the greatest gloom.

Hogarth had taken his stand near the Tottenham Court Road turnpike. At that point, the suburban thoroughfare wandered off across the open country. On either side were public houses known as the King's Head and the Adam and Eve; and the whole of the King's Head, in Hogarth's picture, is occupied by the inmates of Mother Douglas's Covent Garden brothel, the mistress herself, whose pendant sleeves and vast bosom overhang the window-ledge, raising her eyes to Heaven and uttering a patriotic prayer. The head of the column marches away into the distance, and beyond we have an aerial glimpse of the blue line of the northern hills and of the village of Highgate perched upon a sunny slope. But the rear-guard has broken ranks as it approaches the narrow turnpike; stragglers, drunkards and camp-followers form a jostling inextricable mob, in their midst a pieman, a milkmaid, a ballad-vendor, a newspaper-seller and a pair of Jacobite spies; while a prize-fight is being held under the sign of the Adam and Eve tavern. A typical product of Hogarth's

middle age, *The March to Finchley* combines many of the
attributes of his dramatic series. It illustrates his insatiable
interest in the vagaries of human nature—the tall Grenadier
who occupies the foreground is a handsome, helpless giant,
simultaneously attacked by two possessive females: his love
of pictorial symbolism—one of the two women hawks an
Opposition newspaper, while her rival makes a living from
governmental ballad-sheets: his knack of giving his person-
ages an atmospheric landscape setting: finally his passion
for movement, which has induced him to break up the
scene into a fluid pattern of contrasted shapes, each group
a separate focus of interest yet closely linked to the general
design. Moreover, just as in *Southwark Fair*, a single face
expresses his appreciation of candour and youth and un-
spoiled beauty. High in a laden baggage-cart, beside two
elderly pipe-smoking soldiers' wives, a Madonna-like
young woman sits and nurses her infant child, with a little
boy at her feet blowing on a tin trumpet.

Thus the regiment passes, amid noise and confusion.
But no battle awaited the grenadiers who pitched their
tents at Finchley. The Pretender's impetus was gradually
slackening; at Derby he decided to retreat; and, hotly
pursued by the Duke of Cumberland, the Scottish forces
streamed home. Falkirk was a Jacobite victory; but at
Culloden, on April 16th 1746, the clansmen were even-
tually routed and the entire clan-system of the Highlands
was swept away into the historic past. Hogarth completed
his record of the campaign with the portrait he drew and
etched of a typical Scottish clan-leader. Simon Lord
Lovat had the virtues and vices of his kind. " This power-
ful laird . . . (we are informed) was one of the last chieftains
that preserved the rude manners and barbarous authority
of the early feudal ages." His house, which contained
" only four rooms on a floor, and those not large ", would

have been considered " but an indifferent one for a very private, plain country gentleman in *England* ". Yet there he had held " a sort of court, and several public tables; and had a numerous body of retainers always attending. His own constant residence, and the place where he received company, even at dinner, was in the very place where he lodged; and his lady's sole apartment was her bedroom . . ." His retainers slept upon piles of straw, " which they spread every night, on the floors of the lower rooms, where the whole inferior part of the family, consisting of a very great number of persons took up their abode ".[1]

To primitive dignity and feudal nobility Lord Lovat united the instincts of a medieval robber baron. He was crafty, greedy and violent. It had been his ambition to become known as the " greatest Lord Lovat that ever was "; and, in early life, having failed to abduct the child-heiress of his relation, the tenth Lord Lovat, he had forcibly married his prospective victim's widowed mother, her screams of protest being drowned by a chorus of pipers stationed outside the bedroom door. During the rebellion of 1745, Lovat had played a double game, professing his devotion to the Hanoverian monarch and, at the same time, instructing his son to join the Young Pretender's army. Arrested after Culloden, he was brought to London to stand his trial. Hogarth, determined to commemorate the trial, hurried up the Great North Road and met the prisoner and his guards, on August 14th 1746, at the White Hart in St. Albans. Apparently they had already met; for Lovat, who was being shaved, rose and kissed him heartily, smearing the painter's face with soap-suds. Then he sat down again and began to describe the rebellion, ticking off

[1] From " Mr. *King's* observations on ancient Castles, in the *Archaeologia*, Vol. IV," quoted by Nichols: *Biographical Anecdotes*.

on his fingers the names and contributions of the various Scottish chiefs. Hogarth drew him as he was thus employed: a squat, heavy, broad-shouldered old man—at the time Lord Lovat was almost seventy—with a shabby coat, wrinkled stockings and a foxy expression that betrays neither repentance nor fear. He is unperturbed by the prospect of death; yet he could not have doubted that his head must fall; and Hogarth, thinking of the headman's axe, noted that his neck-muscles were " of unusual strength, more so than he had ever seen ".

Hogarth's print, " Drawn from the Life and Etch'd in Aquafortis . . . Publish'd according to Act of Parliament August 25th 1746 ", found an extraordinarily ready sale. The price of the second impression was a shilling; and, when he had finished this plate, " a printseller offered its weight in gold for it. The impressions could not be taken off so fast as they were wanted, though the rolling-press was at work all night for a week together. For several weeks afterwards he is said to have received at the rate of 12 *l.* per day." [1] *The March to Finchley*, on the other hand, was the object of a royal rebuff. The King had commanded him to send round his canvas (which he afterwards presented to the Foundling Hospital) for inspection at St. James's Palace. With remarkable naivety, the artist complied, not suspecting that this scene of military indiscipline might offend the tenderest feelings of a particularly zealous martinet; and the picture was returned to his studio without a word of praise or comment. Hogarth was surprised and hurt. The engraved version was therefore dedicated, not to the King of England, but to His Majesty Frederick William II, the young, highly educated and supposedly liberal King of Prussia.

[1] Nichols: *Biographical Anecdotes.*

X

Portrait of the Artist

MOST ARTISTS have painted a self-portrait; some have returned again and again to the delineation of their own features; and the desire to portray himself seems often to mark a decisive period in the history of the painter's growth. Does it not betoken a sense of fulfilment? Having concluded one chapter of his existence, and feeling that he will soon begin another, the artist appears to be taking stock, asking himself what he was, what (according to his reflection in the glass) he has since become, what at length he hopes to be. Hogarth's temperament was by no means introspective; but in 1745—the *annus mirabilis* of his middle age, just as 1728 had been the memorable year of his early life—he sat down to render a painstaking account of the self that now confronted him. We shall do well to examine that portrait side by side with Roubiliac's bust, executed twelve years previously. Hogarth enjoyed good living, and the sitter's face has filled out. Cheeks and jowls are rounder and heavier, softening the effect of the awkward prognathous jaw; but the eyes are as keen and alert, and the general expression is as bellicose and obstinate. He is still wearing a tasselled cap; and we recognise the deep ugly scar running upwards from the right eyebrow. In the foreground he has placed his dog and his palette— the latter adorned with a thin curving golden filament, raised from the polished wood and mysteriously labelled

" The Line of Beauty and Grace "; and the oval canvas rests on a pile of calf-bound books, Milton, Swift and Shakespeare.

Hogarth was now forty-eight, affluent and widely famous; and, although no record as vivid as the *Peregrination* illuminates his middle years, many contemporary references recall the features of the self-portrait. Success had done nothing to weaken his character: indeed, the trials attendant on fame seem to have given it a rougher edge. Always " fond of mirth and good fellowship ", he had not lost the habit of expressing his opinion in a " strong and pointed " manner, regardless of the company's feelings, and proved just as incapable of resisting the charm of some seductive piece of flattery. Now and then, his friends would exploit this failing; and we read, for instance, of a London dinner party at which he was told that a surgeon named Freke had asserted not long ago " that Dr. Greene, the musician, was as eminent and skilful a composer as Handel ". Hogarth's protests were loud and vigorous. " That Freke (he pronounced) is always shooting his bolt absurdly: *Handel is a giant in music; Greene is only a light Florimel kind of composer.*" " True (replied a member of the party, who clearly understood Hogarth), but that same Freke declared you were as good a portrait painter as Vandyck." Hogarth, characteristically, did not decline the lure. *There* Freke, he observed, had been in the right. " So by God I am, give me my time, and let me choose my subject." [1]

" . . . A strutting, consequential little man ", remembered Benjamin West, the veteran President of the Royal Academy. And, indeed, to the aggressiveness that often distinguishes persons of very short stature and to the blustering self assertiveness of a poor man's son who had risen in the

[1] Ireland: *Graphic Illustrations of Hogarth.*

world, Hogarth added much of the excitability and natural irritability of the creative artist. He piqued himself, however, on his championship of absent friends and on never saying behind an acquaintance's back what he would not care to say to his face. Rightly proud of his own achievements—and never reluctant to sing his own praises—he was extremely conscious of his personal dignity; and, now that his income was substantial and regular, he lived in some state at his commodious house in Leicester Fields. He kept a good table, we are informed, and liked everything about him to be solid, orderly and well-appointed. Towards the end of his career, as we know from a brilliant collection of portrait-heads, the Hogarths employed at least six servants—three maids, a couple of men and a boy. But neither of his menservants wore livery, as, of course, they would have done in a more pretentious household; and Hogarth, who was a strict but kindly employer and a " punctual paymaster ", had sternly forbidden his dependants to follow the common eighteenth-century practice of extorting tips or " vails ". Thus one of his sitters, a Mr. Cole, recollected how, " on my taking leave of our painter at the door, and his servant's opening it or the coach door, I cannot tell which, I offered him a small gratuity; but the man very politely refused it, telling me it would be as much as the loss of his place, if his master knew it. This was so uncommon, and so liberal in a man of Mr. *Hogarth's* profession at that time of day, that it much struck me, as nothing of the sort had happened to me before."

The house in Leicester Fields—at the bottom of the east side, behind the site of the modern memorial bust— was the painter's home, during the spring and winter months, and his permanent place of business. Over its door hung the celebrated Golden Head, and upstairs was the large painting-room where he received professional visitors.

When the weather was warm, he retired to the country, the last of successive rural retreats being the small house he acquired at Chiswick. It still stands, half lost in a labyrinth of grim suburban buildings; but there, opposite a row of mean cottages and under the lee of a towering steam laundry, is the neat little three-storeyed red-brick box, with a white-painted wooden bay projecting over the front door, surrounded by a miniature walled garden which contains the riven trunk of a tall and ancient mulberry tree. The pleasant panelled rooms on the ground and first floors are neither large nor high-ceilinged; and a stable-loft at the end of the garden, which had been " laid out in a good style ", served Hogarth as his studio. Not far away flowed that " amiable creature ", the Thames; but Hogarth had little interest in landscape if its prospects were divorced from the activities of mankind; and no doubt he had selected the Thames Valley because so many entertaining and intelligent men and women were to be found among his immediate neighbours. Chiswick House was a citadel of the enemy, where Lord Burlington, the arch-priest of false taste, entertained his monstrous acolyte, William Kent; and with Horace Walpole at Strawberry Hill the artist was never on an easy footing. But he enjoyed the companionship, intellectual or convivial, of other ingenious and learned spirits. For example, the Reverend Thomas Morell,[1] antiquary, classical scholar and author of the libretti of several of Handel's oratorios, whose sharp good-natured features and broad-brimmed hat frequently appeared at Hogarth's garden-gate, coming from the direction of Turnham Green.

James Ralph,[2] one of Pope's chief butts in the *Dunciad*, and a versatile hireling journalist, who had collaborated

[1] Thomas Morrell, 1703–1784.
[2] James Ralph, 1705?–1762.

with Fielding on the *Champion*, published a violent *Criticism of the Administration of Sir Robert Walpole*, and edited the *Rembrancer*, a scurrilous opposition sheet conducted in the interests of the Prince of Wales's faction, was also a country neighbour and a member of the artist's synod. Hogarth seldom dipped into aristocratic

Hogarth invites a friend to the Mitre
" to eat a bit of pie "
from *Biographical Anecdotes* by Nichol
first published in 1781

society; and there is a story—not related, however, by Walpole himself—that, when he was bidden to Strawberry Hill to make the acquaintance of Thomas Gray, the painter and the poet disappointed their talkative host by remaining obstinately speechless. Both at Chiswick and at Leicester Fields, Hogarth's circle, as in the days of the *Peregrination*, was usually recruited from the intellectual middle-class. Besides Morell and Ralph and the two brothers Hoadly (with whom his relationship has been mentioned elsewhere)

he saw much of James Townley,[1] headmaster at the Merchant Taylors' School and latterly the author of the popular farce *High Life Below Stairs*; and he was on sociable terms not only with Fielding but with Samuel Richardson, in whose suburban parlour he is said to have first encountered Samuel Johnson, still comparatively little known, but already a puissant and commanding personage. So remarkable was the scholar's appearance, as he stood alone in the window, " shaking his head and rolling himself about in a strange ridiculous manner ", that Hogarth immediately assumed he must be some harmless lunatic; and, when Johnson suddenly joined the discussion, delivering a fierce attack on the character of the present monarch—he had not yet become the passionate loyalist of his later period—Hogarth " actually imagined that this idiot had been for a moment inspired ". Delighted with Johnson's eloquence, he was disconcerted by a vehemence that exceeded his own. Among his friends was John Salusbury, father of the future Mrs. Thrale; and, speaking of Johnson to Salusbury, " That man (says Hogarth) is not contented with believing the Bible, but he fairly resolves, I think, to believe nothing *but* the Bible. Johnson (added he), though so wise a fellow, is more like King David than King Solomon; for he says in his haste that all men are liars."[2]

It must have been early in the seventeen-forties that Hogarth began his firm friendship with Johnson's one-time pupil, David Garrick, who in 1741, at the age of twenty-four, had achieved his conquest of the London stage by his interpretations, during the same twelve months, of Shakespeare's satanic Richard III and Farquhar's gay Sir Harry Wildair. There was a similarity between

[1] James Townley (1714–1778.)
[2] Piozzi: *Anecdotes of the Late Samuel Johnson.*

189

the two great artists—each of them being short, spirited, vain, gregarious, with a needle-sharp eye for the comedies of every-day existence, which Hogarth rendered in paint and Garrick reproduced through his incomparable powers of mimicry. A silhouette portrait shows them side by side —Hogarth, the shorter by several inches, wearing an old-fashioned bushy wig, and carrying a crooked stick and his hat under his left arm; while Garrick, who has risen to welcome him, unlike the painter is wearing a sword and a wig that terminates in a fashionable *queue*. Each was good-hearted and generous; but Garrick's closest friends could not refrain from observing that his genial qualities were accompanied and set off by much histronic artifice. He was exceedingly careful of the effect he made, and since (according to Malone and Reynolds)[1] " it was a rule with him not to leave any company saturated ", as soon as he was confident of having delighted the gathering he usually arranged to receive a message that he was wanted in some other place. " He never came into company (declared George Colman) without laying a plan for an escape out of it "; and a fellow comedian, the " irresistible " Foote, voted him " not only the greatest actor on, but off the stage ". " Garrick (said Boswell) was pure gold, but beat out to thin leaf." Yet Johnson, elsewhere a captious critic, although he agreed that his old pupil had " friends, but no friend ", and was " so diffused " that he had no real intimate " to whom he wished to unbosom himself ", added that he was a " very good man, the cheerfullest man of his age; a decent liver in a profession which is supposed to give indulgence to licentiousness, and a man who gave away, freely ", the money that his triumphs brought him. To Hogarth, at a moment of serious crisis, he would cer-

[1] See *Portraits of Sir Joshua Reynolds*, edited by Frederick W. Hilles. The Yale Edition of the Private Papers of James Boswell. 1952.

tainly prove a loyal ally; and, besides portraying him with his young and attractive wife in one of his latest conversation-pieces, the painter, about 1745, represented him in the part of Richard III—a somewhat unfortunate attempt at historical and dramatic sublimity.[1]

Of Hogarth, no one could have asserted that he was gold beat out to " airy thinness ". Although his vanity may have encouraged artifice, the affectations he displayed were habitually of the most ingenuous kind; and, while Garrick had blossomed into a man of the world and, as the head of a profession whose representatives not long ago had been classed among " rogues and vagabonds ", was the first English actor to deal on equal terms with members of polite society, Hogarth remained an artist-tradesman, the respectable householder of Leicester Fields. If in his youth he had affected some occasional airs of dandyism, in middle age he made few concessions to the vagaries of modern taste. The bushy wig, revealed by his silhouette, was of the type that distinguished lawyers, clergymen and school-masters. When all his contemporaries had abandoned the fashion, Hogarth clung to his " rockelo " or " roquelaure ", the loosely-fitting, many-buttoned outer garment that the duc de Roquelaure had popularised in Paris during the reign of Louis Quatorze; and, wearing his rockelo, which was of scarlet cloth, " his hat cocked and stuck on one side, much in the manner of the Great Frederick of Prussia ",[2] he could be seen strolling at the end of the day up and down the gravelled walks that faced his London front door.

Behind him ambled his pug-dog, Trump, an insepar-

[1] *David Garrick & his wife* is now in the Royal Collection at Windsor: *Richard III* in the collection of the Earl of Feversham.

[2] We owe this glimpse of Hogarth to a local tradition, preserved in the *Mirror* of 1823; from which it is quoted by Austin Dobson.

able companion who appears in *The Strode Family* painted about 1738 and again in the self-portrait of 1745. Trump had a bad habit of protruding his tongue and seems not to have been completely pure bred, since he is longer-faced and less "cobby" in build than his charming twentieth-century counterparts. But Hogarth loved him devotedly; and his affection for the company of his dog, together with something decidedly puglike in his own snub-nosed and heavy-jowled features, caused him afterwards to be branded as "Painter-Pugg" by unfriendly caricaturists. He had also, we hear, a favourite bull-finch and, when it died, gave it decent burial beneath a stone (which has now vanished) bearing the inscription, carved and embellished by himself:

Alas poor Dick!
1760
Aged eleven

To have an affection for animals is often to love and understand children; and that Hogarth, whose wife was childless, and who is credited by history with no illegitimate offspring, had an especial interest in the young might very well be inferred from his pictures and prints. The inference is strengthened by several different anecdotes. During Hogarth's apprenticeship, Nollekens recollected that he had frequently observed him "saunter round Leicesterfields, with his master's sickly child hanging its head over his shoulder"; and later we read of the local children whom the successful painter entertained beneath his mulberry tree at Chiswick, and of the little foundling girls entrusted to his care by Captain Coram's hospital.[1] Moreover, he possessed the invaluable gift of entering into

[1] Two children, Susan Wyndham and Mary Woolaston, were living at Chiswick when he died.

192

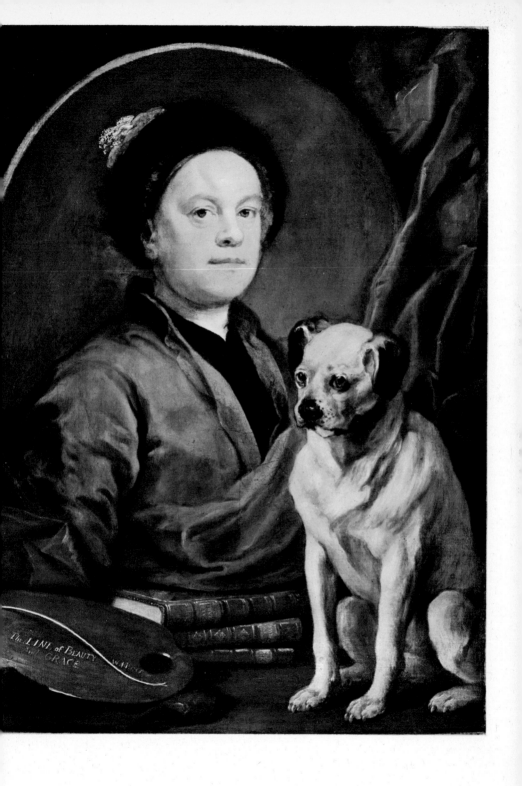

Hogarth and Trump, 1745
By courtesy of the Trustees of the Tate Gallery, London

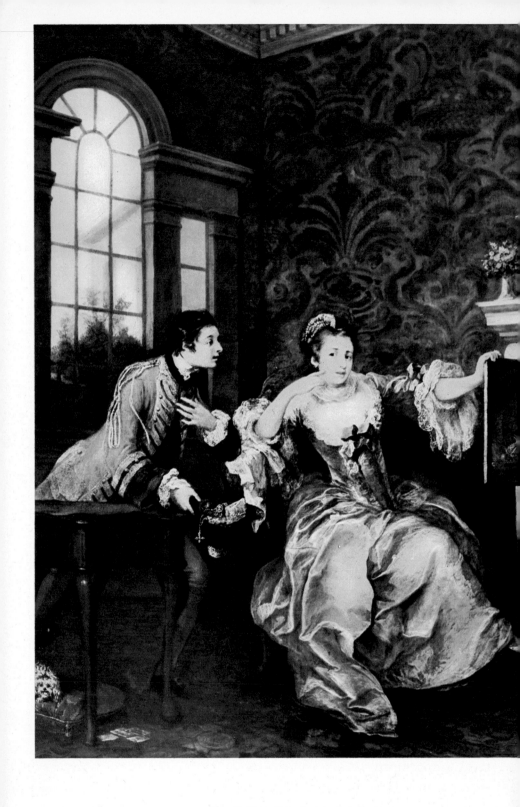

Detail from *The Lady's Last Stake*
By courtesy of the Albright Art Gallery, Buffalo, New York

childish pursuits and sharing the childish point of view. ". . . My father (writes Nollekens's biographer) . . . asked Barry, the Painter, if he had ever seen Hogarth. ' Yes, once,' he replied. ' I was walking with Joe Nollekens through Cranbourne-alley, when he exclaimed; ' There, there's Hogarth.' ' What ! ' said I, ' that little man in the sky-blue coat?' Off I ran, and though I lost sight of him only for a moment or two, when I turned the corner into Castle-street, he was patting one of two quarrelling boys on the back, and looking steadfastly at the expression in the coward's face, cried, ' Damn him! if I would take it of him; at him again! ' "

He was no less at home in a conventional nursery, for instance among the Salusbury children; and Hester Piozzi, glancing back down the vista of her long life to the days when she was a pretty and high-spirited girl of twelve or thirteen, recalled how one day after dinner (which then took place at three o'clock) she had been anxious to play with some little cousins at a new game " called Game of the Goose ". The players needed a round table; but Hester hesitated to ask for it, " half afraid of my uncle's and my father's grave looks ". Hogarth noticed her dilemma and, crying " *I* will come, my dears, and play at it with you ", immediately deserted his grown-up friends. Clearly he joined the game in a serious spirit. " The pool rose to five shillings . . . and when I won it, I capered for delight ".[1] The same intuitive sympathy that drew him towards the quarrelling boys, and led him to encourage the boy who had been defeated to give his valour another trial, enabled him to plunge wholeheartedly into the excitement of a Game of Goose. The strain of childishness in Hogarth's adult character seems to have been the product of a very real simplicity.

[1] Piozzi: *op. cit.*

193

As Hogarth met her when she was not yet fourteen, and
Hester Salusbury had been born in 1741, the heyday of
their acquaintanceship must have occurred about 1753.
Mrs. Piozzi goes on to declare that she sat for the lady in
a romantic " problem-picture ", *The Lady's Last Stake*,
completed in 1758 or 1759, explaining that, while he
painted, Hogarth drew her attention to its moral symbolism.
" Now look here (she believed she remembered him saying),
I am doing this for you. You are not fourteen years old
yet, I think, but you will be twenty-four, and this portrait
will then be like you. 'Tis the lady's last stake; see how
she hesitates between her money and her honour. Take
care; I see an ardour for play in your eyes and in your heart;
don't indulge it. I shall give you this picture as a warning,
because I love you now, you are so good a girl." This
report may possibly be over-coloured—the reporter was
an elderly woman; but that Hogarth should have added
many useful hints on dress, dancing and deportment, and
other important aspects of a young girl's upbringing, is
perfectly in character. We know that he was deeply con-
cerned with the problem of how children might be taught
at an early age to acquire elegance and freedom of move-
ment; and his only full-length literary work, *The Analysis
of Beauty*, contains a long passage of advice on the value of
correct training:

"As to the motions of the *head*; (he announces) the
awe most children are in before strangers . . . is the
cause of their dropping and drawing their chins down
into their breasts, and looking under their foreheads, as
if conscious of their weakness, or of something wrong
about them. To prevent this aukward shyness, parents

and tutors are continually teasing them to hold up their heads, which they get them to do with difficulty, and of course in so constrained a manner that it gives the children pain . . . And there is another misfortune in holding down the head, that it is apt to make them bend too much in the back; when this happens to be the case, they then have recourse to steel-colours, and other iron-machines; all which shacklings are repugnant to nature, and may make the body grow crooked. This daily fatigue both to the children and the parents may be avoided, and an ugly habit prevented, by only (at a proper age) fastening a ribbon to a quantity of platted hair, or to the cap, so as it may be kept fast in its place, and the other end to the back of the coat . . . of such a length as may prevent them drawing their chins into their necks; which ribbon will always leave the head at liberty to move in any direction but this aukward one they are so apt to fall into."[1]

Hogarth was always a practical theorist; and the crowded margin of one of the two large engravings, with which he illustrated *The Analysis of Beauty*, includes a small cut to show exactly what he had in mind.

Just as his vision of children was unclouded by sentimentality—Moll Hackabout's little boy completely forgets his dead mother with the help of a new spinning-top—Hogarth's attitude towards women remained critical and realistic. It was not that women had failed to arouse his emotions, or that he was ever inclined to neglect their pictorial possibilities. Nearly two thousand five hundred separate personages are said to have been introduced by Balzac; and, in the three series that make up his far smaller, if scarcely less ambitious, version of the *Comédie*

[1] *The Analysis of Beauty*, Chapter XVII, "Of Action."

Humaine, Hogarth, at a tentative reckoning, depicts a hundred-and-sixty different characters. Male performers out-number female; but among his women are many of the creations whose features we remember best. Some are innocent and seductive; but, although Hogarth dwells on these faces with satisfaction, he never strikes us as unduly gallant. In an age that coined the word "sentimental" and saw the apotheosis of the aristocratic painter, Hogarth was the least courtly of artists, and approached his feminine subjects without the smallest suggestion of chivalric deference. Few portrait-painters have been quite so dispassionate. Hogarth, indeed, was that rare phenomenon—a man who obviously liked women but was seldom really dazzled by them, and who continued to regard them as coolly and impartially as he regarded his own sex. His portraits of women possess a peculiar charm; but, when carefully analysed, it is the sober charm of verisimilitude.

At home, his feminine companions formed a decorous and worthy group. Jane Hogarth hovers in the background—quiet, stately, undemonstrative; and she was presently joined by her husband's sister Ann, when Mary, his elder sister, died, and their millinery business closed down. Another member of the household was Jane's unmarried cousin, Mary Lewis,[1] whom Hogarth held in high regard. The domestic atmosphere of Chiswick and Leicester Fields, though soothing and reassuring, was perhaps not very stimulating; and Hogarth, in common with most intelligent and active Londoners of the eighteenth century—or Southern Europeans of our own time— must have spent much of his leisure away from home, dining at a tavern with a party of masculine friends or

[1] Daughter of the "celebrated David Lewis, Harper to George II." The portrait of her brother, playing on the flute, is said to have been introduced into the fourth scene of *Marriage-à-la-Mode*. But it seems more probable, given the context, that Hogarth would have depicted a foreign musician. See W. T. Whitley, *op. cit.*

talking and reading the newspapers at a Covent Garden coffee-house. It seems unlikely that he ceased to frequent the Rose or pay occasional midnight visits to such resorts as Tom King's. He had a wide acquaintance with the London *demi-monde*, and, if he still sought amatory adventures, he would undoubtedly have discovered them there; but we find no hint of any illicit relationship among the scanty records of his private life. Nor can we credit him with any romantic passion, despite a story that the Drummeress of *Southwark Fair* was a young woman whom he had seen being maltreated by some goatish persecutor, and that the " five-foot painter " stood up to the bully and, being an agile and athletic opponent, thrashed him in bare-fisted battle. From this tradition it is tempting to conclude that Hogarth's Beautiful Drummeress, like Wilkie Collins's Woman in White, was rescued by the artist to become a source of inspiration: that Hogarth used her face in many of his pictures, not only in *Southwark Fair* but as the attractive girl who perches on the baggage-waggon in *The March to Finchley*, or as the scribbler's wife in *The Distressed Poet* (whom Hartley Coleridge considered possibly the " most loveable figure that ever Hogarth drew "), looking up, startled and gentle, as she listens to the vociferous reproaches of the indignant milkmaid.[1] This entertaining fantasy, however, has no foundation in established fact.

Hogarth, I have suggested, judged woman as impartially as he judged men; and the comparison of his pictures of Bishop Hoadly and Captain Coram might be followed by a similar comparison of three very different feminine portraits—*Mrs. Salter*, *Peg Woffington* and *Lavinia Fenton*, afterwards Duchess of Bolton. The portraits of Mrs.

[1] The scene takes place on Michaelmas Quarter Day; and the milkmaid—a typically Hogarthian touch—wears a garland of Michaelmas daisies, wreathed around the brim of her hat.

Salter and Lavinia Fenton now hang in close proximity;[1] and, whereas the former reveals Hogarth both as a supremely gifted master of paint and as a subtle and sympathetic interpreter of the personality he had set out to portray, the actress and the one-time songstress receive comparatively harsh treatment. All three pictures are thought to have been executed between 1740 and 1745; and, according to a modern critic, the portrait of Miss Fenton has probably suffered a good deal of re-painting, while that of Peg Woffington has certainly been over-cleaned. Yet, even allowing for such misfortunes, how astonishing the difference is! With Mrs. Salter Hogarth was on familiar terms. He was not alienated by her solid plumpness, and found no difficulty in discerning her underlying worthiness. He did not pretend to disguise her banality; but from that banality he extracted a memorable and moving beauty. The stout young woman in the tawny-yellow dress, with a string of pearls threaded into her hair and linen ruffles, exquisitely rendered, running from her neck to her waist, is a triumph of pictorial skill; every plane of her features is alive and sensitive; so that, beside her, Woffington and Fenton look strangely wooden and insignificant. To understand the difference in the artist's approach, we must take into account his individual prejudices.

Thus Mrs. Salter—whose portrait was originally supposed to represent one of Hogarth's shop-keeping sisters—proves to have been Elizabeth, the newly married wife of the Reverend Samuel Salter, an ambitious political clergyman, later Doctor of Divinity and Master of the Charterhouse. Nothing to dazzle or intimidate here. Mrs. Salter was just such a sensible middle-class woman as Hogarth respected and understood; whereas Lavinia Fenton and

[1] In the Tate Gallery, London, where Bishop Hoadly also hangs. The portrait of Peg Woffington is in the collection of Lord Glenconner.

Peg Woffington were highly fashionable and popular characters, each distinguished by her wit and vivacity, and doubtless inclined to talk and fidget, when all that the painter asked of them was to sit quiet and hold their tongues. Since Miss Fenton had deserted the *Beggar's Opera*, she had been richly maintained by an adoring Duke, while he waited for his wife to die; and it was the future Duchess whom Hogarth portrayed—a face from which the gaiety and simplicity of her youth have altogether disappeared, imperious and proud and self-satisfied, above a green dress with trimmings of rose-bronze, and golden tassels and golden frogs. Peg Woffington's story is better known. Offspring of a Dublin bricklayer and an itinerant vendor of fruit and vegetables, this "bold Irish-faced girl" was reputed to be the handsomest woman who had ever performed on the London stage. She was also among the most violent-tempered. Everyone knew how she had driven Mrs. Bellamy off the boards and, armed with a theatrical dagger, stabbed her just behind the scenes. She chose her lovers as recklessly as she made professional enemies; and when, discussing her great success in the part of Sir Harry Wildair, she remarked to her fellow comedian James Quin [1] that she had played the part so often that half the town, she supposed, must imagine her to be a real man, well, the *other* half, Quin retorted, must unquestionably be better informed. In Hogarth's portrait, the elegant virago has a somewhat sharp and shrewish expression; and such romantic feeling as his subject aroused is concentrated on the clothes she wears—on the rose-pink and ash-grey symphony of her lace-covered sleeves and bodice.

Yet, although Hogarth's practice of his art cannot be

[1] James Quin (1693–1766). Like Peg Woffington, he was of Irish descent. He specialised in tragic heroes, but is said to have been "unexcelled in the rôle of Falstaff".

divorced from his vision of humanity, and that vision was deeply influenced by private quirks and prejudices, we must not (as did many contemporary critics) lose sight of the inspired painter in the accomplished social commentator. During the fourth decade of his existence, the painter had risen to his full height. We are suddenly aware that the brilliant pictorial dramatist, who planned and staged his earlier series, has become a masterly executant who loves his medium for its own sake, and who handles it with a freshness and boldness unknown among his English rivals. Paint swirls beneath the master's brush: ruffles, hands, the surface of a cheek, the gleaming or shimmering texture of his sitter's draperies, are rendered with a liquidity and lightness that sometimes recall the work of Fragonard. By comparison, the other eighteenth-century English artists who preceded Reynolds and Gainsborough are mere industrious journeymen. In 1745, Hogarth could claim to have established a genuinely English school, and to have shown that English painting might make a new and important contribution to the art of Europe. Every school has some affinity with the natural scenes amid which it first developed; and Hogarth's sense of colour must surely have originated in his knowledge of the English landscape, so vivid and subtly luminous, without violent contrasts of light and shade. Strange that his contemporary admirers should have complained that the great social historian was but a coarse and unimaginative colourist! To appreciate the absurdity of this judgement, we need only turn to *Mrs. Salter*, in which (as a recent critic has pointed out) Hogarth employs a " system . . . followed a century later by Eugène Delacroix, who was under the impression that he was its inventor. The high lights and the deep shadows are in each case two primaries, which unite to form the half-tone. The dress which produces the effect of yellow is yellow in

the high lights, red in the deepest shadows, and orange in the transitions; so with the scarf, the three tints of which are yellow, green and blue ".[1] As for the young woman's face, Hogarth (he adds) has conferred on her sleek healthy skin an air of soft translucency; her fresh commonplace features are transfigured by a delicate inward glow.

[1] Sir William Armstrong: "The Art of Hogarth," printed as introduction to Austin Dobson's *William Hogarth.*

Hogarth and Garrick
a silhouette from Ireland's *Graphic Illustrations*, 2 vols.
first published in 1794 and 1799

XI

Calais Gate

DESPITE HIS reverses in the field of " history-painting "
(towards which, as Austin Dobson has remarked, he
was perpetually drawn back like a moth towards a candle)
Hogarth could now claim to have achieved most of the
objects that he had originally set himself; but, having his
full share of creative restlessness, he was still very far from
satisfied. He would seem, indeed, about his fiftieth year,
to have entered a period of discontent; and his temper
was not improved by his galling experiences during
the foreign holiday he undertook in 1748. Since 1739,
England had been at war, originally with her maritime
rival Spain, eventually with a formidable coalition uniting
both the Bourbon powers. But, during the Spring of
1748, on the signature of the Peace of Aix-la-Chapelle,
tranquillity returned to Europe; the road to Paris was
again thrown open: and through the gates of Calais
streamed a long procession of eager and inquisitive tourists.
Among them came William Hogarth, in a party of profes-
sional friends which included Hayman and Hudson, the
painter, and Henry Cheere, the sculptor.[1] Hogarth was

[1] Hogarth and Hayman soon returned: their companions went on from Paris
to the Low Countries. Vertue records, in May 1743, that " Mr. Hogarth is set
out for Paris—to cultivate knowledge and improve his stock of art ". There is
no confirmation of this journey having actually taken place. Henry Cheere
(1703–1781) was created baronet in 1760. He produced statues for Queen's
College, Oxford, and executed chimneypieces for Ditchley, Kimbolton Castle and
Kirklington Park, the seat of Sir James Dashwood.

devoted to his native city—such was his attachment to London that he appears very seldom to have ventured beyond the Home Counties: and this was the last—and probably the first—occasion on which he was persuaded to travel abroad. How delightful to have had an impression of his tour written in the same care-free style as the famous *Peregrination* of 1732! Then every prospect had enchanted the traveller, every passing mishap had been the source of noisy jokes. Very different was the mood in which he landed upon French soil. As he looked around him, almost everything that he saw produced an agony of irritation—" a farcical pomp of war (he wrote), pompous parade of religion, and much bustle with very little business. To sum up all, poverty, slavery, and innate insolence, covered with an affection of politeness, give you . . . a true picture of the manners of the whole nation: nor are the priests less opposite to those of *Dover* than the two shores. The friars are dirty, sleek and solemn; the soldiery are lean, ragged, and tawdy; and as to the fish-women—their faces are absolute leather."

Nor did courtesy oblige him to conceal his disgust. When the travellers had reached Paris, which then harboured a large colony of Scottish and Irish exiles, he was constantly alarming his friends by his incautious remarks in public places. In the streets, we learn—true, our informant is the spiteful Stevens—" he was often clamourously rude. A tatter'd bag, or a pair of silk stockings with holes in them, drew a torrent of imprudent language from him." His companions' advice he always laughed to scorn, " and treated the offerer of it as a pusillanimous wretch, unworthy of a residence in a free country, making him the butt of his ridicule for several evenings afterwards ". He was no better pleased with the exquisite refinement manifested by

French architects,[1] cabinetmakers, tapestry-weavers and designers of porcelain. " If an elegant circumstance either in furniture, or the ornaments of a room, was pointed out as deserving approbation, his narrow and constant reply was, ' What then ? but it is *French*! Their houses are all gilt and——' ". Yet, although Hogarth pretended a contempt for French art—just as in England he was careful to hide his respect for the genius of Titian, since to admire an Italian artist might seem to be playing into the hands of the monstrous regiment of Connoisseurs [2]—it is possible that even in Paris he did not altogether waste his time. He must have visited certain studios; for there exists a letter, written during 1749 by a collector named Daniel Wray to a fellow enthusiast, the Honourable Philip Yorke, in which he advises him, when he is exploring Paris, to " call in . . . at Chardin's, who paints little pieces of common life, and upon Liotard, admirable in crayons . . . The crayonist whom I meant to commend (from Hogarth's testimony) is La Tour. I confounded him with Liotard." [3]

He was delighted, nevertheless, to take the homeward road again; and, while he was at Calais, waiting for his boat to sail, he amused himself strolling around the town and paused at the ancient gate-way, " which it seems was built by the English, when the place was in our possession " and bore " some appearance of the arms of England on the front. By this and idle curiosity, I was prompted to make

[1] The massive dignity of the Louvre, nevertheless, evoked in Chapter VI of *The Analysis of Beauty* a somewhat grudging tribute: " The Façade of the old Louvre at Paris is also remarkable for its quantity. This fragment is allowed to be the finest piece of building in France. . . ."

[2] " Mr. Hogarth, among the variety of kindnesses shewn to me when I was too young to have a proper sense of them, was used to be very earnest that I should obtain the acquaintance, and if possible the friendship of Dr. Johnson, whose conversation was to the talk of other men, like Titian's painting, compared to Hudson's, he said : ' but don't you tell people now, that I say so (continued he), for the connoisseurs and I are at war, you know; and because I hate *them*, they think I hate *Titian*—and let them!' " Piozzi: *Anecdotes of the late Samuel Johnson.*

[3] Quoted by W. T. Whitley, *op. cit.*

a sketch of it . . ." But, as he drew, a heavy official hand descended on his shoulder. In a moment he was being marched through the streets—from what we have learned of Hogarth's disposition, no doubt emitting voluble protests —and hailed before the Governor of Calais in the character of an English spy. There he was " forced to prove his vocation by producing several *caricaturas* of the French; particularly a scene of the shore, with an immense piece of beef landing for the Lion-d'Argent, the English inn, and several hungry friars following it." [1] The Governor considered his sketches and, having the Gallic readiness to be beguiled, agreed that they were diverting efforts, and that his sketch of the gate was unlikely to " serve the purposes of an engineer ". But he warned the draughtsman that, " had not the peace been actually signed, he should have been obliged to have hung him up immediately on the ramparts ", and confined him to his room until the wind had changed, when he was hustled on to the channel packet accompanied by two armed guards. These despicable but inescapable jailors continued to keep watch over their captive, " till he was three miles from the shore. They then spun him round like a top, on the deck; and told him that he was at liberty to proceed on his voyage without farther attendance or molestation." [2]

No sensitive person likes to be roughly used; and, if the victim is short and quick-tempered, and finds himself being spun round, before an audience of his own compatriots, by a brace of ragged foreign soldiers, the physical indignity may well become intolerable. Yet Hogarth's revenge, although the state of mind that inspired it shows him in the worst light, reveals him at his best both as a satirist and as a creative artist. While his domestic scenes

[1] Horace Walpole to Mann, Dec. 15 1748.
[2] Nichols: *Biographical Anecdotes.*

have an unmistakably English colouring—homely and warm and dim, tinged with the clouds of coal-smoke that drifted across the roofs of London—his picture of *Calais Gate* (published in 1749 as a print entitled *O the Roast Beef of Old England*) is suffused throughout the composition by a dismal air of foreignness. The effect is desolate and chilly and drab. Beneath the arches of the massive gate, we see a long gloomy street, that stretches away into the unknown distance, and a religious procession escorting the Host, decked out in all the pomp of vestments, crosses and lighted tapers. Here are the ribald fish-wives with their leathery grins: here are the tattered soldiery whom Hogarth had observed, and who now gaze with hungry astonishment at an enormous side of English beef. Under the outer gate, an exiled Jacobite is slowly perishing of neglect and hunger; but a sleek and dirty monk appraises the joint, his mouth salivating and his eyes rolling. It has been suggested that Hogarth meant to draw an allusive and sacrilegious comparison between the wafer carried by the priest and the richly substantial burden supported by the cook's messenger. This theory must be left to the spectator's judgement; but we know that, in portraying the friar, Hogarth used the likeness of his burly friend, the engraver John Pine, who was thereupon nicknamed "Friar" Pine and grew so tired of his friends' teasing that he petitioned the artist to change his portrait.

A self-portrait was slipped into the picture—Hogarth busily at work, unconscious of authority's impending hand. Back in Leicester Fields, he presumably blessed the fate that had caused him to enter the world as a free-born British subject. Yet, in fact, the condition of affairs at home was little calculated to encourage any Englishman to feel unduly proud of his own country. The English middle classes might enjoy comparative freedom and a high degree

of domestic comfort: their social inferiors, particularly the London mob, provided a terrifying display of drunkenness and lawlessness. The crime-wave, which had slowly mounted during the previous decade, reached its climax about 1749;[1] when a gang of armed desperadoes took the Gatehouse prison by storm, London and the surrounding districts teemed with pickpockets and highway-robbers and Horace Walpole complained that, even in the middle of the day, it had become necessary to travel " as if one was going into battle ". Henry Fielding, Justice of the Peace for Westminster since 1748, while laying his plans, which at length proved eminently successful, to combat the increase of crime, published his *Enquiry*, in which he asserted that the luxury bred of foreign commerce gave the criminal an added incentive. But among the main causes of poverty, and hence of criminality, was the national addiction to gin. The poorest labourers depended on gin as Chinese coolies depend, or used to depend, on the stimulus of opium. Gin, Fielding declared, was the " principal sustenance . . . of more than an hundred thousand people in this metropolis. Many of these wretches there are who swallow pints of this poison within twenty-four hours." As early as 1725, it was calculated that, throughout whole neighbourhoods, every fifth or seventh house purveyed gin, from the chandler's where maidservants sipped a comfortable glass while they performed their morning errands, to dram-shops that dealt in gin alone and exhibited the notorious advertisement: *Drunk for a Penny, Dead Drunk for Twopence, Clean Straw for Nothing*. The eighteenth century attached no excessive importance to the moral virtues of sober living. But the practical issue could scarcely be disregarded; for the population of London had

[1] See F. Homes Dudden: *Henry Fielding: His Life, Work & Times*. Oxford University Press, 1952.

remained almost static between 1700 and 1750; and, between 1740 and 1742, London parish registers recorded twice as many burials as baptisms.[1] The metropolis still attracted a flood of country immigrants, but a large proportion were wiped out before they had begun to multiply.

Notwithstanding his arrogant chauvinism, Hogarth was not unconscious of the misery at his own door. The artist, whom his contemporaries had claimed as a moralist, now accepted their estimate and became a moralist of the most didactic type. *Industry and Idleness*, published in 1747, before he visited France, *Beer Street* and *Gin Lane* and the *Four Stages of Cruelty*, issued in 1751, are all conceived as moral lessons; and, when he was preparing his attack on cruelty, he determined that he must avoid any suspicion of æsthetic artifice. The " leading points " (he announced) had been " made as obvious as possible, in the hope that their tendency might be seen by men of the lowest rank. Neither minute accuracy of design, nor fine engraving, were deemed necessary; as the latter would render them too expensive for the persons to whom they were intended to be useful . . . To expressing them as I felt them, I have paid the utmost attention; and, as they were addressed to hard hearts, have rather preferred leaving them *hard* . . . The prints were engraved with the hope of in some degree correcting that barbarous treatment of animals, the very sight of which renders the streets of the metropolis so distressing to every feeling mind. If they have had this effect, and checked the progress of cruelty, I am more proud of being their author, than I should be of having painted Raphael's Cartoons."

In this bold assertion, was he completely sincere? We cannot doubt that Hogarth detested cruelty—he had been brought up within sight of Smithfield Market; but it

[1] See G. M. Trevelyan: *English Social History.* Longmans, Green, 1944.

seems possible that, about this time, he may have experienced one of those mysterious lapses of creative energy which chequer the progress of every artist's lifework, and that he was no longer completely sure of the direction that he wished to follow. Be that as it may, *Industry and Idleness* and the *Four Stages of Cruelty* are comparatively uninspired productions, in which both Virtue and Vice cut wooden and uninteresting figures. The Virtuous Apprentice is a moral tailor's dummy, who ingratiates himself with his wealthy employer, woos and wins his master's daughter and achieves the summit of renown by being elected Lord Mayor of London; while his lazy and vicious acquaintance, Tom Idle, sinks by rapid stages, into the metropolitan underworld and eventually gets his deserts beneath the shadow of Tyburn Tree. Hogarth's compositions are unusually stiff and crude. Each plate, however, adds something to his picture of the London background; for, as the Idle Apprentice is shipped off to sea, he passes Cuckold's Point, on the lower reaches of the river, where an executed pirate is hanging in chains; and, when he becomes a footpad, we follow him into a notorious thieves' kitchen, known as the " Bloody Bowl " cellar, which was to be found in Alsatia, the criminal district between the Thames and Fleet Street. The career of the Industrious Apprentice, on the other hand, illustrates the splendours of the City—the sober, dignified brick-built street, lined with the houses of successful merchants, where the virtuous bridegroom, leaning through a ground-floor window in dressing-gown and night-cap, dispenses largesse to the chorus of butchers who have gathered to serenade him, carrying marrow-bones and meat-cleavers: and the stately hall of the Fishmongers' Company where, amid scenes of unrestrained guzzling, he attends a civic banquet. That last plate and the view of Tyburn are certainly the best of the series. Tom goes to

his death, escorted by cavalry and foot-soldiers, and accompanied in the cart by his own coffin and a proselytising Methodist preacher.[1] On a waggon, Mother Douglas —obviously a keen amateur of public solemnities—is raising her eyes and lifting a glass of gin. The hangman smokes his pipe, as he lounges above the scaffold, along the gallows' cross-bar.

The lesson taught by the *Four Stages of Cruelty* is no less deliberately rammed home. Tom Nero, an undeserving Charity Boy, begins by torturing a stray dog, as the driver of a hackney carriage unmercifully thrashes his broken-down horse, murders a servant-girl whom he has previously seduced and persuaded to steal her master's silver, and last appears as a disembowelled corpse, exposed to the cold scientific brutality of the anatomists at Surgeons' Hall. Only in *Gin Lane* does Hogarth seem to have worked with as much imagination as moral fervour. Horace Walpole pronounced it " horridly fine "; and the demonic intensity of Hogarth's vision raises it far above the level of mere copybook morality. Yet the subject-matter was derived from everyday life; and none of his contemporaries complained that his treatment was in the least exaggerated. The stupefied seller of ballads and gin, whose ribs start through the flesh and whose face has shrunken to a skull-like mask, was an apparition actually encountered and drawn: " his cry was, ' buy my ballads, and I'll give you a glass of gin for nothing ' ". A drunken woman lies on the steps, taking snuff and smiling to herself in euphoric coma, while the child rolls from her knees and pitches headlong into the alley below; and the loss of innumerable children, through neglect, disease or infanticide, was one of the chief evils that provoked the passing

[1] Possibly Silas Told, author of the interesting little autobiography, *The Life of Mr. Silas Told, written by Himself*. Epworth Press, 1954.

of the Gin Acts. " What must become an infant (Fielding had demanded in his *Enquiry*) who is conceived in gin, with the poisonous distillations of which it is nourished, both in the womb and at the breast? " Beneath the steps, a dram-shop opens its jaws: above stands the thriving establishment of *S. Gripe. Pawn-Broker;* and a committee, appointed by the Middlesex Sessions in the year 1735, had already reported that weavers, and " other persons of inferior trades concerned in our manufactures ", were in the habit of selling their journeymen daily draughts of gin on credit, " whereby at the week's end " the workers " find themselves without any surplusage to carry home to their families ";[1] which would inevitably drive them first to the pawn-broker, afterwards to starvation or parish-relief. Hogarth's scene is laid in St. Giles's, a district in which gin-shops were particularly numerous; and the pyramidal spire of St. George's, Bloomsbury, completed by Nicholas Hawksmoor in 1730, looks down over the dilapidated house-tops—a symbol of national prosperity and dignity to set off the horrid vision of proletarian degradation.

The reverse of the picture is displayed by *Beer Street.* England was a prosperous country, where the industrious apprentice might, with luck and application, hope to become his own master, and the prudent artisan need not despair of rising in the commercial scale. The English standard of living had always been high: food was plentiful and usually cheap:[2] and the blacksmith, the chairman, the porter, the road-mender and the London fish-wife, if undebauched by poisonous gin, could still afford to refresh themselves with huge pewter tankards of strong ale. Published together at the beginning of February 1751,

[1] See M. Dorothy George: *London Life in the Eighteenth-Century.* Kegan, Paul. 1925. " Hogarth's *Gin Lane* (the author writes) is a historic document whose essential truth is confirmed in numberless details incidentally recorded in the Old Bailey *Session Papers.*"
[2] See M. Dorothy George, *op. cit.*

Hogarth's attacks on cruelty and drunkenness (both of which had a popular effect that may be compared to the effect afterwards exerted by the novels of Charles Dickens) were his last attempts to simplify his art in the interests of a straightforward moral lesson; and even here the artist sometimes prevails against the moralist. Henceforward, as at an earlier period, he was generally more preoccupied with the spectacle of life, so complex, dramatic and absorbing, than with its underlying moral significance; and he was also increasingly concerned with the elaboration of an æsthetic theory. Many vague ideas had been circling in his mind. Many problems had been demanding a solution. What was beauty? How could it be pursued and captured? Was there any single principle, in all the objects he admired, that evoked the exquisite sensations of æsthetic pleasure?

The theory with which Hogarth replied to these questions had been germinating for several years. In his self-portrait of 1745 we have noticed the long curving golden line that rises from the surface of his palette, accompanied by an enigmatic legend: " The Line of Beauty and Grace." During the same year, Vertue records that, among his friends, " Hogarth . . . much comments on the inimitable curve or beauty of the S undulating motion line, admired and inimitable in the antient great Sculptors and painters." As Hogarth was himself to admit, he had introduced it into his self-portrait with the deliberate intention of arousing curiosity. He wished to draw out the artists and critics, whose ideas, he believed, were often " uncertain and contradictory ", and therefore depicted a " serpentine line lying on a painter's palett, with these words under it, THE LINE OF BEAUTY. The bait soon took; and no Egyptian hieroglific ever amused more than it did for a time; painters and sculptors came to me to know the meaning of it, being as much puzzled as other people, till

it came to have some explanation; then, indeed, but not till then, some found it out to be an old acquaintance of theirs, tho' the account they could give of its properties was very near as satisfactory as that which a day-labourer who constantly uses the lever, could give of that machine as a mechanical power." [1]

Hogarth, in fact, must have been developing his system of æsthetics at least since 1745. But the theorist was also an ardent controversialist; he needed a theory against which to react; and one of his strongest incentives in " commencing author " was his desire to expose the pretentions of previous contestants in the critical field. Distinguished among these was Jonathan Richardson. Himself a painter, whom Joshua Reynolds praised for his scientific knowledge of his craft, with the reservation that the style he had adopted was lamentably " cold and hard ", between 1715 and 1719 he had published three important essays, *The Theory of Painting*, *The Art of Criticism* and *The Science of a Connoisseur*. Clearly Richardson was a man of intelligence. Besides writing verse and annotating Milton, he had produced the first English guide-book—compiled during his travels abroad—to Italian works of art. But he was no slavish votary of foreign schools, and had expressed his conviction that English artists might one day rival the Old Masters. This was a point of view that naturally delighted Hogarth; and it has been suggested that Richardson's essays encouraged him to prepare his ambitious scheme of decoration for the staircase of St. Bartholomew's Hospital. Moreover, he paid Richardson the compliment of remembering and re-fashioning certain salient passages. Richardson, too, had asserted that art was an " universal language "; and, while Hogarth announced that he meant to " compose pictures on canvas similar to representations

[1] *The Analysis of Beauty:* Preface.

on the stage ", and that he " endeavoured to treat his subjects as a dramatic writer ", Richardson had already opined that theatrical spectacles were a " sort of moving, speaking pictures, but these are transient; whereas painting remains and is always at hand ". Finally, while Hogarth asks that the " figures in either pictures or prints be considered as players dressed either for the sublime—for genteel comedy, or farce—for high or low life ", Richardson observes that " painting, as well as poetry ", requires an " elevation of genius beyond what pure historical narration does; the painter must imagine his figures to think, speak, and act, as a poet should do in a tragedy or an epick poem . . ."[1]

There the theorists parted company. Richardson's standpoint, after all, was that of the classical idealist: nature (he insisted) must be " improved ", since " common nature is no more fit for a picture than plain narration is for a poem. A painter must raise his ideas beyond what he sees . . . Particularly with respect to mankind, he must as it were raise the whole species." Again he writes: " Nature with all its beauties has its poverties, super-fluities, and defects, which are to be avoided and supplied . . ." And, descending to details, he goes on to declare that, if a painter would achieve the essential qualities of " Grace and Greatness ", when, for example, he is portraying draperies, he must be sure that the linen is " clean and fine: the silks and stuffs new . . ." Like other painters of the eighteenth century—including Watteau, who once advised Lancret never to fail in his attendance at the school of the " master of all masters, Nature "—Hogarth was much exercised over the relationship that should rightly exist between nature and the creative artist, and had himself an almost superstitious reverence for the beauties

[1] *An Essay on the Theory of Painting.*

of " nature unimproved ".[1] Thus he was deeply vexed by Richardson's theories, so alien to his own practice; and the quarrel assumed a personal colouring when, about 1734, he recorded his vexation in a somewhat cruel and indelicate caricature.[2] It seems to have been dashed off at the meeting of a club, which then assembled in St. Martin's Lane at Old Slaughter's Coffee House, the resort of " many respectable literary characters, and of artists of the first eminence . . ."

Here it was customary (says Samuel Ireland) for any member who " had produced an effusion of genius intended for the public eye " to allow his fellow members a private glimpse; and Richardson (who had been born in 1665 and by 1734, no doubt, was an amiably talkative old gentleman) exhibited a " specimen of his intended publication on the works of Milton ", remarking, " in apology for being little conversant in classic authors, that he looked into them through his son. Hogarth (Horace Walpole informs us) whom a quibble could furnish with wit, drew the father peeping through the nether end of a telescope, with which his son was perforated, at a Virgil, aloft on a shelf." Richardson had died in 1745; but for Hogarth he remained a type of the academic virtuoso, a critic, moreover, who had pretended to exalt the miserable trade of connoisseurship to the dignity of an exact science. His essays were in the artist's mind when he decided that he himself might give his ideas a literary shape; and this decision would appear to have coincided with his mood of general restlessness. Already restive during his disas-

[1] See Hogarth's autobiographical sketch: ". . . I grew so profane as to admire nature beyond the first productions of art, and acknowledged I saw, or fancied, delicacies in the life, so far surpassing the utmost efforts of imagination, that . . . I could not help uttering blasphemous expressions against the divinity even of Raphael Urbino, Corregio, and Michael Angelo."

[2] This caricature, a rare example of Hogarth's scatological humour, is to be found in Ireland's *Graphic Illustrations of Hogarth*, vol. i.

trous journey abroad, he was further exasperated by a professional mischance that befell him in 1751. The pictures of *Marriage-à-la-Mode* were still on his hands; the frame-maker's bill had been somewhat heavy; and he now hoped to dispose of them by advertising a second public sale. The painter (Vertue noted) was " after projecting schemes to promote his business in some extraordinary manner ". His extraordinary scheme proved far too elaborate. Hogarth had announced that for the next month his works would be on exhibition, while intending purchasers of the series could write down, seal and deposit their bids, and that, at the end of the month, it would be disposed of to the highest bidder. Though Hogarth's popularity had by no means declined, the public's response was disappointing. Only one collector came forward with a bid; and, after waiting until three o'clock in the expectation of a last-minute rush, he was obliged to accept £126 from a Mr. Lane of Hillingdon.[1] Noticing the artist's dismay, Mr. Lane, who had at first offered £120, suggested that the sale should be kept open for another hour or two, and afterwards generously volunteered to make his sovereigns guineas. Hogarth succeeded in restraining his emotion so long as the purchaser was under his roof; but, once he had taken his leave, a storm of fury swept the studio. According to Vertue, " the sale so mortified Hogarth's high spirit and ambition that it threw him into a rage, and he cursed and damned the public and swore they had all combined together to oppose him . . . And on that day following, in a pet, he took down the Golden Head that stood as a sign above his door."

Such (Vertue felt bound to conclude) was the penalty of unguarded arrogance—Hogarth's " haughty carriage or

[1] By Mr. Lane the pictures were left to his nephew, who sold them in 1797, for £1,050, to Mr. John Julius Angerstein: from whose collection they passed into the National Gallery.

contempt of the other artists ". His behaviour seems to have been particularly unguarded during the course of 1751; for that year he participated with Benjamin Wilson in an elaborate and unkind plot to " render ridiculous certain artists and amateurs who imagined themselves to be connoisseurs of Rembrandt's etchings ".[1] .Thomas Hudson, who, incidentally, had been Richardson's pupil, and with whom Hogarth had had an irritable brush in the sale-room, was selected as the chief victim. Etchings were forged, which Hudson was persuaded to buy, and great excitement prevailed among enthusiastic art-fanciers. So far the joke had been Wilson's, but Hogarth's assistance was soon secured; and, feeling that the pleasantry had gone on long enough, they next determined that they would devote the profits of the fraud to organising a large supper-party, at which the deception would be unmasked and friendly apologies given and received. Twenty-three artists were invited to a gathering, styled by its organisers " an English roast "; Wilson, who sat at the head of the table, had Hudson and Hogarth on his left and right; and a sirloin of beef was placed before him, garnished not with the usual vegetables, but with the spurious etchings stuck on skewers. Hudson, however, remained entirely unperturbed. Apparently he had noticed nothing, until Hogarth leant across their neighbour and handed him an alleged Rembrandt dangling from the point of a fork. His indignation was then extreme, and, his remonstrances becoming loud and angry, Wilson also lost his temper and informed Hudson that, since he was unable to appreciate a harmless jest, it should be published to the world at large. The fictitious etchings were therefore put on sale and eagerly snapped up by frequenters of the metropolitan print-shops.

[1] See W. T. Whitley, *op. cit.* Benjamin Wilson (1721–1788). An industrious and successful painter, noted for his avarice.

Although Wilson had originated the hoax, and both men had rather belatedly planned that it should have a happy ending, Hogarth's share in it must have increased his reputation for haughtiness and self-sufficiency. Despising or distrusting most of his professional colleagues, he had now begun to rely more and more upon the companionship of his literary friends; and, when he set to work to systematise his theory of art, his advisers and assistants were all chosen from among men of letters. No artist was asked to supply suggestions. Hogarth himself had as many ideas as he needed; what he required was practical help in giving them a coherent form. By the painter's enemies it was later suggested that Hogarth's volume had been the product of a caucus, and that his own share in the authorship of the *Analysis* was comparatively trifling. This fallacy has enjoyed a long existence. Only in recent years has modern scholarship, by careful comparison of the handwriting that appears upon successive drafts, shown that Hogarth was, in fact, the sole author of this ambitious essay, and that his supposed collaborators merely revised his text and provided authorities and apposite quotations from their less restricted store of learning.[1] Hogarth freely acknowledged the debts that he owed—to " a gentleman of distinction and known ability " who " took me by the hand, and kindly assisted me more than a third part through the press ", and to other " ingenious friends " who had taken up the task of correction, which, " owing to distance and his particular avocations ", his first mentor had been obliged to leave unfinished. His synod of literary advisers consisted of James Townley, who corrected the preface: Benjamin Hoadly, the son of the Bishop, the " gentleman

[1] See *The Analysis of Beauty, with the Rejected Passages from the Manuscripts and Autobiographical Fragments.* Edited with an Introduction by Joseph Burke. Oxford University Press, 1955. My deep indebtedness, both to Professor Burke's monograph and to his help and encouragement, I have acknowledged elsewhere.

of distinction " who supervised the opening chapters:
James Ralph, Hogarth's neighbour at Chiswick, with
whom the essayist found it difficult to work and who very
soon resigned his functions: and Thomas Morell, also a
country neighbour, who gave his advice on the remaining
sheets. Together they presided over the birth of a book
that must rank among the oddest and most original produc-
tions in the English language.

XII

The Line of Beauty

THE GENESIS of the book was by no means easy. Hogarth
produced two drafts, and in the second greatly enlarged the
outlines of his argument, embellishing his manuscript with
many marginal drawings to be incorporated in the engraved
plates. The third extant draft was made by a copyist,
while a fourth (which has since disappeared) was presumably
the text from which the printers worked. He was constantly
elaborating and enriching his thesis, and altering the
position of individual passages; and any reader who has
had some experience of the pains of authorship—and
knows the difficulty of persuading an author, even when
he seems most anxious for advice, to adopt the suggestions
he actually receives—will sympathise both with Hogarth
himself and with the sufferings of his helpful friends. His
prose style was lively but slipshod—he had had the benefit,
after all, of little formal education; and, in struggling to
improve his sentences, the correctors often gave them a less
idiomatic and characteristic turn. We may assume that,
at least over certain favourite passages, he fought his
assistants step by step. Luckily, the untidy, eccentric
Morell was a patient and good-natured man. He per-
suaded Hogarth to approve his revision of the concluding
chapters; and on December 1st 1753 a handsome quarto
volume reached the hands of an inquisitive public—THE
ANALYSIS OF BEAUTY. *Written with a view of fixing*

the fluctuating IDEAS of TASTE. BY WILLIAM
HOGARTH ... LONDON: *Printed by* J. REEVES
for the AUTHOR, *And Sold by him at his House in*
LEICESTER-FIELDS, MDCCLIII.[1] The well-designed
title-page bore a significant quotation from *Paradise Lost:*

> *So vary'd he, and of his tortuous train*
> *Curl'd many a wanton wreath, in sight of Eve,*
> *To lure her eye . . .*

Beneath these lines was the representation of a crystal-
line pyramid, enclosing an S-shaped curve that rears up like
an angry serpent.

Having considered this mysterious image, the purchaser,
before he embarked on a text that promised to provide
further mysteries, would no doubt have scrutinised the
couple of large engraved plates folded away at the end of
the volume. Plate I depicts a statuary's yard, in which he
would have recognised the Farnese Hercules, the Laocoon,
the Cnidian Aphrodite, the Belvedere Apollo, a reclining
Silenus and a couchant sphinx. But whence has sprung
this elegant French dancing-master who touches a statue's
broken arm? Why is the grotesque effigy of a kilted
Roman general completed by a modern periwig? And
wherefore, all about the central design, with cast-iron rails
closing the background and a multitude of strange inven-
tions—masses of carved stone, scrolls, open books and a
massive wooden leg—scattered across the foreground, has
the artist woven an elaborate border divided into more than
fifty small compartments, each enclosing a separate cut
and showing objects as various and unexpected as a spiny
cactus, a pensive cyclamen, a cherub, two old men's heads,

[1] Like his engravings, his book was subscribed for, the subscription-ticket being
the plate entitled *Columbus Breaking the Egg.* Here Columbus stands for Hogarth
himself, surrounded by detractors who, once they have seen his triumph, declare
that nothing could be more easy. The Line of Beauty is indicated by two eels
on a dish.

a tendril of acanthus, a torso transfixed by a line, an ancient citizen hand-in-hand with an ape, a succession of women's corsets, a brace of candlesticks and a barber's block? Nor, at a glimpse, is Plate II any less extravagant. Here is an admirable ball-room scene, showing the humours of a country dance. But attention is soon distracted from the dancers to the engraved sketches that fill the surrounding frieze—children's faces, the capital of a column, studies of Jacobean ornament, a horn, a convoluted cornucopia, a human thigh-bone and a pair of fingers: lastly, at the top on the left hand, to some entirely incomprehensible diagrams composed of swooping arabesques. If this was art-criticism, the purchaser may have decided, the critic had surely taken his degree at the University of Cloud-Cuckooland.

Slightly more reassuring are the Preface and Introduction, divided by a table of contents. The author had planned his work on a moderately conventional pattern. The first six chapters are said to deal with *Fitness: Variety: Uniformity, Regularity, or Symmetry: Simplicity, or Distinctness: Intricacy: Quantity;* after which he proposes to discuss *Compositions with the Waving Line* and *Compositions with the Serpentine Line*—both topics clearly connected with the serpent-shape upon his title-page—until, in Chapters XVI and XVII, he reaches *Attitude* and *Action,* the latter sub-titled: "*A new method of acquiring an easy and graceful movement of the hand and arms. 2. Of the head, &c. 3. Of dancing, particularly the minuet. 4. Of country-dancing, and, lastly, of stage-action.*" Richardson himself had laid down a somewhat similar scheme, and had discoursed successively on *Invention, Expression, Composition, Design or Drawing, Colouring, Handling, Grace and Greatness, The Sublime;* but, whereas Richardson had likened painting to the other arts, notably dramatic and epic verse, in order to suggest that the

painter must follow the poet, and that he would only
succeed if the ideas he inculculated were " sublime " and
" elevating ", Hogarth, at a single stroke, endeavours to
cut through the critical link that connected æsthetic and
moral beauty. The origins of beauty—and the explanation
of its deep influence upon the human mind—must be
looked for elsewhere. ". . . Though beauty is seen and
confessed by all, yet, from the many fruitless attempts to
account for the cause of its being so, enquiries on this head
have almost been given up; and the subject generally
thought to be a matter of too high and too delicate a nature
to admit of any true or intelligible discussion ". Previous
attempts, he asserts, had failed because search had been
made in the scholar's book-closet or the collector's gallery,
rather than in the professional artist's studio. " It is no
wonder this subject should so long have been thought in-
explicable, since the nature of many parts of it cannot
possibly come within the reach of mere men of letters;
otherwise those ingenious gentlemen who have lately
published treatises upon it (and who have written much
more learnedly than can be expected from one who never
took up the pen before) would not so soon have been be-
wilder'd in their accounts of it, and obliged so suddenly
to turn into the broad, and more beaten path of moral
beauty . . . and withal forced for the same reasons to amuse
their readers with amazing (but often misapplied) enco-
miums on deceased painters and their performances;
wherein they are continually discoursing of effects instead
of developing causes; and after many prettinesses, in very
pleasing language, do fairly set you down just where they
first took you up; honestly confessing that as to GRACE,
the main point in question, they do not even pretend to
know anything of the matter. And indeed how should
they? . . ."

223 ·

Hogarth's *Analysis of Beauty* (its editor reminds us) is "the first work in European literature to make formal values both the starting point *and* basis" of an entire aesthetic system, "a novel and original attempt to define beauty in empirical terms."[1] Such was the strength of his literary production; its weakness is derived from the underlying theory; for the celebrated Line soon becomes what Sterne would call a "Hobby-horse", on which he caracoles wildly over the extensive kingdom of art with mettlesome enthusiasm and cheerful disregard of consequences. Like many of his theories and prepossessions, it had had originated in his early youth. While he was young, as we have already learned, he had "endeavoured to habitate himself to the exercise of a sort of technical memory" and had evolved an artistic shorthand, by means of which he was able to retain the faces and attitudes that caught his attention. This was a method he never abandoned; and Nichols reports a story, told him by a "gentleman still living", who "being once with our painter at the *Bedford Coffee-house* . . . observed him to draw something with a pencil on his nail. Enquiring what had been his employment, he was shewn the countenance (a whimsical one) of a person who was then at a small distance". Hogarth's shorthand was also employed to fix his memory of entire scenes; and, in the extreme left-hand corner of the second plate attached to *The Analysis of Beauty*, we find a row of perplexing hieroglyphics, which (he assures us) was his "preliminary sketch" of the complicated country dance that he has portrayed below. He bids us remark "how few lines are necessary" to convey his subjects' attitudes. "The curve and two straight lines at right angles gave the hint for the fat man's sprawling posture . . . The prim lady . . . in the riding-habit, by

[1] Joseph Burke, *op cit.*

pecking back her elbows, as they call it, from the waste upwards, made a tolerable D, with a straight line under it, to signify the scanty stiffness of her petticoat; and a Z stood for the angular position the body makes with the legs and thighs of the affected fellow in the tye-wig . . . The uniform diamond of a card, was filled up by the flying dress, &c. of the little capering figure in the spencer-wig . . . and lastly, the two waving lines were drawn for the more genteel turns of the two figures at the hither end."

The " genteel ", or graceful, dancers, it will be observed, are represented by undulatory lines; and, Hogarth's head, and his sketch-books and any loose scraps of paper that he happened to carry about with him, being always a repository of linear notes, he seems gradually to have arrived at the daring conclusion that this primitive pictorial alphabet was something far more important than a rough-and-ready technical device: that from it might perhaps be deciphered the secret of aesthetic beauty. Was there not one line that constituted beauty—the gently rolling and expanding curve; while the others—the angles and bulges—were chiefly suited to the delineation of grotesque and comic subjects? An important distinction is made between the Line of Beauty and the Line of Grace; for, whereas the Line of Beauty is two-dimensional, the Line of Grace, its superior, is said to " wave in three dimensions ",[1] if it be static, embracing a whole surface: if it be fluid, as in the motions of a dancer or a race-horse, following the invisible patterns that the moving body appears to describe. Not that all curving lines are beautiful or graceful; " for as amongst the vast variety of waving-lines that may be conceiv'd, there is but one that truly deserves the name of *the line of beauty*, so there is only one precise serpentine-line that I call *the line of grace*." And he proceeds to enforce

[1] Joseph Burke, *op. cit.*

225

his argument by such homely illustrations as whale-boned bodices and chair-legs, sketched for his reader's benefit upon the ample margin of Plate I.

Every theory contains some germs of absurdity; and, before Hogarth had finished his last page, they had already flowered and borne fruit. To assert that the painter or draughtsman should achieve excellence by remaining faithful, in all his undertakings, to one exactly established line is to place an intolerable restraint upon the creative artist's operations; and in his own practice Hogarth never allowed himself to bə unduly hampered by the gospel that he so assiduously preached. He was well aware " that there are no lines in nature ":[1] Chapter XII of *The Analysis of Beauty* informs us that the appearances which an artist's eye reflects are composed of " *lights, shades,* and *colours* "; and Chapter XIII goes on to add that the " pleasure arising from composition, as in a fine landskip, &c. is chiefly owing to the dispositions and assemblages of light and shade, which are so order'd by the principles called OPPOSITION, BREADTH AND SIM-PLICITY, as to produce a just and distinct perception of the objects before us." Even in his drawings, of which comparatively few remain, " the lines (according to a modern expert) are scratchy at times or tremulous, and always broken ... His line is descriptive, rather than searching or incisive, but descriptive of action or movement rather than of form ..." [2] In fact, the doctrine of the Line of Beauty has an emotional and instinctive, but not an intellectual, basis; while the *Analysis* itself is full of obscurities and ambiguities; for Hogarth never quite overcomes the difficulties of his unaccustomed medium. Yet at frequent intervals he breaks through the barrier of words;

[1] A. P. Oppé: *The Drawings of William Hogarth.* Phaidon Press. 1948.
[2] A. P. Oppé, *op. cit.*

and, as often as he succeeds in doing so, the result is capti-
vating. Most of the authorities, with whom he supports
his thesis, were provided, once he had begun to write, by
members of his literary group. Thus Lomazzo's *Trattato
dell'Arte della Pittura*, from which he derived a " certaine
precept of *Michael Angelo* ", advising a painter always to
make his figures pyramidal or serpentlike, had been recom-
mended to his attention by Dr. Kennedy, the " learned
antiquary . . . of whom I afterwards purchased the book ";[1]
but Lomazzo, despite the gibes of his critics, was not a
source on which he originally drew. Nor did Dufresnoy's
Latin poem,[2] translated by Dryden into English prose,
provide more than a few passing hints. Hogarth's *Analysis*
was mainly an original work. It carries the signature of his
personality written large across almost every page.

Thus, although, from a strictly logical standpoint, the
basic theory propounded may not bear examination, the
Line of Beauty has a symbolic value, seen in the context of
his life and work. It denotes not only a method of designing
(which Hogarth did not always follow) but a manner
of seeing and feeling discernible throughout all pictures.
It stands for movement, the spirit of activity, the perpetually
unrolling curve of time; and in Lomazzo's book he had
been delighted to discover, as a confirmation of his own
beliefs, that Leonardo had advised his pupil always to give
his figures a pyramidal or serpentlike form, since " the
greatest grace and life a picture can have, is, that it expresse
Motion: which the Painters call the *spirite* of a picture.
Nowe there is no forme so fitte to express this *motion*, as
that of the flame of fire, which according to *Aristotle* . . . is
an elemente most active of all others: because the form of

[1] Joseph Burke, *op. cit.* Giovanni Paolo Lomazzo (1538–1600) had taken up
literature, on going blind at the age of thirty-three. His treatise was published
in 1584.
[2] Charles Alphonse Dufresnoy (1611–1665), friend and collaborator of Mignard;
his poem, *De Arte Graphica*, appeared in 1668.

the flame thereof is most apt for motion: for it hath a
Conus or sharpe pointe wherewith it seems to divide the
aire, that so it may ascende to its proper sphere. So that
a picture having this forme will be most beautifull."
Dufresnoy had been of the same opinion. "Large
flowing, gliding outlines (he had written) which are in
waves, give not only a grace to the part but to the whole
body . . . A fine figure and its parts ought always to have
a serpent-like and flaming form: naturally those sort of
lines have I know not what of life and seeming motion in
them, which very much resembles the activity of the flame
and of the serpent."

Hence the sharp-pointed pyramid, enclosing a snaky
curve, which the author of the *Analysis* had placed upon his
title page. It symbolised not so much a hard-and-fast
system as the general tendency of the artist's mind—his
delight in movement and variety, and his preference for
the type of composition that keeps the spectator's eye
wandering to and fro between many different centres of
interest. It has been asserted that the *Analysis* is " in
essence the record of the conversion of a baroque artist to
the new rococo faith." [1] This is to employ terms that
Hogarth himself might not have fully understood; and,
moreover, we must not forget that he was still endeavouring
to paint pictures in the Baroque style several years after
the publication of his famous treatise. But, if by "rococo"
we mean an art that has discarded the dramatic solemnity of
Baroque for a more nervous and mobile—or, as Hogarth
would have said, a more " wanton "—approach, he certainly
displays some of the characteristics of the true Rococo
artist. He had much of the restlessness of the Rococo
genius; the fifth chapter of the *Analysis* is devoted to
Intricacy; and here, beginning with the assumption that

[1] J. Isaacs in the *Listener*, July 1947.

" the active mind is ever bent to be employ'd ", he throws
out a series of highly illuminating images:

> " Pursuing is the business of our lives; and even ab-
> stracted from any other view, gives pleasures. Every
> arising difficulty, that for a while attends and interrupts
> the pursuit, gives a sort of spring to the mind . . .
> Wherein would consist the joys of hunting, shooting,
> fishing . . . without the frequent turns and difficulties
> that are daily met with in the pursuit?—how joyless does
> the sportsman return when the hare has not had fair
> play? how lively, and in spirits, even when an old
> cunning one has baffled, and out-run the dogs! "

By means of *Intricacy* and *Variety* (qualities already
dealt with in his second chapter), the artist should do all
that he can to play upon this human instinct:

> " The eye hath this sort of enjoyment in winding walks,
> and serpentine rivers, and all sorts of objects, whose
> forms, as we shall see hereafter, are composed principally
> of what, I call, the *waving* and *serpentine* lines. Intri-
> cacy in form, therefore, I shall define to be that pecu-
> liarity in the lines, which compose it, that *leads the eye
> a wanton kind of chace*, and from the pleasure that gives
> the mind, intitles it to the name of beautiful . . ."

This is the mood—expecting and enjoying a " wanton
kind of chace "—in which we should return to the study
of Hogarth's pictures and of his best engravings, even
though their composition may prove to include as many
straight lines and acute angles as gracious undulating
curves. The *Analysis* provides an important clue to the
proper appreciation of its artist's work; and it has the
additional charm of constantly revealing the author's tastes
and private interests. Apart from his passion for movement

and his love of variety, we note his liking for objects that are substantial, well-built and well adapted to the purpose they serve:

> " Whatever appears to be fit, and proper to answer great purposes, ever satisfies the mind . . . How pleasingly is the idea of firmness in standing convey'd to the eye by the three elegant claws of a table, the three feet of a tea-lamp, or the celebrated tripod of the ancients? "

As a very small man, he is impressed by magnitude, which he associates with a sense of dignity:

> " Elephants and whales please us with their unwieldy greatness. Even large personages, merely for being so, command respect: nay, quantity is an addition to the person which often supplies a deficiency in his figure. The robes of state are always made large and full, because they give a grandeur of appearance, suitable to the offices of the greatest distinction . . . The grandeur of the Eastern dress, which so far surpasses the European, depends as much on quantity as on costliness."

An admirer of strength and practical dexterity, he has at times frequented the boxing-ring:

> " I have heard a blacksmith harangue like an anatomist, or sculptor, on the beauty of a boxer's figure, tho' not perhaps in the same terms; and I firmly believe that one of our common proficients in the athletic art would be able to instruct and direct the best sculptor living. . . in what would give the statue of an English boxer, a much better proportion, as to character, than is to be seen even in the famous group of antique boxers . . . so much admired to this day."

He is fascinated by the exquisite mechanism of the human

body, and prefers the beauty of flesh and blood to the most celebrated ancient marbles:

" Who but a bigot . . . will say that he has not seen faces and necks, hands and arms in living women, that even the Grecian Venus doth but coarsely imitate? "

Yet he is astonished—and here perhaps we may detect a reference to the virtuous but impassive Mrs. Hogarth—that " nature hath afforded us so many lines and shapes to indicate the deficiencies and blemishes of the mind, whilst there are none at all that point out the perfections of it beyond the appearance of common sense and placidity ". For he is always scrutinising the human face—and not only the face itself, but the whole structure of the physical frame as it is developed by a man's profession:

" When we consider the great weight chairmen often have to carry, do we not readily consent that there is propriety and fitness in the tuscan order of their legs? . . . Watermen, too, are of a distinct cast, or character, whose legs are no less remarkable for their smallness . . ."

He is invariably captivated by grace of action, whether in a dancer, a woman curtseying or a pure-bred Arab horse:

" It is known that bodies in motion always describe some line or other in the air . . . Whoever has seen a fine arabian war-horse, unback'd and at liberty, and in a wanton trot, cannot but remember what a large waving line his rising, and at the same time pressing forward, cuts through the air; the equal continuation of which, is varied by his curveting from side to side; whilst his long mane and tale play about in serpentine movements."[1]

[1] There had been Arab horses in English stables since the end of the seventeenth century. Between 1684 and 1724, three famous stallions arrived from the East—the Byerley Turk, the Darley Arabian and the Godolphin Arabian, to become the progenitors of modern bloodstock.

Among the monumental arts, **he** is particularly concerned with that of architecture,[1] and has not lost his early regard for the splendid achievements of Sir Christopher Wren, whose steeples and spires, " dispers'd about the whole city, adorn the prospect of it, and give it an air of opulency and magnificence . . . Of these, and perhaps of any in Europe, St. Mary-le-Bow is the most elegantly varied. St. Bride's in Fleet-street diminishes sweetly by elegant degrees, but its variations, tho' very curious when you are near them, not being quite so bold and distinct . . . it soon loses variety at a distance." For London is constantly in the background of his thoughts: Bartholomew Fair, for example, where, discussing his theory of humour —which he believes often to consist in the association of " improper, or *incompatible* excesses "—he recollects that a clown dressed as a baby " always occasion'd a roar of laughter ". His relish of theatrical spectacles has extended, we learn, to the Italian *Comedia dell' Arte;* and he comments on its different personages, Harlequin, Scaramouch, Pierrot, Punchinello, according to the linear effect they make:

> " Punchinello is droll by being the reverse of all elegance
> . . . The beauty of variety is totally, and comically
> excluded from this character . . . His limbs are raised
> and let fall almost altogether at one time, in parallel
> directions, as if his seeming fewer joints than ordinary,
> were no better than the hinges of a door."

His own sense of humour is playful and easy. In St. Paul's and other London churches, he has often been amused by the congregation of painted and gilded cherubs, with a pair of duck's wings placed under each dimpled chin, " supposed always to be flying about singing psalms.

[1] It is interesting to note that Hogarth had a high opinion both of Windsor Castle and of Westminster Abbey—which he describes as being in " a good gothic taste ".

A painter's representation of heaven would be nothing without swarms of these little inconsistent objects . . . and yet there is something so agreeable in their form, that the eye is reconciled and overlooks the absurdity . . ." He is no less diverted by the contemplation of a " rough shock dog "—such a dog as appears in *Marriage-à-la-Mode*, sniffing at the lace cap that the Earl has stuffed into the pocket of his coat: " The ideas here connected are the inelegant and inanimate figure of a thrum mop, and that of a sensible, friendly animal . . ."

Hair-dressing, botany and the technique of engraving are also included in the subjects that Hogarth lightly touches on:

" It was once the fashion to have two curls of equal size, stuck at the same height close upon the forehead, which probably took its rise from seeing the pretty effect of curls falling loosely over the face. A lock of hair falling thus cross the temples, and by that means breaking the regularity of the oval, has an effect too alluring to be strictly decent, as is very well known to the loose and lowest class of women . . ."

As for his interest in botany, which may well have been encouraged by his friendship with John Ellis, the naturalist,[1] the *Analysis* contains both a description and a delightful illustration of that " curious little flower called the Autumn Syclamen . . . the leaves of which elegantly twist one way only." Hogarth's illustrative images are always based on personal knowledge. If he writes of a flower, it is a flower he has seen and handled; the curls he mentions have been

[1] In a letter, dated November 28th 1757, Hogarth thanks Ellis for his " pretty little seed-cups . . . they are a sweet confirmation of the pleasure Nature seems to take in superadding an elegance of form to most of her works . . . How poor and bungling are all the imitations of art! When I see you next we will sit down —nay to kneel down if you will—and admire these things."
Quoted by W. T. Whitley. *op, cit.*

examined, and probably sketched, in the Covent Garden *demi-monde*; and the homeliness and freshness of his observations often give an imaginative charm to his most pedestrian passages. Thus we have a glimpse of the laborious engraver, who as he works at his copper plate, (which he has already " wrought all over with an edg'd-tool, so as to make it print one even black like night ") inch by inch scraping off the rough grain to produce the high lights and cleaning up the masses of shadow, suddenly reflects that " a landskip, in the process of this way of representing it, doth a little resemble the first coming on of day." Dawn advances beneath the creator's touch, slowly and hesitantly, then more and more deliberately. Dense shadows soften and dissolve. Harmonious outlines at length emerge from the matric of primæval Chaos.

It is no doubt understandable that *The Analysis of Beauty* should have been more warmly welcomed by men of letters than by connoisseurs and professional artists. The literary papers published eulogistic notices; and persons of fashion —then, as now, apt to borrow books that they were not positively obliged to buy—wrote to their friends soliciting the loan of a copy, Lady Luxborough, Shenstone's correspondent, going so far as to regret that, since her marriage, she no longer had an S in her name.[1] Hogarth meanwhile, on November 25th, had despatched a copy to Dr. Thomas Birch, the bustling Secretary to the Royal Society:

> Sir, I beg the favour of you to present to the Royal Society the enclosed work, which will receive great honour by their acceptance of it. I am, Sir, your most obedient humble servant,
>
> <div align="right">WM. HOGARTH</div>

[1] She was the daughter of Henry St. John, first Viscount Bolingbroke.

At Strawberry Hill, Horace Walpole had turned the pages with dispassionate interest. *The Analysis* contained (he decided afterwards) " many sensible hints and observations ", though it " did not carry the conviction, nor meet the universal acquiescence " that its author had expected. But, as a distinguished member of the fashionable world, he added that Hogarth's " two samples of grace "—the young lord and lady represented in the ball-room scene— were " strikingly stiff and affected . . . a *Bath* beau and a county Beauty ". The " hints " that the Analyst provided soon attracted imitators. Four years later, a Dr. Brown, in his *Estimate of the Manners and Principles of the Times*, besides paying a brief compliment to the writer's genius, appropriated several of his theories; whereat James Ralph, reviewing the volume, complained that Dr. Brown had " chosen to be niggard of his acknowledgments ", and asserted that, thanks to Hogarth's efforts, the secret of Beauty had at length been revealed; " composition is at last become a science; the student knows what he is in search of; the connoisseur what to praise; and fancy or fashion, or prescription, will usurp the hacknied name of taste no more." During the same year Edmund Burke himself, in his *Enquiry into the origin of our Ideas of the Sublime and Beautiful*, referred to the " very ingenious Mr. Hogarth, whose idea of the line of beauty I take in general to be extremely just ". The fame of *The Analysis* presently crossed the Channel. German and French translations had appeared before the author's death. In France, the book was both attacked and plagiarised by Diderot; but Lessing published an enthusiastic criticism in a Berlin newspaper.

The author's personal feelings were somewhat mixed. Presumably his hopes ran high—he was always of a sanguine nature; but once again it was " with a smile at his own temerity " that he approached the public in a novel

rôle. The occasion indeed had already provoked him to compose a scrap of verse:

> *What!—a book, and by Hogarth!—then twenty to ten,*
> *All he's gained by the* pencil, *he'll* lose *by the pen.*
> *Perhaps, it may be so,—howe'er, miss or hit,*
> *He will publish,—*here goes—it's double or quit.

In the event, by " commencing author " he won a Pyrrhic victory; for, although literary critics were as kind as he may have expected, the attitude of his fellow artists was even more unfavourable; and they seized on this opportunity of humiliating their haughty colleague. Not a few of them had scores to pay off—Paul Sandby among others, then an ambitious young man of twenty-eight, who, with his elder brother, Thomas, had worked his way up from an ill-paid post attached to a government department and was now establishing his reputation as a minor master of topographical draughtsmanship. He had clashed with Hogarth over the affairs of the St. Martin's Lane School, which Hogarth had helped to found and in which he still took a proprietary pride. Various proposals were at the time on foot for the institution of a Royal Academy, established according to the French model; and it was suggested that the St. Martin's Lane School should be incorporated in the proposed Academy, which would receive an official grant, appoint salaried officers and encourage promising students to travel abroad. Hogarth had attacked this plan —and continued attacking it—with all his usual intemperate zeal. In the first place, he doubted its usefulness: in the second, he deeply distrusted any attempt to give the artist an official standing. Independence must be the artist's watchword; it was by independence that he had prevailed himself. If an Academy were ever imposed on art, he foresaw a generation of subservient painters and a

superfluity of bad pictures. Surely bad pictures were sufficiently numerous? "The world is already glutted with these commodities, which do not perish fast enough to want such a supply."

Thus Hogarth had spoken his mind, bitterly offending Paul Sandby and other keen supporters of the academic project. Their chance came when *The Analysis* emerged. At last Hogarth was open to attack; and their campaign, like so many eighteenth-century campaigns, was launched with the assistance of the London print-sellers, whose windows reflected the scandal, controversies and political gossip of the current season. Inquisitive citizens watched these displays no less eagerly than they scanned the newspapers; and, during December 1753, they were amused by the first of a series of vitriolic prints in which the painter-author was held up to ridicule as a strange specimen of vulgarity, vanity and gross sub-human idiocy. By the standards of the time, the satirist's methods were not exceptionally savage—Hogarth himself had dealt not very charitably with the egregious Kent and the sententious Richardson; but Sandby showed an undoubted skill in catching his subject's personal traits and contriving grotesque improvisations upon his private circumstances. The victim was nicknamed " Painter Pugg "; and it is as half a pug-dog and half a human being that, in *Burlesque sur le Burlesque*, he is shown seated before a monstrous canvas, attended by his dog and an appreciative friend, and surrounded by unsold copies of *The Analysis of Beauty*. *Puggs Graces* was equally diverting; for here the pug-legged and pug-tailed painter confronts a weird sisterhood of repulsive naked models—their deformed carcases, fat or thin, each exemplifying the " Line of Grace "—while a book lies beside him, labelled " Reasons against a Publick Academy ", and a disciple, peering over his shoulder, gives signs of

blank bewilderment. *The Analyst Besh———n* is in a coarser vein; as the ghost of Lomazzo rises from the shades, his imitator is supposed to succumb to the most humiliating effects of physical fear. A numbered key, engraved at the bottom of the plate, identifies, among the various points of interest, "an Author Sinking under the weight of his Saturnine Analysis", "Lomazzo's ghost detecting the Fraud," "Deformity Weeping at the Condition of her Darling Son", "His Faithful Pugg finding his Master by the Scent", "The Author's Friend and Corrector Astonished at the Sight of the Ghost and Smell of the Author" and "A Publick Academy Erecting, in spight of his endeavours to prevent it". Next we have *The Author Run Mad*—Hogarth, fantastically robed and crowned, daubing away at the walls of his cell: *A new DUNCIAD*—Hogarth, in his second infancy, flanked by a harlequin and playing with a child's toy: and *The Painters March from Finchley*, which represents him in full flight from a country village, the latter a parody of *Evening*; for, notwithstanding the well-known innocence of Mrs. Hogarth's character, his head is surmounted by a cuckold's horns.

In Hogarth's defence appeared only a somewhat feeble print, entitled *A Collection of CONNOISSEURS;* whereas his opponent's elaborate and spirited engravings, although overcrowded with letter-press and over-loaded with supernumerary detail, have a fantastic and imaginative quality that gave the satire an added strength. One, at least, has a certain romantic appeal. In a fine setting of classical architecture and melancholy moon-lit trees, Hogarth, the new Herostratus, having set fire to the temple of Ephesian Diana, delves at the impregnable foundations of another antique monument. Sandby's misbegotten monsters and goblins are evidently derived from Callot; but his sketches of Hogarth and his friends are clearly based on observation.

Herostratus's torch-bearer, a stout parsonic shape, was no doubt an impression of his assistant, the Reverend James Townley; while the arrogant, irresponsible Pugg, with his blunt nose and his crooked chin, his large mouth and his round protuberant eyes, bears a convincing resemblance to the features of the self-portrait. Sandby has also captured the small, solid, broad-shouldered frame, the strutting military gait, the hat—so suggestive of Prussian Frederick —" cocked and stuck on one side ". Such personal references seldom fail to wound; and behind Sandby's attack was the impetus of real hatred. Hogarth, it is true, affected a stoical air, remarking that human life was chequered with reverses, and that " every success or advantage " produced some complementary setback; but his stoicism was not proof against this outpouring of inspired malice. " However mean the vender of poisons, the mineral is destructive: —to me (he freely admitted) its operation was troublesome enough."

XIII

Humours of an Election

LUCKILY, PUBLIC affairs were soon to distract his thoughts. Hogarth had always been a keen student of the London newspapers; he was not a man, one supposes, who often threw a newspaper down until he had studied it to the bottom of the sheet—or, rather, if he flung it down, his natural inquisitiveness, sooner or later, would have persuaded him to pick it up again; and the journals of 1753 and 1754 were full of the forthcoming General Election, with particular reference to the County Election to be held at Oxford. Long before the hustings were actually manned, the political struggle waged in the university city, and throughout the adjacent hundreds, had become the " constant topic of almost all our coffee-houses in town "; and the diatribes of envenomed academic pamphleteers and mercenary local journalists were echoed and re-echoed in the columns of the urban press. What gave this provincial election a nation-wide significance? The modern reader, accustomed to the procedure established by a succession of nineteenth-century Reform Bills, is apt to forget that, during the eighteenth century, parliamentary elections were frequently arranged by a system of judicious compromise. Local interests divided the field between them, thus preserving the stability of a time-honoured feudal *status quo*. County elections were unusually expensive, owing to the large numbers of forty-shilling freeholders whose sym-

pathies must be ascertained, aroused or suborned against the advent of election day; and there was no reason to procure at considerable expense results that might equally well be obtained by means of a quiet private treaty. While the magnates of the county were determined to keep the peace, their tenants or dependants, the electors, need not hope to break it.[1]

At times, naturally, they might wish to do so; for, besides much pleasurable excitement and the gratifying sensation that they were exercising a free choice and gallantly enacting the rôle of patriotic Englishmen, a contested election was bound to bring them many material advantages. Whereas the lowlier sort were feasted with beef and beer—election " treats " were always numerous and costly—obscure shopkeepers received a sudden influx of aristocratic patronage, and the humble parson a haunch of venison from his Grace's or his Lordship's park. These benefits might be short-lived: they were none the less agreeable. And when, in the year 1752, the Duke of Marlborough, a devoted Whig or champion of the " New Interest ", decided to break the truce and launch an attack on Oxford—or, as he preferred to style it, " the little kingdom of Jacobitism "—his decision was as welcome to the freeholders as it was disconcerting and exasperating to wealthy supporters of the opposite cause.[2] His challenge, however, could not be disregarded; and for the next two years—under the Septennial Act Parliament was not due to be dissolved until the spring of 1754—the opposing forces gradually assembled in an atmosphere of increasing

[1] In Northamptonshire, for example, during the whole century, contests were held on only three occasions; only three counties would go to the polls in the General Election of 1761. See R. J. Robson's entertaining and informative volume, *The Oxford Election of 1754*. Oxford University Press, 1949.

[2] According to the previous arrangement, Lord Guilford and the Duke of Marlborough, as Whigs, had controlled the boroughs of Woodstock and Banbury, while the County was represented by Tory country gentlemen.

excitement, Homeric taunts being hurled to and fro, while the protagonists looked to their weapons and buckled on their armour.

Both physically and politically, none loomed so large as that massive champion of the " Old Interest ", Sir James Dashwood of Northbrook and Kirklington, a tun-bellied country gentleman who since 1740 had represented the County of Oxford in the House of Commons. A rich and important landowner, Sir James had a wide circle of Jacobite acquaintances—with whom his association, nevertheless, seems generally to have been convivial rather than political—and was rumoured to have demonstrated his loyalty to the Stuarts by planting a covert of Scottish firs upon a knoll that dominated Kirklington Park. As an orator, he was undistinguished; and the best that his friends could say of one of the rare speeches he found it expedient to deliver in the House of Commons was that he had " spoken intelligibly with the voice of a man and an Englishman ". Yet this perfect type of the Conservative squire, corpulent, good-humoured, hard-drinking, devoted to his generous stake in the county that he helped to govern, was separated by only two generations from the world of commerce. His grandfather, Alderman George Dashwood, had been a brewer and a scrivener; and by his adversaries Sir James was often referred to as " The Jolly Brewer ":

> *See but yesterday's knight, how lordly he struts,*
> *With a carcase the size of his ancestor's butts.*

Arrayed at his side, in the ranks of the Old Interest, stood his cousin, Lord Wenman of Thame and Caswell, holder of an Irish title and member for the City of Oxford; while confronting them were Sir Edward Turner of Ambrosden, an amiable if somewhat ineffective personage with a taste for Gothic architecture and an unfortunate record of

political tergiversation, and Lord Parker, the eldest son of the astronomer Earl of Macclesfield. Such were the adversaries brought into the lists by the Duke of Marlborough's inconsiderate move; and, although the standards they raised bore various devices and their war-cries were frequently inspired by local spite and prejudice, the main issues they disputed were of consequence to the whole kingdom. The New Interest were henchmen of the Court Party: the Old Interest, representatives of a large and influential section of the British populace that had not yet acquiesced in the blessings of Hanoverian rule. They opposed the extravagance of modern governments and deplored the rapid growth of taxation, both direct and indirect. The Land Tax was specially offensive; and they complained that the proceeds of taxation were devoted to the upkeep of huge and unnecessary standing armies. More vaguely, they asserted that every Whig, notwithstanding his adherence to the present dynasty, was at heart a Republican, an unrepentant " King-Killer ", just as the New Interest claimed that every Tory was at heart a Jacobite, pointing out that it was the existence of Jacobite plots that obliged the government to impose taxes, maintain a standing army and increase the burden of the National Debt. The Tory country gentlemen made a virtue of their " independency "—the independence enjoyed by any party that has been long in opposition.

Each Interest had its colours—blue for the Old, green for the New; and very soon verdant and azure cockades began to blossom thick along the streets of Oxfordshire towns and villages. As early as the December of 1752, Dashwood and Wenman, attended by a body-guard of gentlemen's servants, marching two and two, musicians with drums, trumpets and French horns, a large procession of freeholders, fifteen coaches and banners bearing the legends

Pro Patria, No Bribery, No Corruption and *Liberty, Property, Independency,* had advanced on the town of Henley, where a dinner was held and speeches were delivered, in which the candidates, disdaining the urban wiles of their subtle Whig antagonists, apostrophised their well-fed supporters, not in " pathetick " or " admirable " phraseology, but " in the honesty of their true British hearts ". Similarly, during February 1753, the New Interest summoned their partisans to attend them at the Bear Inn in Oxford, there to approve the choice of Turner and Parker as candidates, and thus " exercise a right of which they have long been deprived ". As the New Interest procession assembled outside Christ Church, they were assailed by the clamour of an " honest " Old Interest mob, rhythmically bellowing " A Wenman! A Dashwood! . . ."

Canvassing of equal vigour was carried on, not only in Oxford and the surrounding districts, but in London itself, where many Oxford freeholders had their houses and places of business; and we hear of Dashwood hard at work among wax-chandlers, brandy merchants, cheesemongers and sugar-bakers, whom he entertained regularly at the King's Arms and One Tun Tavern opposite Hungerford Market and the Saracen's Head in Friday Street; while Parker and Turner retorted with a lavish opposition treat. Volleys of satirical election literature were discharged on both sides; and not a few minor contestants, recommended by their oddity or absurdity, achieved a passing journalistic fame. For instance, there was Lady Susan Keck—nicknamed " Lord Sue " by writers of the Old Interest—wife of the candidate for Woodstock (the Duke of Marlborough's family preserve), who devoted herself with passionate energy to the campaign against the Old Interest and, mounted on horses from her husband's racing stable, spurred like a political amazon into the remotest villages.

Also singled out for particular notice was a New Interest don, Thomas Bray of Christ Church (a college that, together with Exeter, was distinguished from the rest of the University by its Whiggish and Hanoverian bent), whom an ignominious private misfortune had exposed to widespread public ridicule. A certain Theodosia Cornel, an Oxford street-walker, had imputed to Mr. Bray the paternity of her illegitimate child; and, although the woman was afterwards convicted of slander, Bray and his Theodosia became favourite targets of Old Interest pamphleteering. Professional journalists, of course, took a share in the game; but amateur satirists were not behindhand; and several eminent academic personages contributed lampoons, parodies and squibs, which added to the virulence of Grub Street all the accumulated rancour of an Oxford senior common room. Augustan Oxford, usually so stagnant, had seldom seen such entertaining years.

Described by its modern historian as the " most literate " of eighteenth-century election contests, the Oxfordshire Election was to derive a fresh impetus, and acquire new acrimony, from the events of 1753. A further issue emerged—the notorious " Jew Bill ". This mild and praiseworthy measure would have enabled foreign Jews, resident in England, to become naturalised by Act of Parliament, subject to the same limitations as their native co-religionists.[1] The Jewish colony was by no means numerous, though respectable and influential; and it seemed fair enough that those who had been born abroad should be allowed to exercise the restricted freedom already granted to their English kin. The proposal, however, aroused fierce resentment and drew down upon the heads of the government an " inexhaustible torrent of ribaldry."

[1] These disabilities they shared, of course, with Roman Catholics and Dissenters.

It was suggested that the Jewish influx would soon absorb the whole realm; an unknown Jew, near the Royal Exchange, was alleged to have been overheard remarking that he now hoped to live to see the day when he would " not meet a Christian in this place or any Englishmen in the Kingdom "; and there was talk of the probable condition of England in the year 1854, when a Sanhedrin would sit at Westminster, St. Paul's would be a synagogue, and for the statue of Sir John Barnard in the City would have been substituted that of Pontius Pilate. The agitation spread to the provinces; and Ipswich urchins were said to have surrounded the Bishop of Norwich, noisily begging him to circumcise them. The government thereupon gave way; and, six months after it had been passed, the alarming Act was hastily repealed.

Meanwhile, Old Interest propaganda had not let the occasion slip. As True-Blue defenders of British liberty, Wenman and Dashwood were loud in their condemnation of this invidious and subversive Bill; and Dashwood, contrary to his usual practice, addressed his fellow members—in a " very curious speech of almost unheard-of oratory ". At Oxford, where a Jew can very rarely have been seen, except as an itinerant pedlar, and the idea of a Jewish invasion was correspondingly dreadful, his anti-Semitism had the required effect. The New Interest might compare him to a pantomime-actor, and announce that, in the " new farce called Repeal or Harlequin ", the part of Harlequin had been " done intolerably bad ". But Oxfordshire responded to his call; and at Bicester the church bells rang all day, and loyal toasts were vociferously drunk, amid shouts of " No Jews! No Naturalization! Wenman and Dashwood for ever! "

So the preliminary stages of the election followed their lively and disorderly course. Treating was lavish, drunk-

enness widespread and physical violence not uncommon. In January 1754, the Old Interest offered the corporation and freemen of Oxford the " most plentiful entertainment ever known in the memory of man "; whereas the New was content to meet at various taverns and drink the health of the Duke of Marlborough, because (hinted their opponents) the two sheep-stealers commissioned to procure mutton had just been arrested and committed to the local gaol. Frequent clashes occurred between organised mobs. At Banbury, an Old Interest gang, inflamed with free liquor by the " domestick of a certain gentleman ", grossly affronted " one honourable person " who had attended a New Interest supper-party; and at Chipping Norton, where the Old Interest faction had set an example by throwing stones, the New Interest burst into the White Hart and brutally assaulted a Tory gentleman who was dining there.

At length the electors went to the polls—from April 17th to April 23rd 1754. Hustings had been erected in front of Exeter College; but New Interest supporters found it difficult to penetrate the dense Old Interest mob that opposed them twenty men deep; and at this point the Fellows of Exeter, devout adherents of the government party, resorted to a skilful and (their adversaries considered) an extremely unfair stratagem. Voters were admitted through the back-gate on the Turl and allowed to pass out again through the Broad Street main-gate. They could thus enter the hustings from the rear; but, during its passage, the ungrateful electorate abused the Fellows' hospitality. The Hall of the College became a scene of Bacchanalian merriment, " offuscated " with clouds of tobacco smoke, obstructed by casks of ale and polluted by the presence of loose women. Exeter, as the Tory Vice-Chancellor declared, had signally disgraced itself and, by

the excesses it permitted, remained " *per aliquot dies foedata et conspurcata . . .*"

Yet Exeter's stratagem failed to turn the tide; and, when the poll was made known, both Old Interest candidates had sizeable majorities. A scrutiny was at once demanded; petitions, alleging corruption and other irregularities, were eventually laid before the House of Commons; and, after numerous sittings, Turner and Parker were declared to be the rightful victors. But controversy did not die down. Two pretended plots, the " Rag " and " Watch " plots, each of them intended to convict the Old Interest of treasonable Popish designs, were opportunely brought to light; and, on the heels of the High Sheriff's inconclusive scrutiny, there was a final burst of violence as a body of New Interest supporters drove in procession across Magdalen Bridge. Their carriages were pelted with filth, and an " honest " mob made desperate attempts to hurl them into the river below; at which a Captain Turton leaned from his post-chaise and shot down, mortally wounding, an aggressive Tory chimney-sweep.

So much for the topical background of Hogarth's *Election Series*, the last pictorial drama that he was ever to stage. But a comparison of his picture with the actual course of events at once reveals many significant discrepancies. The Oxford contest had supplied a hint; but, as always, Hogarth did not make use of his material until it had gone through lengthy interior processes of digestion and assimilation. Clearly he did not attempt to provide a literal representation of Oxfordshire scenes or personages. His election is held in the country; behind the final scene, *Chairing the Member*, we observe the unpretentious redbrick buildings of a quiet English country town. Indeed, since a scrutiny was at once demanded, none of the candidates was carried in triumph; while Hogarth seems

deliberately to have confused his audience by giving orange, instead of green, cockades to the supporters of the New Interest. But the campaign against the Jew Bill is reflected in the *Entertainment* episode; and, in the same picture, we find a reference to one of the actual Whig contestants. A blue banner—probably snatched from the Tory procession by the broken-headed New Interest bravo whose raw wound is being dressed with gin—bears the inscription: *Give Us Back Our Eleven Days*; and, as President of the Royal Society, Parker's father, Lord Macclesfield, had helped Chesterfield to prepare his case for the adoption of the Gregorian Calendar in September 1752, by which September 3rd became arbitrarily September 14th. This "Popish" innovation both puzzled and dismayed the British proletariat; and the cry, "Give us back the eleven days we have been robbed of!" was taken up by the conservative mob, who felt that eleven precious days had been wrenched out of their life-span. Some of Lord Macclesfield's consequent unpopularity appears to have followed his son to Oxford.

Yet, in another aspect, the resemblance is close. It was the singularity of the Oxfordshire Election, at a period when such conflicts were rare, that excited Hogarth's fancy; and what he gives us is a generalised view of party corruption and political discord. Though he himself had sprung from the people, he had a realistic appreciation of the dangerous effects of popular feeling. Popular agitation had defeated the Jew Bill, just as in 1733 it had whipped up the Excise Riots; and *The Election Entertainment*—one of those "treats" which Old and New Interests alike showered on their supporters—shows us a popular orgy that threatens to overwhelm the politicians who promoted it. The New Interest is standing treat here—they have disfigured the portrait of a Stuart sovereign which decorates the dining-room

249

wall; but beneath the window of the country inn streams an excited Old Interest procession, armed with staves and brickbats, carrying the effigy of a bearded Jew, roughly labelled " No Jews ", and flags displaying the legends " Liberty " and " Marry and Multiply in spite of the Devil ".[1] A chamber-pot is emptied on to their heads, and three bricks skim through the open casement. One of them scores a lucky hit; and the election agent reels from his stool at the table, dropping the register of votes and over-turning a bottle of wine.

Within the room, all is heat and confusion and noise. A fiddler scrapes: punch is brewed on the floor: the chairman, his fork still impaling a very large oyster, has succumbed to apoplexy. An " ignorant and ferocious populace " is swilling and guzzling at their betters' expense; and the gentry join in the fun with varying degrees of cynicism or good humour. The elder candidate, not very sober himself, struggles feebly against the boisterous endearments of two extremely drunk supporters; but his colleague, a smooth and fashionable youth, submits complacently to the lascivious caresses of a stout and aged Doll Tearsheet, though a little girl is filching his diamond ring and his wig is being set on fire. *Canvassing for Votes* and *The Polling* depict further stages of a contested election in full swing. Money is pressed into a farmer's palms by representatives of both parties, a plump ingratiating innkeeper and a lean and truculent sailor; and the blind, the dying and the mad are hustled to the polling-book. Then, at last, the victorious member is chaired—incidentally, he does not resemble either of the two candidates hitherto exhibited, since Hogarth has chosen to portray that notorious place-hunter and backstairs-politician, George Bubb

[1] A reference to the recent Marriage Bill, introduced by the first Lord Hardwicke and aimed at the suppression of irregular marriages.

Dodington—and is nearly upset by a fight that breaks out in the crowd between an old sailor, turned bear-leader, and a furious countryman swinging a flail. Blackened chimney-sweeps look down from the churchyard gate; and politicians and political agents are carousing in an upper chamber. As the banner carried by the procession explains, it is the Old Interest that has gained the day.

Although the *Election Series* has a topical message and a political and moral point of view, like Hogarth's earlier series it is also an illustration of how far the artist's creative impulse may transcend and transform the limited aims that he had begun by setting himself. In their present resting-place, Sir John Soane's Museum, they hang alongside the *Rake's Progress*, executed in 1733; and, during the last twenty years, the artist-dramatist had first immensely enlarged, then completely escaped from, the narrow framework of his original stage. Whereas the Rake's decline and fall is presented by means of a succession of entertaining, but often cramped and somewhat badly lighted, peep-shows, in the *Election Series* every window of the painter's imagination appears to have been thrown wide. A golden illumination beams down from the summer sky: noble trees soar into the air among the rose-red house-fronts. As for the human figures who move in the foreground, they combine the charm of incisive characterisation —Bubb Doddington's terrified face: the swooning girl behind the churchyard-wall, supported by a negro servant: even the elderly man at the election banquet who is suffering agonies from an attack of the gravel—with a proper regard for the complex decorative schemes in which they are incorporated. The effect is tumultuous but never over-crowded; again the spectator's eye is led on a " wanton kind of chase "; and, having considered the *dramatis personæ*, he may find equal enjoyment in the details of their

251

still-life setting: a heap of oyster-shells, a wine-bottle over-turned, a jug, a lobster, a pile of dirty plates, a flowering plant under the arch of a bridge, or the folds of a linen cloth dragging from a three-legged table.

The painted series was sold to David Garrick, who hung them in his Thames-side villa; the engravings, which started with the *Election Entertainment*, were published at intervals between February 1755 and January 1758. Meanwhile, for the last time, Hogarth had returned to " history-painting ", and in 1756 had accepted a fee of £525 to produce a canvas that should embellish the altar of St. Mary's Redcliffe, Bristol—another gallant attempt at a manner of expression that did not suit his real genius. During the same year, he endeavoured to beat a patriotic big drum. The peace of Europe had once more been broken: during 1756 England found herself involved in a bitter colonial struggle with France, which engaged her men and ships in America, India and the West Indies. Abroad, Pitt's " object was to take the initiative in every quarter of the globe and prevent the French from concentrating their efforts on any one field of action, bewildering them by lightning strokes and so leading them to dissipate their forces . . ." [1] But, at home, there were often threats of invasion; and Hogarth issued a pair of topical prints, *The Invasion* or *France and England*, which display the beef-bred English cheerfully preparing to defend their own soil, while the starveling French, accompanied by a sadistic monk and all the apparatus of the Inquisition's torture-chambers, get ready to embark in a flotilla of invasion craft.

No invasion, in fact, was ever launched; and, after the succession of blunders and disasters with which every Eng-

[1] Basil Williams : *The Whig Supremacy, 1714–1760.* Oxford History of England. Oxford University Press. 1939.

lish government is accustomed to begin a war, despatches soon reached London that announced brilliant victories by land and sea—Wolfe victorious, Clive triumphant, Rodney sweeping the Channel and battering the French ports—until the church-bells rang so often for victory that they were said to be almost past ringing. Hogarth shared in the national prosperity. The lucrative commission to produce an altar-piece was followed, a year later, by his appointment—with the help of " my friend Mr. Manning and the Duke of Devonshire "—as " Serjeant-Painter of all his Majesty's works ", a post that had fallen vacant on the death of his brother-in-law, John Thornhill. His official salary was only ten pounds; " but by two portraits at more than eighty pounds each . . . and some other things," it had (according to his subsequent calculation) " for these last five years, been one way or other worth two hundred pounds per annum ". He assumed his appointment on June 6th 1757. Together with the " profits of my former productions ", it left him (he tells us) " tolerably easy in my circumstances ". But he was still by no means easy in his mind; and, having declared that henceforward he meant to devote himself to portrait-painting, he now as suddenly announced that, being at length " thoroughly sick of the idle quackery of criticism ", he had determined to lay aside his brush and revert to his engraving tools. " In this humble walk I had one advantage: the perpetual fluctuations in the manners of the time enabled me to introduce new characters, which being drawn from the passing day, had a chance of more originality, and less insipidity, than those that are repeated again and again, and again, from old stories. Added to this, the prints which I had previously engraved were now become a voluminous work, and circulated not only through England but over Europe. These being secured to me by an act which I had

253

. . . got passed, were a kind of an estate; and as they wore, I could repair and retouch them; so that in some particulars they became better than when first engraved."

From this decision to revert to engraving (which, indeed, he had not yet given up) sprang a pair of accomplished prints, *The Bench* issued in 1758, and *The Cockpit* in 1759. Neither is particularly topical: for each deals with some of the basic qualities of human nature rather than with the extravagances of the passing day. *The Bench* depicts Justice under its most forbidding aspect. Hogarth's sketches of a bevy of eminent judges, drawn from life in the Court of Common Pleas, bring out all that is pompous, insensitive, perhaps secretly sadistic, in the judicial character. The fat-faced judge is loftily scanning a document; his lean colleagues suggest a pair of vultures, slumbering amid their plumage. It is their swaddled impassivity, their bewigged and befurred bulk, that makes these figures formidable; while a hurricane of insensate activity revolves around *The Cockpit*. Here, as in the gambling episode of the *Rake's Progress* and the Countess' levée in *Marriage-à-la-Mode*, Hogarth portrays a crowd made up of isolated human beings, every individual the prisoner of his own passions, cut off from the rest of humanity by the urgency of his own desires. But none is stranger or more solitary than the central personage. As regards composition, Hogarth would appear to have been indebted to Leonardo's *Last Supper*; and the master of the feast is a renowned sporting eccentric named Lord Albemarle Bertie, a younger son of the Duke of Ancaster. He is also to be seen in *The March to Finchley* where he attends a prize-fight. Records of eighteenth-century life, in addition to the long list of dilettante noblemen, describe many celebrated sporting swells; but " what rendered his lordship's passion for amusements of this nature very singular, (writes the Reverend John Trusler,

author of *Hogarth Moralized*) was his being totally blind."
Alone, secluded in utter darkness, his hat before him
brimming with bank-notes—one of which a neighbour
steals—he presides over pandemonium, still offering and
accepting bets. He cannot see the cocks which are dying
on the sand; but he can hear and feel the corybantic
excitement, the " celestial anarchy and confusion ", of his
fellow gamblers. Their meeting-place is the Old Cock Pit,
off Birdcage Walk, St. James's Park. At least in its pursuit
of pleasure, the eighteenth century was a democratic age;
and the Cockpit, like Tom King's, attracted a strangely
various company. A foreigner ambassador and an English
duke, the latter wearing his star, the former the Order of
the Saint Esprit, are packed in here among butchers and
jockeys, chimney-sweeps and pickpockets. On the wall is
a portrait of Nan Rawlins, the well-known London cock-
handler; and the shadow of a man in a basket is thrown
across the arena below. He is an unlucky or dishonest
gambler, punished by the " merry mob . . . for having lost
a bet he was not able to pay". But even from the basket he
continues to follow the game, and is now desperately
attempting to pledge his watch.

Hogarth's determination to abandon painting had not,
of course, been formed in secret. Naturally he published
it to the world at large; and, just as naturally, he allowed
himself to be persuaded to undertake a farewell-picture.
The request came from Lord Charlemont, " an amiable
nobleman." [1] As for the subject, it was to be " my own
choice, and the reward,—whatever I demanded." The
story he had pitched upon (the painter explains) was a
young and virtuous married woman, who, while playing
cards with an officer, loses her money and her jewellery;

[1] A fine unfinished portrait of the Earl of Charlemont, looking conspicuously
amiable, is now in the Keith Kane Collection.

" the moment when he offers them back in return for her honour, and she is wavering at his suit, was my point of time ". There resulted the *Lady's Last Stake*, a gay and well-painted piece of pictorial narrative, in which Hester Salusbury (as she afterwards claimed) supplied the portrait of the hesitant lady. Lord Charlemont " highly approved " of his purchase, and in a letter dated January 29th 1750 enclosed a draft for one hundred pounds—a " noble " payment, Hogarth considered; though " the manner in which it was made . . . was, to me, infinitely more grati-fying than treble the sum." The covering letter, indeed, throws an agreeable light on the happy relationship that often existed between an eighteenth-century artist and his aristocratic patrons. Each was conscious of benefits con-ferred and received. He was " really much ashamed (Hogarth's patron confesses) to offer such a trifle in recom-pense for the pains you have taken, and the pleasure your picture has afforded me. I beg you would think that I by no means attempt to pay you according to your merit, but according to my own abilities . . . Imagine that you have made me a present of the picture, for literally as such I take it, and that I have begged your acceptance of the inclosed trifle. As this is really the case, with how much reason do I subscribe myself,

Your most obliged humble servant,

CHARLEMONT "

Unfortunately, " this elevating circumstance " encour-aged the artist to attempt a second farewell-gesture. While he was at work on the *Lady's Last Stake*, " a gentleman (now a nobleman) "—Sir Richard Grosvenor, who was raised to the peerage as Earl Grosvenor in 1761—" seeing this picture, pressed me with much vehemence to paint another for him upon the same terms." Hogarth tells us

Bubb Dodington. Detail from *Chairing the Member*. From the *Election Series*

Details from *The Banquet*. From the *Election Series*

that he agreed " reluctantly ", and adds that, by doing so, he had " brought on a train of most dissatisfactory circumstances, which by happening at a time when I thought myself, as it were, landed, and secure from tugging any longer at the oar, were rendered doubly distressing." Sir Richard's conduct turned out to be as shabby as Lord Charlemont's had been graceful. But the painter must also bear some blame; for he now revealed one of those astonishing errors of judgement of which he had often been guilty since he arrived at middle age. Again he showed a remarkable blindness to the character of his true gifts, and elected to treat a literary theme in the Italianate Baroque-heroic style. "... As I had been frequently flattered for my power of giving expression, I thought the figure of Sigismunda weeping over the heart of her lover,[1] would enable me to display it. Impressed with this idea, I fixed upon this very difficult subject. My object was dramatic, and my aim to draw tears from the spectator ... It ... struck me that it was worth trying, if a painter could not ... touch the heart through the eye, as the player does through the ear. Thus far I have been gratified; I have more than once seen the tear of sympathy trickle down the cheek of a female, while she has been contemplating the picture." But Sir Richard Grosvenor proved less impressionable, notwithstanding his polite protests; and the majority of contemporary critics, including almost all Hogarth's professional colleagues, greeted the canvas with opprobrious laughter. They dismissed *Sigismunda* as a contemptible daub, that contrived to violate every canon of beauty.

For the features and attitude of the heroine herself, they reserved their most abusive phrases—abuse that the artist found particularly painful, since his model had been Jane

[1] Hogarth's literary source was Dryden's adaptation of Boccaccio's story.

Hogarth, and he is said to have been inspired by the sketches he had once made of his wife weeping over her mother's bier. To-day the indignation that this picture provoked is somewhat difficult to understand. True, *Sigismunda* is a laborious and conventional work, in which the painter employs an unfamiliar and unsympathetic style, merely for the satisfaction of showing he has mastered it; true, the disconsolate heroine has a somewhat mawkish and affected air; but there is nothing about the canvas to excuse or explain the tempest of fury that it drew down. Critics responded to it as though to a personal insult. Horace Walpole was especially aggrieved. Sigismunda (he informed George Montagu on May 5th 1761) " is exactly a maudlin whore, tearing off the trinkets that her keeper has given her, to fling at his head. She has her father's picture in a bracelet on her arm, and her fingers are bloody with the heart, as if she had just bought a sheep's pluck in St. James's Market." He returned to the charge in *Anecdotes of Painting*: " Not to mention the wretchedness of the colouring,[1] it was the representation of a maudlin strumpet just turned out of keeping . . . with eyes red with rage and usquebaugh . . ." Here the strength of the critic's indignation has led to some inaccuracies. Sigismunda's eyes are inflamed with grief; but her large, handsome, rather stupid face does not suggest a whisky-drinker. She is not in the act of tearing off her trinkets; nor, at least in the completed version, are her finger-tips imbrued with blood . . .

Hogarth seems to have worked slowly and administered many loving retouches; but, while the canvas was still on the easel, Sir Richard Grosvenor took sudden fright. The painter could only suppose that his arch-enemies, the

[1] Though dim, the colour-scheme is not unpleasing—an arrangement of blues, olive green and slightly tarnished yellow.

" dealers in old pictures ", had once again been actively
engaged; and he therefore wrote to Sir Richard, offering
to release him from his bond. It was both a sensible and
a magnanimous letter:

" SIR,
 I have done all I can to the picture of Sigismunda;
you may remember you was pleased to say you would
give me what price I should think fit to set upon any
subject I would paint for you, and at the time you made
this generous offer, I in return made it my request, that
you would use no ceremony in refusing the picture when
done, if you should not be thoroughly satisfied with it.
This you promised should be as I pleased, which I now
entreat you to comply with, without the least hesitation,
if you should think four hundred[1] too much money for
it. One more favour I have to beg, which is, that you
will determine on this matter as soon as you can con-
veniently, that I may resolve whether I shall go about
another picture, for Mr. Hoare the banker, on the same
conditions, or stop here."

Sir Richard's reply was patently disingenuous:

" SIR,
 I should sooner have answered yours of the 13th
instant, but have been mostly out of town. I understand
by it that you have a commission from Mr. Hoare for
a picture. If he should have taken a fancy to the Sigis-
munda, I have no sort of objection to your letting him
have it; for I really think the performance so striking
and inimitable, that the constantly having it before one's
eyes, would be too often occasioning melancholy ideas to

[1] Sir Richard Grosvenor had recently paid £400 for a picture alleged to be
by Correggio—in fact, by Francesco Furini—based upon the same theme.
Hogarth had calculated his fee accordingly.

arise in one's mind, which a curtain's being drawn before it would not diminish in the least."

Hogarth wrote again, a little more anxiously:

" SIR RICHARD,

As your obliging answer to my letter in regard to the picture of Sigismunda did not seem quite positive, I beg leave to conclude you intend to comply with my request, if I do not hear from you within a week."

Sir Richard (we are told) did not think fit to " take any further notice of the affair." During his youth, Hogarth had been confronted with a somewhat similar mischance; an aged peer, renowned for his ugliness, had declined to take delivery of his completed portrait; and the painter had thereupon warned his client that, unless he were prepared to accept the picture, it would presently be put on exhibition in a celebrated wild-beast show. Such light-heartedness was no longer possible. Although with the help of a friend, the poetaster Paul Whitehead, he commemorated Sir Richard's alleged susceptibility in some doggerel verses—

> *I own he chose the prudent part,*
> *Rather to break his word than heart;*
> *And yet, methinks, 'tis ticklish dealing,*
> *With one so delicate—in feeling.*

—the wound that had been dealt him penetrated very deep. Even worse than the attacks that followed the publication of *The Analysis of Beauty* was the hurricane of ridicule that burst over Sigismunda's head. " Ill-nature spread so fast that now was the time for every little dog in the profession to bark . . . The anxiety that attends endeavouring to recollect ideas long dormant, and the misfortune which

260

clung to this transaction, coming at a time when nature demands quiet, and something besides exercise to cheer it, added to my long sedentary life, brought on an illness which continued twelve months." Hogarth entered the sixth decade of the century a tired and dispirited man.

XIV

Wilkes and Churchill

THE EXACT NATURE of his illness we do not know; but apparently it was an internal disorder; and, when he " got well enough to ride on horse back ", Hogarth tells us that he " soon recovered ". Little work was done in 1760; but, during 1761 and the first eight months of 1762, he produced some lively and characteristic engravings, which suggest that neither his talents nor his prejudices had yet begun to lose their strength. For example, there were the frontispiece and tailpiece to the *Catalogue of Pictures exhibited in Spring Gardens*. At this exhibition, organised during May 1761 by the Society of Arts of Great Britain in opposition to a rival body, the Society of Arts, which Hogarth had already attacked, he showed not only the *Election Entertainment, Calais Gate,* the *Lady's Last Stake* and three portraits, but the unlucky *Sigismunda* herself, stationing a man close to the canvas, with instructions that he should take down in writing every criticism that he overheard. The most pertinent observation came from a visitor who seemed to be a lunatic, and who, after staring at the picture for some time, abruptly turned away, muttering: " Damn it, I hate those white roses! " Hogarth then noticed that the folds of Sigismunda's sleeves [1] were " too regular and had more the appearance of roses than of linen ",

[1] The painting of *Sigismunda's* right sleeve is, indeed, far livelier and fresher than any of the surrounding brushwork.

and made the necessary alterations. The picture, nevertheless, remained unsold; and, whereas his frontispiece expresses the artist's hopes—independent British art is protected and cherished by enlightened royal patronage —the tailpiece reflects his abiding sense of grievance. A fashionably attired, Gallicised ape—no doubt fresh from the Grand Tour—winks malevolently as he holds a watering-can over three flower-pots containing withered " Exoticks ".

In *Time Smoking a Picture* (originally planned as a subscription-ticket for *Sigismunda*, at a time when he still hoped that it might be sold by auction) he dealt yet another blow, almost his last, against the picture-dealers and the Connoisseurs. Here Time, with his scythe and his wings and a large jar of disfiguring varnish, puffs tobacco-smoke over the picture that he intends to darken and thereby improve. Hogarth had never reverenced antiquity for its own sake; and when, in 1761, James Stuart and Nicholas Revett announced the forthcoming publication of their famous and influential work, *The Antiquities of Athens Measured and Delineated*, Hogarth satirised such antiquarian zeal by proposing, in *The five orders of Perriwigs . . . measured Architectonically*, that the triumphs of the modern hairdresser should be studied and classified according to the same system. Other prints issued before the autumn of 1762 are the excellent profile of *Henry Fielding, Aetatis XLVIII*—drawn from memory, since the novelist, worn out by his varied labours, had died in 1754—and *Credulity, Superstition, and Fanaticism. A Medley.* The latter is full of curious contemporary detail; for Hogarth's object was to provide a " lineal representation of the strange effects of literal and low conceptions of Sacred Beings, as also the Idolatrous tendency of Pictures in Churches and Prints in Religious Books "; and, besides a fire-breathing Papist and

a canting Methodist, he includes two well-known impostors
—" the Bilston nail-spouter ", who professed to vomit
rusty nails, and Mary Tofts, " the Godalming rabbit-
breeder ", who pretended that, during her convulsive
paroxysms, she frequently gave birth to rabbits . . .[1]

Meanwhile the satirist's attention had again shifted
towards the political prospect. This was a period of intense
public excitement " when war at home and contention at
home engrossed every one's mind ", and prints, that did
not possess some direct topical and controversial appeal,
were " thrown into the background ". Hogarth believed
that he was in danger of losing his audience: he had a
feeling that he might be left behind; " and the stagnation
rendered it necessary that I should do some *timed thing*, to
recover my lost time, and stop a gap in my income ". Such,
at least, was the excuse he afterwards gave; although a
biographer who reviews his previous record, and remembers
the spirit of restlessness and contrariety that seems to have
dogged him throughout his middle years, may conclude that
he was probably obeying some deeper and more irrational
impulse. If the result of his decision may be described as
a tragedy, Hogarth had many of the qualifications of the
tragic victim—the pride, accompanied by secret dissatis-
faction, that often follows great success, the state of hybristic
self-confidence that prepares the way for a sudden downfall.
In so far as he walked into a trap, we are bound to admit
that he did so of his own accord, and that even the opponents
who eventually sprang the trap warned him that, should he
persist, he must expect to take the consequences. But
the victim, once he had recovered his health, was parti-
cularly impatient of advice or criticism; and his state of

[1] Mary Tofts's claims were championed by a notorious medical charlatan,
Monsieur Saint-André, who had gained considerable favour at the Court of
George I. Her story was widely believed; and " the public horror was so great
that the rent of rabbit-warrens sunk to nothing; and nobody, till the delusion
was over, presumed to eat a rabbit."

mind is nowhere more clearly reflected than in Horace
Walpole's account of a conversation that took place during
1761.

Walpole pretended to believe that the painter was losing
his wits. "... The true frantic Oestrus (he wrote to George
Montagu on May 5th) resides at present with Mr. Hogarth;
I went t'other morning to see a portrait he is painting of
Mr. Fox.[1] Hogarth told me he had promised, if Mr. Fox
would sit as he liked to make as good a picture as Vandyke
or Rubens could. I was silent—'Why now,' said he, 'you
think this very vain, but why should one not speak truth?'
This *truth* was uttered in the face of his own Sigismunda ...
As I was going, Hogarth put on a very grave face, and said,
'Mr. Walpole, I want to speak to you.' I sat down, and
said, I was ready to receive his commands. For shortness,
I will mark this wonderful dialogue by initial letters.

"*H.* I am told you are going to entertain the town with
something in our way. *W.* Not very soon, Mr. Hogarth.
H. I wish you would let me have it, to correct; I should
be very sorry to have you expose yourself to censure; we
painters must know more of these things than other people.
W. Do you think nobody understands painting but painters?
H. Oh! so far from it, there's Reynolds, who certainly has
genius; why, but t'other day he offered a hundred pounds
for a picture, that I would not hang in my cellar; and,
indeed, to say truth, I have generally found, that persons
who had studied least were the best judges of it; but what
I particularly wished to say to you was about Sir James
Thornhill ... I would not have you say anything against
him; there was a book published some time ago, abusing
him, and it gave great offence ... *W.* My work will go
no lower than one thousand seven hundred, and I really

[1] The first Lord Holland. The portrait is now in the possession of Lord
Ilchester.

have not considered whether Sir J. Thornhill will come within my plan or not; if he does, I fear you and I shall not agree upon his merits. *H*. I wish you would let me correct it; besides, I am writing something of the same kind myself; I should be sorry we should clash. *W*. I believe it is not much known what my work is, very few persons have seen it. *H*. Why, it is a critical history of painting, is not it? *W*. No, it is an antiquarian history . . . *H*. Oh! if it is an antiquarian work, we shall not clash; mine is a critical work; I don't know whether I shall ever publish it. It is rather an apology for painters. I think it is owing to the good sense of the English that they have not painted better. *W*. My dear Mr. Hogarth, I must take my leave of you, you now grow too wild—and I left him. If I had stayed, there remained nothing but for him to bite me."

This dialogue, recorded by the greatest social reporter of his age, shows both Hogarth and Walpole in their more unpleasing aspect. The painter is pompous and officious: the fashionable critic, insolently bland. Walpole seems to have caught, however, the characteristic tone of Hogarth's voice—a tone in which bustling self-assertiveness was now mingled with uneasiness . . . But, to understand the disaster that overtook him during 1762 and 1763, we must look back for a moment towards the autumn months of 1760. Last night (wrote Horace Walpole to George Montagu on October 25th) the King had gone to bed in perfect health and, being the most punctual of men, had risen at six o'clock, his usual hour, " looked, I suppose, if all his money was in his pocket, and called for his chocolate. A little after seven, he went into the water-closet; the German *valet de chambre* heard a noise, listened, heard something like a groan, ran in, and found the hero of Oudenarde and Dettingen on the floor, with a gash on his

right temple, by falling against the corner of a bureau. He tried to speak, could not, and expired." His elder son, the indiscreet and unfortunate Frederick, whom both his father and his mother had bitterly detested, having died in 1751, the throne devolved upon his grand-son, an innocent and high-minded young man, born in 1738. The immediate impression that George produced was favourable: his reign (Walpole reported) had begun " with great propriety ", and the new King had " in general behaved with the greatest propriety, dignity, and decency." It soon became evident, nevertheless, that George III was likely to play a far more active political rôle than had been played by George II or George I. " The King seems resolved (commented Laurence Sterne) to bring all things back to their original principles . . . The present system being to remove that phalanx of great people, which stood between the throne and the subjects "—in other words to break down the oligarchic rule of the great Whig families which had now continued without interruption for over forty-five years. As Lord Waldegrave, his former Governor, had remarked in 1758, the young man was " strictly honest "; but the resolution he displayed was " mixed with too much obstinacy ".[1] His obstinacy was not long in emerging: " he is inflexible (added Sterne)—this puts the old stagers off their game."

Behind him—so, at least, his critics considered—there lurked an evil genius, John Stuart, third Earl of Bute, whose intimate friendship with Frederick Prince of Wales was said to have begun at a cold and showery race-meeting, when the Prince was looking around for a courtier to take a hand at cards. After Frederick's death he had remained at Leicester House as the young Prince's adviser and his

[1] See "King George III. A Study in Personality" by Sir Lewis Namier. *History Today*. September 1953.

mother the Princess's friend and confidant; and, once George had succeeded to the throne, he started on a cautious but steady ascent towards the highest office of the state. He had achieved that position by the early summer of 1762. Pitt had resigned during the previous autumn. At the end of May, as First Lord of the Treasury in succession to the Duke of Newcastle, Bute, a Scotsman and a Tory, became the King's chief minister. Every royal favourite incurs some odium: the public campaign against Bute was prosecuted with hysterical violence. Not even Sir Robert Walpole had been more fiercely maligned. " The Thane " was a beggarly Highlander: an adulterous Machiavell, whose influence was derived from an illicit connection with the Princess: a fount of domestic corruption: an intriguing peace-monger, pledged to abandon the profits of a glorious and successful war. Bute retaliated by organising his private troop of journalistic men-at-arms. As a counter-blast to the *Monitor*, a lively Opposition sheet, he commissioned Tobias Smollett, a fellow Scotsman, to edit a new weekly, entitled the *Briton*, of which the first number appeared on May 29th. Lord Temple, Pitt's brother-in-law and the Opposition's moving spirit, then enlisted the services of that powerful controversialist, John Wilkes—Member of Parliament for Aylesbury and already known as " Lord Temple's man "—who founded a paper entitled the *North Briton*, which opened its campaign against the Government at the beginning of the next month. Less than a week had elapsed before the *Auditor*, edited by Arthur Murphy—the Irish dramatist, Johnson's " dear Mur "—was launched in defence of the administration. Among writers allied to the Government, besides Smollett and Murphy, was Samuel Johnson who, despite his previous strictures on pensions and pensioners, now himself received a royal pension of £300 a year; but Wilkes had the help

of Robert Lloyd and—a far more talented assistant—the celebrated satirist, Charles Churchill.

Wilkes and Churchill together might have intimidated all but the boldest or most incautious adversary. Each of them possessed great gifts, hampered by very few scruples: each had the temperament of a soldier of fortune, who relishes conflict for its own sake. Each was courageous, and each was dissolute. John Wilkes, spoiled son of a wealthy distiller, was at the time a man of thirty-four. Member of Parliament since 1757, he had entered politics in the hope of obtaining some lucrative official reward and, preparatory to attacking the administration, had made numerous attempts to secure an embassy or a governorship. It was his boon-companion, Thomas Potter, rakish offspring of the Archbishop of Canterbury, who had first recommended Wilkes to Pitt and Temple, just as it was through Potter that he seems to have been initiated into the priapic mysteries of the Hell Fire Club. In both circles he had soon distinguished himself. For Wilkes, pleasure and business were never hard to reconcile: he was equally at his ease amid the " Monks of Medmenham ", whoring and drinking with Sir Francis Dashwood's raffish cronies, or in serious political conclave with the chieftains of the Opposition group. But, to counterbalance his successful opportunism, he had many more endearing qualities. That he was intrepid, none could deny: he hazarded his life in a number of desperate duels—once with an opponent whom he believed to be a hired assassin—and, to courage and pugnacity and abounding vitality, he added an extraordinary personal charm. Though his appearance was unusually ill-favoured, the effect of a ferocious squint being accentuated by his short ugly nose and his underhanging lower-jaw, he claimed that he needed only half an hour in which to " talk away my face "; and, while men were

delighted by his conversation, his gaiety and air of masculine vigour captivated a long series of adoring mistresses. Nor was he incapable of genuine affection. Wilkes proved a bad husband, but an indulgent and devoted father. The companions he really valued found him a considerate and loyal friend. For Charles Churchill he had a deep regard, which, although based on a community of ambitions and appetites, at length transcended self-interest.

Less engaging are the features of Churchill, whose large, loosely pendent jowl frames the sharp angry mask of a thin man imprisoned in a fat man's carcass. His wide sensual mouth has a cruel downward twist; and the black hair combed over his low bulging forehead gives him the expression of an adolescent school-bully. Unlike Wilkes, he had experienced early hardships; his father was an obscure London clergyman; and Churchill himself had unwillingly taken Holy Orders. He had also, when he was sixteen and still at the University, contracted an imprudent marriage; and thereafter he had existed as best he might, occupying a couple of country parsonages, teaching at a boys' school and a fashionable academy for young ladies, becoming curate in succession to his father at a London parish church and finally adventuring into the journalistic and literary world. *The Rosciad*, his first successful poem, a picturesque satire on the modern stage, appeared in February 1761; and, having now discarded his improvident wife and thrown off some of the load of debt that for the last few years had been steadily accumulating, he emerged as a poetic celebrity and a well-known man of pleasure. Instead of the black gown that suited his profession, he assumed a blue coat, " edged with narrow gold lace ", a buff waistcoat and black silk breeches. Churchill's demeanour was as bold as his appearance was dashing. He possessed a physical strength uncommon in

literary men; to back up his satirical verve, he had the muscular equipment of a veteran prize-fighter.

Where he encountered Wilkes we do not know; but in 1762, at the time when Wilkes had undertaken to found the *North Briton* and was searching him for a likely co-editor, it was natural that he should apply to Churchill, who had repeated the success of *The Rosciad* by publishing *The Apology*, a poem in which the critics of *The Rosciad*, especially Smollett, were belaboured in his most ferocious style. Both men were acquainted with Hogarth, an old frequenter of Covent Garden and a fellow member of the Shakespeare Club, " a weekly club (according to Horace Walpole) . . . held at the top of Covent Garden Theatre and composed of players and the loosest revellers of the age ", for whose president, David Garrick, Hogarth had designed an elaborate chair,[1] with a portrait-medallion on the back carved from the wood of Shakespeare's mulberry-tree. Since he had already had some opportunity of studying his antagonists at close quarters, it seems doubly strange that Hogarth should suddenly have decided to rush into the lions' den. He had had no training in political controversy and, at least until the publication of the *Election Series*, he had advertised no political interests. Nevertheless, he allowed it to be understood that he now considered himself a champion of the ministerial party, and that he contemplated producing " some *timed thing* ", in which Bute would be defended, and his opponents, Temple and Pitt, and their chief henchmen, Wilkes and Churchill, would receive an appropriate reprimand. Though Nichols and Steevens were afterwards to suggest that Hogarth had undertaken this print " through a hope the salary of his appointment as Serjeant-Painter would be increased by

[1] This curious and unattractive piece of furniture is depicted in Ireland's *Graphic Illustrations*.

such a show of zeal ", we need not assume that his motives were first and foremost mercenary. The King (he may have considered) was young and well-meaning; and Hogarth, who loved the young, had always been an advocate of fair play. Besides, there was the question of personal good faith. As a salaried servant of the Crown, did he not owe allegiance to the Monarch's favourite minister? At all events, having announced his decision, he refused obstinately to be turned back.

Wilkes was bellicose, but by no means hard-hearted; and when news reached him, in his lodgings at Winchester, where, as colonel of the Buckinghamshire militia, he commanded a prisoner-of-war camp, that Hogarth intended to produce a satire that ridiculed himself and his allies, he did everything he decently could to persuade the satirist to think again. He had " remonstrated (says Wilkes) by two of their common friends to Mr. Hogarth " that the step he proposed " would not only be unfriendly in the highest degree, but extremely injudicious "; for his " pencil ought to be universal and moral, to speak to all ages, and to all nations, not to be dipt in the dirt of the faction of a day . . ." Hogarth's answer to this good-natured warning revealed a singular insensitiveness. He replied that neither Wilkes nor Churchill was attacked in his print, " though Lord Temple and Mr. Pitt were ", and that the production of which Wilkes spoke would very soon be published. Wilkes prided himself on his loyalty to his friends; and he therefore despatched a second message, carried by the same agency, informing Mr. Hogarth that " Mr. *Wilkes* should never believe it worth his while to take notice of any reflections upon himself; but if his friends were attacked, he should then think he was wounded in the most sensible part, and would, as well as he was able, revenge their cause; adding, that if he thought the *North Briton* would insert what he

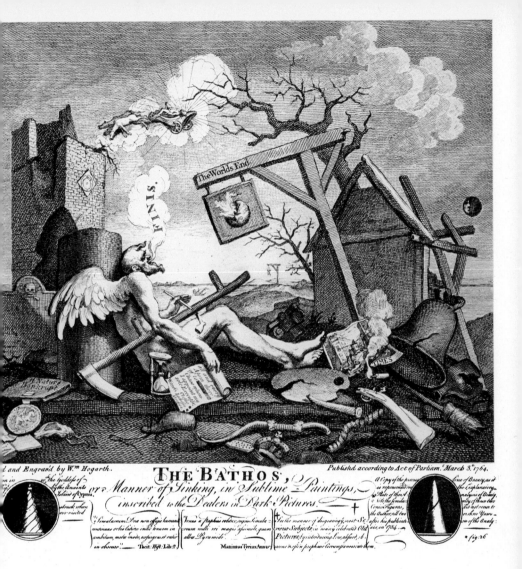

Tail Piece: The Bathos

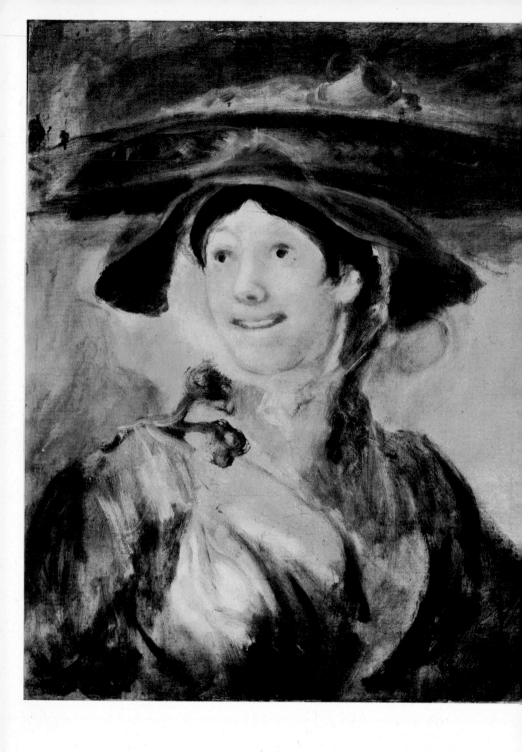

The Shrimp Girl

sent, he would make an appeal to the public on the very *Saturday* following the publication of the print." The *North Briton* was, of course, his own organ; but, at the moment, foreseeing his future difficulties, Wilkes was still anxious to disclaim the editorship.

The Times appeared on September 7th. Like most eighteenth-century cartoons, Hogarth's engraving is somewhat confused and over-crowded; but he has managed to give his symbolic imagery a strikingly dramatic and portentous form. A great city has been set ablaze; the glare of the conflagration wavers up towards a darkened sky; and the flames that have already engulfed a street now threaten an impressive corner-building, which over its open doorway exhibits the sign of the Globe. The globe itself has begun to catch fire; and, as a fireman, who wears a royal badge, a grenadier, a trousered sailor and a group of kilted Highlanders, do their best to avert the catastrophe with the help of a chain of buckets and a clumsy wooden fire-engine, various sinister personages work desperately to impede their efforts. Poised upon stilts, wielding a pair of bellows, is the tall emaciated figure of William Pitt; from a window of the " Temple Coffee House ", a featureless malcontent— Lord Temple was always careful to remain an anonymous influence behind the scenes—directs the jet of a huge doctor's syringe at the firemen in the street below; while from an attic his two assistants also bring their syringes to bear. Simultaneously, a grimacing madman—said to have been intended for the Duke of Newcastle—trundles his barrow, loaded with copies of the *Monitor* and the *North Briton*, across the engine's leaky hose. Victims of the conflagration encumber the foreground, including a moribund female, who has just given birth to a still-born child, and a crazy fiddler in a gold-laced hat, believed to represent the King of Prussia. Only a Dutch merchant seems

thoroughly contented, as he squats puffing at his clay pipe: war-mongers who ruin their own country help to increase the legitimate profits of the neutral businessman.

At his house in Great George Street, Westminster, to which he had been recalled from his regiment by the affairs of the *North Briton*, Wilkes received *The Times* on September 9th. " Hogarth (he wrote to Churchill) has begun the attack to-day—I shall attack him in hobbling prose, you will I hope in smooth-pac'd verse . . ." [1] Churchill, the most unreliable of assistants, was just then undergoing one of his numerous amatory misadventures—" What I imagined to be St. Anthony's fire turns out to be St. Cytherea's "—and irritably looked forward to yet another salivation; but he replied that he would soon be coming to London to examine and discuss the print. Meanwhile, on September 25th, Wilkes produced his own rejoinder. Number 17 of the *North Briton*, headed by a caricature of the artist, reminiscent of the small self-portrait in *Calais Gate*, was almost entirely devoted to tearing Hogarth limb from limb. Wilkes's invective may be less polished than that of the anonymous author of the Junius letters: it remains an admirable specimen of journalistic diatribe. Each point is carefully considered. Wilkes begins, moderately enough, by suggesting that the artist had been unwise to leave his proper field:

" The humourous Mr. *Hogarth*, the *supposed* author of the *Analysis of Beauty*, has at last entered the list of politicians . . . *Words are man's province*, says *Pope*; but they are not Mr. *Hogarth's* province . . . We all titter the instant he takes up a *pen*, but we tremble when we see the *pencil* in his hand. I will do him the justice to

[1] See *The Correspondence of John Wilkes & Charles Churchill*. Edited by Edward H. Weatherly. Colombia University Press, 1954.

say, that he possesses the rare talent of gibbetting in colours, and that in most of his works he has been a very good moral satirist. His forte is there, and he should have kept it. When he has at any time deviated from *his own peculiar walk*, he has never failed to make himself perfectly ridiculous."

Here Wilkes cites his victim's latest failure to achieve distinction in the grand style:

" The favourite *Sigismunda*, the labour of so many years, the boasted effort of his art, was not *human*. If the figure had a resemblance to any thing ever on earth, or had the least pretence to meaning or expression, it was what he had seen, or perhaps made, in real life, his own wife in an agony of passion; but of what passion no connoisseur could guess. All his friends remember what tiresome discourses were held by him day after day about the transcendent merit of it, and how the great names of *Raphael*, *Vandyke*, and others, were made to yield the palm of beauty, grace, expression, &c. to him, for this long laboured, yet still, *uninteresting*, single figure. The value he himself set on this, as well as on some other of his works, almost exceeds belief . . ."

If Hogarth has failed in the grand style, it is because he has always been concerned to " shew the *faulty* and *dark* side of every object. He never gives us in perfection the *fair face of nature*, but admirably well holds out her deformities to ridicule. The reason is plain. All objects are painted on his *retina* in a grotesque manner . . . He has succeeded very happily in the way of humour, and has miscarried in every other attempt. This has arisen in some measure from his head, but much more from his heart." Did he not set out, after *Marriage-à-la-Mode*, to portray the

satisfactions of a happy marriage?[1] ". . . The rancour
and malevolence of his heart made him very soon turn with
envy and disgust from objects of so pleasing contempla-
tion . . ." In his attitude towards professional colleagues,
he has displayed no less envy and no less spite. " How
often has he been remarked to droop at the fair and honest
applause given even to a friend, though he had particular
obligations to the very same gentleman! " The public at
large he secretly despises: it has " never had the least share
of Hogarth's regard, or . . . good-will. *Gain* and *vanity*
have steered his little bark " from his prosperous beginnings
to his disastrous close. For now the artist's genius, " which
should take in all ages and countries ", has " sunk to a level
with the miserable tribe of party-etchers . . . entering into
the poor politics of the faction of the day, and descending
into low personal abuse, instead of instructing the world,
as he could once, by manly moral satire ". Although, in the
March to Finchley, he had not hesitated to satirise the dis-
cipline of the Royal Foot Guards, he is to-day Serjeant-
Painter to the King—" I think the term means the same
as what is vulgarly called *house*-painter "; whereas " the
post of portrait-painter is given to a *Scotsman*, one *Ramsay* ".
This interloper will be commissioned to fill the royal
portrait-gallery: Mr. Hogarth, his critic imagines, " is
only to paint the wainscot of the rooms . . ." The reference
to Allan Ramsay was particularly galling, because Hogarth
shared Wilkes' opinion of the Scottish painter's professional
talents; and many other gibes, woven into the essay, were
calculated to catch him off his guard. But it was the
mention of Jane Hogarth that seems to have offended and
hurt him most. Perhaps there had been trouble between
husband and wife, caused, it may well be, by Hogarth's

[1] Traces of this unfinished series are preserved in three oil-sketches and three
much later engravings, said to have been based on Hogarth's work. See R. B.
Beckett, *op. cit.*

rambling bohemian habits. His private life, he felt, had
been brutally profaned; his critics had " endeavoured to
wound the peace of my family. This was a cruelty hardly
to be forgiven . . ." But the enemies he had so carelessly
aroused had even crueller weapons in store.

XV

"Tail Piece: The Bathos"

BEFORE THE second assault had been opened, Hogarth was exposed to a hail of savage pinpricks. During the next twelve months, over twenty-five cartoons were circulated in which the rash author of *The Times* was more or less directly ridiculed. One of the caricaturists was a personal foe—Paul Sandby renewed his attacks in 1762 and 1763; but the majority were industrious journeymen who turned on Hogarth merely because he was now identified with the defenders of the ministerial party. Yet each had his separate barb: each injected his tiny gout of venom. The Line of Beauty was re-christened " The Line of Buty ", alternatively " The Line of Booty ". Many of Hogarth's own prints were adapted and parodied; and only a few days after the publication of *The Times*, Sandby produced *The BUTIFYER*, based on Hogarth's juvenile *Burlington Gate*, in which the artist is shown white-washing a gigantic jack-boot, with a Scottish peasant and his bare-bottomed brats hovering greedily nearby. " The Boot," a popular symbol of oppression, and his alleged satellite's famous Line are often caricatured in the same plate. Thus Lord Townshend, a Whiggish amateur with a taste for draughtsmanship, contributed *The Boot & the Block-Head*, where a barber's-block, which arises from a boot, is surmounted by a Scottish bonnet, its pendant ribbons forming the pre-

scribed curve; while Hogarth, who holds *The Times*, cowers at the approach of Churchill, who grasps a copy of the *North Briton*. *A set of BLOCKS for Hogarth's Wigs*, issued in September 1762, also refers to the *Analysis*. Hogarth throughout is represented as one of Bute's chief mercenaries, said to grow fat on the rich pickings of ministerial oppression and fraud.

Thus, in *The VISION or Ministerial Monster; addressed to the Friends of Old England by Sybilla Prophecy*, 1763, we see Corruption suckling its young, and Hogarth crouching at its feet with his palette and his paint-pot. He reappears in a cartoon entitled *The Hungry Mob of Scriblers and Etchers*, a group that includes Samuel Johnson and Tobias Smollett: in *The Raree Show—a Political Contrast to the Print of the Times*: in *A Brush for the Sign-Painters*: in *Tit for Tat*, which depicts him wearing a kilt: and in *Observations on The Times*, which imposes Hogarth's jaunty head upon the neck of a despondent donkey. Although the artist is roughly handled, he receives no more outrageous treatment than the King's mother and her friend Lord Bute. Their alleged *liaison* was endlessly satirised, with every scabrous detail that happened to occur to the satirist's fancy; and these brutal and indecent sheets, like the cartoons attacking Hogarth, were freely exhibited by all the London print-sellers. But Hogarth at the moment was unusually vulnerable. Ill-health had sapped his powers of resistance; and, as he was " at that time very weak, and in a kind of low fever," Wilkes's " malign " and " infamous " essay, he declared, " could not but seize upon a feeling mind ". For days, we are told, he had carried the paper round in his pocket, constantly pulling it out to show to his acquaintances. Wilkes (he liked to believe), " till now rather my friend and flatterer ... when pushed even by his best friends, was driven ... to say, he was drunk when he

wrote it." But this was little consolation—Wilkes, drunk or sober, had not failed to send his shafts home; and the attentions of the hack-caricaturists helped to keep the wound open. Their adversary, Wilkes informed Lord Temple, was dying of a broken heart.

Hogarth was by no means dying: the " fiery particle " of his genius was not yet extinguished: but his constitution, already shaken, had received a serious setback. We know that he was ill in 1759 and during the greater part of 1760; and his malady may well have begun at a far more distant period. Throughout his life he is said to have been absent-minded and to have suffered from a bad memory; but in later life his absent-mindedness, which often indicates some deep physical disturbance, became extremely noticeable. Thus, soon after he had " set up his carriage "—its door emblazoned with a symbol representing the principle of Serpentine Beauty—he once had occasion to visit the Lord Mayor at the Mansion House. " When he went, (Nichols tells us) the weather was fine; but business detained him till a violent shower of rain came on. He was let out of the Mansion-house by a different door from that at which he entered; and, seeing the rain, began immediately to call for a hackney-coach. Not one was to be met with on any of the neighbouring stands; and our artist sallied forth to brave the storm, and actually reached *Leicester-fields* without bestowing a thought on his own carriage, till Mrs. Hogarth (surprised to see him so wet and splashed) asked where he had left it."

Certainly he was in weak health towards the end of 1762; and Wilkes writes to Churchill on December 5th that " Hogarth is too ill to be able to attend " a meeting of the Shakespeare Club. It is possible that he was also reluctant to confront his unfriendly fellow-members; but he had never been accused of cowardice and, had his condition

been sound, he might have welcomed a decisive trial of strength. For Hogarth had not yet withdrawn from the struggle; he was still nursing ideas of revenge; and Wilkes's career, faster and more dangerous as the months went by, gave him reason to hope that he would soon find his opportunity. The *North Briton* remained as savage and reckless as ever; stung by some abusive references in the number of August 21st, Lord Talbot, the Lord High Steward of the realm, had challenged the editor to a duel; and the two gentlemen had met with horse-pistols on Bagshot Heath. The duel, as it happened, had concluded in laughter and good-fellowship; Talbot, impressed by Wilkes's courage, had paid him effusive compliments, and desired that " we might be good friends, and retire to the inn to drink a bottle of claret together . . ." But Wilkes's quarrel with the Tory government, although its ministers proved remarkably forbearing, was not to be settled on such easy terms.

Again and again, he had cheerfully dabbled in treason. On three occasions, at least, he had published extremely broad hints that Lord Bute and the Princess of Wales maintained an adulterous intercourse; yet not until the spring of 1733 did the administration strike back. Meanwhile Bute had resigned, and had been succeeded by George Grenville, Lord Temple's brother but his political antagonist. In April, when Parliament reassembled, Wilkes, who had temporarily suspended publication of the *North Briton*, renewed his campaign with the famous Number Forty-Five, fiercely criticising the King's Speech—which " has always been considered by the legislature, and by the public at large, as the *speech of the Minister* "—attacking the recent conclusion of the peace-treaty, and describing the Grenville administration as a " weak, disjointed, incapable set ", through whom " the favourite still meditates

to rule this kingdom with a rod of iron ". The editor and printers of the *North Briton* were thereupon arrested under a so-called " General Warrant ". The legality of the warrant, which authorised the arrest of several unnamed persons, including Wilkes and all his helpers, was thought to be exceedingly questionable; and Wilkes, who now became, as he himself afterwards observed, " a patriot by accident ", succeeded in raising his own plight to the dignity of a constitutional issue. On April 30th 1763, he was committed to the Tower of London: on the following Tuesday, he appeared before Lord Chief Pratt—luckily a supporter of Pitt—at the Court of Common Pleas. Although Pratt declined to pronounce positively that general warrants were illegal, he declared that Wilkes was immune from arrest as a member of the House of Commons. Wilkes left the Court a popular hero. For the first time the thunderous war-cry " Wilkes and Liberty! " was heard along the London streets.

Hogarth had attended the court—skulking (Wilkes complained) " in a corner of the gallery . . . and while Chief Justice *Pratt* . . . was enforcing the great principles of *Magna Charta*, and the *English* constitution . . . wholly employed in caricaturing the *person* of the man . . ." He made prompt and effective use of the sketches that he brought away, and on May 16th issued a shilling print, *John Wilkes Esq.* *Drawn from the Life and Etch'd in Aquafortis* . . ., one of his finest satirical portraits and, according both to his friends and to his foes, an inimitable likeness of the person represented. Here is Wilkes in his hour of triumph, impudent, easy and self-assured, grinning cheerfully at his allies in court, squinting sardonic defiance at his official persecutors. Beside the chair he straddles are copies of the *North Briton*: Number 45, his criticism of the King's Speech, and Number 17, which had contained

his attack on William Hogarth. It is the portrait of an unscrupulous demagogue; but Hogarth was too good an artist, despite the fury with which worked, to remain entirely single-minded. He could not utterly condemn a character whom secretly he half admired; and, although he credits Wilkes with an air of devilish guile —accentuated by his crooked leer and the strange hornlike curls running backwards from the peak of his wig—he conveys the impression that this diabolical agitator may have had some of the qualities of a *bon diable*. As for Wilkes, he acknowledged the resemblance " with his usual good humour ". The print, he agreed, was an " excellent compound *caricatura*, or a *caricatura* of what nature had already *caricatured*". But, after all, he " did not make himself" and (he explained in his autobiography) " never was solicitous about the *case* of his soul, as Shakespeare calls it, only so far as to keep it clean and in health . . . His form, such as it is, ought to give him no pain, because it is capable of giving pleasure to others . . . While the share of health and animal spirits, which heaven has given him, shall hold out, I can scarcely imagine he will be one moment peevish about the *outside* of so precarious, so temporary a habitation, or will even be brought to own, *ingenium Galbae male habitat. Monsieur est mal logé.*"

Churchill, however, was fiercely indignant. For some months he had had a poem on hand, that should follow up in " smooth-pac'd verse " Wilkes's attack in " hobbling prose "; but illness and debauchery had damped down his creative fire. Yet the subject continued to attract him; he found it (he assured Wilkes) " the best Subject for a Poem I ever had in my life ". " My Head is full of Hogarth (he added the same week), and as I like not his Company I believe I shall get him on Paper, not so much to please the Public, not so much for the sake of Justice, as for my own

ease . . . a motive ever powerful with indolent minds." He had begun already: " I have laid in a great stock of gall, and I do not intend to spare it on this occasion . . ." Meanwhile Garrick was endeavouring to preserve the peace. " I must entreat of you (he wrote to Churchill) by yᵉ Regard you profess to me, that you don't tilt at my Friend Hogarth before you see me . . . He is a great and original Genius, I love him as a Man, and reverence him as an Artist. I would not for all yᵉ Politicks and Politicians in yᵉ Universe that you two should have the least Cause of Ill-will to each other ".[1] Alas, the satirist would not be deterred. Hogarth, as it happened, obtained a temporary respite when the poet again fell ill, and was obliged to keep to his room, disabled by a further " Eruptio Veneris " and " feeling most confoundedly bad "; but the poem he was meditating, his ferocious *Epistle to William Hogarth*, finally appeared on July 2nd. Few more virulent poetic satires have ever been launched against a private citizen. Churchill was a master of invective, whose verse makes up in rhetorical energy for what it lacks in literary grace. But at his best he was also a true poet, appreciative of the splendours of the English language and capable, now and then, of producing an exquisitely turned line; and in the *Epistle*, although it is an uneven work, poet and rhetorician were for a moment reconciled. Hogarth was pilloried in couplets destined to become a part of literature.

" Printed for the author, and sold by J. Coote ", Churchill's *Epistle* closely follows Wilkes's essay. Like Wilkes, he pays a high tribute to his victim's former genius. Hogarth was indeed a great artist, who had well deserved his early laurels:

[1] Quoted by Austin Dobson from an " autograph note in the Forster collection ".

" *Tail Piece : The Bathos* "

That praise be HOGARTH'S; freely let him wear
The Wreath which GENIUS wove, and planted there.
Foe as I am, should Envy tear it down,
Myself would labour to replace the Crown.
In walks of Humour, in that cast of Style,
Which, probing to the quick, yet makes us smile;
In Comedy, his nat'ral road to fame,
Nor let me call it by a meaner name . . .
Where a plain Story to the eye is told,
Which we conceive the moment we behold,
HOGARTH unrival'd stands, and shall engage
Unrival'd praise to the most distant age.

But observe the contrast between the artist and the man!
And Churchill proceeds to describe a character corroded
through and through with self-love, always loud in his own
praises, reckless and relentless in his criticism of his fellow
artists:

Speak, but consider well—from first to last
Review thy life, weigh ev'ry action past . . .
Canst Thou remember from thy earliest youth,
And as thy God must judge Thee, speak the truth,
A single instance where, Self laid aside,
And Justice taking place of fear and pride,
Thou with an equal eye did'st GENIUS view,
And give to Merit what was Merit's due?

The unhappy *Sigismunda* does not, of course, escape reproof.
In that ludicrous production the exhausted artist had at
length revealed his decadence; just as he had revealed his
increasing lack of judgement by his wild plunge into the
muddy waters of political controversy. For Hogarth had
now entered his second childhood; and although his age,
according to Horace Walpole who had frequent oppor-

tunities of meeting him, " was neither remarkable nor decrepit ", Churchill portrays the painter as a weak and maundering dotard, only kept alive by an inextinguishable fund of malice:

> *With all the symptoms of assur'd decay,*
> *With age and sickness pinch'd and worn away,*
> *Pale quivering lips, lank cheeks, and faultering tongue,*
> *The spirits out of tune, the nerves unstrung,*
> *Thy body shrivell'd up, thy dim eyes sunk*
> *Within their sockets deep, they weak hams shrunk,*
> *The body's weight unable to sustain,*
> *The stream of life scarce trembling thro' the vein,*
> *More than half killed by honest truths which fell,*
> *Thro' thy own fault, from men who wish'd thee well,*
> *Canst thou, e'en thus, thy thoughts to vengeance give,*
> *And, dead to all things else, to malice live?*

The strength of Churchill's attack is its rhetorical gusto. In one passage, however, rhetoric merges into poetry. His vision of the ageing Hogarth—established, it may be, under his mulberry tree at Chiswick, rambling repetitiously on and on, while his friends sit around in amazement and the sun sinks behind his garden-wall—has something of the grandeur and pathos we associate with epic verse:

> *Oft have I know Thee, HOGARTH, weak and vain,*
> *Thyself the idol of thy awkward strain,*
> *Through the dull measure of a summer's day,*
> *In phrase most vile, prate long, long hours away,*
> *Whilst Friends with Friends, all gaping sit, and gaze*
> *To hear a HOGARTH babble HOGARTH'S praise.*

The popular caricaturists had also been busy. With a cloven hoof and a satyr's hairy thigh, Hogarth, flanked by his faithful pug dog and wearing his celebrated cocked hat,

sits at his easel, holding his portrait of Wilkes; but behind him on the canvas an ape describes the Line of Beauty, and a tall, emaciated, one-eyed hag admires her reflection in her looking-glass. Personally even more offensive was a second cartoon entitled *Tit for Tat*, where the artist, whose eyes have a goitrous bulge, is again shown at his easel, sporting a Cap of Liberty and overlooked by a large travesty of his unsold *Sigismunda*, to which the caricaturist has added a strikingly improper touch. He had heard (Nichols tells us) from " the friend who first carried and read the invective of *Churchill* to *Hogarth*, that he seemed quite insensitive to the most sarcastical parts of it. He was so thoroughly wounded before by the *North Briton*, especially with regard to what related to domestic happiness, that he lay no where open to a fresh stroke. Some readers, however (adds Nichols), may entertain a doubt on this subject "; and certainly Hogarth lost little time in issuing a counterblast. Seizing the copper-plate from which he had printed his engraved version of the self-portrait of 1745, he erased his own features in the central frame and substituted a grotesque impression of *The BRUISER C. CHURCHILL (once the Rev:ᵈ!) in the Character of a Russian Hercules, Regaling himself after having kill'd the Monster* Caricatura *that so Sorely Gall'd his* Virtuous *friend,* the Heaven born WILKES. A bear in tattered clerical bands, embracing a massive club—of which the knobs are labelled *Lye* 1, *Lye* 2 and so on down to *Lye* 15—Churchill slobbers over a pot of porter, his oval picture having as its support not Milton, Swift and Shakespeare, but *A List of Subscribers to the NORTH BRITON* and Massinger's comedy, *A New Way to Pay Old Debts.* Trump retains his position in the foreground; but he has Churchill's *Epistle* beneath his paws and is contemptuously making water across the poem's title-page.

" Never did two angry men of their abilities (declared Horace Walpole) throw mud with less dexterity." Yet Churchill, when it was his turn to be pelted, seemed almost as much aggrieved as Hogarth. *The Bruiser* was published on August 1st; and on August 3rd he wrote Wilkes an unusually long and indignant letter: " I take it for granted You have seen Hogarth's Print—was ever any thing so contemptible . . . He has broke into my pale of private Life, and set that example of illiberality, which I wish'd . . ." The matter should not be allowed to rest there: " I intend an Elegy on him, supposing him dead." But the mistress with whom he was then established, " my dear C. W., who is this instant at my elbow, and towards whom I feel my Spirit stir and my bowels yearn tells me he will be really dead before it comes out. Nay, she at the last tells me with a kiss that I have kill'd him, and begs I will never be her enemy. How sweet is Flattery from the Woman we Love, and how weak is our boasted Strength when oppos'd to Beauty and Good Sense with Good Nature! "

Despite the encouragement supplied by his mistress and his friends, Churchill was not destined to finish his proposed elegy; and Hogarth himself, though he had originally intended to issue—and had, indeed, already drawn and engraved—a second instalment of *The Times*, which symbolised the benefits of the new reign, was evidently losing his taste for controversial rough-and-tumble. But, so long as the set-to continued, it had provided an exhibition that much amused the public. Squibs appeared in the press, satirising both opponents—for example, *A Slap at BOTH SIDES:*

Whilst Bruin *and* Pug *contend for the prize*
Of merit in scandal, would parties be wise,
And with honest derision contemn the dispute,

" *Tail Piece : The Bathos* "

The Bear *would not roar, and the* Dog *would be mute:*
For they equally both their patrons betray,
No sense of conviction their reasons convey .

—and an advertisement announcing the publication of a
fresh anti-Hogarthian caricature:

" *Tara, Tan, Tara! Tara, Tan, Tara!*
THIS Day made its appearance at the noted SUMP-
TER's Political Booth, next door to the *Brazen Head*,
near *Shoe-Lane, Fleet Street*, which began precisely at
twelve at noon, a new humourous performance, entitled,
THE BRUISER TRIUMPHANT: or, The Whole
Farce of the *Leicester-fields* Pannel Painter. The prin-
cipal parts by Mr. H——, Mr. W——, Mr. C——, &c.
&c. &c. Walk in, Gentlemen, walk in! No more than
6d. a piece! "

The professional world was deeply exercised; and tender-
hearted yet inquisitive David Garrick wrote from Chats-
worth to George Colman in London, deploring one old
friend's treatment of the other, but urgently demanding
the latest news:

" Pray let me know (he begged) how the town speaks of
our friend Churchill's ' Epistle '. It is the most bloody
performance that has been published in my time . . .
I am really much, very much hurt by it. His description
of his age and infirmities is really too shocking and bar-
barous. Is Hogarth really ill, or does not meditate
revenge? . . . Pray, write me a heap of stuff, for I
cannot be easy till I know all about Churchill and
Hogarth."

Garrick's appetite for news must have been disappointed:
the exciting conflict was never resumed. Hogarth was
tired and discouraged; Churchill, committed to a new

289

intrigue, and in some danger of being ambushed and shot down by members of the girl's family; while Wilkes was taking fresh risks and encountering unexpected perils. That November he narrowly escaped death, when Samuel Martin, a former Secretary to the Treasury, who had been attacked in the *North Briton*, and who was said to have received large sums from the government for his " secret and special service ", challenged the editor to a duel, during which four shots were exchanged and Wilkes received a serious wound. At the same time, Number 45 was denounced in the House of Commons as a " false, scandalous, and seditious libel ". Both Pitt and Temple were now beginning to lose patience with their too-intrepid adjutant; and the discovery of the *Essay on Woman*, an obscene poem of which Wilkes had printed off a few copies for his own use, helped to discredit its alleged author beyond any hope of immediate recovery. Faced with a summons to appear before the House of Commons, he asserted that he had not yet recovered from the effects of Martin's pistol-shot, then, eluding the surveillance of government-spies, slipped away to Dover and immediately crossed the Channel. Since he resolutely refused to return, he was at length pronounced an outlaw. There seemed no doubt that he was a ruined man. His allies had finally abandoned him; even Pitt had emerged from retirement to describe the *North Briton* series as " illiberal, unmanly, and detestable." Wilkes reckoned himself " an exile for life ". Luckily, he observed, he had " some philosophy "; and that philosophy, coupled with a sanguine disposition and an unusual degree of physical and nervous strength, enabled him to endure—and often to enjoy—his lot, until the moment had come for a triumphant re-emergence .

No such recovery awaited Hogarth: his physical strength was gradually declining. True, he put on a brave face,

and pretended that he saw nothing to regret in the mishaps of his recent career. " The pleasure, and pecuniary advantages, (he remarked) which I derived from these two engravings "—*The Bruiser* and the sketch of Wilkes—" together with occasionally riding on horseback, restored me to as much health as can be expected at my time of life." In fact, his health and his spirits were both precarious. A year earlier, he had " complained of an inward pain "; and the pain, which did not leave him, was accompanied by symptoms of " a general decay ". Yet he still worked hard, " retouching his plates with the assistance of several engravers whom he took with him to Chiswick "; and among the productions that he retouched and revived was his last attempt at a self-portrait, originally executed in 1758. The sixth version of the portrait, entitled *William Hogarth* 1764, represents him confronting a large unfinished picture of the Muse of Comedy. Here the face that studies the Comic Muse is already scored with tragic lines.[1] His features have lost their rotundity, his expression its air of genial arrogance, the " sort of knowing jockey look " afterwards commented on by Leigh Hunt. The cheeks sag: the eyes are heavily circled. Only the attitude in which he considers his canvas—palette and brushes in his left hand: the right hand impatiently thumbing the shaft of a broad palette-knife—suggest that, so long as he worked, he had still moments of happiness and flashes of creative energy.

Yet the depression that had enveloped him was never wholly shaken off; and, during the early months of 1764, " while the convivial glass was circulating round his own table ", he startled his guests with the sudden announcement: " My next undertaking shall be the *End of all*

[1] There is an interesting contrast between the earlier and later states of this print. Up to the third (1758) Hogarth wears a smile, which afterwards completely vanishes.

Things ". " If that is the case," answered a friend, " your business will be finished; for there will be an end of the painter." That would be so, said Hogarth, sighing heavily; " and, therefore, the sooner my work is done, the better." Next day he began his farewell-plate, delivered to the public on March 3rd. The title he adopted was deliberately misleading: *THE BATHOS or Manner of Sinking, in Sublime Paintings, inscribed to the Dealers in Dark Pictures* —a satire, according to the artist's footnote, on the " *manner of disgracing yᵉ most Serious Subjects, in many celebrated Old Pictures, by introducing Low, absurd, obscene & often profane circumstances into them.*" Embellishing the margin below are two small representations of " *The Conic Form in wᶜʰ the Goddess of Beauty was worshipᵈ at paphos in yᵉ Island of CYPRUS . . .*" and "*A Copy of the precise Line of Beauty, as it is represented in the 1st explanatory Plate of the Analysis of Beauty. Note, the similarity of these two Conic Figures, did not occur to the Author, till two or three Years after his publication of the Analysis in* 1754."

The genuine title surmounts the plate: it is simply *Tail Piece*. For into the compass of this strange engraving Hogarth has gathered a crowd of diverse images symbolising decline and disillusionment. We notice a ruined tower and a shattered column: a cracked bell and a withered tree: a crown, a bow, a gun, a palette and a wine-bottle, all of them broken and thrown aside: a clock-face that can no longer tell the hour and, high in the heavens above, the expiring Sun God on his chariot behind a yoke of dying horses. Near the decrepit sign-post of a tavern called The World's End, sprawls the exhausted figure of Time himself. The blade of his scythe has been snapped off; and at his feet a print of *The Times* is shrivelling and blackening in the flame of a candle. Time holds a copy of his will, in which he appoints Chaos as his " sole Executor ".

" *Tail Piece : The Bathos* "

His eyes are closed, and he is breathing his last with the single word FINIS. When he designed and engraved his farewell, Hogarth may have remembered Pope's magnificent conclusion to the fourth book of *The Dunciad*:

> *Lo! thy dread empire, CHAOS! is restor'd;*
> *Light dies before thy uncreating word:*
> *Thy hand, great Anarch! lets the curtain fall;*
> *And universal darkness buries all.*

But the world he showed crumbling and vanishing was the universe of his private hopes and plans; and the curtain that the Anarch released came down upon his own tragedy.

His friends now sometimes suspected that the painter had not long to live. Nevertheless, he did not desist from work; and the account of his life which he had long been writing—and which Nichols was one day to publish, having acquired the manuscript from the artist's widow—was finally wound up in a brief and somewhat pathetic paragraph:

> " Thus (he informed the reader) have I gone through the principal circumstances of a life which, till lately, past pretty much to my own satisfaction, and, I hope, in no respect, injurious to any other man. This I can safely assert, I have invariably endeavoured to make those about me tolerably happy, and my greatest enemy cannot say I ever did an intentional injury; though, without ostentation, I could produce many instances of men that have been essentially benefited by me. What may follow, God knows."

All that summer and part of the autumn, Hogarth remained at his Chiswick house. On October 24th, he took up *The Bench* again, adding the frieze of mysterious ectoplasmic heads—examples of " Caricatura " as distinct from

" Character "—which appears above the row of judges. But, on October 25th, the state of his health evidently alarmed his family; and he was transported from Chiswick to Leicester Fields, " in a very weak condition, yet remarkably chearful ". At Leicester Fields he found a pleasant diversion—" an agreeable letter from the *American* Dr. *Franklin*"—and immediately sat down to draft a reply. Before he had finished his answer, he decided that he would go to bed, but not until he had consumed a good dinner, at which " our artist . . . boasted of having eaten a pound of beef-steaks ". He was then " to all appearance heartier than he had been for a long time before ". But in bed he was " seized with a vomiting " and, in his usual impetuous fashion, rang the bell so violently that he broke the bell-rope. Mary Lewis was summoned, and two hours later he died in her arms. His disease, the doctors decided, had been some form of aneurism.

Charles Churchill did not long survive his most celebrated and most vulnerable quarry. Crossing to France in order to meet Wilkes, who hankered after the company of his old friend, he died at Boulogne on November 4th, the victim of typhoid or, as his contemporaries said, a " putrid fever ". He was only thirty-two, but enfeebled by work and debauchery; and Garrick had already compared " the bold Churchill " to a " noble ruin ". Wilkes wept over the ruin's fall; " he had never before suffer'd the loss of any friend to whom he had been so greatly attach'd " and he spent a day and a night " in tears and agonies of despair ". Carried back across the Channel, Churchill's body was committed to an English graveyard; and there, in a derelict weedy little plot, under the steep slope of the Sussex chalk downs, his brief epitaph may still be read:

" *Tail Piece : The Bathos* "

" Life to the last enjoy'd, *here* Churchill lies."

It was the epitaph he had himself composed: which, in
The Candidate, he had imagined some lonely traveller might
contemplate, not without sympathy and affection, while he
was awaiting his meal at the inn.[1] Half a century later,
Churchill's grave met Byron's eye, on his last day in
England, as he prepared for life-long exile; and he paid
his predecessor the tribute of some irregular but memorable
lines.

Far more elaborate was Hogarth's epitaph. He had
been buried in the church-yard at Chiswick; and in 1771
a committee of friends raised over his head an appropriately
dignified monument, topped by a classical urn and enriched
by Garrick's funereal verses:

> *Farewell, great painter of mankind,*
> *Who reach'd the noblest point of art;*
> *Whose pictur'd morals charm the mind,*
> *And through the eye correct the heart.*
> *If* genius *fire thee, reader, stay,*
> *If* nature *touch thee, drop a tear;*
> *If neither moves thee, turn away,*
> *For* Hogarth's *honoured dust lies here*

Garrick, it appears, had had some trouble with the compo-
sition; and he had appealed for help to Samuel Johnson,
whose regard for Hogarth prevailed over his habitual idle-
ness and stirred him to produce a strangely moving
quatrain:

[1] "Let one poor sprig of Bay around my head
Bloom whilst I live, and point me out when dead . . .
And when, on travel bound, some riming guest
Roams thro' the Church-yard, whilst his dinner's dress'd,
Let it hold up this Comment to his eyes;
Life to the last enjoy'd, *here* Churchill lies;
Whilst (O, what joy that pleasing flatt'ry gives)
Reading my Works, he cries—*here* Churchill lives."

The Hand of Art here torpid lies
That traced the essential form of grace:
Here Death has closed the curious eyes
That saw the manners in the face.

But Garrick was almost as vain of his literary, as of his mimetic, gifts; and Johnson's emendation was not incorporated in the ponderous verses that the stone-mason carved.

Meanwhile, Jane Hogarth had settled quietly down as the dignified relict of a great man. In a will dated August 16th 1764, Hogarth had left her his whole fortune, apart from a legacy of £100 to Mary Lewis and an annuity of £80 a year, payable to his surviving sister, Ann. Much of his property consisted of engravings and plates; and Mrs. Hogarth, who kept on the Golden Head, continued, with the help of Mary Lewis, to publish and market her husband's prints, until the copper plates had been so often used that they were almost worn out. But, whenever she could, particularly during her later years, she preferred to live at Chiswick. Every Sunday she attended the parish church—a stately old woman, carrying a crotched stick and wearing an old-fashioned " sacque " and a black calash, or hood, over a lofty antiquated head-dress. Mary Lewis escorted her; and an aged man-servant, named Samuel, who had wheeled her to the church-door, preceded her up the aisle, carrying the prayer-books and opening and shutting the family pew. In old age, her circumstances are said to have grown difficult, and she was granted a small yearly pension by the Royal Academy. An excellent woman, though presumably of limited intelligence, she died at the age of eighty on November 10th 1789.

Besides the apparatus of Hogarth's print-trade, she had also inherited a collection of his pictures. There was poor

Sigismunda, a perpetual source of grief, which the artist had made her promise that she would not sell for less than five hundred pounds;[1] and there were other more interesting canvases, some still unfinished, stacked up in his studio. For example, the two extraordinary productions nowadays known as *Hogarth's Servants* and *The Shrimp Girl*. The former is a study of heads, which Hogarth himself might not have ranked among his pictures intended for the general public; the latter, a rapid sketch, possibly the achievement of a single morning's inspired work. But each of them lights up his genius; and each seems to display it from a somewhat different point of view. Solidity is the key-note of *Hogarth's Servants*. Could anything be more substantial, more matter-of-fact, yet more sensitive and sympathetic, than Hogarth's handling of these proletarian English faces, with their honest unthoughtful eyes and blunt undistinguished noses and chins? The portrait of the little boy is one of Hogarth's most memorable feats. As always, when he is portraying childhood, he expresses affection and sympathy, but avoids any suspicion of sentimental prejudice. His sitter is stupid, perhaps a trifle doltish: the high smooth forehead and transparent childish skin receive the same dispassionate attention as the ugly pouting lower lip.

In love with the rich solidity of the visible world, Hogarth was also fascinated by its shimmering and dazzling evanescence. " The greatest grace and life a picture can have (he had once quoted Leonardo) is that it expresse Motion "; and, although he was enamoured of texture and linear form—we are aware of the density and volume of every object that he represents—he had soon arrived at the conclusion that " there are no lines in nature ", and that " *lights, shades,* and *colours* " make up the appearances that

1 It remained unsold until her death, when it fetched £58 16s. od.

a painter studies. Hence the realist, or pictorial dramatist, became towards the end of his career the first of the Impressionists. " Pursuing (he had declared) is the business of our lives ": movement and variety were the essence of beauty: and Hogarth's method of artistic pursuit is nowhere better illustrated than in his impression of the shrimp girl. It has been said that, in this enchanting picture, Hogarth applies to the human figure the vision that John Constable afterwards applied to landscape ;[1] and a French critic, Elie Faure, who was inclined to disparage the quality of his earlier work, agrees that, in this canvas at least, he " looks on the world like a great painter " and catches the " wandering harmonies " of his moist and temperate native land. The range of pigments employed is remarkably narrow; but their combination produces an effect of exquisite vivacity and sensuous warmth. A moment, we feel, has been snatched from time: immortality conferred on the experience of a few seconds. There is nothing classical about the shrimp girl's face; for classical beauty is always static; and her beauty is the charm of youth and vigour, which irradiates her high-coloured cheeks, her coarse dark hair and her candid smile, as, mouth half open to cry her merchandise, she swings along a London pavement. Perhaps she was crossing Leicester Fields when Hogarth threw his window up. Perhaps, on her way from Billingsgate, he sighted her in Covent Garden. But unmistakably she was a product of the London world, his own world, the nursery of his talent, the forcing-house of his creative gifts. No artist has been more deeply devoted to the city in which he was born and died; and such was the enthusiasm with which he portrayed his background that his imaginative re-creation has become a part of " real life ". A London crowd is still Hogarthian: there are

[1] See *Hogarth* by William Gaunt. Faber, 1947.

many corners of the modern metropolis where his influence is still strong, and where the dramas that he staged might even to-day find an appropriate setting. Immense was the painter's debt to London; yet it seems scarcely so considerable as London's debt to William Hogarth.

BIBLIOGRAPHY

ANTAL, F. *Hogarth's Borrowings.* The Art Bulletin. College Art Association of America. March 1947.

ARMSTRONG, SIR WILLIAM. *The Art of Hogarth.* Printed as introduction to Austin Dobson's *William Hogarth.*

BECKETT, R. B. *Hogarth.*

BERESFORD CHANCELLOR, E. *The Annals of Covent Garden and Its Neighbourhood.*

BOAS, FREDERICK S. *An Introduction to Eighteenth-century Drama.*

BOWEN, MARJORIE. *William Hogarth: The Cockney's Mirror.*

British Museum. *Burney Newspaper Collection.*

British Museum. *Catalogue of Political and Personal Satires.*

BROWN, G. BALDWIN. *William Hogarth.*

BROWNLOW, JOHN. *The History and Design of the Foundling Hospital.*

BURKE, JOSEPH. *The Analysis of Beauty, with Rejected Passages from the Manuscript Drafts and Autobiographical Fragment.* Edited with an Introduction.

COCKS, J. G. B. (with STRATHEARN GORDON). *A People's Conscience.*

COLERIDGE, HARTLEY. *Essays and Marginalia.*

COMPSTON, H. F. B. *Thomas Coram: Churchman, Empire Builder and Philanthropist.*

COOK, THOMAS. *Hogarth Restored.*

CUNNINGHAM, ALLAN. *The Lives of the Most Eminent British Painters.*

DOBSON, AUSTIN. *William Hogarth.*

ESDAILE, KATHERINE A. *The Life and Works of Louis François Roubiliac.*

FERRERS, E. *Clavis Hogarthiana: or, Illustrations of Hogarth . . . from Passages in Authors he never read.*

FRY, ROGER. *Reflections on British Painting.*

GAUNT, W. *Hogarth.*

GAY, JOHN. Poetical Works.

GAY, PHOEBE FENWICK. *Life of John Gay.*

GEORGE, M. DOROTHY *London Life in the Eighteenth Century.*

GORDON, STRATHEARN (with J. G. B. COCKS). *A People's Conscience.*

GRANT, DOUGLAS. *The Poetical Works of Charles Churchill.*

HAZLITT, WILLIAM. *The Round Table.*

HERVEY, LORD. *Memoirs of the Court of George II.* Edited by Romney Sedgwick.

HOGARTH, WILLIAM. *The Analysis of Beauty.* MDCCLIII.

HOMES DUDDEN, F. *Henry Fielding, His Life, Work and Times.*

IRELAND, S. *Hogarth Illustrated. Graphic Illustrations of Hogarth.*

IRVING, W. H. *John Gay's London.*

JOURDAIN, MARGARET. *The Work of William Kent.*

KURZ, HILDE. *Italian Models of Hogarth's Picture Stories.* Journal of the Warburg Institute, Vol. XV, 1952.

LESLIE, C. R. *A Hand-Book for Young Painters.*

LEWIS, W. S. *Three Tours Through London in* 1748, 1776, 1797.

MITCHELL, CHARLES. *Hogarth's Peregrination.*

MOORE, R. E. *Hogarth's Literary Relationships.*

MORLEY, HENRY. *Memoirs of Bartholomew Fair.*

NAMIER, SIR LEWIS. *The Structure of Politics at the Accession of George III.*

NICHOLS, J. B. *Biographical Anecdotes of William Hogarth.*
 The Genuine Works of William Hogarth: with Biographical Anecdotes.

OPPÉ, A. P. *The Drawings of William Hogarth.*

Bibliography

PHILLIPS, HUGH. *The Thames about* 1750.

PIOZZI, H. L. *Johnsoniana.*
 Autobiography, Letters and Literary Remains of Mrs. Piozzi (*Thrale*), edited by A. Hayward.
 Thraliana. The Diary of Mrs. Hester Lynch Thrale (*Later Mrs. Piozzi*), edited by Katherine C. Balderston.

POSTGATE, RAYMOND. *That Devil Wilkes.*

READ, STANLEY E. *Bibliography of Hogarth Books and Studies,* 1900–1940.

REYNOLDS, SIR J. *Portraits of Sir Joshua Reynolds,* edited by Frederick W. Hilles.
 Yale Edition of the Private Papers of James Boswell.
 Discourses.

RICHARDSON, JONATHAN. *The Theory of Painting: Essay on the Art of Criticism: The Science of a Connoisseur.*

ROBSON, R. J. *The Oxford Election of* 1754.

ROCQUE, JOHN. *Plan of London,* 1746.

ROUQUET, JEAN. *L'Etat des Arts en Angleterre.*
 Lettres de Monsieur xx à un de ses Amis à Paris, pour lui expliquer les Estampes de Monsieur Hogarth. MDCCLVI.

SALA, GEORGE AUGUSTUS. *William Hogarth: Painter, Engraver, and Philosopher.*

SANDBY, WILLIAM. *Thomas and Paul Sandy, Royal Academicians.*

SHERRARD, O. A. *A Life of John Wilkes.*

SITWELL, SACHEVERELL. *Conversation Pieces* and *Narrative Pictures.*

SMITH, J. T. *Nollekens and His Times.*

SUMMERSON, JOHN. *Wren.*

TAYLOR, TOM. *Leicester Square: Its Associations and Its Worthies.*

THRALE, H. *Thraliana,* edited by Katherine C. Balderston.

TRUSLER, THE REV. JOHN. *Hogarth Moralized.*

VERTUE, GEORGE. *Notebooks.*

WALPOLE, HORACE. *Letters.*
 Anecdotes of Painting in England.

Bibliography

WARD, NED. *The London Spy.*

WEBB, GEOFFREY. *Wren.*

WHEATLEY, H. B. *London Past and Present.*
 Hogarth's London.

WHITLEY, W. T. *Artists and their Friends in England.*

WILENSKI, R. H. *English Painting.*

WILKES, JOHN. *The Correspondence of John Wilkes and Charles Churchill.*
 Edited with an Introduction by Edward H. Weatherly.

WILLIAMS, BASIL. *The Whig Supremacy, 1714-1760.*

WORLEY, GEORGE. *St. Bartholomew the Great.*

YORKE-LONG, ALAN. " George II and Handel." Article in *History Today.*
 Oct. 1951.

INDEX

Account, An, of . . . the Five Days Peregrination (Forrest), 109-117, 203

Adams, Elizabeth (prostitute), 100

Addison, Joseph, 50, 163

" Alsatia " (slum district), 157, 209

Amelia, Princess, 163 ✗

Analyst Besh—n, The (Sandby), 238

Anecdotes of Painting (Walpole), 258

Anecdotes of William Hogarth— see Nichols, J. B.

Anna, Princess of Orange, 121-123 ✓

Anne, Queen, 36 ✓

Anraadt, Pieter van, 63

Antiquities of Athens Measured and Delineated, The (Stuart and Revett), 263

Apology, The (Churchill), 271

Arbuthnot, Dr. John, 50

Archer, Lord, 149

Argyll, John, second Duke of, 58

Armstrong, Sir William, 200-201

Arne, Mr. (undertaker), 76

Astley, Thomas (wig-maker), 78

Auditor, The, 268

Augusta, Princess of Wales, 268, 281

Author Run Mad, The (Sandby), 238

BAMBRIDGE, THOMAS (Warden of the Fleet), 76-78

Banbury, 247

Baron, Bernard, 170

Barry, James, 193

Bartholomew Close, H's childhood in, 13, 19, 20, 146

Bartholomew Fair, 15-16, 59, 146n., 232

Beckett, R. B., 66n.

Beckford, Alderman William, 92n.

Beckingham, Stephen, 65

Bedford, Francis, fourth Earl of, 24, 105

Bedford Arms, Covent Garden, 85, 108-109, 111, 116, 117

Bedford Coffee House, 108, 224

Bedlam, 133-136, 144

Beggar's Opera, The (Gay), 52, 56-61, 96, 102, 199; its effect on H, 59, 61; his scenes from, 64, 65

Bellamy, George Anne, 199

Benson, William, 37

Bentley, Mother (bawd), 100

305

Berkeley, Mrs. Theresa (bawd), 84

Berkeley Square, 153n.

Bertie, Lord Albemarle, 254-255

Billingsgate, 111

Birch, Dr. Thomas, 234

Blake, Joseph (highwayman), 60

" Bloody Bowl " cellar, 209

Bolton, Charles Paulet, third Duke of, 59, 65, 199

Bononcini, Giovanni Batista, 55

Boswell, James, 60, 135, 190

Boucher, François, 74

Boydell, Alderman, 126

Bray, Thomas, 245

Bridewell, 98

Bridgeman, Charles, 128

Bristol, St. Mary's Redcliffe, 252

Briton, The, 268

Brown, " Capability," 128

Brown, Dr., 235

Buckingham, George Villiers, Duke of, 101

Burke, Edmund, 235

Burke, Professor Joseph, 218, 224, 225, 227

Burlesque sur le Burlesque (Sandby), 237

Burlington, Richard Boyle, third Earl of, 38, 40, 41, 55, 64, 172, 187

Burlington, Lady, 55

Burlington House, 43-44

Bute, James Stuart, third Earl of, 267-268, 271, 278, 279, 281

Butler, Samuel (*Hudibras*), 47

Button's Coffee House, 50

Byron, Lord, 295

CALAIS, 202-203, 204-206

Callot, Jacques, 238

Campbell, Colin, 38, 43

Canaletto, Antonio, 156, 157, 158

Candidate, The (Churchill), 295

Cardigan's Head Tavern, 151

Careless, Betty (prostitute), 136

Carestini, Giovanni (singer), 175

Caroline Wilhelmina, Queen, 52-53, 55, 66n., 67, 122, 123-124, 128n., 161, 166-167, 267

Castell, Mr. (architect), 75

Castlemaine, Sir Richard Child, Viscount, 65, 66

Champion, The, 138n., 188

Chandos and Buckingham, James, Duke of, 41, 44, 45

Chardin, Jean-Baptiste, 204

Charing Cross, 151, 158; pillory, 81-82, 83

Charlemont, Earl of, 255-256, 257

Chartres, Colonel Francis, 93-94, 97

Chatham, 112, 113

Cheere, Henry, 202

Chelsea, 160

Chelsea Hospital, 36

Chéron, Louis, 39

Chesterfield, Philip Stanhope, fourth Earl of, 44

Child's Coffee House, 50

Chipping Norton, 247

Chiswick, 41, 54; H's house at, 187, 192, 196, 291, 293-294; H buried at, 295

Chiswick House, 187

Churchill, Charles, 269-274, 280, 283-290, 294-295

Cibber, Caius Gabriel, 134, 135

Cibber, Colley, 56

Cibber, Theophilus, 103

Clerkenwell, Richard H's house in, 21, 23, 27

Cock Lane, 17

Coghill, Faith (later Wren), 39

Coleraine, Lady, 68, 69, 70

Coleridge, Hartley, 197

Colman, George, 190, 289

Conduitt, John (Master of the Mint), 68

Constable, John, 298

Coram, Captain Thomas, 160, 162-165

Cornel, Theodosia (prostitute), 245

Correggio, Antonio, 174, 259n.

Covent Garden, 24, 27, 31, 85, 197, 234; Thornhill's studio in, 50, 104, 118; bohemian life of, 104-109, 175; in H's *Morning*, 149-150

Covent Garden Journal, 107

Covent Garden Theatre, 271

Cowper, William, 134-135

Cox, Mary, 65

Craftsman, 120, 121

Cranbourne Alley, 193; H's apprenticeship in, 23, 24, 28

Crébillon, Claude P. J. de, 174

Crooke, Japhet (forger), 81-82

Cuckold's Point, 209

Culloden, 181, 182

Cumberland, William Augustus, Duke of, 54, 68, 69, 179-180, 181

Cuzzoni, Francesca (singer), 43

Daily Courant, 78, 85

Daily Journal, 59, 78, 81, 91

Daily Post, 78, 79-80, 83, 84, 91, 170

Dalton, James (highwayman), 96

Dance, George, 17

Danckerts, Henry, 62

Dashwood, Sir Francis, 269

Dashwood, Alderman George, 242

Dashwood, Sir James, and Oxfordshire Election (1754), 242, 243-244, 246

De Arte Graphica (Dufresnoy), 227n.

Defoe, Daniel, 87-88, 101, 102

Delacroix, Eugène, 200

Derby, 179, 181

Desaguliers, John Theophilus, 68

Devonshire, William Cavendish, fourth Duke of, 253

Dickens, Charles, 144, 159, 212

Diderot, Denis, 235
Diego, Hannah (convict), 60n.
Disputationes Grammaticales (R. Hogarth), 20, 88
Dobson, Austin, 191n., 201n., 202, 284n.
Dodington, George Bubb, 74, 250-251
Douglas, Mother (procuress), 106, 180, 210
Dowe, Robert, charity founded by, 18
Drury Lane, dissoluteness of, 81, 83-84, 96, 128
Drury Lane Theatre, 86, 102, 103; rejects *Beggar's Opera*, 56
Dryden, John, 68-69, 227
Dubois, Luke (duellist), 128
Dufresnoy, Charles Alphonse, 227, 228
Dunciad, The (Pope), 98n., 121n., 157n., 187, 293
Duncombe, Mrs. Lydia, 119
Dung Wharf, 156

EDWARDS, MARY, 168-170
Ellis, John, 233
Ellis, William, 136
Enquiry into the origin of our Ideas of the Sublime and Beautiful (Burke), 235
Epistle to Dr. Arbuthnot (Pope), 66n.
Epistle to William Hogarth (Churchill), 284-286
Essay upon Projects (Defoe), 87
Estimate of the Manners and

Principles of the Times (Brown), 235
Eugène, Prince, of Savoy, 75n.
Evelyn, John, 35

Fables (Gay), 54
Falkirk, 181
Farinelli (singer), 56, 129, 175n.
Fatal Extravagance, The (Hill), 87
Faulkner, George (bookseller), 138
Faure, Elie, 298
Fawkes, — (conjurer), 80, 146
Fenton, Lavinia (later Duchess of Bolton), 57-59, 197, 198-199
Fermor, Lady Sophia, 68
Fielding, Henry, 75, 136, 188, 189; and crime-wave, 80, 207, 211; praises H's *Progresses*, 138; H's profile of, 263
Figg, James (prize-fighter), 128
Finchley, 180-181
Fisher, Kitty (courtesan), 170
Fleet Canal, 157
Fleet Prison, 75-77
Folkes, Martin (Foundling Hospital governor), 164
Foote, Samuel, 190
Forrest, Ebenezer, and *Peregrination*, 109-118
Foundling Hospital, 163-164, 183, 192
Fox, Henry, first Lord Holland, 67, 265

Fox, Stephen, first Lord Ilchester, 67
Fragonard, Jean Honoré, 74
Franklin, Benjamin, 294
Frederick, Prince of Wales, 267
Frederick William II, King of Prussia, 183
Freke, John (surgeon), 185
Freshwater, Elizabeth, 20
Furini, Francesco, 259n.

GAMBLE, ELLIS, H apprenticed to, 23, 32
Garrick, David, 252, 271; character of, 189-190; H's portraits of, 191; and H's feud with Churchill, 284, 289, 294; his epitaph for H, 295-296
Garth, Sir Samuel, 50
Gay, John, 105n.; disappointed in George II, 53-54; and *Beggar's Opera*, 56-61; and *Trivia*, 154-155, 167
Gentleman's Magazine, 80, 137
George I, 33, 52, 53, 55
George II, 52-53, 54, 55, 122, 161, 166, 167, 183, 266-267
George III, 267-268, 272
George, M. Dorothy, 211n.
Gibbons, Ann—*see* Hogarth, Ann (mother)
Gibbs, James, 43, 142
Gibson, Edmund (later Bishop of London), 19, 97
Giulio Cesare (Handel), 55
Goadly, Mrs. (procuress), 84
Golden Head, Leicester Fields,

H's establishment at, 104, 118, 186, 188, 196, 216, 296
Gonson, Sir John, 82-83, 93, 97
Gostling, William, 109n.
Gould, Mrs. (procuress), 84
Gourlay, John (pimp), 93
Grain, Isle of, 112
Grant, Sir Archibald, of Monymusk, 77
Gravesend, 111, 112, 116
Gray, Thomas, 188
Greene, Dr. Maurice (musician), 185
Greenwich Hospital, 36
Greenwich Palace, 25, 124
Grenville, George, 281
Grosvenor, Sir Richard, and *Sigismunda*, 256-260
Grosvenor Square, 153n.
Grub Street Journal, 98n., 143
Guilford, Frederick, second Earl of, 241n.

HACKABOUT, KATE (prostitute), 83-84
Hampton Court, 25n., 36
Handel, Georg F., 55, 57, 72n., 185, 187
Hardwicke, Philip Yorke, 1st Earl of, 250n.
Hardy, William (goldsmith), 32
Harley, Robert, Earl of Oxford, 132
Harrison, Elizabeth, 119
Hawksmoor, Nicholas, 36, 37, 38, 211

Hayman, Francis, 130, 170n., 202

Hazlitt, William: on *Beggar's Opera*, 61; on *Marriage à la Mode*, 173, 174, 178-179

Heidegger, John James, 43

Hell Fire Club, 269

Henley, 244

Hervey, John, Baron, 66-67, 70, 122, 123, 167

Hervey, Moll (brothel-keeper), 82-83, 84

Heywood, Thomas, 86

High Life Below Stairs (Townley), 189

Highgate, 29

Highmore, Joseph, 39

Hill, Aaron, 56, 87

Hoadly, Benjamin (Bishop of Bangor and Winchester), 160-162

Hoadly, Benjamin jr., 160, 188, 218

Hoadly, John, 160, 188

Hoare, Mr. (banker), 259

Hog Lane, 152

Hogarth, Ann (mother), 20, 21, 30, 31; death, 126

Hogarth, Ann (sister), 21, 30, 31-32, 196, 296

Hogarth, Jane (wife), 117n., 125, 276, 280, 293; runaway marriage, 70; character of, 71-72, 196, 231, 238, 296; childless, 192; model for *Sigismunda*, 257-258; last years, 296

Hogarth, Mary (sister), 21, 30, 31-32; death, 196

Hogarth, Richard (father), 22-23; failure as schoolmaster, 19, 97; hack-writer, 19-21, 88; his Latin dictionary, 20; educates son, 21, 27; death, 30

Hogarth, William: birth and ancestry, 13, 19-21; scanty education, 21, 220; apprenticed to silver-plate engraver, 23-25, 27-29; established in Long Lane, 30; begins feud with Kent, 39; bookseller's hack, 42; independent, 42; plates pirated, 43; wins law-suit, 47-48; attends Thornhill's classes, 49; introduces conversation-piece, 61-70; marries Jane Thornhill, 70

Reconciled with Thornhills, 103; his tour to Gravesend, 109-118; his Copyright Act, 121, 126-127, 136; fails in "grand style," 141-143, 257-261, 275; sale of pictures, 170-171; rebuffed by George II, 183; self-portrait, 184-185; home life, 186, 196; friendships, 187-190; visits France, 202-206; quarrel with Richardson, 213-216; failure of second public sale, 216; publishes *Analysis of Beauty*, 220; appointed Serjeant-

Painter, 253; reverts to engraving, 253-255; "farewell" pictures, 255-261; illnesses, 261, 262, 280, 290; disastrous quarrel with Wilkes and Churchill, 271-290; ridiculed, 278-279, 284-287; death, 294

Characteristics, interests, etc.:

Absent-mindedness, 280; aggressiveness, 185; animals, love of, 192; appearance, 31, 72-73, 112, 115, 184-185, 190, 239, 291; arrogance, 115, 216, 218, 264-266; bohemianism, 104, 277; botany, interest in, 233; boxing, interest in, 230; children, love of, 69, 192-195, 297; connoisseurs, dislike of, 139-141, 215; cultivation, alleged lack of, 117; dandyism, 31, 191; dress, 184, 191; humour, sense of, 110, 113, 118, 185, 232; idleness, 25, 27; irascibility, 102, 118, 186; literature, interest in, 189, 218; magnitude, impressed by, 230; memory, technical, 28-29, 86, 90, 224; mimicry, gift for, 21; movement, passion for, 178, 181, 229; pleasure, love of, 26-27, 50, 104; praise, strong appetite for, 138, 185, 190; shortness, 31, 72, 112, 115, 190; stage, love of, 21, 59, 63, 89, 92, 146, 232; women, attitude towards, 195-197

Works:

After, 73-74; *Analysis of Beauty, The* (book), 169n., 194-195, 204n., 213, 218n., 220-239, 260, 279; *Assembly at Wanstead House, The*, 65-66; *Bathos, The*, 292-293; *Battle of the Pictures, The*, 171; *Beckingham, Stephen, and Mary Cox, Wedding of*, 65; *Beer Street*, 19, 208, 211-212; *Before*, 73-74; *Beggar's Opera* (scenes from), 64, 65; *Bench, The*, 254, 293; *Bruiser, The* (*C. Churchill*), 287-288, 291; *Calais Gate*, 204-206, 262, 274; *Characters and Caricaturas*, 145; *Charmers of the Age, The*, 145; *Cockpit, The*, 147n., 254-255; *Columbus Breaking the Egg*, 221n.; *Conquest of Mexico, The*, 65, 68-70, 179; *Consultation of Physicians, A*, 145; *Coram, Captain Thomas*, 160, 162, 164-165, 168; *Credulity, Superstition, and Fanaticism*, 263-264; *Distressed Poet, The*, 145, 146, 197; *Edwards Family, The*, 168; *Election Series*, 248-252, 262, 271; *Emblematical Print on the South Sea Scheme*, 42; *Enraged Musician, The*, 145, 146; *Enthusiasm Displayed*, 106n.; *Fenton, Lavinia*, 197, 198;

Fielding, Henry, 263; *Figg, James*, 128n.; *Five orders of Perriwigs, The*, 169n., 263; *Four Stages of Cruelty*, 81, 208, 210; *Four Times of the Day, The*, 145, 146, 149-152, 171; *Fraser, Simon, Lord Lovat*, 182-183; *Garrick, David, and his Wife*, 70, 191; *George II and Family*, 124; *Gin Lane*, 19, 208, 210-211; *Good Samaritan, Parable of the*, 142-143; *Graham, Lord George, in his Cabin*, 70; *Graham Children, The*, 70; *Harlot's Progress, A*, 86, 89-103, 118, 120, 127, 136, 138, 144, 171, 173; *Hervey, Lord, and his Friends*, 65, 66-68; *Hoadly, Dr. Benjamin, Bishop of Winchester*, 160-162, 168, 198n.; *Hogarth, William*, 291; *Hogarth (Self-Portrait) with Dog*, 184-185; *Hogarth's Servants*, 186, 297; *Industry and Idleness*, 106n., 208, 209-210; *Invasion, The*, 252; *Lady's Last Stake, The*, 194, 256; *Laughing Audience, The*, 145; *Lottery, The*, 42; *Malcolm, Sarah*, 119-120; *Man of Taste, The, or Burlington Gate*, 44, 121; *March to Finchley, The*, 106n., 180-181, 183, 197, 254, 276; *Marriage-à-la-Mode*, 79, 170-179, 196n., 216, 233, 254, 275; *Masquerades & Operas, or Burlington Gate*, 43; *Midnight Modern Conversation, A*, 128m, 145; *Miracle at the Pool of Bethesda, The*, 142, 143; *Rake's Progress, A*, 120, 127-139, 141, 144, 145n., 160, 168, 171, 251, 254; *Richard III*, 191; *Salter, Mrs.*, 197-198, 200; *Scholars at a Lecture*, 145; *Shrimp Girl, The*, 297-298; *Sigismunda*, 257, 262-263, 275, 285, 287, 297; *Sleeping Congregation, The*, 145; *Southwark Fair*, 128n., 145, 146-147, 181, 197; *Strode Family, The*, 192; *Strolling Actresses dressing in a Barn*, 145, 146, 147-149, 171n.; *Taste in High Life*, 168-170; *Time Smoking a Picture*, 263; *Times, The*, 273-274, 278, 279, 288; *Wanstead House, The Assembly at*, 65-66; *Wedding of Stephen Beckingham and Mary Cox, The*, 65; *Wilkes, John*, 282-283, 291; *Woffington, Peg*, 197, 199; *Wollaston Family, The*, 65

Hogarth Moralized (Trusler), 255

Holland, Henry Fox, first Lord, 67, 265

Holt, Mrs. (warehouse-keeper), 32-33

Hooke, Robert, 134

Houghton Hall, 66, 117

Howard, John, 17

Hudibras (Butler), 47

Hudson, Thomas, 202, 204n.
Huggins, John (Warden of the Fleet), 76, 121n.
Huggins, William, 121
Hunt, Holman, 129
Hunt, Leigh, 291

ILCHESTER, STEPHEN FOX, FIRST LORD, 67
Imitation of Horace (Pope), 75n.
Indian Emperor, The (Dryden), 68-69
Ireland, Samuel, 50, 185, 215, 271n.
Isaacs, J., 228

" JEW BILL " (1754), 245-246, 249-250
Jew Decoy'd, The (ballad-opera) 103
Johnson, Dr. Samuel, 60, 74, 135, 204n., 268, 279; H's first encounter with, 189; on Garrick, 190; rejected verse for H's monument, 295-296
Jones, Inigo, 24, 104, 157, 158
Joseph Andrews (Fielding), 138
Judith (Huggins), 121n.

KECK, LADY SUSAN, 244
Kennedy, Dr. (antiquary), 227
Kensington Palace, 36, 48
Kent, William, 48, 54, 59, 65-66, 68, 172, 187; H's hatred of, 39-42; his attacks on, 42-46, 121, 123-124, 128, 237
King, Moll, 107
King, Tom, 104, 106, 107
King's Coffee House, 104, 106-108, 125, 130, 137, 149, 150, 197
Kirkby Thore (Westmorland), 19
Kirkhall, Elisha, 121
Kneller, Sir Godfrey, 62
Kurz, Hilde, 84n.

LAGUERRE, LOUIS, 25
Lambert, George, 121
Lancret, Nicolas, 214
Lane, Mrs. Fox (later Lady Bingley), 175
Lee, Richard (tobacconist), 32
Legion Club, The (Swift), 137
Leicester Fields, 24, 27, 104; H's headquarters in, 118, 186, 188, 196, 294
Leicester House, 24, 53, 55, 267
Lempster, Lord, 68
Lennox, Lady Caroline, 68
Leslie, C. R., 147, 149
Lessing, G. E., 235
Letter Concerning Design (Shaftesbury), 37
Lewis, David (harper), 196n.
Lewis, Mary (cousin of Jane H), 196, 294, 296
Lewis, Paul (convict), 60n.
Lillo, George, 86-87, 102
Lincoln's Inn Frields, 43, 57, 58

Liotard, John, 204
Lomazzo, Giovanni Paolo, 227, 238
London, *passim;* background of H's childhood, 13-19, 23-24; Wren's rebuilding plans, 36, 153; crime-wave in, 80-86, 207, 209; drunkenness, 81, 207, 210-211; pleasure-quarter of, 104-109; H as a reporter of, 144-159, 298-299; population of, 152, 208-209; crowded and form-less, 153, 155, 176; Thames-side, 155-158
London Bridge, 155-156, 176
London Merchant, The (Lillo), 86, 102
London Spy (Ward), 16, 106
Long Lane, Smithfield, H's home at, 30, 31-32, 45
Louisa, Princess, 68, 69
Lovat, Simon Fraser, twelfth Lord, 181-183
Lure of Venus, The, 103
Luxborough, Lady, 234

MACCLESFIELD, 179
Macclesfield, Earl of, 243, 249
Malcolm, Sarah (murderess), 74, 103, 119-120
Mapp, Sarah (bone-setter), 145
Marlborough, Charles Spencer, third Duke of, 241-242, 243
Martin, Samuel, 290
Mary, Princess (daughter of George II), 68, 69

Minster, 112
Misaubin, Dr. John, 98-99, 173
Moll Flanders (Defoe), 84n., 88
Momus turn'd Fabulist (Forrest), 110
Monitor, The, 268, 273
Montagu, George, 258, 265, 266
Montagu, Lady Mary Wortley, 53
Montagu House, 158
Moorfields, 134-135
Moral Essays (Pope), 44, 94n., 101
Morell, Rev. Thomas, 187, 188, 219, 220
Morris, Joshua (upholsterer), H's law-suit against, 47-48
Muffet, Mary (prostitute), 98n.
Murphy, Arthur, 268

NABBES, THOMAS, 16n.
Nature Adorned by the Graces (Rubens), 91n.
Needham, Mother (bawd), 82, 84-85, 93, 97
New Dunciad, A (Sandby), 238
Newcastle, Thomas Pelham-Holles, first Duke of, 273
Newgate Gaol, 16-17, 18, 103, 119-120; and *Beggar's Opera,* 56, 59-60
Newton, Sir Isaac, 68
Newton, Rev. John, 134
Nichols, J. B., his biography of H, 29, 117-118, 120, 140, 143, 182, 183, 205, 224, 271, 280, 287, 293

Nollekens, Joseph, 192-193
Nollekens and his Times (Smith), 130
Nonsuch House, 156
North Briton, The, 268, 271, 272, 273, 274, 281-282, 287, 290

OGLETHORPE, JAMES EDWARD, 74-75, 77
Old Bailey, Richard H's school in, 19, 21, 23
Old Slaughter's Coffee House, 215
Oliver Twist (Dickens), 15n., 16n.
Orange, Prince of, 121-123
Orange, Anna, Princess of, 121-123
Ossory, Lady, 171
Ottone (Handel), 55
Oxford, 81; County Election (1754), 240, 241-252

PADDINGTON OLD CHURCH, H married in, 70
Painters March from Finchley, The (Sandby), 238
Paris, 155, 203-204
Parker, Lord, 243, 244, 248, 249
Parr, Dr. Samuel, 117n.
Pelham, Henry, 74
Pennant, Thomas, 156
Pepusch, Dr. John Christopher, 57
Pepys, Samuel, 110, 147

Peregrination, An Account of . . . the Five Days (Forrest), 109-117, 203
Peterborough, Charles Mordaunt, Earl of, 43
Pine, John, 121, 206
Piozzi, Hester—*see* Thrale, Mrs.
Pitt, William (later Earl of Chatham), 268, 269, 271, 272, 273, 290
Polwarth, Lord, 79-80
Pope, Alexander, 44-45, 50, 53, 56, 66, 75n., 94n., 101, 121, 128n., 187, 293
Portmore, Lord, 169-170
Potter, Mrs. (procuress), 84
Potter, Thomas, 269
Pratt, Sir Charles, 282
Prestonpans, 179
Price, Ann, 119
Puddle Dock, 156
Puggs Graces (Sandby), 237
Pulteney, William, Earl of Bath, 74

QUEENBOROUGH, 112, 114
Queenhithe, 156
Queen's Theatre, Haymarket, 56
Queensberry, Duchess of, 54, 57
Queensberry, Charles, third Duke of, 56
Quin, James, 57, 199

Radamisto (Handel), 55, 56

Index

Rahere, founder of St. Bartholomew's Hospital, 13-15, 20

Rake Reformed, The, 108n.

Ralph, James, 187-188, 219, 235

Ramsay, Allan, 276

Ravenet, Simon François, 170

Rawlins, Nan (cock-handler), 255

Remembrancer, The, 188

Repton, Humphry, 128

Revett, Nicholas, 263

Reynolds, Sir Joshua, 170, 190, 213, 265

Riccardo Primo (Handel), 55-56

Rich, John, 57, 133

Richardson, Jonathan, H's disagreement with, 213-215, 222, 237

Richardson, Samuel, 189

Richmond, Charles Lennox, second Duke of, 67, 158

Richmond House, 158

Rinaldo (Handel), 57

Robinson, Nell (prostitute), 143

Robinson Crusoe (Defoe), 20, 88

Rochester, 112, 114

Rocque, John, 105n.

Rosciad, The (Churchill), 270, 271

Rose Tavern, Russell Street, 108, 129, 130-131, 137, 197

Roubiliac, Louis François, his head of H, 72-73, 184

Round Table, The (Hazlitt), 179

Rouquet, John, 131, 174

Roxana (Defoe), 88

Royal Academy, proposed, 236-237

Royal Academy of Music, 55

Rubens, Sir Peter Paul, 91n.

Rummer Tavern, 151

SACHEVERELL, DR. HENRY, 96

St. Albans, 182

Saint-André, M., 264n.

St. Bartholomew the Great Church, 13-14, 20, 30

St. Bartholomew's Hospital, 142, 164, 213

St. Bride's Church, 232

St. Clement Danes, 45-46

St. George's Church, Bloomsbury, 211

St. Giles's, 211

St. James's Evening Post, 140

St. James's Palace, 122-124

St. Luke's Hospital, 134n.

St. Martin's Lane, 215; H attends drawing-school in, 39, 49; Academy, 125, 236

St. Mary-le-Bow, 232

St. Mary's Redcliffe, Bristol, 252

St. Paul's Cathedral, 23, 25, 36, 232

St. Paul's Church, Covent Garden, 149

St. Sepulchre's Church, 17-18, 59

Salter, Mrs. Elizabeth, 197-198, 200-201

Salusbury, Hester—*see* Thrale, Mrs.

Index

Salusbury, John, 189, 193
Sandby, Paul, 157, 236-239, 278
Savoy, Palace of, 157
Scotin, Louis Gérard, 170
Scott, Samuel, 156, 157; and *Peregrination*, 109-118
Sedgwick, Romney, 67n.
Senesino (singer), 56
Settle, Elkanah, 146
Shaftesbury, Anthony Ashley Cooper, third Earl, 37, 55
Shakespeare Club, 271, 280
Sheerness, 112, 114
Sheppard, Jack, 60, 119
Sheppey, Isle of, 112
Smith, John Thomas, 130
Smithfield, 14-15, 21, 30, 208
Smollett, Tobias, 268, 271, 279
Society of Arts, 262
Society of Arts of Great Britain, 262
Somerset House, 157
Sorbière, M., 15
Southwark Fair, 146-147
Stanhope, Mrs. (procuress), 84
Steele, Sir Richard, 104
Steen, Jan, 62
Steevens, George, 117, 271
Sterne, Laurence, 109-110, 267
Stoke (Kent), 112, 114, 115
Strawberry Hill, 187, 188, 235
Stuart, Charles Edward, 179-181
Stuart, James (author), 263
Suspicious Husband, The (Hoadly), 160

Swift, Jonathan, 53, 55, 56, 138, 159

Talbot, William, Earl, 281
Tamerlano (Handel), 55
Taylor, W. (publisher), 20
Temple, Richard Grenville, first Earl, 268, 269, 271, 272, 273, 280, 290
Temple Bar, 24, 47
Thames, River, 155-158
Theatre Royal, Lincoln's Inn Fields, 52, 57-59
Thomson, James, 54
Thornhill, Jane—*see* Hogarth, Jane
Thornhill, Sir James, 25-26, 39, 47, 71, 72, 91n., 103, 137, 265-266; H attends his classes, 49-50, 51; H marries his daughter, 70; interviews Sarah Malcolm, 119; death, 124; influence on H, 124-125, 139
Thornhill, Lady, 103, 125
Thornhill, John, 48, 70, 103, 253; and *Peregrination*, 109-118
Thrale, Mrs. (Hester Salusbury, and later Piozzi), 170, 189, 193-194, 204n., 256
Tofts, Mary (" rabbit-breeder "), 264
Told, Silas, 210n.
Tom Jones (Fielding), 98n.
Tom K—'s: or the Paphian Grove (pamphlet), 107

317

Tothall, William (draper), and *Peregrination*, 109-118

Tottenham Court (Nabbes), 16n.

Townley, Rev. James, 189, 218, 239

Townshend, Charles, Viscount, 58, 278

Trattato dell'Arte della Pittura (Lomazzo), 227

Trivia (Gay), 105n., 154, 167

Troost, Cornelius van, 63n.

Trump, H's pug-dog, 191-192, 287

Trusler, Rev. John, 254

Turner, Sir Edward, 242, 244, 248

Tyburn, 209-210

Tyler, Wat, 14

UPNOR (Kent), 112, 114

VANBRUGH, SIR JOHN, 36, 37

Vanderbank, John, 39, 48, 49, 125

Vandergucht, Gerard, 121

Veil, Sir Thomas de, 150

Verrio, Antonio, 25

Verses on the Death of Dr. Swift (Swift), 53n.

Vertue, George (engraver), 89, 103, 216-217

Vinci, Leonardo da, 227, 254, 297

Vitruvius Britannicus (Campbell) 38

WALDEGRAVE, LORD, 267

Wales, Augusta, Princess of, 268, 281

Wales, Frederick, Prince of, 267

Walker, Thomas (actor), 57

Walpole, Horace, 44, 45, 77, 89n., 147, 187, 188, 205n., 207, 215, 265, 271, 285, 288; on *Good Samaritan*, 143; at H's public sale, 171; on *Four Stages of Cruelty*, 210; on *Analysis of Beauty*, 235; on *Sigismunda*, 258; describes death of George II, 266-267

Walpole, Horatio, 162

Walpole, Sir Robert, 33-34, 42, 52-53, 58, 117, 138, 166, 167, 268

Wanstead House, 65-66

Ward, Dr. Joshua, 96

Ward, Ned, 106n.

Watteau, Jean Antoine, 214

Webb, Geoffrey, 35, 37

Weekly Journal, 87

Weidman, Carl Friedrich (flautist), 174

Wemyss, James, fourth Earl of, 94n.

Wemyss, Francis, fifth Earl of, 94n.

Wenman, Lord, 242, 243-244, 246

West, Benjamin, 185

Westminster Abbey, 232n.

Whiston, Rev. William, 136

White's Chocolate House, 132-133, 137

Index

Whitehall Palace, 158

Whitehead, Paul, 260

Wild, Jonathan, 60

Wilkes, John, 268-276, 279-284, 287-288, 290, 294

William, Prince, 124

Wilson, Benjamin, 217-218

Windsor Castle, 232n.

Winnington, Thomas, 67

Woffington, Peg, 197, 198, 199

Woman Killed with Kindness, A (Heywood), 86

Woodstock, 241n., 244

Woolaston, Mary, 192n.

Wray, Daniel, 204

Wren, Sir Christopher, 23, 25, 34-39, 232

Wyndham, Susan, 192n.

York Water-gate, 157

Yorke, Hon. Philip, 204

7

Designed, Engraved, and Published by Wm. Hogarth, March 5th, 1753, according to Act of Parliament.